Let's See

PETER SCHJELDAHL

Let's See

Writings on Art

from The New Yorker

Thames & Hudson

First published in 2008 in hardcover in the United States of America by
Thames & Hudson Inc., 500 Fifth Avenue, New York, New York 10110

thamesandhudsonusa.com

Library of Congress Catalog Card Number 2007904771

ISBN 978-0-500-23845-5

Printed and bound in the USA by The Maple Press

Contents

Preface

This book gathers, in mostly retitled and slightly revised form, seventy-three "The Art World" columns, one "Talk of the Town" piece, and one profile from my years, since 1998, as art critic of *The New Yorker*. Having nothing to say by way of introduction that isn't at least implicit somewhere in these pages, I have had recourse to a format invented and often employed by the artist, critic, and curator Matthew Higgs: twenty questions, each posed by a different interested and interesting person. Thank you, Matthew; and thank you, questioners. I am grateful to the editor of *The New Yorker*, David Remnick, for hiring and abiding me, and to my exacting editors Charles Michener (until 2003) and the really wonderful Virginia Cannon. This book is dedicated to Brooke Alderson, Ada Calhoun, and Neal, Blake, and Oliver Gary Medlin.

Introduction: Twenty Questions

Can you think of occasions when your first response to a work of art has been, immediately and overwhelmingly, physical instead of intellectual? I mean tears, nausea, shivers, dizziness, or even sexual excitement. Could you describe one or two examples? (Ben Brantley, Chief Drama Critic, New York Times)

Aren't all responses physical—laced with hormones? Attraction or repulsion and curiosity or indifference announce themselves with bodily sensations. (Indifference feels worst: vitality gurgling down a drain.) Intellect comes along later, with its forensic tool kit. Two factors usually attend my really intense encounters: extraordinary art and a state of mind conducive to hysteria. The first time I saw Velázquez's *Las Meninas*, I had flown to Madrid through the night, unsleeping and drunk, at first, then hungover. My hotel room wasn't ready, so I found myself the first person in line—the only person, as I recall it, though that seems unlikely—at the Prado when it opened for the day. I went straight to the famous painting. I think I underwent most of the sensations that you mention, as well as one that stands out in my experience. Among the peculiarities of *Las Meninas* is how some of the pictured characters seem to meet your gaze, while others are plainly unaware of you. You have just entered the room. Your eye contact with, say, the Infanta is a fraction of a second old; her face retains the expression it had before you appeared. There's a flicker of actual time in the painting. Discovering this, exhausted in the silent museum, I became obsessed with looking at the characters faster than they could look at me. (How this was supposed to work, I can't imagine now; I was beside myself.) Then I had an auditory hallucination. I distinctly heard a rustling of one of the *menina*'s crinolines, as she was turning. This induced two thoughts: "So that's what that sounds like" and "Get to the hotel, now."

What is "taste"? (Melissa Holbrook Pierson, author, The Place You Love Is Gone)

Sediment of aesthetic experience, commonly somebody else's.

Do you still write poetry? (Luc Sante, author, Kill All Your Darlings)

No. It gave up on me in the early 1980s. I never had a real subject, only a desperate wish to be somehow glorious. When you lean too hard on anything, it breaks. This happens to all sorts of artists, all the time. I wish them the luck that I had: discovering that what you have been doing for money is what you were meant to do.

Which poets were important to your prose style and why?
(Roberta Smith, Art Critic, New York Times)

Some intoxicating sounds in my head during the poetry-active years, between the ages of seventeen and thirty, in roughly chronological order, were, besides Shakespeare's, those of T. S. Eliot, Ezra Pound, Allen Ginsberg, Richard Crashaw, Alexander Pope, Hart Crane, W. H. Auden, John Ashbery, Frank O'Hara, F. T. Prince, Wallace Stevens, D. H. Lawrence, William Blake, and Eliot again. (I omit numerous foreign poets who,

even when I could read French a little, I couldn't properly hear—except Vladimir Mayakovsky, by something like telepathy.) Rhetorical rather than formal qualities hooked me: ways of winning arguments through beauty, never mind if the argument was even comprehensible. Ashbery became my hopeless ideal: persuasion in a void of reason. At the same time, I yearned for the ghostly sanction of Rimbaud: "Take rhetoric and wring its neck." For years, I practiced automatic writing, William-Burroughsian cut-up, drugged-state notation, irrational rules, sestinas, and the like—anything to not make sense, impressively. I turned out to be an incorrigibly figurative writer. But I believe that the exercise fostered certain habits: tracking truth by ear, stalking surprise, not knowing what I have to say until I've said it. Rewriting for me is largely a matter of resaying things until they no longer worry me or perplex my editor. An utterance that sounds good isn't always right, but one that sounds bad is invariably wrong.

Back when you were writing poetry, did you ever address any art works?
Can we have a sample? (Walter Robinson, Editor, Artnet *magazine)*
Lovely, faux-naïve flower images by the artist-poet Joe Brainard inspired me to write what I hoped were lovely, faux-naïve verse aphorisms, beginning "Flowers are beautiful: this opinion / Is a democratic pleasure / As is birds are beautiful and free" and ending "What everybody knows / Is what will see us through / If anything."

Does art criticism count as an art form? An art form in the true sense, i.e., not in the sense in which mixing drinks or designing shoes is nowadays proclaimed to be right up there with painting the Mona Lisa. *Have you heard about the new boutique in SoHo where the shoes are sold in limited editions of fifty, as if they were Jeff Koons multiples? (Deborah Solomon, author,* Utopia Parkway: The Life and Work of Joseph Cornell)
Art criticism is indeed like shoe design, though it aims to fit something different. There's an art to doing anything with exceptional care, but it's just gravy when the thing—footwear, a review, a marketing plan—meets a practical need. Art proper exceeds or alters, or invents, its job description. That said, effective criticism usually has elements of performance art—a little song and dance, some standup comedy.

It's one thing for a critic to write about literature, quite another to write about visual arts: the media don't mesh. How much do you focus on a thing's objective appearance and how much on your response to it? How does physical description meld with metaphor and analogy? (Arden Reed, author of upcoming Slow Art: From Tableaux Vivants to James Turrell)
I like the discipline of writing about mute things. It feels like honest work. Words about words, when I write them, feel vaguely depraved (incestuous). Art's brute factuality makes for philosophical drama. A fact is a reality with consequences; it exists both as something and for something. Responding to art works, we rehearse attitudes toward anything that matters. As for writerly strategy, if you get the objective givens of a work right enough, its meaning (or failure or lack of meaning) falls in your lap. Metaphor and analogy fulfill description by incorporating feeling and thought, but

they are unruly and must be checked point by point, for accuracy and relevance, against the object. I want to say the most interesting and entertaining things that a work lets me say and nothing that it doesn't.

Could you cite the emulatable virtues you find in some of your role models?
(Dave Hickey, writer and lecturer)
Baudelaire's hyperalertness to consequences of the aesthetic, Guillaume Apollinaire's devotion to quickening art talk, Edwin Denby's rigorous noticing, Fairfield Porter's studio sense, Clement Greenberg's crust, Frank O'Hara's allergy to other people's ideas, Thomas B. Hess's suavity, Red Smith's valor ("Writing is easy. I just open a vein and bleed."), Roger Angell's "insatiable vicariousness," and, Dave, your melodious penetration.

I am curious about whom you read.... A colleague once said to me that I was the only
person he knew who read both Rosalind Krauss and Peter Schjeldahl with equal enthusiasm.
Do you have any enthusiasms that might come as a bit of a surprise to us—writers,
perhaps unlike you, who in their own way seem exemplary and mean something to you?
(Jack Bankowsky, Editor at Large, Artforum)
I read very few contemporary writers with enthusiasm—the feeling that a stranger has written with me alone in mind—though many with respect and some with affection. Nor do I read intellectual heroes of mine such as Baudelaire and William James that way, but with held-breath tension, straining toward their levels of intelligence and integrity—a state that has been induced in me also, incidentally, by writers uncongenial to me, including Krauss, whose ways of thinking affect the climate of criticism. If you don't consent to understand a little, on its own terms, what you dislike, your love loses muscle tone. Poets aside, writers who fill my sails tend to be novelists and essayists, usually long dead. On the couple of occasions when I've led writing workshops, I've assigned three books: Jane Austen's *Persuasion*, W. H. Auden's *The Dyer's Hand*, and Raymond Chandler's *The Big Sleep*. I won't try to say why; that would violate the terms of my intimacy with the authors.

Cite five works or shows that changed your life and five, during your career,
that changed the world. (Jerry Saltz, Art Critic, New York magazine)
Two epiphanies in 1965 in Europe, where I was passing a dismal year as a semi-starving poet, fated me. The first was brought on by Piero della Francesca's fresco *The Pregnant Madonna*, in a cemetery chapel in Monterchi, Italy, and the second by a show of Andy Warhol's Flower paintings in Paris. The Piero converted me to adoration of art, the Warhols to adoration of art in the absolute present. Since then, I've had red-letter spells with all sorts of things—movies, theater, dance, music, and books perhaps as strongly as art works, though not as often. (I'm not paid to seek rapture in other mediums.) To complete the list: Willem de Kooning's watershed painting *Pink Angels* (1945), which, in his 1967 Museum of Modern Art retrospective, became my personal totem of cosmopolitan-American triumph and sass; Cindy Sherman's show of "centerfold" self-photographs at Metro Pictures, in 1982, the breakthrough of the era's most original artist,

which convulsed my thinking about pictorial rhetoric and the uses of beauty; and Rembrandt's *Flora* of *c.* 1634 (the one in the Hermitage), a revelation of ordinary love in majestic paint that, at the Met in 1988, cured me of art for (solely) art's sake. As for world-altering occasions, the first three of the five that leap to mind have in common that I initially resented them—they wrecked notions of mine about how art stood and would stand, without immediately providing compensatory pleasures. Of course, I adjusted. (1) The sequential debut shows of Bruce Nauman and Richard Serra, early in 1968, at the Leo Castelli Gallery, initiating a reign of intimidating Postminimalism that I hoped would end soon; it hasn't yet. (2) Philip Guston's "Ku Klux Klan" show at Marlborough in 1970 (treated elsewhere in this book). (3) Joseph Beuys at the Guggenheim in 1980, a retrospective that blew away the assumption, which I had shared, that only America really mattered in new art. (4) See above, Cindy Sherman. (5) A Projects show curated by Laura Hoptman at the Museum of Modern Art, in 1997, of paintings by Luc Tuymans, John Currin, and Elizabeth Peyton, which proved that figurative painting had regained timely spunk after decades of desuetude.

I wonder if you could comment on the relationship between two recent statements—
"A test of true art is a real subject" (9/11/06) and the lament in your review of Brice
Marden (11/6/06) that he "offers something that is increasingly rare in art: high stakes."
(Stanley Fish, Professor of Law and Humanities, Florida International University)
The second statement assumes satisfaction of the first—Marden has a real subject, which I take to be a oneness of abstract form and his feelings—and alludes to a situation of art in the world: given that a painting is good, does it matter? Art used to seem a mirror and power source for cultural ideals and developments. In the 1960s, we loved that Plato quote, "When the mode of the music changes, the walls of the city shake." (Well, our music just about did that; our art may have made walls quiver slightly.) Today it's a lot when new art simply pays its freight, in small change of intrigue or charm. The Marden show gave me a whiff of the old sense of crisis, as a challenge, ethical as much as aesthetic, to eclectic, lazy values. Of course, you can bet enormously and neither win nor lose, if no one else plays. That's why I hedged Marden's thrust as an "offer." It may be wishful, but I perk up when anything bodes to deflect art-world gatherings from jabber about real estate.

Given the hugely inflated prices paid for every form of art these days and the vastly
increased publicity and critical and personal attention that attends each crowded
gallery opening and biennial and world-class retrospective, has it occurred to you
that writing about art has inevitably become another form of sports writing?
(Roger Angell, author, Let Me Finish*)*
Yes. Money and celebrity govern the art game now, and covering it is pretty well reduced to reporting scores. Goodbye to critics functioning as scouts, umpires, scorers, clubhouse cronies, and occasional coaches—not a dire loss, perhaps. Good collectors routinely display keener judgment of relative quality than critics. Preposterous

amounts of money seem to concentrate the mind. Of course, they also affect how criticism is read. These days, when you use the word "value" and mean something besides price, you probably have to spell it out. That's disheartening. But there remain plenty of interested people who put only the cost of ballpark (I mean, museum) admission where their mouths and hearts are. They like to look and to talk over what they've seen. Critics, like sports writers, inform and flavor impassioned conversations. Meanwhile, there remains at least one nice difference between art and baseball: in art, none of the players knows for sure what the game is. I enjoy pointing this out.

You once said that naïveté is the holy grail of artists. How is this still possible given the current art world, which is ineluctably "the apparatus the artist is threaded through," to borrow a phrase from Robert Smithson? (Lynne Cooke, Curator, Dia Art Foundation)
Everybody a Parsifal. I conceive of the artist's naïveté as mulish resistance to all reasonable or righteous explanations of how things are or should be. Blinking in the face of the world's certainties, the artist thinks, "Even so ..." (Anyone might, but with far less at stake.) Baudelaire called the artist a child who has acquired adult capacities and discipline. I think it's self-evident. Artistic temperament sets in at an early age, though it may not be realized until later, if at all. (Only fools and dilettantes deem it a happy fate.) Unlearnable, the vocation of art entails idiosyncratic strategies for learning, toward unclear but peremptorily felt ends. Sincerity and belief in something are indispensable, never to be compromised; but they are perfectly consistent with sophistication and even guile. (A spy always in enemy territory, the artist must be cunning to survive.) Smithson's remark is deliciously sly, coming from a dinosaur-loving, religiously obsessed New Jersey kid who made up mutations of both art and the art world as he went along, to suit himself.

You have been a critic through four or five generations of artists. I wonder how it all seems to you now, looking back. I think of the book by Tom Brokaw, The Greatest Generation, *about how the time of the Second World War produced great leaders. That was certainly the case in art. Can you talk about changes since then? (Marian Goodman, gallerist)*
Intellectually, I shun myths of decline. The present is always the best time, by dint of being the only time there ever is. But, like anybody else's, my heart has its tragic tale. My Greatest Generation straddles Brokaw's, in ways that I realize only now. My father fought in that war. He got a medal but scorned it. He said he hated the Germans less than his officers. I grew up with a double romance of patriotism and insubordination. That wasn't rare in my war-baby (a tick older than baby-boom) cohort; it tore many of us to moral shreds in the 1960s. The Abstract Expressionists, when I discovered them, seemed to knit those extremes, giving me intimations of wholeness that fired me with nostalgia for a time I hadn't known. In the 1960s, that synthesis split into Pop (democratic glee) and minimalism (democratic anomie). I shuttled between them to visit parts of myself. I hung around some of the tough-minded, experimental, hermetic scenes of the 1970s, without enthusiasm. They daunted me. I even tried quitting art criticism but found myself really suited for nothing else. (Being a college dropout

saved me from teaching.) The early 1980s revival of painting and public sensation aroused me. I saw great promise in the moment and a role for myself in promulgating it. Its disintegration taught me a lesson in humility. I was bored by the installational, make-believe-political 1990s, but by then I had ceased looking to new art for redemption. The recent sprawl of plural styles is fine with me. It affords lots of options to criticism. But yes, Marian, we will not disbelieve that there once were giants.

You have closely observed several generations of artists. Do you think that things have changed for women artists, or are they still at a disadvantage compared with their male colleagues? (Ann Philbin, Director, UCLA Hammer Museum)
Leading artists are still mostly male and overwhelmingly white. Oddly enough, for a nest of liberals, the art world is mystically conservative. One reason is compulsive responsibility to past art, which preserves old values. Consider avant-gardism: a legacy of boys' clubs, in which women and minorities, to register, have been expected to enter pleas for their special identities. Concern for identity is murder on artists. Art, Gertrude Stein observed, is a pursuit of *entity* that succeeds "while identity is not." That changes for nobody. It takes time for new values to seep down to the water table of full-strength tradition. This is happening. Rather suddenly, most of the freshest painting these days is by women. Another generation or two should suffice to retire the question, at least in the United States.

This collection showcases your abundant virtues as a critic and a writer. So what are your vices as a critic and a writer? (Christopher Knight, Chief Art Critic, Los Angeles Times)
Shh! My detractors have enough ammunition already. I'll cite just one outstanding frailty: short-windedness. My muse won't play except at standard column lengths. I can manage a bit more with the right subject and a tailwind, but north of two thousand words I start to lose all sense of structure and seize up. I've tried writing books. Other people write books. What can't be said swiftly seldom gets said by me.

If a brilliant piece of art criticism earned the writer a work of art discussed therein, what object would now be gracing your home? (Ann Temkin, Curator of Painting and Sculpture, Museum of Modern Art)
Brilliance being in the eye of the beholder, my readers would have decided that, and I might well be stuck with some albatross that I rashly used for target practice. So it's just as well that journalistic propriety forfends the thought.

In his book Blink, *Malcolm Gladwell writes about rapid cognition, about the kind of thinking that happens in the blink of an eye. He says that, typically, your mind takes about two seconds to jump to a series of really powerful and important conclusions— though not necessarily good or proper conclusions—about, say, someone you are meeting for the first time, or a car you are thinking of buying. What do you learn about*

*an art work you've never seen before in the first two seconds? And then what do you do,
as a writer, to capture in prose what you have intuited—and to get beyond that first
impression, if your critical faculties impel you to?*
(Gerald Marzorati, Editor, New York Times Sunday Magazine*)*

Thanks for making me feel like a fish asked how it swims! And I haven't read
Gladwell. But here goes. I think I don't get beyond my first impressions of art works
so much as rerun them—having second and third first impressions, if you please.
Unlike people and car salesmen, art stands still—all there, all at once. It doesn't alter;
we do. Most artists understand that their work's effect should be permanently instan-
taneous. (Those who slow viewing down or trip it up are special cases: Chardin, early
Cubism, Marcel Duchamp.) Mistakes are part of the experience. They aren't even
mistakes, necessarily, but supplementary information. Say a painting reminds me
of de Kooning, and the comparison goes nowhere. I drop the idea but remember it:
saying how the painting is not like a de Kooning may be a useful way to talk about
it later. First impressions are always cluttered with associations. We can't immedi-
ately know anything except in terms of what we already know. (Wallace Stevens
wrote, "Sight / Is a museum of things seen.") So I look again, each time with less
thought, letting the work's strangeness (if it has any; if it doesn't, I'm gone) take over.
Then it's a matter of how many relooks are required to reach the work's bedrock of
fact, where its meaning resides. In the best instances, I am reduced to alert, receptive,
immaculate stupidity.

*Is there a process you use, whether analytical or emotional, when considering
unfamiliar or new works of art? (Steve Martin, author and performer)*
Yes, in hard cases. If I strongly like or dislike a work, I simply argue for my response,
finding things to say to win your agreement. That's straightforward. Art that doesn't
excite me, either way, demands a method. Call it secondhand narcissism. I ask myself
what I would like or dislike about a work if I liked or disliked it. Or else, putting
myself in the place of the artist, I wonder why I would have done that, if I did it. I
build a lawyerly case that justifies the work's existence, character, and consequence.
I take professional pride in being able to do this, just not too often. Nothing ruins a
critic like pretending to care.

What question would you like to ask yourself?
(Matthew Higgs, artist, critic, and Director, White Columns, New York)
"Peter, what are your loves?" My family; a number of other people, most of whom
know who they are; baseball; and fireworks (the ones I set off, with help from friends,
at our annual Fourth of July party in Bovina, New York—reader, you're invited;
bring a dish).

AMERICA

What's American? I am. I've always been obsessed with my nationality—not that I understand it. Americanness is the world's most abstract political and spiritual condition. For one thing, anyone from anywhere might become an American. Raise your right hand and you're in like Benjamin or Aretha Franklin. To call yourself something special—a chip off the old *Mayflower*, say—and to uphold it as being exceptionally American is obnoxious. You will get jumped, deservedly, if you try it. Americanness is nobodiness. Deep down, I feel like nobody; and this void in me is the earnest of my belonging. A hole in my heart pledges allegiance to America.

As a nation, the United States is a fiction that stands on three legs: first, a set of eighteenth-century political documents, which we argue about continually; second, the cautionary example of the Civil War, which fates us to stick together no matter what; and, third, daily consumption of mass culture. That's it. Everything else, however tremendous, is secondary. Tripods are precarious, as I'm reminded whenever I encounter intimidatingly foursquare foreigners, with their knitted residues of land, race, religion, and language. The rest of the world deems Americans superficial, and that is correct. What the rest of the world may not grasp is that we are profoundly superficial. The supple, adhesive, masking surfaces that are maintained by our culture industries around the clock let us pass for a people. (As a balance-of-trade bonus, their shimmer seduces paying audiences everywhere.)

For me, the most telling nugget of American literature is two lines in Julia Ward Howe's *The Battle Hymn of the Republic*: "In the beauty of the lilies / Christ was born across the sea." That is to say, Christ sure didn't come from anywhere around *here*. We lack sacred ground except by expropriation from the Indians. We skitter about this beautiful continent like drops of water on a hot plate. Meanwhile, we shrink from national introspection for a good reason. Every inward probe of Americanness runs off a cliff immediately. It is in free fall that we recognize ourselves and, often with rather complicated laughter, salute one another.

We have one main poet and one main artist. The poet is Walt Whitman, who finessed the indecency in America of being someone in particular by becoming, for the course of a poem, everyone in particular. Our artist is the mooncalf Jackson Pollock, whose drip paintings give lyrical and lumpen, comprehensive presence to nobodiness. Andy Warhol gave presence to a symptom of the condition: America's cult of fame. Throughout our tradition, the real American feeling appears in fissures and fragments, when nonentity blooms. It happens in *The Great Gatsby*. Much of the blues is about it. It ate Edgar Allan Poe up.

"Make Some Sense of America," say the ads for the Whitney Museum of American Art in New York's huge, desperately ambitious exhibition "The American Century: Art and Culture, Part I, 1900–1950," which jams all five floors of the building with about seven hundred thematically grouped art works and artifacts. The command rankles. What does the Whitney imagine we're up to, out here today? ("Take a Break from Making Some Sense of America"—now, that would entice.) I have nonetheless obeyed the ad literally, postponing until now my verdict that the show is forced and lame. Its wrongheadedness starts with the title, a stupid torturing of Henry Luce's hortatory slogan of 1941, and goes to the bone. Lessons can be learned from this sizable failure.

One is that triumphalism, the quite respectably American form of hysteria which Luce pushed, is not fungible. It is perfect for a day or two after our team wins the big game, but ordinarily we must have recourse to milder ways of feeling good about ourselves. By trying to inject fifty years' worth of multitudinous stuff with V-J Day juice, the Whitney makes most of it look baffled and sullen—especially the painting and sculpture, which dominate the show. The modest prestige of American modern art from before the Second World War, strenuously nurtured by revisionist art historians since the 1960s, may never be recovered. Having applauded, at various times in the past, the rediscovery of many of the little masters in this show, I now find myself understanding why each of them came to be neglected in the first place. Even the passionate Marsden Hartley and the irrepressible Man Ray come off as shrunken and stale. The show exudes the exquisitely demoralizing air of a salesman hawking goods for which he has no personal use.

Nearly all American art of the period in question was not only provincial in relation to European art but off the point of America. It was a nervous, prickly, hothouse assortment of transplants and grafts, directed toward unselfconfident New York circles even when it affected universalist or heartland bona fides. Edward Hopper was an exception: a New Yorker who invented an empire of American solitude. Sometimes I feel like going down on my knees in front of a Hopper, but what would I do then? Pray to nothing? Another exception was Norman Rockwell, a homegrown adept of democratic manners who, in the show, seems to be smiling beatifically at so many fellow Americans doing their things, however incomprehensibly.

Halcyon American sophisticates were bound to despise Rockwell, because, as a magazine illustrator, he stood with industrialized popular culture. As long as Americans felt inferior to Europe, many of us were more Roman than the Romans, parading secondhand high-cultural hauteur. America's spontaneous strengths were dubbed "kitsch"—an epithet that obliterates clear thought. Note what happens at the Whitney when some choice product of popular culture—music, movie clips, filmed dance, photojournalism—obtrudes in the installation: a viewer's heart leaps with joy is what happens. The video replay of a cherry-toned pan of the incredible pseudo-Babylonian set in D. W. Griffith's *Intolerance*—a beauty-of-the-lilies orgasm if ever there was one—struck me, for a moment, as being worth whole rooms of

semi-Cubist paintings. This wasn't the paintings' fault. It was the Whitney's for pitting frail and sensitive art against the juggernaut of classic Hollywood on suicidally level ground.

The Whitney's arrangements of things from the 1920s ("Jazz Age America") and 1930s ("America in Crisis") endorse Romantic diddles: nature-mystifying as in Georgia O'Keeffe, industry-idolizing as in Charles Sheeler, folkmongering as in Thomas Hart Benton, proletariat-vanguarding as in Ben Shahn. These rhetorical jags feel pathetic. They presume that the chronic isolation of creative individuals in America can be redeemed by goodwill gestures toward the common people. I am reminded of the Great American Joke: Lone Ranger and Tonto surrounded by hostile Indians. Lone Ranger says, "It looks like curtains for us, Tonto." Tonto says, "What you mean 'us,' white man?" In America, one speaks for oneself in the never certain case that one has a self to speak for and that anybody will be impressed.

For greatest American artist of the first half of the twentieth century, I nominate Arshile Gorky, who puts in a perfunctory appearance at the end of the show. He counted for the most in the most resonant and consequential way. A traumatized and manic Armenian immigrant, Gorky took up the cause of modern painting (from the top, with Picasso) as if his life depended on it. He developed drenchingly songful modes of abstracted thicknesses and thinnesses, which he taught to Willem de Kooning. He conveyed the possibility of local world-class painting to all of the fledgling Abstract Expressionists. He made works that give and give, feeding himself into them. After a Job-like siege of personal misfortunes, he scrawled "Goodbye My Loveds" on a crate and hanged himself in 1948. I can imagine nothing finer and more terrible than to feel like a Loved of Arshile Gorky.

By corralling miscellaneous forms of American art in a form that is typical of our culture at its most overbearing—the blockbuster exhibition—the Whitney has caught itself in a bind. It's as if a box of candy were delivered on the back of an elephant. How likely is it that the recipient will devote undivided attention to the sweets? This blundering beast of a show is, finally, viewer-proof. It comes across as so thrilled with itself that one's own little opinions are irrelevant—if one could muster enough concentration to form opinions amid the ambient razzmatazz. We are left with a pretty good demonstration of what art, like the individual soul, is still and always up against in America.

April 17, 1999

BEAUTY

I
t was a beautiful day in Washington, D.C. when I travelled there to see
"Regarding Beauty," a show of contemporary art at the Hirshhorn. The Mall was
a river of yellow sunshine. The Washington Monument in its present lacy sheath of
scaffolding looked as breakably slender as a wand. I popped into the National Gallery.
Rembrandt's *Lucretia* brought me close to tears. Then a Titian portrait started in on
me—but time was short. As usual while walking in L'Enfant's maze of a city, I got
lost. I asked a woman in a cherry-red coat for directions. She said, "I'm going that
way. Follow me." I did so, slowing to her pace and towed along in a turbulent wake of
redness amid greenery that was singed by encroaching autumn, under a furiously
blue sky.

"Regarding Beauty" added little to my delights that day. This interests me.
The show reflects a growing, wonderfully confusing debate in the art world about the
value of aesthetic pleasure. The curators, Neal Benezra and Olga M. Viso, are not
about to go whole hog for that value. After a period of thirty years in which art theory
(and the training of curators) has carefully excluded—or downright insulted—the
animal joy of the mind that is beauty, Benezra and Viso demonstrate nerve just by
broaching the subject. Their selection favors works that, rather than being beautiful,
are "about" beauty or, if beautiful, are presented in the antiseptic manner of chloro-
formed butterflies. The curators approach beauty cautiously. Benezra ventures in the
show's catalogue that "today beauty might be praised as a concept that acknowledges
regular shifts in cultural perception."

But beauty is not a concept. To begin with, it is a common word, defined in
a dictionary as "the quality present in a thing or person that gives intense pleasure or
deep satisfaction to the mind." Unless we are desperately sad or angry, we have occa-
sion to use the word every day—almost always correctly, even when the pleasures
and satisfactions in question are only a little bit intense and a little bit deep. Is beauty
in the eye—and the brain, heart, and gut—of the viewer? Sure. That's where it can
do the most good. Beauty harmonizes consciousness from top to bottom. It is as
organically vital as digestion. Beauty is, or ought to be, no big deal, though the lack of
it is. Without regular events of beauty, we live estranged from existence, including
our own. Yearnings for beauty in one who is incapable of it give rise to thoughts of
suicide: beautiful surcease.

We don't depend on new art to provide us with beauty, which is just as well.
Don't blame the artists for this. Ever since art lost the patronage of clerics and aristo-
crats who required beauty to promote their authority, it has been stuck with serving
the scarcely voluptuous agendas of bureaucratic and educational institutions,

novelty-craving commerce, political ideologies, and, in the best instances, rawly ambitious and audacious individuals. As a professional priority now, beauty belongs to organs of commercial culture which must please or die. Glance at the ads in any slick magazine. Many are beautiful, albeit in a cause that does not stir the soul. Few artists today can muster uses for beauty that are as compelling as an advertising art director's home mortgage. We will have beauty galore in art if we give it cogent motives beyond our mere hankering. Can beauty pay again? That's the crux of the beauty debate in the art world.

O.K., what's beautiful in "Regarding Beauty"? My scoring tots up a couple of dozen of the show's eighty-eight works, representing nine of thirty-four artists: Matthew Barney (color photographs related to his celebrated "Cremaster" films); Vija Celmins (dense paintings of starry skies); Félix González-Torres (a string of glowing light bulbs); Roy Lichtenstein (a cartoonish sunset); Agnes Martin (a blue-and-gold abstract painting); Charles Ray (a giant female mannequin with red dress and icy attitude); Gerhard Richter (Photo-Realist landscapes); Pipilotti Rist (a video in which an actress insouciantly smashes car windows with a flower); and Andy Warhol (*Marilyn Monroe's Lips, Triple Elvis*). Each of these works brought about in me, if only mildly, the simultaneous physical relaxation and mental arousal that are beauty's hormonal signature. They did so without boosts from the show's hanging, which gives equal weight to every item.

"There's no accounting for taste," it is said. Actually, there is every kind of accounting for taste, but there's no accounting for beauty. Beauty sails past the office in the brain where accounts are kept—and where failed beauty accumulates. Why don't perceptually ravishing works by Anish Kapoor and James Turrell make my cut? Kapoor's hole in the wall lined with gorgeous red pigment and Turrell's disorienting chamber of exquisite light effects entertain, certainly. My personal accounting staff explains that these works lack sufficient capital investment in the coin of meaning. They are glamorous rather than beautiful: hedonistic and only too confident of pleasing, like people who pride themselves on being irresistible. Beauty isn't beauty if it doesn't inspire awe for a specific proposition about reality. Beauty makes a case for the sacredness of something—winning the case suddenly and irrationally. It is always too late to argue with beauty.

Reviewing my list of the Hirshhorn show's gems, I note that all of them, except the painting by Agnes Martin, reach beyond fine art for their propositions, importing content from theater (Barney), science (Celmins), interior decoration (González-Torres), commercial art (Lichtenstein), fashion display (Ray), nature photography (Richter), rock video (Rist), and publicity (Warhol). It's as if each artist had coaxed a divine genie from a mundane bottle, then broken the bottle. What moves me is a feat of purification that could not occur unless it started with impurities. Beauty in art often hinges on something gauche. The amateur melodrama of the scene in Rembrandt's *Lucretia*—a young Dutch model in a fancy dress, pretending that she is going to stab herself—is essential to the picture's gradually dawning

paroxysm of terror and tenderness. Like many another great artist, Rembrandt finesses his medium's artificiality by embracing it. *Lucretia* is capricious and sacred—beautiful.

Does much recent art reveal our culture's corrupted state as regards beauty? So goes an argument for work that delivers deliberately failed beauty straight to the mind's accounting office for forensic analysis. Such work may indict visions of feminine beauty, say, as a conspiracy to make women feel bad about themselves—as if then making viewers feel bad about themselves evened the score. But authentic unhappiness commands respect. Cindy Sherman's ten self-photographic works in this show burlesque the formal rhetoric of moviemakers and Old Masters with magical skill and a hurting heart. I'm reminded of the editor Shrike's advice to the hero of Nathanael West's *Miss Lonelyhearts*: "When they ask for bread ... give them stones." Sherman piques our hunger for beautiful images even as she feeds us grotesqueries. The moral knowledge of her intoxicating art is profound.

"Regarding Beauty" thinks too much. It tries to put intellectual handles on a phenomenon that suppresses intellect altogether, to the understandable dismay of theorists and scholars. Beauty isn't articulate. Beauty isn't nice. The curators, taking their eyes off the ball, reproduce vulgar misunderstandings of beauty, confusing it with lesser qualities, such as prettiness. They chose for the cover of their catalogue an assemblage of silk flowers by Jim Hodges. It looks terrific, but its effect stands in relation to beauty as a friendly wave does to a punch in the mouth. To say that beauty is mysterious to the thinking mind isn't enough. Beauty presents a stone wall to the thinking mind. But to the incarnate mind—deferential to the buzzing and gurgling body—beauty is as fluid, clear, and shining as an Indian-summer afternoon.

November 1, 1999

CALDER IN BLOOM

An interviewer once asked Alexander Calder if he ever felt sad. "When I think I might start to," he replied, "I fall asleep." On another occasion, he spoke of the "big advantage" he had because of his inclination to be "happy by nature." Calder, who died in 1976 at the age of seventy-eight, in fine productive fettle almost to the end, made many such remarks, which are certain to daunt ordinary maladjusted citizens. Perhaps vengefully, some people persist in regarding him as trivial, which he isn't. His work is often great, sometimes O.K., and once in a while fairly bad, but it always operates at a high level of formal and philosophical intelligence. It also wears well. The plangent insouciance of Calder's best work looks ever stronger—and, in a real way, more serious—than most other canonical styles of the twentieth century. (And the flat champagne of his failures comes across as a test to see if we're paying attention.) Above all, Calder was an extraordinarily successful maker of public art in an age when the terms "public" and "art" began to consort with each other like cats in a sack. It's not quite that we love his costume jewelry for the world's plazas. Better, we take it in stride as self-explanatory and all but inevitable. A Calder doesn't set off the questions that abort so much public art in our democracy: What is that? What is it doing there? When will it go away?

A rangy outdoor and indoor exhibition entitled "Grand Intuitions: Calder's Monumental Sculpture" has opened at the Storm King Art Center, in Mountainville, New York. The show is a good excuse, where none is needed, for spending leisurely hours in Storm King's forty-one-year-old sculpture park, which is the most enjoyable one that I know. The five-hundred-acre spread descends in cliffs and hillocks from its stone château of a visitor center, where small art works nestle. There are paths and meadows, woods and water, massed rhododendrons, and an august maple allée. Toy-like cars and trucks moving along a nearby, picturesque stretch of the New York State Thruway contribute soft whizzes and hums to a musical mix of wind and birdsong. The permanent collection includes one big black Calder, *The Arch*; a number of pieces by David Smith, which will convert any doubter of Smith's genius; and several huge—by which I mean enormous—works by Mark di Suvero, which make the best possible case for this artist. Worth a trip by itself is Richard Serra's sublime *Schunnemunk Fork*: four massive steel plates that jut from slopes over a wide area. (A famous sourpuss, Serra may be the anti-Calder; one fancies that when he starts to feel sad he perks up.) The Serra stands out in a conservatively modernist collection whose mind has wandered from major names since its peak acquisition period, in the 1960s and 1970s. (Don't look for a Nauman, a Shapiro, a Cragg, a Deacon, a Puryear, or a Koons.)

There are abundant unexciting works at Storm King, many of them grimly swearing by fashions of yesteryear. But finding works to disparage makes a stimulating contribution to the park's experience. Your critical mood is dignified by the presence of so much art of unimpeachable excellence and buoyed by natural and landscaped beauty that does not quit. In the case of Calder at Storm King, quality comparisons are tempered by the realization that a sylvan setting doesn't really suit his talent. Public Calders work best with architecture, largely because they symbolize absent nature. He was so good at giving tons of painted steel sprightly airs of flora and fauna that even his weakest urban sculpture makes its site a better place. Viewed amid greenery, the artificial characteristics of Calders come to the fore, and only his most rigorously considered pieces hold up. The show includes two such masterpieces.

One of them is *Southern Cross* (1963), whose orange, four-legged base rises twenty feet and supports a mobile of ten black petals that spans twenty-seven feet. It's a marvel, and it aces my usual test for sculptures that have more than one footing: each of its encounters with the ground conveys a distinctive weight and pressure, as articulated as a ballet step. The overhead mobile is like a congeries of holes in the sky. Turning on the wind, it suggests two shattered figures scrambling endlessly after each other. The work is grand but so affable that you forget to be awed. At the same time, it exudes a certain bothered urgency. Imagine someone using gestures to describe a tree to people who have never seen one: "This thing comes out of the ground and goes up, and there's stuff above that spreads out and hangs down—aw, the hell with it." As an abstractionist, Calder doesn't seem to derive forms from nature so much as fumble to reinvent nature from hearsay. His style touches something heroic and hapless in us all.

Calder's originality is not a matter of his work's stylistic repertoire of spiky lines and blobby shapes, which he openly cribbed from Picasso, Arp, and Miró. It consists in giving confident presence to sculpture as a real object set loose in the real world. When modern art brought sculpture down from its traditional pedestal, it entered into an often self-defeating combat with buildings, trees, people, and all other regularly existing things. Calder met the challenge with polymorphous charm. A work by him may be *like* a building, *like* a tree, *like* a person, and so forth, in ways that we can't quite determine, because we're kept too busy enjoying the effect. His sculptures fail when there is a rupture between our scrutiny of their parts and our perception of their wholeness; this happens when an element (such as the flag shape atop a piece called *Black Flag*) feels clunkily arbitrary or when some tricky dynamic (such as an illusion of interpenetrating planes, which never works for Calder) seems far too pleased with itself. As if to admonish its erring brethren, the faultless *Five Swords* (1976) holds forth at the focal center of Storm King. The work is orange-red, faded by the sun in places to a suave salmon. It is a cluster of five half-moonish shapes whose every aspect surprises. The "swords" snap into being when the planes are viewed end-on, then vanish when seen from the front. From one vantage point, the ensemble reads as a logo of the artist's initials.

"Five Swords" is the liveliest bunch of stationary matter imaginable. It possesses in full measure the bristling concision of Calder's indoor work, which is represented at Storm King by many maquettes for monumental projects and by, among other things, two of the best sculptures of the last hundred years: *Devil Fish* (1937) and *Black Beast* (1940). Both consist of cut-out, thin, black-painted metal sheets. The roughly six-foot-high, surrealistic *Devil Fish* sports random fins and, depending on one's point of view, seems viscerally to leap, dive, or flop to the side. (Viewed at one angle, it limns a woman in sensual abandon.) *Black Beast* is a fiesta of ravishing modern-art vamps that defies rational description.

One merely silly piece at Storm King, the archly cartoony *A Two-Faced Guy* (1969), made me realize how seldom the doggedly whimsical Calder is silly. Indeed, his gravity as an artist cannot be separated from his insistence that ephemeral pleasure is a sufficient goal for both good art and a good life. Calder took everything seriously except seriousness. As a consequence, his reputation steps easily from his time into ours, while innumerable self-important moderns stay mired in their receding heydays. At Storm King, my companion and I chatted giddily about this phenomenon as we strolled in the force field of the endlessly stunning work by Serra—an artist who takes nothing lightly except lightness. We could see Calders as shaped accents of color in the distance. They seemed to be waving amiably to the saturnine Serra, whose embedded slabs induce consciousness of the earth's sullen, immemorially surging mass. Meanwhile, grasses swayed and clouds kited. Whatever other people in the world were doing that afternoon, we had them beat.

June 25, 2001

TWIN PEAKS: MATISSE/PICASSO

"Matisse Picasso," at MoMA's temporary home, in Queens, is a double-barreled blast of an exhibition with a popgun hook. With sixty-seven mostly top-drawer paintings, drawings, and sculptures by Picasso and sixty-six by Matisse, the show hardly needs a pretext, but it has one: a running dialogue of mutual attractions and abrasions between the twin godheads of modern painting. "This exhibition tells one of the most compelling and rewarding stories in the entire history of art," the catalogue introduction by the art historian John Golding begins. I'll buy that. But to extract the story—an elliptical tale, full of hints, puzzles, and fine discriminations—while looking at so much stupendous art is like trying to check the oil in a speeding truck. The show's insiderish self-regard, radiant with the leisurely delectations of an eminent curatorial team, is unlikely to charm ordinary viewers, who, clutching their twenty-dollar, timed tickets, must elbow through packed rooms for disjointed encounters with the works. But to miss this event would be a shame. It will be a permanent reference point in the challenge of deciding what survives of the rich, estranged legacy of twentieth-century art in our drastically altered times.

At the heart of the show's appeal is a cultural come-on that has not changed: stardust. To have been the best at something in a sufficiently consequential way still earns historical figures—Albert Einstein, T. S. Eliot, Muhammad Ali—near-religious prestige. In the case of Picasso and Matisse, there's the added fascination of two giants whose respective claims to the Best Painter award involve sharply disparate talents, temperaments, and philosophics. Both of them had the same ambition at the same time and in the same place: to make art that would exploit the novelty and uncover the continuity of a world under convulsive stress. Neither artist, while rolling over lesser rivals, could eclipse the other, as each freely admitted. Plainly, they made each other better, but in ways that are far more difficult to evaluate than the show's confident presentation suggests. In fact, their give-and-take is hardly unusual among artistic contemporaries. Art history is Hobbesian; all ambitious artists compete with all other artists, living and dead. This showdown of a show is an absent-minded standoff—no Ali versus Frazier, though similar in its even match of antithetical styles.

Matisse was a thirty-one-year-old paterfamilias and a presence in the Parisian art world when he began showing in 1901, the year that Picasso, a twenty-year-old tyro from Barcelona, arrived in town. Although they were immediately aware of each other, they did not meet until 1905 or early 1906, when they were brought together by the champion salonistes Gertrude and Leo Stein. Alfred H. Barr, the founding director of MoMA, once decided, on the basis of Matisse's early *Blue Nude*,

of 1901, that the older artist inspired the younger's Blue Period. Evidently, this wasn't so. The use of a dominant, pure color—especially blue—was in the air then. A magical colorist, Matisse rose to fame as the chef d'école of the new century's first major art movement, Fauvism. At the same time, he was adapting structural principles from Cézanne, notably the strategy of arranging all the parts of a subject frontally, in splayed, shallow pictorial spaces. Violent color and crackling composition fused in Matisse's revolutionary masterpiece *Joy of Life* (1905–06)—which could not be borrowed from the Barnes Foundation for this show, and is sorely missed. Picasso, in tandem with Matisse's erstwhile Fauve comrade Braque, would build on Cézanne more radically, with the stroke-by-stroke faceting of Cubism. (Matisse called Cézanne "the master for all of us"; Picasso said that he was "like the father of us all.") Picasso's breakthrough painting of 1907, *Les Demoiselles d'Avignon*, which, in Queens, hangs next to Matisse's magnificent but hardly competitive *Bathers with a Turtle* (1908), might be considered his lean-and-mean riposte to *Joy of Life*—Arcadia as a whorehouse.

Matisse coined the name Cubism as a derisive joke. He initially hated the aggressively drab new style, which incidentally torpedoed his leadership of the avant-garde. In 1908, according to Picasso's mistress Fernande Olivier, Matisse "lost his temper and talked of getting even with Picasso, of making him beg for mercy." Picasso, for his part, took offense at the arbitrariness of Matisse's decorative distortions. He said of Matisse's amazing *Blue Nude: Memory of Biskra* (1907), "If he wants to make a woman, let him make a woman. If he wants to make a design, let him make a design. This is between the two." Picasso thereby put his finger on what was disturbing about the picture while begrudging its success: in *Biskra*, the tension between the subject (the nude model) and formal invention (her serpentine contour) is both flaunted and transcended, producing a new kind of image that celebrates the painter's freedom to do as he likes, purely for the sake of pleasure. Picasso could never be so insouciantly free. His way with form had to be in strict agreement with his attitude toward the subject and with the aesthetic task at hand.

Both artists understood how opposed their world views were. At a dinner in Picasso's studio in 1907, they exchanged two paintings, neither of which owed anything to the other. MoMA shows them side by side: a very tough, ugly, proto-Cubist still life by Picasso, and a cartoonishly simplified, sweet portrait of Matisse's daughter Marguerite. Several of Picasso's katzenjammer friends—including the poets Guillaume Apollinaire, Max Jacob, and André Salmon—made fun of the socially uneasy bourgeois Matisse, and, later, made *Portrait of Marguerite* a target for rubber-tipped arrows. "A hit! One in the eye for Marguerite!" Salmon wrote in a colorful memoir. Picasso, according to Salmon, said nothing.

The masters' fans battled by proxy. "The feeling between the Picassoites and the Matisseites became bitter," Gertrude Stein later recalled. In 1911, an anonymous reviewer in Paris reported that the Cubists "are reacting, they say, against the 'colored debauchery' of Matisse." (Ah, when taste was militant!) Through it all, the

two artists often paid gracious homage to each other. In 1913, when their styles were most polarized, they got along particularly well, as both reported in letters to Stein. Picasso wrote, "We take horseback rides with Matisse through the forest of Clamart." Matisse told Stein, "Picasso is a cavalier. We are cavaliers together. This astonishes a lot of people." Matisse later told a friend that he had run into Max Jacob and said to him, "If I weren't doing what I am doing, I'd like to paint like Picasso." Whereupon Jacob said, "Well, that's very funny! Do you know that Picasso made the same remark to me about you?" The cavalier analogy is apt. The two men were courtly peers, profoundly understanding of each other while ready to come to swords' points where honor was concerned. What is moving about their rivalry is that honor, for each, centered not on their egos but in their ideas of what was worth doing in art and how it ought to be done. Their brushes were their weapons.

At MoMA, the most striking moment of influence occurs in 1916. Dazzled by Picasso's large, heraldic *Harlequin* (1915), which transposes the dynamics of Cubist paper collage into paint, Matisse took up the potential for expanding scale with broad, flat blocks of color in such paintings as *The Piano Lesson*—my favorite work in the show, with its chord-like planes of green, orange, pink, and gray, and racy accents in black and white. Each figurative element—boy, window, window grille, music rack, sculpture, candle, metronome, sketchy woman on a stool—exudes a hieratic but easy, breathing presence. I can think of nothing else in art that is at once so solemnly august and so disarmingly everyday. The picture's audacious style comes with the comforting assurance that modernity only enhances the joys of ordinary life. Produced when Europe was engulfed in war, the painting, with its beautiful elegiac gray, doesn't ignore the tragedy, but simply proposes that music and art maintain their imperturbable truth in all times.

Two things may be said about *The Piano Lesson* in the context of the show. First, its formal power seems inconceivable without the benefit of Picasso's provocative innovations in *Harlequin*. If we measure artistic greatness by formal inventiveness, Picasso is the more formidable genius, running ahead of Matisse at every juncture after 1907. But the poetry of *The Piano Lesson*—a sort of brilliant passivity, surrendering to an ineffable logic of paint and color—falls entirely outside Picasso's range. Picasso could not let anything in his work speak, let alone sing, for itself. His continual struggle with color is like his compulsive imbroglios with women, stemming from a need to control what is intrinsically uncontrollable. Picasso's will, in the form of peremptory drawing, declares itself everywhere in his art. By contrast, Matisse's line is yielding; it seems to accept the mysterious need of shapes and colors to seek their proper place and proportion. His contours are like the borders of wetness left by waves on a beach. The one major work in which Matisse tries for something like Picasso's high-handedness—the Cubistic pastiche *The Moroccans* (1915–16)—is a mess. At MoMA, it hangs next to Picasso's staunch *Three Musicians* (1921), which scolds it like a drill sergeant. But it's a tribute to Matisse's freedom that he risked failure in his efforts to extend his scope. Picasso, except during spells in his

later years, when he lived like a pampered sultan on the Riviera, could not permit himself that luxury.

The two artists are just so overwhelmingly different from each other. Each was most himself in the 1920s, when Picasso became a demiurgic Surrealist, re-creating reality to mirror his raging desires, and Matisse dawdled in Nice hotel rooms, dressing and undressing pretty models as harem girls. Both were style mechanics, shaping the look and outlook of modern culture. Perhaps only in the Renaissance, with the likes of Leonardo and Raphael, did other pairs of artists imprint history with such clashing sensibilities. The aesthetic friction between Picasso and Matisse goes to the root of conflicts that have been fundamental to Western culture since the time of the Greeks: line versus color, thought versus feeling, knowledge versus experience. The great service of "Matisse Picasso" is to hone a sense of those antinomies in action, making us reflect on how we think about art. One is compelled to take sides, though the preference may be a close call. For the record, during my first tour of the show I decided that it was no contest: Picasso ruled. A couple of hours and several viewings later, I had swung the other way. At a party, it often happens that the person you find most glamorous is not the one you think of when it's time to go home.

March 3, 2003

A WALK WITH DAVID HAMMONS

At a Starbucks in Cooper Square one recent evening, I waited in vain to meet David Hammons, the charismatic, elusive African-American artist whose much anticipated current solo show, at the Ace Gallery, is his first in New York in ten years. As the minutes went by and Hammons failed to appear (it would turn out that he was waiting for me at another Starbucks, across the square), I weighed the odds that I was being treated to a custom-designed work. Hammons's astonishing, strangely moving new installation, entitled *Concerto in Black and Blue*, consists entirely of empty, pitch-dark rooms which visitors are invited to explore with tiny flashlights in the company of other visitors whose presence is registered only by whisperings, footsteps, and firefly points of blue light. What, I thought, could be a more apt complement to an exhibition of nothing than a non-rendezvous with the artist himself?

Hammons, who is fifty-nine years old, has long flouted an art world eager to make him a star. Museums and collectors prize such racially charged objects as stones crowned with hair, which the artist collects from black barbershops, and drawings made by repeatedly bouncing a soiled basketball on ten-foot sheets of paper. He sells these works privately, often in Europe. His installations and performances tend to be ephemeral in the extreme. Perhaps his most famous work survives only in a droll photograph of the artist standing on a winter street in 1983, peddling snowballs. "I decided a long time ago that the less I do the more of an artist I am," Hammons had said to me on the phone. "Most of the time, I hang out on the street. I walk." He agreed to let me walk with him.

Apparently stood up at Starbucks, I took the walk myself, throughout the East and West Villages. I looked at things in what I fancied was a Hammonsy way: with an eye for the odd human touch. He is a connoisseur of the frowzy and the ad hoc. He once told an interviewer, "I really love to watch the way black people make things ... just the way we use carpentry. Nothing fits, but everything works.... Everything is a thirty-second of an inch off." He makes both an aesthetic and an ethic of that spirit, with or without regard to its racial provenance. Back home, rather pleased with myself, I got a perplexed call from the artist, who, after waiting for me, had set out on his own.

The following evening, Hammons and I met at the St. Mark's Bookshop, of which there is only one. A pleasantly gaunt, soft-spoken, watchful man, he wore a voluminous overcoat and a colorful knit cap. He shrugged off a crack that I made about the proliferation of Starbucks. He reveres Starbucks, he let me know, for having made café culture universal and, not least, for providing toilets to walkers in the city. He takes walking seriously. In his company, I felt introduced to the East Village, which has been

my neighborhood since 1973. Street people—or were they just people on the streets?—greeted him warmly, like constituents of a popular politician. He responded with courtly deference, giving them his full attention.

During our stroll, Hammons paused to behold casual marvels: a peculiar arrangement of potted plants braving the chill air outside a Japanese barbershop—"I always check out this place," he said—or a swath of gleaming aluminum foil, held down with dirty bricks, set to block drafts under an unused door of a restaurant on St. Mark's Place. In shadowy Tompkins Square Park, we passed a woman walking a dog that wore a floppy plastic supermarket bag on an apparently injured foot. "Something like that is worth a whole night out," Hammons said, gazing after the gimpy animal.

Hammons was born and grew up in Springfield, Illinois, the youngest of ten children of a single mother who worked menial jobs. "I still don't know how we got by," he said. A poor student, he was shunted to vocational courses. He found drawing and other art activities so easy that he had disdain for them. In 1964 he moved to Los Angeles, where, after a halfhearted foray into commercial art, he attended the Chouinard Art Institute (later CalArts). He became excited by the antagonistic avant-gardism of such L.A.-based international artists as Bruce Nauman and Chris Burden. He joined a scene that was both laid back and irascible. "If you showed more often than every three years, no one took you seriously," he said. "Some people worked and worked and never showed at all. That's what I come from." He is friends with many jazz musicians, whose scornful attitudes toward commercial success he described with relish.

Hammons's brand of Dada isn't substantially original. Yves Klein exhibited a vacant gallery, entitled *The Void*, in 1958. Innumerable artists have exploited the poignance of shabby materials. Hammons freely admits to having been influenced by Arte Povera. (He told me that he was thrilled when that movement's master, Jannis Kounellis, agreed to a dual show with him in Rome in 1993.) But nothing in contemporary art matches his poetic compound of modesty, truculence, and wit. His radical independence stands out, to say the least, in today's scrabbling art world. It also distinguishes him from the itinerant artist-shamans who pop up regularly at international festivals. He regards that circuit as a trap. "The way I see it," he said, "the Whitney Biennial and Documenta need me, but I don't need them."

At one point in our meanderings, Hammons went into a bodega on First Avenue and bought a box of rice. A few minutes later, as we were passing a church, he said, "Watch this," and tossed a few handfuls of grains the steps. I said, "Who's getting married?" He said, "The wedding was earlier. We missed it." He added, "That's for somebody who'll come along and have to deal with it." I found the stunt hokey at the time, but now I can't shake a vision of that forlorn rice, pale on cold concrete, testifying to a wedding that never took place. Hammons married young, and he has two adult children. Divorced in the early 1970s, he has never remarried. "As an artist, you have to keep reinventing yourself," he said. "In a marriage, you have to be consistent. It's difficult."

Hammons mentioned having once heard a tape of a rehearsal at which the late mystical jazzman, Sun Ra, instructed his musicians to play a standard—that is, an artifact of white culture—"incorrectly." Ra explained, "They don't need you to play their music correctly. If you do, they have you." Hammons commented, "That got to me. You know, you can play every note sharp or flat and still carry the tune." For him, violating norms and expectations seems to be a craft that demands painstaking attention to detail.

I didn't ask him what it's like being black in a profession that remains overwhelmingly white. But he volunteered, "It's like a white man in the jazz world, like Chet Baker or Jerry Mulligan. They had confidence. I feed off the confidence of jazz greats. It's a matter of confidence, nothing else." He disparaged the academic ironies of younger artists, including blacks, who pose as subversives. He said, "I'm the C.E.O. of the D.O.C.—the Duchamp Outpatient Clinic. We have a vaccine for that smartness virus that's been in the art world for the last fifty years." The cure may be expressive activity that is streetwise, heartfelt, and utterly matter-of-fact.

We stopped for dinner at a Japanese restaurant on Avenue A. Under his overcoat, Hammons wore a lavender leather sportcoat and an orange pullover shirt. He likes Japan, he said as we ordered. He recently did a work in Yamaguchi: a huge boulder set in a miniature Japanese landscape (done by a local plant nursery) on a flatbed truck, which travelled from neighborhood to neighborhood. Hammons's experience in Japan helped inspire *Concerto in Black and Blue*. A visit to the Zen gardens in Kyoto made him realize, he said, that "there are so many different kinds of nothingness."

Ace, an immense gallery on Hudson Street near the Holland Tunnel, is run by Doug Christmas, a maverick dealer whose career has been almost as unpredictable as the artist's. "Doug was after me for six years to show with him," Hammons said. "I had to wait until I analyzed the space. If you try to dominate it, it will make a fool of you every time." He said that he dislikes the sterility of most New York galleries and museums, preferring European institutions, which are steeped in history. "The only place I really would like to show at in New York is the Metropolitan," he said. "It's full of spirit."

The nothingness of *Concerto* feels beautifully measured, as if a mountain of darkness had been carved to fit snugly into the gallery's echoey rooms. As I wielded my dim cone of soft blue light, I felt curious about the identities of my invisible fellow-explorers but somehow forbidden to approach them. If the experience was profoundly disorienting, it was also endearingly funny in its frugality—a quality that is always crucial to the artist. Hammons told me that he was aggrieved that many people had been stealing the flashlights, which, he said, cost seventy cents apiece. He added that the installation, whose only materials are the flashlights, can be bought for a lofty price that varies according to how much space the buyer wants to darken. Our laughter, he didn't need to point out, is free.

December 23, 2002

RUNAWAY: PAUL GAUGUIN

A year before Paul Gauguin died, in 1903, from complications of syphilis in the Marquesas Islands, he wrote that he had a "fondness for running away." As a nine-year-old in Orléans, he recalled, he decided one day to light out for the forest after seeing a picture of a vagabond carrying a packed handkerchief on a stick. The boy filled his own handkerchief with sand, and set forth. "Watch out for pictures," Gauguin said at the end of the tale, giving it a moral that seems double-edged: beware the power of romantic images to banish common sense; but attend to it, too, and relish the sorcery. For Gauguin, running away was a theatrical act: his solitude in the South Seas played beautifully, making him a figure of scandal and envy among the bourgeois who bought his sensual visions of escape. In a letter that he wrote to a friend from Tahiti in 1897, he shrewdly prophesied, "A time will come when people will think I am a myth, or rather something the newspapers have made up." Gauguin anticipated a culture that would be avid for artistic personas. His legatees include Salvador Dalí, Andy Warhol, and Jeff Koons. Viewed with the right squint, the art world of recent decades can appear to teem with little Gauguins.

"Gauguin in New York Collections: The Lure of the Exotic," at the Metropolitan Museum of Art, is the painter's first extensive exhibition in New York since the last Met show of Gauguin, in 1959. The title perpetuates the colonial-era trope of a distant Arcadia that fueled Gauguin's pictures of savage innocence. The idea of a South Seas paradise was bunk already a century ago, by which time Polynesia was ruinously civilized. The native population of the Marquesas had fallen from an estimated high of eighty thousand to three thousand when Gauguin arrived there from Tahiti, in 1901. Encouraged by customs that lightened paternal obligations, he fathered at least four children with island women—adding to the five he had abandoned, along with his much abused Danish wife, in the mid-1880s—but his life in the tropics was not idyllic. He had the kind of petty run-ins with local authorities that dog arrogant misfits in resort towns everywhere. But no disappointment prevented him from baiting the wishful imaginations of Europeans.

Gauguin entered the world of advanced art as a collector. One-eighth Peruvian—one of his mother's ancestors had been a colonial viceroy—he spent his early childhood in Lima. At the age of seventeen, he began six years of seafaring in the French merchant marine and Navy. In Paris, he took comfortable jobs in finance and set up as a conventional paterfamilias. A passionate hobbyist in drawing and carving, he bought paintings—starting with three by Pissarro and proceeding to works by other Impressionists and by Cézanne. His tangy personality got him welcomed in studios. Degas and Manet both urged him to take his own art seriously, and

for several years he was a protégé of the fatherly Pissarro. Not long after the stock market crashed in 1882, he cast his lot as a painter. Academically unschooled, he belonged to the first generation of artists who built their styles on the airy heights of the avant-garde. Throughout his career, whenever his inventiveness flagged, the influence of Degas or Cézanne would visibly take charge.

Gauguin was not nice. He was a liar and a braggart, a competitive manipulator of weaker men, and a self-pitying wife beater who lusted after pubescent girls. Eventually, he alienated most of his allies. The drama of his relationship with van Gogh is complex. It's hard to say whether Gauguin's cruelties or the Dutch artist's deluded infatuation with his friend played a greater role in van Gogh's razoring of his ear, in 1888. But even Gauguin's later fond remembrance of the superior painter reeks of self-centeredness. "I owe something to Vincent, and that is, in the consciousness of having been useful to him, the confirmation of my own original ideas about painting," he wrote in his memoir, *Before and After*.

The Met's exhibition demonstrates how hard collectors in New York fell for Gauguin—without a great deal of discrimination—starting with the 1913 Armory Show. Significantly, the Tahitian works on the Met's walls far outnumber the paintings that Gauguin did in Paris, Brittany, and Arles. Among the Tahitian masterpieces are *Manao Tupapau (Spirit of the Dead Watching)*, from the Albright-Knox Art Gallery, in Buffalo, and the Met's own *Ia Orana Maria (Hail Mary)*—pictures whose transparently bogus religious content strangely enhances their intensity as art. But the show is dominated by lesser paintings, drawings, sculpture, reliefs, woodcuts, and such oddities as a walking stick decorated with images of a snake, a nude, and a shoe, which are not so much examples as souvenirs of Gauguin's creativity. More uneven, perhaps, than any other artist of his rank, Gauguin cheerfully confessed his limitations, notably in drawing from life. He plainly trusted the cachet of his legend to halo anything he produced; and in the United States, as elsewhere, he won that bet.

Still, Gauguin's contributions to modern painting were tremendous. His use of emotionally fraught secondary colors—aromatic strains of green, orange, and purple—was innovative, as was his way of making paint and line practically independent of each other. In *Spirit of the Dead Watching*, for example, the summary, piquant cartoon of a frightened nude prone on a bed, with a grotesque shaman figure behind her, occupies a surface that sings with unusual, sonorous color and intricate, excited brushwork. The linear design and the painterly execution register differently, though with equal force. Each can indulge in extreme decorative artifice without weakening, because the tension between them is constant and eventful, full of jangling and caressing surprises. Our eyes revel in contradictory effects that baffle our rational minds. The formal dissonance in Gauguin's paintings was the engine of his seductiveness, and it blazed a trail for modern art.

Four years after Gauguin's death, a variant of this dynamic became transcendent in *Les Demoiselles d'Avignon*, in which Picasso, while also employing exotic imagery, set the twentieth-century standard for art that transposes all sensation,

thought, and feeling into purely and aggressively visual terms. A comparison with Picasso exposes the conventionality of Gauguin's compositions, which were already conservative in relation to those of Manet and Degas. For all his fiery inspiration in color and technique, Gauguin never ceased to be a painter of regular French pictures, which unsettle traditional taste without really challenging it.

Gauguin was a transitional figure between van Gogh, the last great painter of a whole world, and Picasso, who embraced the fracturing of modern sensibility. In other words, Gauguin is neither here nor there. For him, art was more a means of disguise than an exercise in self-expression. His paintings are advertisements for himself, especially for his libertine sexuality. He didn't subsume himself in a sensuous transformation of reality, as van Gogh did, and, unlike Picasso, he was never straightforward about the nature of his erotic drives. In a vigorous recent biography, *Gauguin: An Erotic Life*, Nancy Mowll Mathews argues that the artist was strangely androgynous, and that if he was not actively homosexual, he was most stimulated by other men. Certainly, his paintings of women seem profoundly indifferent to their subjects as people and even to whatever he may have felt about his relations with them.

Gauguin's art dazzles, but it cannot be trusted. Relentlessly directed toward the art world in Paris, his immersion in the South Seas produced no reliable knowledge of island life but only romantic spice. It was as if Melville, having written the early adventure books *Typee* and *Omoo*, had never proceeded to *Moby-Dick*. And yet Gauguin's very incompleteness both as an artist and as a man gives him a peculiar immortality in the popular imagination. It is inconceivable that van Gogh or Picasso could ever be the model for a convincing fictional character, as Gauguin was in Somerset Maugham's *The Moon and Sixpence*, which became an international best-seller when it was published, sixteen years after the artist's death, in 1919. Standing somewhere between history and myth, Gauguin persists as an evergreen contemporary: the artist as narcissist and provocateur, whose genius is inextricable from his posturing.

July 29, 2002

CASPAR DAVID FRIEDRICH

A small, svelte show at the Metropolitan celebrates the museum's recent acquisition of its first painting by the great, strange, and vexing German Romantic Caspar David Friedrich (1774–1840). The work, *Two Men Contemplating the Moon* (*c.* 1830), is the last of three versions of the same imaginary scene—figures in autumnal woods at nightfall, beholding a crescent moon—that Friedrich made over the course of eleven years. The other two paintings, in one of which the figures are a man and a woman, have been lent for the occasion by museums in Germany, where all but a few Friedrichs unbudgeably reside. In its purchase of *Two Men*, the Met has jumped at a rare chance. Hung together, the lunar triad affords a revealing look at an artist who worshipped nature without ever painting directly from it. (At most, he would mix and match elements from outdoor sketches.) Also in the show are six other works by Friedrich and ten by some of his like-minded, if less adept, contemporaries. Friedrich towered in his milieu.

"Caspar David Friedrich: Moonwatchers" takes for a theme the moon as a fashionable subject of poetry, art, music, and science in eighteenth- and early nineteenth-century Germany. Scientific documents of the period are offered as a counterpoint to Friedrich's mystical pathos. The history lesson is mildly interesting, but extraneous to the effect of the paintings, whose glowering sensibility still packs an unassimilated, radical punch. An artist of the so-called sublime who gets more complex and disquieting the more one contemplates his work, Friedrich is a troublemaker among the masters. His slipperiness is like that of the concept of the sublime—a hopelessly jumbled philosophical notion that has had more than two centuries to start meaning something cogent and hasn't succeeded yet. As an adjective in common use, the word is correctly employed not by Immanuel Kant but by Frank Loesser: "The compartment is air-conditioned, and the mood sublime." Mentioning Friedrich to a serious painter invariably sparks lively talk, pro or con. Rarely direct, his enduring influence has a perennially cultish, Lou Reed-like tinge. You can generally detect its presence in works that bank smoldering emotional fires in motifs of dead calm. Friedrich holds the patent on brooding, vatic fervor.

Born into a family of soap- and candlemakers in Pomerania, Friedrich lived most of his fairly sheltered life in Dresden. He belonged, as Joseph Leo Koerner has written in a study of the artist, *Caspar David Friedrich and the Subject of Landscape*, to "the surplus of over-educated, highly ambitious, under-employed, and deeply frustrated middle-class young men" who fuelled the explosion of Romanticism around 1800. Goethe was an early champion, but the tough-minded bard got fed up with Friedrich's doomy, free-floating religiosity and willful arbitrariness regarding

color. "One ought to break Friedrich's pictures over the edge of a table; such things must be prevented," Goethe remarked on what we must charitably presume was a bad day. Friedrich was touchy and taciturn. "In order not to hate people, I must avoid their company" is one of his few recorded remarks. He was convinced of his genius on the new Romantic law-unto-oneself model, and admirers in Germany and other northern countries, including Russia, were quick to agree. He despised France, and it returned the compliment. The Louvre didn't acquire its own first Friedrich until 1975.

Fashions in art turned to naturalism and genre painting well before his death, and Friedrich slipped into near-oblivion. He was later exalted under the ugly auspices of the Nazis, who adored him as a paladin of the Aryan soul. His obscurity in the United States lasted until the appearance, in 1975, of the art historian Robert Rosenblum's hugely consequential *Modern Painting and the Northern Romantic Tradition: Friedrich to Rothko*, which shook up the Francophilia of American taste in modern art. Rosenblum's linking of Rothko's poignant color space to Friedrich's moodily hued, often empty-centered compositions was historically questionable but visually persuasive. (Rothko might as well have been thinking of Friedrich when he characterized his own abstractions as "pictures of a single human figure—alone in a moment of utter immobility.") Friedrich's legacy flared in the 1970s and 1980s amid triumphs of new German painting. Anselm Kiefer made references to the artist in works that, while efficiently stirring sensations of "sublime" landscape, probed retrospective, ghastly ironies of German Romanticism—a liberal movement that had some unpropitiously apocalyptic strains.

The Met's painting is no bigger than a briefcase, but, as often with Friedrich, it becomes monumental in memory. The two men stand on a steep path and look down on a low crescent moon whose full disk is dimly visible in a peachy glow of reflected light from Earth. The planet Venus glimmers nearby in a lavender sky. A partly uprooted oak overarches the scene. A young man leans chummily on the shoulder of a sternly upright elder, who, like many of Friedrich's heroes, defiantly wears German medieval garb, which was banned under the Metternichian order of Europe after the Napoleonic wars. Friedrich had a habit of combining nationalist resentment and spiritual transport, as if they automatically belonged together. That presumption can make one want to turn his mopey characters around and slap them. (At least, one might tell the older man that his immense, puffy beret—tradition or no tradition—looks ridiculous.) An erotic subtext is hinted at by the presence of Venus: the men are feasting their eyes on the cosmological Eternal Feminine.

Apart from his lyrical endorsement of male comradeship, there isn't a lot to be said for Friedrich's apparent ideals of human relations. Rewald writes in the show's catalogue, "Friedrich astounded his friends when he married in January 1818, having been a confirmed bachelor until the age of forty-four." In *Man and Woman Contemplating the Moon* (c. 1824), the eponymous couple stand—with her hand perched deferentially on his shoulder—as stiffly as chess pieces. A happy home is not

evoked. Nearly the same postures are struck in *Sisters on the Harbor-View Terrace* (1820), a faintly hilarious painting on loan from the Hermitage in St. Petersburg. Primly dressed, the two young women stand at a balustrade and gaze into a nocturnal, phallic forest of masts and Gothic spires. In this instance, the oddly peremptory hand-on-shoulder gesture calls irresistibly for a caption on the order of "Steady, girl." Laughing at the artist's crotchets is the only way I know to stay engaged with some of his more solemn scenes.

To stay engaged opens us to Friedrich's aesthetic genius, which sneaks up on the viewer with cunning compositions and, especially, with slow-acting color. When not converging on literally nothing, his pictorial schemes address objects that are either remote, like the moon, or obdurate, like the battered oak. Human figures intercept our gaze and transmit it into ineffable distance. The pictures don't give; they take. Something is drawn out of us with a harrowing effect, which Friedrich's use of color nudges toward intoxication. What at first seem to be mere tints in a tonal range combust into distinctly scented, disembodied hues: drenching purples and scratchy russets, plum darks and citron lights. One doesn't so much look at a Friedrich as inhale it, like nicotine. Friedrich is an artist of dusky fire, of twilight that sears. It is well worth sticking around for his shuddery pleasures, laced with something cold and weird.

October 1, 2001

DARK STAR: VIJA CELMINS

If I were stranded on a desert island and could have only one contemporary art work, it would be a picture of a starry sky, a spiderweb, or a choppy ocean by Vija Celmins—a smallish painting, drawing, or print that is somber, tingling with intelligence, and very pure. I imagine that the work's charge of obdurate consciousness would give my sanity a fighting chance against the island's lonely nights, insect industry, and engirdling, unquiet waters. Celmins, who is sixty-two, is the least well-known major figure of a generation that includes Ed Ruscha in Los Angeles, where she spent formative years, and such old friends as Chuck Close and Brice Marden in New York. Her low profile becomes her. An art-lover's artist, she inspires proprietary passion in her admirers. She seems as immune to fame as Giorgio Morandi, whose hushed still lifes move the world one solitary viewer at a time. Her eight paintings and six prints in a beautiful show, at the McKee Gallery, represent the artist in top form, casting a hermetic spell that can seem at once too deep and too obvious for words.

Celmins is a painter of nature who operates at a considerable distance from her subjects. She works from clippings of reproduced, usually black-and-white photographs, some of them decrepit or blurry, and builds her labor-intensive paintings with many glazed and sanded layers of alkyd or oil on wood-backed linen. An early anticipator of Photo-Realism—like Close, and akin to the great German Gerhard Richter—she has convincingly demonstrated that photography, far from being the death of painting, can give the medium a foundation on which to re-establish its exclusive powers. The force of her work does not come through in reproduction: you have to be there. With subtle effects of texture and captured light, her starscapes at McKee register as physical objects even as they convey infinity. You see that the "stars" are dots of white and gray paint and not distant suns, and that grayish washes are something more tangible than the nebulae or the fogs of terrestrial light that they suggest. You may reflect that each picture represents a tiny fragment of even the visible firmament, but its integrity makes for a satisfying sense of wholeness. This is a miracle of every successful painting: a world at a glance. Celmins's starscapes dramatize it with their intimate treatment of the largest possible subject. The double sensation of humility and grandeur is at once thinner and sharper in her superb prints. To evoke the spongy blackness of deep space she employs the rare technique of mezzotint, which is produced by burnishing a uniformly roughened copper plate. Her woodcuts of rumpled ocean surfaces stun. Their enraptured precision recalls the musical tapestries of Philip Glass, and, I like to think, brings a collegial smile to the spectral lips of Albrecht Dürer.

Celmins was born in 1938, in Riga, Latvia. In 1991, she described her childhood to Chuck Close: it was, she said, "full of excitement and magic, and terror,

too—bombs, fires, fear, escape—very eventful." She went on, "It wasn't till I was ten years old and living in the United States that I realized living in fear wasn't normal." A church agency brought her and her family to America. They eventually settled in Indianapolis, where she attended art school. In 1961, she won a scholarship to Yale's summer-school art program; there, she met Close and Marden. Travelling in Europe, she was astonished by her first face-to-face exposure to Velázquez, in the Prado in Madrid. "I remember remembering those paintings for a long while," she told Close. After moving to Los Angeles, in 1962, she began to paint moody, oddly Velázquez-like still lifes of things in her studio—a lamp, a hot plate, a space heater—and a view of the freeway from a snapshot that she took in her car. (That sun-bleached roadscape strikes me as the all-time definitive Los Angeles painting.) Early memories reemerged in images of fire and violence. Celmins also made poetically desolate grisaille paintings from old news photographs of Second World War aircraft. One showed a bomber aloft with stilled propellers, and with indistinguishable objects spilling from its rear door. It may be the loneliest picture I've ever seen. All of Celmins's art feels at once depressive and furiously game.

Celmins, who lives by herself in New York, is the sort of loner who has innumerable chums. She is a dog-lover, a bird-watcher, a hiker of remote deserts, and a bedevilled perfectionist. She postponed her current show once and nearly put it off again. "I was working thirteen and fourteen hours a day," she told me recently, in a tone less of complaint than of appalled surprise. "It's so hard, you know?" Her struggles with artist's block are legendary among her friends. Often, her way of dealing with it is to impose some exceptionally gruelling, low-yield task on herself. During one such period, in the 1970s, she embarked on a not quite pointless sculpture project. She cast small, found stones in bronze and painted the casts. Displayed in pairs, the natural and faux stones at first appear to be identical. On closer inspection, they reveal minute distinctions. It took her five years to complete eleven sets of the stones, which she collectively titled *To Fix the Image in Memory*. No mere trompe-l'oeil stunt, the work is haunted by a fact of difference that the artist's skill pounded down to an almost subliminal wisp. When Celmins returned to painting, she treated images as she had the stones, rendering them in ways that are both meticulously faithful and utterly artificial. Like a detective in love with crime, Celmins both exposes and dotes on our readiness to embrace illusion.

As Velázquez did—with his realistic and yet ineffable grays—Celmins operates at and beyond the frontiers of normal perception. Her painterly nuances slither into visual equivalents of sounds that only dogs can hear. (I haven't mentioned her use of color, because I almost never consciously notice the cerulean blue, yellow ochre, and burnt umber that, according to her, often infiltrate her night skies.) She once wrote in a journal, "My eyes were honed in nature. I practiced seeing the desert." And, yes, she has studied Tibetan Buddhism. Her show at McKee is satori material. It is a glum sight when you enter: clenched, dark, blocky little canvases, widely spaced in a big white room. Approaching one, you make out an image of stars

or a spiderweb. Coming closer, you discern that it is a painting. (The show made me grateful for my bifocals.) These pictures of timeless subjects take lots of time to see. I had been perusing *Night Sky #17* (2000–01) for a long while when I began to wonder about the delicate gray haze that spills from its lower right. Might that be an intruding glow of city lights? It might, I realized. With a melancholy thrill, I was struck by the homeless, cold vastness of space.

Celmins's spiderwebs amount to self-portraying symbols of her spirit as an artist. Embedding ghostly gray lines in dirty black grounds, they pay tribute to creatures that, like painters, toil in two dimensions. That she paints them from reproduced photographs minimizes any sentimental guff about nature's splendor. She divorces the subject from experience, then returns it to experience as painting. The photographs she works from are variously imperfect, and so are the pictured webs. We think of spiders as precise geometricians, but their craft—which need only withstand the thrashing of a trapped fly—is not that demanding. Spiders drop or cross silky stitches continually, and make ungainly supporting cables when required. The aim of their labor is to assure that there will be future generations of spiders to act in the same way, repeating an old, old pattern with infinitesimal variations. Celmins's web pictures do for time what her starscapes do for space: they make its unknowable extent felt. A spider's—or a painter's—fleeting stab at perfection is a negligible stitch in an unbounded fabric. Its only significance lies in our own momentary, mortal gaze as we reckon with eternity.

June 4, 2001

LIGHT IN JUDDLAND: FLAVIN AT MARFA

To get to Donald Judd's Chinati Foundation, you fly to El Paso and drive nearly two hundred cruise-control miles through sullen desert and unambitious mountain ranges to the agreeably beat-up former cattle town of Marfa. The last big event in Marfa (population about twenty-five hundred) was the filming of *Giant*, in 1955. The most robust local institution is a headquarters of the Border Patrol. A pretty good Mexican restaurant called Carmen's heads the very short list of local amenities. Judd, who died in 1994, at the age of sixty-five, first visited the town in 1971. "I think Judd sensed that he needed to get to Marfa," the architect Michael Benedikt told a symposium at Chinati in 1998. "He knew that for his Minimalist pieces to work they really had to be in a maximalist environment. He needed natural and changing light, greenery, old concrete, old buildings, and materials that had palimpsestic value." Much of an adjacent, defunct Army base, Fort D. A. Russell, was bought for Judd by the Dia Art Foundation before the artist, ever litigious, fell out with that avant-gardish patron. On his own, he snapped up additional disused facilities around Marfa dirt cheap, including airplane hangars, a bank, and a supermarket. He fashioned them into an austere utopia of concrete, metal, glass, Sheetrock, brick, and adobe. The place should be world famous. But Chinati, like its founder, bristles with defenses against vulgar renown. Such is its cussedness and esoteric glamour.

Despite Chinati's reputation as the Xanadu of Minimalism, I had somehow avoided visiting it until late this summer, on the occasion of the installation of a work, *Untitled (Marfa project)*, by Judd's closest artistic peer, the late Dan Flavin. The piece deploys three hundred and sixty colored fluorescent lights in six former barracks. Its effect, like that of Chinati overall, is both punctilious and intoxicating. Chinati anticipates visitors who are more pilgrims than tourists. Some twenty remodelled buildings house sculpture, pictorial art, furniture, and architectural designs by Judd and chosen contemporaries. Modest collections of works representing German Constructivism, Dutch de Stijl, and the Bauhaus invoke ancestral gods. The Arena, a former gymnasium, is a colossal meeting hall, whose floor of exposed gravel and concrete beams generates a raw grandeur. Under the Foundation's director, Marianne Stockebrand, a German curator and the companion of Judd's last years, Chinati keeps growing, in accord with the artist's plans. It's hard to think of a precedent for it. The best I can imagine is a cross between Frank Lloyd Wright's Taliesin West and Constantin Brancusi's sculpture park at Tirgu Jiu, in Romania. At night, a specially invited artist or writer (not me: I stayed in the Riata Inn motel) may dream on an islanded mattress in one or another building that permits no distinction between art space and space for living. Navajo blankets, pottery, and

turquoise jewelry, in Judd's own as-he-left-it bedroom, mark the place's closest brush with gemütlichkeit. The artist-designer's rectilinear, anti-comfortable furniture is ubiquitous. Anything vague or soft in your personality cringes.

Naturally, Judd's high-plains empire stars his own stuff, most notably in a kilometer-long procession of concrete modules that loom above the sagebrush, and two huge former artillery sheds that house a hundred-unit suite of his signature aluminum boxes. But Chinati attends to context, too. Back in the 1960s, Judd's claim to pre-eminence for his program of "specific objects" (taciturn forms in sleek materials, splitting a critical difference between painting and sculpture) was contested by the conceptual Minimalism of Robert Morris, Sol LeWitt, and Robert Smithson; by "formalist" work like the painted-metal sculpture of Anthony Caro; and by Pop art. Judd's cast of featured contemporaries—Carl Andre, John Chamberlain, and John Wesley—amounts to a palace guard against those threats. A tour de force by Andre—a building devoted to typewritten, framed poems—marks the limit of Judd's tolerance of conceptualism. Chamberlain's sculptures of crumpled auto bodies flip off Caro. Wesley, a wry painter of enigmatic cartoons, polices the Pop frontier. The result—augmented with single works by Claes Oldenburg and Coosje van Bruggen, Ilya Kabakov, Richard Long, Roni Horn, and others—is a tight, tendentious canon.

Dan Flavin was something of a Braque to Judd's Picasso, though he was less subordinate in achievement. (Flavin died in 1996 of diabetes, at sixty-three.) Flavin's work has brought home to more than one art lover the world-changing import of Minimalism, which reversed the old order of subject and object in artistic experience. Instead of focusing on a thing, a viewer becomes the self-conscious focus of a situation—and what's more situational than light? The experience of being literally illuminated by Flavin's cannily arrayed, perfectly scaled fluorescent fixtures can have emotional consequences that seem preposterously out of proportion to their matter-of-fact cause. His work tends to devastate traditional art in its vicinity. The critic Rosalind Krauss once described the effect that some Flavins had on other work in an exhibition at the Musée d'Art Moderne, in Paris: "The earlier paintings and sculpture look impossibly tiny and inconsequential, like postcards, and the galleries take on a fussy, crowded, culturally irrelevant look, like so many curio shops." I am here to say that the dire epiphany needn't be terminal. After experiencing Flavins, one may live to savor "earlier paintings and sculpture," though only with difficulty in the same place. To do so, one must shrug off the powerful evocation of a world that is comprehensively, vertiginously, rather brutally aestheticized along rational lines.

Untitled (Marfa project) is a handshake of Judd and Flavin at the summit of that world. Pink, green, blue, and yellow fluorescent tubes are arrayed in eight-foot-high, tilted, two-sided racks of twenty, with ten of one color to a side. The color on the back of each rack shows through between the tubes on the front. The units occupy specially built corridors at the end of six U-shaped barracks, in such a way that you either face blazing tubes or observe oblique washes of light. Behind you, as

you face the Flavins, are windows that look out onto West Texas. Daylight segues smoothly into fluorescence, and vice versa. Color combinations vary logically, from pink and green in the first two buildings, through blue and yellow in the third and fourth, to an assortment of the whole spectrum in the last two buildings. The differences feel important. The general effect is enforced meditation. No matter how busy your mind may be, its circuits are overridden by the work's steady efful- gences. The time you spend in each room is as organized as light waves are in a laser beam. The piece would be overbearing if you tried to resist it, but resistance is out of the question. You have never encountered anything that is at once sterner and more beautiful.

Chinati is a climax of the twentieth century's fixations on rational process and aesthetic purification. As such, it has an air of being entirely too good for mere human beings. No wonder that Judd, unlike his foremost contemporary, the all-forgiving Andy Warhol, has no iconic presence in the larger culture: he is ingrati- ation-free. So is Flavin, once you leave the luminous aura of his work. But consider this impressive fact: Chinati isn't getting dated; its look hasn't congealed into a period style. "Somewhere … a strict measure must exist for the art of this time and place," Judd wrote with stunning arrogance. When considered amidst the sunstruck and shadowed buildings of Chinati, the remark verges on plain sense.

The desert looked different to me as Marfa receded in my rearview mirror. Its emptiness seemed a vast frame—or, perhaps, a buffer zone—for what I'd experi- enced at Chinati, as if God were Judd's landscaper. When the first trashy, commercial tentacle of El Paso rose into view, I felt abruptly awakened from a dream of order. I also found myself breathing more easily.

September 25, 2000

DEAD-END KIDS: POLITICAL ART

"October 18, 1977," a suite of fifteen somber paintings by Gerhard Richter, belongs to a tiny category: great political art. Both the rarity and the majesty of the work shine in "Open Ends," a multiplex array of mini-shows at MoMA. The last of three grand decantings of the museum's collection, this exhibition addresses art since 1960. Varieties of political art make up about a quarter of "Open Ends." The emphasis feels well timed. Today, politics is passé on the art scene, after three decades of countercultural rampancy. What was that about? What can it mean now? Because this is MoMA, which skims the cream of every tendency, the survey—including sections entitled "Counter-Monuments and Memory" and "The Path of Resistance"—has more than a few high points. But it would be a scrappy affair without Richter's Saturnian masterpiece at its center.

Most political art is poor art and worse politics. Art is both too sensitive and too ponderous for the necessary roughness and speed of civic conflict. The drive to politicize art may be honorable, saying, in effect, "This is an emergency. Let there be hard light. Away with moonbeams." Art that takes this stance proves its integrity by becoming a relic when its occasion passes. But how many artists are willing to sacrifice their ambition to a fleeting cause? Most of them strike a political posture only when it's in fashion. Beyond that, who even cares what an artist has to say about politics? Every exception seems a miracle. Think of David's *The Death of Marat* and Picasso's *Guernica*. (The rhetoric of *Guernica* is iffy, but the spectacle of an egotist's egotist succumbing to an unselfish impulse still impresses.) Now include *October 18, 1977*, which Richter painted in 1988. It is about the Baader-Meinhof "group," or "gang" (your choice of noun indicates your bias), which convulsed West Germany in the 1970s.

Richter, along with Anselm Kiefer and Sigmar Polke, belongs to a great generation and a half of German painters who leapfrogged American Abstract Expressionism and Pop to the peak of late-twentieth-century achievement. (We discovered them tardily, in the early 1980s; we'll never catch up.) They share an inspired metaphor: the abasement of painting by photographic mediums as a corollary of catastrophic modern history. They are temperamentally distinct. Polke is gleefully demonic, Kiefer acridly theatrical. (Both are represented in "Open Ends"—Polke by a manic painting of a concentration-camp guard tower and Kiefer by one of his vatic landscapes.) Richter, who is sixty-eight, seems almost too intellectually refined to be an artist. His work, which is done in alternating styles of Photo-Realism and abstraction, brings moral depth and piercing beauty to painting in times that are skeptical of painting. The word "elegiac" is apt but too weak for images that feel so much like

extended farewells. In banal black-and-white news, police, and television shots relating to the Baader-Meinhof crew, alive and dead, Richter found his way to a point of crisis in both art and society. The work's social themes are political hope and moral disaster, I guess. But one can't speak with confidence of its meaning, which must be discerned by feel, like an object in the dark.

The Baader-Meinhof saga is long and dense. Briefly, they were young Germans who murdered and robbed to bring down capitalism. Four of them committed suicide in jail. Richter's images include a nice-girl portrait of Ulrike Meinhof alive and three closeups of her head and shoulders in profile on a morgue slab. In two pictures, Andreas Baader lies sprawled, done in with a pistol that was hidden in a record player. There are paintings of the record player and a wall of books in Baader's cell. In another cell, someone is seen hanging from a barred window. This is a woman named Gudrun Ensslin, who is also seen in a sequence of three news photographs: she turns toward us, grins, then turns away. The biggest painting in the series shows a funeral procession for three of the terrorists. The pictures are "grainy" or "blurry"—words that consort oddly with painting, whose effects are always intentional. Richter produced the look with feathered and dragged brushstrokes. Livid whites and light-drinking blacks, bespeaking flash photography, are attained by techniques of good old chiaroscuro glazing.

Given that this is political art, which side is Richter on? He is a citizen on the left, like most artists. (Why are so few original artists rightists? That's easy: the right in culture swears by art of the past.) His early experiences of the Third Reich and of Communist East Germany, which he fled at the age of twenty-nine, left him an avowed hater of ideology. But he has testified to feeling a tug of sympathy for the idealism of the Baader-Meinhof (that of Meinhof and Ensslin especially), along with horror at their deeds. This work is about conflicted conscience. It suggests a cogent sense for the slipperiest political slogan in recent use: "compassionate conservatism." Richter takes on events and social forces—including the ceaseless torrent of media imagery—that threaten to swamp personal ethics and to negate individual vision. Thus assaulted, conscience and painting hang on, marking the hours of a siege. The effort of persistence—which rejects the relief of taking sides—is desolating. This work gives nothing. It sucks oxygen out of the air.

That's Richter's Saturnian quality: a negative energy that may be the quintessence of politics in art, which always conducts attention away from the work itself to something elsewhere. It's worth noting that a great deal of political art—from Goya to the talismanic photograph of a screaming girl at Kent State—employs images of the dead. Death becomes it. Corpses halt thought. Propagandists hope that viewers, while transfixed, will be receptive to opinions that the dead, now martyrs, are safely presumed to endorse. Richter conveys disgust with all opinion, including his own. The field of political art is a spectrum between the extremes of agitation and tragedy. Agitation is ephemeral. If it is employed in a losing cause, it becomes a historical curio; if it is on a winning team, it fades into the cultural background.

Tragedy is obdurate. You can have all sorts of different ideas and feelings about it at different times, but they won't change anything.

The Baader-Meinhof series provides a harsh standard for the rest of the political art at MoMA. So much fancy attitudinizing! What, besides canny design, remains of the feminist agitprop of Barbara Kruger? Her photo-and-text stuff once seemed coolly sardonic; now it's screechy. But some tendentious works hold up. Among the politically fashionable installation artists of an era just ended—their unwieldy works in storage and their very names drifting out to sea—Félix González-Torres, who died of AIDS, in 1996, courts immortality with his ability to reconcile righteousness and charm. His friendly works, such as a replenishable pile of take-one anti-gun posters, appear at several points in "Open Ends." Sue Coe, the English graphic guerrilla, strangles charm. Her big painting here, which is self-descriptively titled *Woman Walks Into Bar—Is Raped by 4 Men on the Pool Table—While 20 Watch* (1983), compares well with the most lacerating works of George Grosz and Otto Dix. Go ahead and hate it. Explain why it's bad. It will still punch your face in. Leon Golub, Robert Gober, and David Hammons are other artists who are likely to outlast their topicality. Then there's James Rosenquist's *F-III* (1964–65), an eighty-six-foot-long Pop painting that arranges images of consumerism and apocalypse on the life-size rendering of a plane that did lethal service in Vietnam. It seems better than ever—a real classic—despite, or maybe because of, its crude rhetoric. There was an emergency brewing in the 1960s, and it felt the way *F-III* looks. Like David, Picasso, and Richter, Rosenquist nailed one historical congruence of art and politics for keeps.

December 11, 2000

Here's how the artist Eduardo Kac made one of the works in "Paradise Now," a show at Exit Art in New York in which thirty-nine artists take up themes of genetics and biotechnology. Kac shortened a verse from *Genesis* to read, "Let man have dominion over the fish of the sea, and over the fowl of the air, and over every living thing that moves upon the earth." He translated the words first into Morse code, and then, using a system of his own devising, into four-lettered genetic code. With the sequence that resulted—"GTCCA" and so on, very catchy—he fashioned a gene and introduced it into live bacteria. Kac cultured the bacteria in a petri dish, which he rigged with a video camera. The apparatus occupies an elegantly designed booth in this show. A magnified, real-time image of the microbe colony is projected onto the wall and, at the same time, broadcast on the Internet. Kac's web site (www.ekac.org) is interactive. With a mouse click from afar, you can zap the bacteria with ultraviolet light, perhaps causing mutations. You thereby rewrite the Bible, see. I think that we are meant to approve this consequence, Scripture being politically retardataire, or whatever. Meanwhile, one can't help noticing that Kac has taken dominion over living things to a level undreamed of in the Pentateuch. Is the irony of the work profound? It may only be clever.

This manic show is a sort of petri dish itself, propagating a hot trend. The curators, Marvin Heiferman and Carole Kismaric, include some works from the misty prehistory of today's biocraze—that is, older than three or four years. Back in 1993, the collector Isabel Goldsmith asked the painter Steve Miller to do her portrait. He responded by submitting a sample of her blood to a process that produced electron-microscope photographs of her chromosomes. He then tricked these up into a big acrylic-and-enamel painting. It's not a very interesting picture unless you have a soft spot for jittery X shapes, but it qualifies Miller as a prophet. Most of the show is dated 1999 or 2000, testifying to a bandwagon in full career. The collective energy level, which is zestful and infectious, helps one suspend judgment about the merits of the individual works as art. Actually, judging is seldom called for with thematic stuff like this, which has the shelf life of fish. If you wish it would go away, you'll be gratified anon. "Paradise Now" typifies a recurrent phenomenon, whereby denizens of the lately aimless art world jump on a breaking story in the culture at large. The last such vogue was broadly cybernetic. I much prefer the new one. It's warmer and squishier. Also, I'm incurious about my computer, but my DNA concerns me.

Notice that I just said "my" DNA. Do I, in fact, own this tangle of immemorial instructions as I own a copy of Windows 98? Here's a nifty conundrum for the conceptual artists Larry Miller (no relation to Steve) and Iñigo Manglano-Ovalle.

Miller presents elaborate certificates of copyright and license for a friend's DNA. Manglano-Ovalle rolls out two hefty steel storage tanks that preserve sperm in liquid nitrogen. The temperature inside is minus three hundred and twenty-one degrees Fahrenheit, it says here. Also chilly is a display of contracts between the artist and one of the sperm producers—spelling out, among other things, the artist's responsibility for the puissant gunk's indefinite survival. The lid of one tank is pink and the other blue, the sperm having been sorted by sex. What makes these exercises art? Well, what else might they reasonably be? They perform tasks that no one assigned. They involve real work that is really gratuitous. In a world of tightly knit job descriptions, that's distinction enough. There's something discouraging about this, perhaps. Art used to crown civilization. Now it skitters through seams and around corners, eagerly parasitic.

"Paradise Now" displays other living things besides Kac's edited bacteria. Brandon Ballengée invites us to observe his selective breeding, in transparent water tanks, of a tiny, dainty, possibly endangered African species of frog. He says that he aims to literally breed "backwards," recapturing the traits of former generations. *Those are cute frogs.* Nearby, Natalie Jeremijenko's *OneTree* presents several growing clones of a Paradox tree (a cross between two varieties of walnut). *Clones are spooky.* Beyond biota, what thrive at Exit Art are texts. This is the kind of show where your experience of a work hangs fire until you finish reading the label. Thinking back later, you may decide that reading the label *was* your experience. This is certainly the case with a few artists who protest corporate uses of biotechnology. As usual, the polemics are unpersuasive—not that they are meant to persuade. They are meant to provide a given "us" with a "them" to despise. This proves to be more than usually iffy in matters pertaining to DNA, which, after all, makes an "us" of everybody, including plankton and asparagus.

The uncanniness of the new bioscience is a boon to practitioners of *l'humeur noir*, who play it for wondering, shivery laughs. Bradley Rubenstein shares with us some undetectably manipulated photographs of adorable little kids who have something strange about them: they look out at us with digitally inserted dogs' eyes. Surrealism is back, this time not as a revolt against reason but as a brand of playful extrapolation. Simply to think along some current scientific lines is to beget monsters, to the point where any monstrosity may assume an air of science. This show includes tomatoes that, having been forced to grow into molds, become daffy cartoon heads. There is an exquisite-corpse video game. I don't know how to characterize a vast photograph, by Heather Ackroyd and Dan Harvey, of two women sunning on a rocky beach. The picture's medium is a kind of grass that stays green after it dies. I'm reminded of a remark attributed to a legendary jazzman: "Everybody around here's doin' somethin'."

Eduardo Kac says he may translate his battered Frankengene back into English at the end of "Paradise Now." He has done it before. After a show last year in Austria, the Biblical sentence came out only slightly rumpled: "Let aan have

dominion over the fish of the sea, and over the fowl of the air, and over every living thing that ioves ua eon the earth." Of course, we know that subtle anomalies in a segment of DNA can make the difference between, say, a Nobel Laureate and a mime. But pardon me for noting something obvious: the changes in the verse are not improvements. Nor do they affect its meaning, which persists in a manner that is as independent of biology as it is of standard spelling. Meaning may arise from ultimately explicable chemical and electrical events in the body and brain, but it then takes wing—across thousands of years, in this case, directly from somebody else's mind to ours. The beauty of the sentence clinches its argument. A creature that can think and sing like that will elude the explanatory grasp of science for the foreseeable future.

October 2, 2000

"SENSATION"

I'm sorry, but I think that this whole Brooklyn Museum deal—the angry Mayor, the elephant dung, all of it—is fun. An exhibition that was hopefully and is now aptly entitled "Sensation," of works by sometimes strenuously naughty young British artists, was fun to start with, not to mention quite good. (All the works are from the collection of the advertising mogul Charles Saatchi.) Rudolph Giuliani's P.C. denunciation of it—politically correct in form and, I suppose, as he prepares to run for Governor, in Buffalo—makes it more fun. His determination to punish the grand and usually lonesome palace of culture on Eastern Parkway may assure attendance to rival that of the show's previous box office successes, in London and Berlin. I imagine the artists shedding grateful tears, in the manner of Sally Field: "He hates me! He really hates me!" One of them, Ron Mueck, contributed a huge, scowling self-portrait that resembles Giuliani. The museum has put it in a gallery with the object of the Mayor's wrath—*The Holy Virgin Mary*, by a thirty-one-year-old British artist of Roman Catholic faith and Nigerian ancestry named Chris Ofili.

In a show that offers plenty of targets for indignation, Giuliani picked wrong—as might anyone else who hadn't actually seen the exhibition. Ofili's lightning-rod canvas is gorgeous, sweet, and respectful of its subject, rendering her as a sternly hieratic African personage in petal-like blue robes. Much of the painting's surface shimmers ecstatically with glitter in yellow resin. Tiny collaged cutouts of bare bottoms from porn magazines evoke putti, and allude to the element of fertility in Mary's symbology, which Ofili did not invent. As for the pachyderm product, it provides one smallish lump attached to canvas and two supporting it on the floor. The first is capped with what appears to be black-and-white beadwork (in reality pushpin heads) in a design of concentric circles. Elephant poop turns out to be innocuous-looking—not unpleasant in color and almost decorative in texture (lots of straw). Ofili makes freer use of it in other paintings. Turds affixed to one entitled *Afrodizzia* bear the names of James Brown, Miles Davis, and other black heroes. Ofili is a large-spirited artist who comes to praise, period.

Does it matter that Ofili is innocent of sacrilege? In political terms, probably not. His work's quality emerges only upon open-minded looking. It can't be summarized in a sentence, and no number of judicious sentences will remove the lasting kick of one in which the words "the Virgin Mary" and "dung" rub shoulders. We know by now that whenever politics and art collide, art loses—at least in these United States, where anything cultural can become politicized at the drop of a grievance. In Britain, things are different. There, politics gets culturized. Here, we attack one another with insinuations of civic evil. They do it with ad hominem insults,

imputing personal awfulness. Now, awfulness is a negotiable artistic tone, while evil is not. In America, an artist can get away with many things within the art world but is crushed if exposed to public opinion. In England, where no one seems to get away with anything, public outrage may be hard to distinguish from cherishing. They fancy their nasties.

For awfulness aforethought, the cake in "Sensation" is taken by Damien Hirst's dead animals and fish, and his dying flies. In an epically disgusting sealed environment, filthy buzzers by the zillions incubate in a latex cow's head, feed on heaps of sugar, procreate, and meet death by a bug zapper as one watches or, perhaps, flees. Close behind are Sarah Lucas, the bard of East End bad-girl attitude, with her dirty-joke arrays of junk and foodstuffs, and Jake and Dinos Chapman, whose phantasmagorias of little-girl mannequins sprouting adult genitalia in odd places (faces, commonly) call for a genre coinage: pedography? I despise the Chapmans' work. I don't trust that they know half of what they are dealing with in presuming to advance themes of childhood and sex. But Hirst is some sort of great artist. His improbable balancing of grossness and finesse will thrill you if you can stand to let it.

The show's senses of "sensation" are more varied than one has been led to expect; it includes works of subtlety and even grace. Only about half of the forty-four artists go for the jugular. While we are dealing with those who do—or are reputed to—note must be taken of Marc Quinn and Sam Taylor-Wood. You have, perhaps, heard of a self-portrait bust fashioned out of nine pints of the artist's blood? That's Quinn's *Self.* It is a quiet presence in its refrigerated case, with dark, suave qualities of a material that I am instantly aware of never having seen before. That the material is frozen blood becomes a bit of detached information, adrift behind my eyes. Taylor-Wood, who is a woman, makes photographic murals. *Wrecked* is a raucous burlesque of *The Last Supper,* starring pals of the artist as the disciples and, doing the Jesus thing, a bare-breasted woman. It will not make you forget the send up of the scene in Luis Buñuel's *Viridiana.*

Derivativeness is a major issue in this show. It is sure to eclipse provocation as a sore spot for New York art worldlings. Technical and formal imitation, often of American originals, abounds. The sculptor Rachel Whiteread, who is the most respectably esteemed member of the crew, has made much of her career by copying an idea that Bruce Nauman nailed in the mid-1960s: taking casts of negative spaces in the real world. Nauman materialized the space under a chair. In Brooklyn, Whiteread fills a room with casts of the spaces under a hundred chairs. O.K., Nauman did his piece in dour cement. Whiteread uses tinted, light-thirsty resin, which is as appetizing as Gummy Bears. Is that difference enough? Meanwhile, Hirst's formaldehyded critters ape Jeff Koons's famous basketballs suspended in treated water, and the British artist's carnival-type spin paintings add nothing except large size and cute titles to precedents by the New Yorker Walter Robinson. Are we angry yet? Well, the English didn't invent rock and roll, either. They just took it to peak levels. Is Whiteread Paul McCartney to Nauman's Buddy Holly?

Is Hirst Mick Jagger? What, after all, is wrong with appropriating other people's research to further one's own development? Regarding American art, the show's message is mixed. On the one hand: sincerest flattery. On the other: a whiff of classical imperialism. You know, home country extracts raw material from colonies and sells back finished goods.

British artists have a group dialectic going, building on each other's variations. Here is a sample of critical prose from an essay in the show's catalogue by one of the artists, Martin Maloney: "Hirst, understanding [Mat] Collishaw's coup with the gunshot wound photograph, created work that brought together the joy of life and the inevitability of death, in the process transforming the secrecy of Collishaw's voyeurism into mass spectacle." Never mind what that's about. Roll the sound of it around on your brain. Maloney's confident high seriousness verges—but only verges—on Monty Python silliness. Hirst and his cohort steer happily between the sublime and the ridiculous, earning equally appropriate academic beard-stroking and tabloid frenzy. It's a matter not of "high" and "low" but of inside and outside: cooking to engage both the gourmets in the kitchen and the rabble in the soup line. The Brits have a real handle on a real conundrum—which is, roughly, how to square the contrarian nature of artists with the bland mentality of a vastly expanded audience. The two can't be squared is the British short answer. The long answer is that a high old time can be had when the situation is exacerbated as inventively and mordantly as possible. Like the honk of a foghorn in the night, the sound of an occasional exploding fatmouth indicates that these artists' course is true.

October 11, 1999

STILL LIFE

I think I have never been less excited by the prospect of an Old Master exhibition than I was before seeing "Still-Life Paintings from the Netherlands: 1550–1720," at the Cleveland Museum of Art. All my museum-going life, I've walked past Dutch and Flemish still lifes on my way from one to another of the portraits, interiors, landscapes, and so on—every kind of picture, each done to everlasting death in oils—that make the seventeenth-century Netherlands a painting-fancier's paradise. I've confirmed, by asking people of my acquaintance, that I wasn't alone in lacking an appetite for all those preening flowers, foodstuffs, and bric-a-brac. Now that I have been converted by the Cleveland show, my former aversion intrigues me. It is partly museum-induced, I've decided. No other class of painting suffers more from being isolated in sterile public galleries. Even religious art, plundered from churches, retains a tincture of its original potency in museums, which, in their secular ways, are nothing if not churchy. What museums aren't is attuned to regular people's private lives. Most Dutch and Flemish still lifes were made to hang on crowded walls in cozy rooms in foggy seaports, busy with trade. Sharing light from oil lamps and candles with the very types of objects that they rendered, the pictures were possessions about possessions. Their rhetoric and poetry depended on physical and metaphysical jostling with nearby real things. Museums banish real things and substitute the curatorial wall label.

Although the Cleveland show is wall-labelled to the gills, it won me over by the immersive quantity of extremely various, variously perfect paintings. Among many sorts of tabletop subjects, there are "breakfast" pictures and "tobacco" pictures. (One of the latter, by Hubert van Ravesteyn, includes a brand-name tobacco pack—perhaps a very early example of Hollywood-style product placement.) There are surreal florals that defy nature by incorporating flowers that bloom in different seasons; fool-the-eye letter-board arrays of paper items; and, for vicarious touches of class, scenes of slain game animals. (Hunting privileges were limited to the nobility then.) And there are vanitas paintings. Human skulls and just-snuffed lamps and candles put a moralizing spin on accumulations of posh goods. Scholars who like digging for coded messages dote on the vanitas, but I suspect that looming mortality was for these painters no more than what lost love is for Nashville songwriters—a standard hook.

"When you've seen one, you've seen them all, right?" a friend of mine remarked in the course of my informal survey. I have a better question: When you think you've seen only one Dutch still life, have you really seen anything? In Cleveland, the genre emerges as a vast lexicon, almost a language, in which each example says something that may be less than profound but is always specific.

The content is more lyrical than allegorical, working in modes of rapture rather than with extractable meanings. When I first entered the show, the paintings were mute to me. On my third go-around, everything was up and talking at once, holding a multitudinous conversation with and about *stuff*. None of the works' exclaiming, seducing, or brooding tones were addressed to me, of course, but to the constituency of a stuff-mad time and place. The museum rooms are filled with ghosts. Those invisible viewers, the exhilarated and anxious burghers of the Netherlands' golden age, are right on time to haunt us, here in our own epoch of nerve-racking affluence. The Dutch are sometimes credited with inventing capitalism. Lately, it seems as if capitalism invented us. The longer I looked in Cleveland, the more familiar seemed the driven production of these paintings and their themes of insatiate consumption. Then, as now, the works functioned in the world as handmade units of money, accepted in payment of debts. The profusion of still-life painting, which was deemed the least valuable of genres, may bespeak the Dutch art economy's need for loose change. (You will have trouble maintaining robust popular trade if your smallest currency is hundred-dollar bills.)

Quality counted. Some painters got rich from their still lifes—almost always the right painters, as far as I can tell. (Dutch taste kept pace with Dutch talent.) But market motives ruled. For the spectacularly accomplished Willem Kalf—whose *Drinking Horn with a Lobster on a Table* (*c.* 1653) has a succulent lobster redness that is cut, in the eye and on the mind's tongue, with a peeled lemon's pale, acidic yellow—it made sense to quit painting in 1680, in favor of art dealing. For the masses of people who owned still lifes, the pictures had added appeal as fantasy extensions of wealth. Consider: the objects depicted in the pictures were often more costly than the pictures themselves. Does this fact shock you? It did me, indicating that these master artists were, in the social scheme of things, little more than humble artisans. They got their subjects right because that was the job, never mind that they painted like angels in the doing of it.

The mystery of the work in this show is no mystery but, rather, a guild secret, notably in the painters' god-like renderings of light. In the Netherlands, seventeenth-century painting of light was an application of collective genius, handed down from masters to apprentices until, quite abruptly, it perished. Anyone who will work hard at it can limn objects in apparent relief with the old techniques of chiaroscuro and highlight, and anyone moderately gifted can make a painted surface appear to glow from within. But nobody, for three centuries, has so matter-of-factly done both at once. The effect is tactile as well as visual—and even olfactory, as in an astonishing painting from the 1650s by Abraham van Beyeren, a "fish painter." Flounders, partly disembowelled haddock, crabs, mussels, and a slice of salmon are heaped in what looks to be a market stall and raked by light that releases a softly gleaming, pungent, disconcerting glory—an ur-fishiness. The finesse of the details draws us in as the beauty of the whole advances toward us. Only an extraordinary concentration on life and art, simultaneously, could achieve such sorcery.

Leave it to Rembrandt to tell the most penetrating story about the magic of Dutch still life. His only known still-life painting, *Dead Peafowl* (c. 1639), is a large picture of two huge, freshly killed birds. One is strung up by its legs, with its wings flung open, from the inside shutter of a glassless window in a massive stone wall. The other lies on a ledge below, exuding a flow of rich blood. A moonfaced little girl leans in at the window, with dark night behind her. Her velvet dress, archaic in style when Rembrandt painted it, hints at a tableau of time past. She smiles with satisfaction at what she sees—which is not what we see. The old Rembrandtian trapdoor of delayed revelation springs when we realize that our view of the birds is the back side of what she beholds—which, to judge from her attitude, is dinner. What is a still life to us is real life to her. She and the gaudy peafowl and the great house and the night belong together, in a world that, like the old, lucky Netherlands, will always charm while never ceasing to exclude us.

December 12, 1999

SEXY SURREALISM

"**S**urrealism: Desire Unbound,**"** at the Metropolitan, is an oddly evangelical exhibition. It seeks to renew the appeal of a movement that sprang from the spiritual wreck of Europe after the First World War and sank in the larger catastrophe of the Second. This is a tall order, given the relative meagerness of canonical Surrealist art. Limp clocks by Salvador Dalí are about as good as it gets. The curators, led by Jennifer Mundy of the Tate Modern in London, where the show originated, and the many scholars who contributed essays to an ambitious catalogue cope with this by casting a wide net. The show encompasses paintings, drawings, photographs, sculptures, collages, and objects—along with masses of books, documents, and ephemera—and includes works by Duchamp, Picasso, Miró, Giacometti, and other major artists who were tangential to the movement. The onslaught promotes Surrealism not as a style but as a web of ideas. The hero of the occasion is a writer— the movement's founder, André Breton. And its selling point is sex.

Breton, who grew up in a provincial family, was a medical student when he served in the First World War as a psychiatric worker, tending shell-shocked soldiers. The fantasy worlds in which some casualties took refuge enthralled him. He was stirred by the ideas of Sigmund Freud, which were then just emerging in France, such as the concept of hysteria as a coherent expression of repressed trauma. Writing in 1920, Breton called hysteria "one of the most beautiful poetic discoveries of our epoch." Freudian lingo, wielded fast and loose, peppers Surrealist discourse. Continual references to "the unconscious" suggest a place as tangible as, say, The Hague. That supposed repository of forbidden truths gave Breton a base from which to assault a society that he was not alone in loathing. Restive youth gathered in the capitals of Europe. The war-born, bitterly frivolous Dada movement, which mocked all cultural authorities, including itself, had disintegrated, leaving a generation primed for more sustained forms of rebellion. The prewar avant-garde's prince, Guillaume Apollinaire, who died of influenza and a combat wound in 1918, had coined the intriguing word "surrealism" in 1917. With the charisma and efficiency of a salon Mussolini, Breton adopted the word, organized a cohort, and promulgated dogma. His tumultuous group, ever gaining converts and shedding apostates, dominated the Paris scene until the German invasion of 1940, from which Surrealism—like French art generally—never recovered, though the movement hung on feebly until after Breton's death, in 1966.

"Desire Unbound" begins with prescient prewar paintings by Giorgio de Chirico and proceeds through an assortment of sexually charged Dada works to the first of two artistic peaks: radically innovative semi-abstractions by Miró, Jean Arp, and André Masson. The second peak—paintings by Picasso and sculptures by Giacometti,

including his vehement masterpiece *Woman with Her Throat Cut* (1932)—lies ahead between roomfuls of vitrines that document the Surrealists' love lives and their enthusiasm for the Marquis de Sade. First come Dalí, Magritte, and other echt Surrealist painters; Man Ray photographs; and a segment called "Transgender," which trots out images of cross-dressing by Duchamp and Frida Kahlo. Farther on is a chamber of superb boxes by Joseph Cornell, the suburban idolater of inaccessible beauty, which leads to photographic work of breathtaking perversity by the German artist Hans Bellmer and the too little known female writer-artist Claude Cahun. The show ends in a large, dishearteningly jumbled gallery, surveying Surrealism's decadence in the 1940s, mostly in New York. Wall texts abound throughout the show, like subtitles for a language—the visual—that is foreign to the curators' thematic mania.

"Desire Unbound" succeeds in generating impressive quotients of coolly libidinous chic along with a certain air of starchy prurience. (Imagine a Starr Report issued by a committee of fallen librarians.) Leave the kids at home. The show's strong suits are erotic photography and drawing. Its star is Bellmer (1902–75), who lived in Paris after 1938. Bellmer, who collaborated with the French theorist of obscenity Georges Bataille, is darkly fashionable these days in both the art world and academe. Kinkiness, thy name is Bellmer. His signature works are elegant, indelibly shocking photographs of fragmented, anatomically preposterous female dolls that he made of wood, plaster, and papier-mâché. Swollen of breast, belly, pudendum, and thigh, the dolls appear in torturous postures redolent of sadomasochistic rites. Their occasional sporting of white ankle socks and Mary Janes seems silly to me, but you never know what some people will deem sacred. Bellmer also made fiercely tidy drawings of orgiastic grapplings. One writer eloquently termed his art "a blend of incredible, pitiless coldness and burning excitement." The writer was his longtime companion—and "victim," in his word— Unica Zürn. She wrote the appreciation several months before her suicide, in 1970.

The disturbing relationship of Bellmer and Zürn is described in a section of the show's catalogue devoted to love among the Surrealists: marriages, adulteries, ménages à trois, daisy-chain affairs. The scorecard of sexual scrimmages goes way beyond gossip, advancing a view of Surrealism as a lived code of anti-conventional ethics and amoralist morality. The editor of the section, Vincent Gille, can be sure of his facts because the Surrealists kept regular records of their amours. Breton urged a tell-all policy on his followers—while being secretive and even prudish, himself. His classic autobiographical novel *Nadja* barely mentions his intimacies with its subject, an intoxicating, half-mad girl, and even that hint was suppressed in a later edition. He proscribed male homosexuality. (Only children were scarcer than gays in Surrealist circles. Among the group's implicit topsy-turvy taboos, sex for procreation stood high.) Lesbianism could be O.K., but preferably as spice on a heterosexual bill of fare. Even while Breton praised the omnisexual, vicious Sade as a prophet of Surrealist freedom, he wrote love poems as tenderly gallant as Provençal minstrelsy. Similarly sweet-tempered—and better as literary art—were poems by Paul Éluard and by Robert Desnos, who was famed in the group for his ability to fall asleep at

a moment's notice and awaken with a fresh, first-rate dream. French Surrealism left its most enduring creative monuments in lyric poetry.

Surrealism was without doubt sexy. It emerged in the most hot and bothered of climates. Paris in the 1920s was a wildly favorable milieu for a young man with a serviceable pickup line. More than a million Frenchmen had died in the war; many others were left incapacitated. Given the surplus of women, even an ill-favored fellow might pass for a Lothario, and if he was a dashing American expatriate like Man Ray, look out. Ray's photographs in the show document an almost monotonous parade of extraordinarily beautiful, smart handmaids of Surrealism. These include his celebrated consorts Kiki de Montparnasse and the photographer Lee Miller. Others with names that still resonate are Nancy Cunard, Elsa Triolet, Yvonne Georges, Nusch (Maria Benz), and the muse's muse Gala (Elena Ivanovna Diakonova), who ricocheted from Éluard through a trio with Éluard and Max Ernst to Dalí. Only in the movement's waning stages did female artists step forth in any numbers. Their arrival was heralded by the instant sensation of Meret Oppenheim's 1936 *Objet (Le Déjeuner en fourrure)*, better known as the Fur Teacup. Aside from the Mexican powerhouse Kahlo, distaff Surrealism didn't amount to much until the gamy efflorescences of New York's own Louise Bourgeois became widely noticed, in the 1970s.

So was Surrealism one long boys' night out? The men's posturings and shenanigans may easily be seen as competitive displays. But a yen for serious, collective purpose is also apparent. It informed Breton's dogged efforts to square his enterprise with Communism, which he pursued in his magazine of the early 1930s, *Surrealism in the Service of the Revolution*. The attempted alliance, untenable on both sides, produced much tortured reasoning and led to schisms. Éluard and the poet Louis Aragon embraced Stalinism. Breton cleaved to Leon Trotsky, with whom he collaborated on a manifesto in Mexico City in 1938. The poet and the doomed ex-commissar excused artists from orthodoxy. They declared that "true art is unable not to be revolutionary, not to aspire to a complete and radical reconstruction of society." This wishful formulation bespeaks Breton's desperation to keep his movement—whose real-world arena was not the street barricade but the rumpled bed—on the sunny side of history. It also helps account for Surrealism's recurrent siren appeal to young artists and intellectuals. The notion of personal imagination as somehow an agent of earthshaking power rode again in the 1960s, when ingesting a drug could seem like a revolutionary deed.

In the United States, Surrealism has always had an imported aura, like fabulously smelly French cheese. The reason is the Surrealists' particular brand of subversion. They were anti-rational Cartesians and atheistic Roman Catholics. They were thrilled by cultivated absurdities and blasphemies—kicks that tend to be lost on pragmatic, culturally Protestant Americans. My own trouble with Surrealism, which becomes acute at the Met, centers on that precious word "desire." The word plays throughout the show and the catalogue like an expensive perfume. The curator

Jennifer Mundy writes that, for the Surrealists, "desire was seen as the authentic voice of the inner self. It was an expression of the sexual instinct, and, in sublimated form, the impulse behind love. It was also a path to self-knowledge." As for love, Breton gassily pronounced it "the sole motivating principle of the world, the only master that humans must recognize." All this exquisite heavy breathing suggests feelings so classy that I am impressed right out of feeling them.

A little earthy skepticism can make short work of "Desire Unbound." Surrealist art's line in illustrated dreams has aged badly. Even at its most entertaining, as in Dalí, it groans with dated conceits. And it plays false with what proved to be Surrealism's most useful insight: that the mind possesses a deep formality that may assert itself when conscious control is suspended. In Surrealist dream pictures, the discovery process ends before brush touches canvas. The rest is whistle-while-you-work, academic execution. Breton unfortunately prescribed such banality by adopting de Chirico as the model for Surrealist painting. According to one of Surrealism's abiding legends, Breton glimpsed a de Chirico from a moving bus in Paris, in 1916, and was so struck that he walked back to look at it. He later acquired the painting, *The Child's Brain*, which depicts a massive and mustachioed but oddly feminized paternal figure confronting a closed yellow book, from which protrudes a thin red ribbon. This work, which is in the show, is terrific in the inimitable de Chirico way of investing spare, bluntly painted scenes with vast portent. No Surrealist painter—least of all the hectic and pedestrian Ernst, who took cues from the sublime Italian—would approach such magic. An exception might be made for the arch philosophical jokes of Magritte, but not by me.

A familiar fixture in the Met's collection—Jackson Pollock's *Pasiphaë* (1945)— delivers the show's biggest jolt. When I encountered this large, pre-drip painting in the last gallery, I felt that I was experiencing it with the astonishment of its first viewers. The painting deploys indistinct human and animal imagery in an august proscenium space of orchestrated violence. Every stabbing brushstroke and surprising color breathes lyrical urgency. The canvas blazes with cumulative energy. Coming upon it after rooms of finicky objects was like exiting an overheated parlor into the Grand Canyon. *Pasiphaë* applies Surrealist principles of impulsive content and impromptu method to painting as an end in itself. Goodbye, Freud. Like other Abstract Expressionists, Pollock preferred Jung, whose psychology posits universal mythic patterns. True or not, that idea helped disperse Surrealism's erotomania and narcissism. Desire was no longer an issue—only conviction mattered. When I reached *Pasiphaë*, all that had come before seemed to me a shaggy-dog story meandering to this marvellous punch line. Such is not the curators' intent, of course. (Pollock was unrepresented at the Tate in London.) They revel in Surrealism's labyrinth of intellectualized sex.

February 25, 2002

THE PLEASURE PRINCIPLE

Before the movies, painting was like the movies. People went to see pictures that were gorgeous and glamorous and had appealing stories. Grand group exhibitions—the Salons—were like multiplexes. At any multiplex today, there is almost always one film that you are dying to see, two that you would rather die than see, and a bunch of others that will do to pass the time. The bunch of others, which are good enough, marks the movies as a successfully popular art. They are the regular fare that fills in between feasts for people who will dine come what may. No such routine gourmandise attends the middling range of painting now—or, really, of any visual art, whether contemporary or historical. For most of the public, art has come to symbolize the singularly superb, exclusively. I suppose that this has to do with the art work's archaic character in a world of mass production as a unique, often hauntingly expensive object. At any rate, consider the prevalence of the locution "masterpieces of" in so many museum shows—you know, "Masterpieces of Mesoantarctic Lint." We are expected to obsess about ultimate quality: best, bester, bestest. Painting, which struggles to stay relevant in present culture, suffers acutely from such pressures.

This summer's most controversial show, "1900: Art at the Crossroads," at the Guggenheim in New York, touches on this and other aspects of a present crisis in the life of art. The show assembles close to two hundred and fifty paintings and sculptures from a cluster of years around the 1900 World's Fair, in Paris, where art of twenty-nine countries was presented. Several hands took part in curating "1900," but it is the brainchild of Robert Rosenblum, the doyen of let's-love-practically-everything revisionism in art history. Rosenblum's alternately majestic and mischievous books range from *Modern Painting and the Northern Romantic Tradition: Friedrich to Rothko* to *The Dog in Art: From Rococo to Post-modernism*. He was gamely picking at canonical modernism before, rather like the Soviet Union, that regime collapsed of its own weight. If, after all, the story of modern art is not a moral allegory—progressive virtue versus reactionary evil—why not admit the charms of, say, the vanquished Adolphe-William Bouguereau? This academic superstar—whose sleek, maudlin, smutty confections were coveted by American millionaires at the turn of the century—is campy fun, no? Shouldn't art be fun? Rosenblum's promiscuity, backed by strong scholarship, drives sober-sided intellectuals nuts. He keeps coming through attacks on him like Godzilla invading Tokyo. By now, Tokyo is in sad shape.

Like other art people I know and like Michael Kimmelmann, in *The Times*, and Hilton Kramer, in the *Observer*, I rather despised "1900" my first time through it. What's the point in playing fair with the mildewed academic platitudes and provincial swoons that dominate the show? Interpolated gems by Cézanne, Degas,

Munch, Klimt, and other heroes of modernity seemed tormented by the context, like aristocrats at a tractor pull. Later I relaxed. I accepted the show's challenge to view it in the way that someone of a century ago might have—as the complicated efflorescence of a changing world and, not incidentally, an entertainment. Something happened to me in the Guggenheim's two-story anteroom near the bottom of the ramp. Hung salon-style with paintings that appeared at the World's Fair, the room gave me my multiplex analogy: aggressively ingratiating pictures with major production values, competing to tempt the public palate. Suddenly a judgmental attitude felt absurd—as if one attended a baseball game only to keep score. At the very least, the show offers an archaeology of pleasure. Why did folks like this stuff? Trying to imagine an answer, I slipped into the popcorn satisfactions of a second-rate (so much better than third-rate) Hollywood product. I ended up enjoying almost everything—except Bouguereau, whose toothsomely eroticized children should have gotten him punched in the face, if not arrested.

Context really counts. Great art may be characterized by what it rejects from its milieu, but not by what it builds a wall against. One of the ways in which museums sterilize great art of the past is by isolating it from the fashions of its time. It's the greatest-hits fallacy—that we understand creativity by focusing strictly on the peaks. Without valleys, peaks could be pimples. So goes one revisionist rationale, which I'm inclined to endorse. Unfortunately, this rationale happens not to be advanced by "1900," whose wall labels and catalogue ponderously spell out sociological and ideological themes. An unaesthetic, educational spirit rules. There is an emphasis on curios: a proto-Dadaist jape by the arch academician Jean-Léon Gérôme, a Portuguese painting of a semi-nude nymph who is distressed by industrial pollution, and a triptych by Léon Frédéric in which hundreds of bare-assed little children swarm over waterfalls and sleep in heaps on the shore. (This last is dully painted, alas: great script, lame cinematography.) For me, the show's keenest finds are instances of regional Naturalism and Symbolism, notably from Nordic countries, reminding us that such artists as Harriet Backer, Prince Eugen, and Magnus Enckell were contemporaries of Ibsen and Strindberg. America's Winslow Homer shines in this company—which suggests an art house, next door to the multiplex, for subtitled and indie films. But I'm interested less by the show's intermittent joys than by issues that it raises about taste.

In 1900 and throughout most of the century that followed, there were identifiable stances of conservative and radical taste in art. One party knew what it liked; the other liked what it dared to. This tension was creative. Superior art is always both conservative and radical, in a ratio that takes time to be recognized and more time to sink in. A living art culture is an arena of arguments that get resolved in unpredictable ways. Nearly no one argues about art today. Common taste has fallen hostage to education, which postpones questions of pleasure until a graduation day that never arrives, and to gossip, which lazily tracks the passage of scenes and styles. Education—including the earnest nattering of museum wall labels and the shaming

moralism of academic scolds—exhausts mental energy to no end. Gossip economizes mental energy to a fault. Magazine layouts that feature the peekaboo midriffs of naughty girl painters satisfy this year's curiosity about new art. Am I lamenting? I sure am. I accept that the decadence of taste comes low on the global list of current human woes; but we are in a sorry enough state when art—the pursuit of higher happiness—succumbs to muddle. Art should be less trouble than it's worth. Today it accumulates troubles like an experiment in entropy.

The Guggenheim's "1900," an entropic fiesta, points up the problem and contains hints of a solution. Rosenblum's brand of art-love vexes me with its levelling embrace of the good, the bad, and the kinky. Liking so much, can one care for anything? But such caprice is a timely antidote to the ten-best-list mentality in a field where most people's attention flags after the top two or three items. We need to recover the pleasure principle in our experience of art and in our public talk about it. Taste cannot be exercised too often or on objects too lowly. Art works are like people who are mysteriously possessed of a will to please us. Perhaps they fail—they may be fools, for example—but how can we not be touched by the effort? Grateful tact is most in order when the intention succeeds to a degree, but less than wholly. That's where art's engines of pleasure are most instructively exposed. A cultivated appreciation of the pretty good sets us up to register the surprise of the great, which baffles our understanding and teaches us little except how to praise. Greatness, a bonus for those who are in the game, can occur only when the game is widely and gladly played.

August 7, 2000

MAX BECKMANN

"**A**h, a great painter,**"** Pablo Picasso remarked of Max Beckmann in 1964. That "Ah"—a sound of sleepy memory bestirring itself—says a lot about Beckmann's place in modern art. The place is left field, where remote associations roam. Beckmann truly is great, as most art lovers take for granted—but great in relation to what? The vehement German, who dropped dead on the corner of Sixty-first Street and Central Park West in 1950, at the age of sixty-six, still awaits an appropriately plumped and fitted reputation. "Max Beckmann and Paris"—a smashing exhibition at the Saint Louis Art Museum that mingles Beckmann paintings, mainly from the 1920s and 1930s, with works by masters of the School of Paris—gets one thinking about art-cultural politics in the twentieth century. People regularly decry fashion in contemporary art. How about fashion of the hallowed past which, infecting the judgments of subsequent generations, becomes standard opinion? There is a word for the process: history—the normalizing of stories that beat out other stories. It is always bunk to some extent.

When you are in the mood for him, Beckmann can look like the best modern painter in an alternate universe—a place not ruled by the Francophile cosmology that became American holy writ by way of MoMA during the century's decisive decades. Beckmann himself was always in such a mood. Sulfurously competitive, he tried in the late 1920s and early 1930s to storm the international big time in Paris, even Frenchifying his style to invite direct comparisons with the reigning gods. He failed. The St. Louis show presents fifty-three paintings by Beckmann, ten by Picasso, eight by Henri Matisse, and lesser numbers by Fernand Léger, Georges Rouault, and Georges Braque. A big, lone Robert Delaunay—*The Cardiff Team* (1912–13), a giddy congeries of rugby players, a Ferris wheel, billboards, and an airplane—is flanked by two Beckmanns on similarly modernity-drunk and athletic themes (carnival balloonists, a soccer match). The linkage of the effervescent Frenchman and the acrid German is a new thought for art history. It is one of many surprises on this occasion that shake up our image of Beckmann as a Teutonic mystagogue of smoky, myth-ridden, dirty-sexy grotesquerie. How German was Beckmann? Less than one might think. It has been this artist's fate to hang in most museums amid German art's local heroes, the Expressionists. But his frame of reference eclipses theirs. Though keyed to non-French influences, including Edvard Munch and Lovis Corinth, Beckmann's aim was a grand style descended (like Fauvism and Cubism) from Cézanne, van Gogh, and the other Post-Impressionist pioneers. Now, in Missouri, the case of his ambition has been taken up at last.

Beckmann and St. Louis: a romance. After hunkering down in Amsterdam during the Second World War, the artist and his wife, Mathilde (Quappi) Kaulbach, came to St. Louis, where Beckmann had accepted a teaching position at Washington

University. He wrote in his diary, "St. Louis. Trees at last, ground under my feet at last.... Here it will be possible to live again." Today, thanks largely to the collecting instincts of the department-store magnate Morton D. May, the Saint Louis Art Museum is unusually rich in German modern art, and it boasts the world's most important concentration of works by Beckmann. But the artist had set his highest hopes on quite another city. In the summer of 1925, Beckmann and his Berlin dealer, Israel Ber Neumann, met often in Paris. They talked career strategy. Already the biggest fish in the modest, determinedly brackish pond of Weimar painting, Beckmann wanted to swim with whales. He didn't care to meet Picasso et al. in person, and he never did. (A feverish youthful attempt to make the Paris scene in 1903 and 1904 had left him humiliated.) The boulder-headed master, a champagne bohemian, craved universal glory. Neumann was supposed to help. The campaign sputtered along vainly for years, until world events called it off. The effort makes a poignant tale. Beckmann's Right Bank game plan ignored the Paris avant-garde, which was Surrealist, in favor of high-society and diplomatic connections—a strategy sure to alienate any art scene's most crucial audience, the young. Countering the bad odor in France of things German, Beckmann had himself touted as "European," whatever that meant. In the studio, he suspended his strong suit of glowering allegory in deference to French formalism. Still, he made stunning pictures. Saddest in this show's tacit portrait of an era is the sense of Parisian cosmopolitanism succumbing to sclerosis—an arrogantly closed club, disdaining fresh blood. Beckmann's eruptive style exposes, by pointed contrast, School of Paris aesthetics, which were beginning to be a little pat. The German challenged the prodigious decorative unities of Parisian picture-making with an abrupt theatrical dynamic: paintings whose every detail fulminates in pressurized, stage-like spaces. Beckmann starts with such a space and then—with each grunting stroke and cold, light-over-dark color effect—muscles things forward to a surface that practically bursts, spilling a world into our laps.

French-type painting begins and ends with the wholeness of a taut surface. This approach had characterized Watteau and Chardin, and it went double for Picasso and Matisse. By means of line, shading, and color, depth illusions are built or carved out parsimoniously, making each nudge into the third dimension a piquant, potentially riveting event. (Cézanne showed how to bring about a tiny climax with just about every brushstroke.) Beckmann clearly recognized this sensibility—and was exasperated by it. He strove to turn it inside out. His flatly worked surfaces respond at all points to a given sense of deep pictorial space, which, beyond being imaginary, advertises Imagination. Here's my scorecard on the St. Louis show: Beckmann wasn't as good as Picasso or Matisse, but the proximate goad of his work makes theirs sweat a bit, very instructively. He was better than Léger, whose status as the tough guy of post-Cubist painting can't withstand the German's force. Beckmann wasn't a painter's painter, like Braque, but, plainly, he could have been, had his ambition been less sprawling. As for Rouault, a brotherly palaver emerges between his work and Beckmann's, surprising me with the thought that the hermetic Frenchman is sorely underrated and merits reconsideration.

Beckmann, like Rouault and the Expressionists of his own homeland, was emotionally committed to subject matter in ways that clanged against the armor of Parisian art-for-art's-sake. Of course, Picasso is emotional, too, but only on grounds that have already been Picassoized. In one of this show's several dazzling juxtapositions, the lasciviously caressed, yielding mass of a 1932 Picasso nude hangs beside the violently swelling fullness of a 1930 Beckmann nude. Beckmann celebrates female fecundity and tacitly brags that he is equal to it. Picasso never brags. He is Mister Man. He utterly dominates the female in all things, all the time. Unable to overpower Beckmann, Picasso trumps him with nuance. Beckmann's emotive range is limited to attitudes befitting his rather rigid persona. (He was a thundering dandy, if you will.) Nothing limits Picasso. Another showdown sets Beckmann's *Large Still Life with Fish* (1927) against Picasso's *Still Life with Fish* (1940). At first blush, the German's composition, in ferocious red and black, outfaces the Spaniard's dyspeptically wan eels, crab, and whatnot. But soon the Picasso's very pallor insinuates a heartstopping unease— a sinister mystery of writhing things which makes mere seafood of the Beckmann. As for Matisse, why do people keep quoting his playful remark about wanting his art to be like an armchair, as if it explained something? If I think of a chair while viewing Matisse—his swimmingly ambiguous *Still Life with Green Sideboard* (1928), in St. Louis, say—it's because I would like to sit down, and not hurt myself by fainting from a dizzy surfeit of pleasure. When painting from life, Beckmann responds enthusiastically to sensuous appearances and conveys his excitement. Matisse gets quietly drunk on visual seduction and induces in viewers a contact high. Matisse can make you hate your life for its comparatively insipid joys. Beckmann is less delightful but more invigorating. His art is about life's stubborn difficulties, which he lays into with relish. He exalts energy that is available to everyone. If you are a man and have a new wife, you may be quite as crazy about her as Beckmann was about Quappi, whom he married in 1925. *Quappi in Blue* (1926) invests the image of a slight, pretty young woman with fire-alarm intensity—an effect of dense, flavorsome colors crossed with fierce tonal contrasts. In Quappi's bone-white face, her red lips assume a sweetly wry expression while visually exploding like a grenade.

Wanting only to be a hero of art, Beckmann got shunted into being a hero of other things. After the Second World War, Alfred Barr, at MoMA, hung Beckmann's mighty triptych *Departure* (1932–35) with Picasso's *Guernica* (1937). It was a handsome gesture, whose political point was a tribute to Nazi-suppressed German genius. Sentimental in a good way, the bracketing with Picasso evoked "Europe" as an embattled ideal. But it was not about art criticism. Beckmann was being leapfrogged from marginal and provincial to established-master status, without having passed through an interim stage of give-and-take contrast and comparison. Among things to regret about the twentieth century, Beckmann's debacle in Paris is pretty trivial, but this wonderful show in St. Louis makes it sting.

March 8, 1999

STILLNESS: CHARDIN

Jean-Baptiste-Siméon Chardin is the most silencing of painters. Seen in a retrospective that concludes its tour at the Metropolitan Museum, the eighteenth-century Frenchman's still lifes and genre scenes put thought and emotion on hold with gentle sternness. I fancy the work saying, "No doubt you are intelligent and full of feeling, but for the moment simply look, if you don't mind." When I first saw the show earlier this year, on a harried day in London, at the Royal Academy of Art, I minded. My attention slid off the dauby or crusty, somber little pictures, and I left feeling irked. Most good art yields some fraction of itself—a style recognition, a grace, a promise—to a merely interested glance. Not Chardin's. If you won't whole-heartedly contemplate it, it will have nothing to do with you. You must relax and gaze. No special effort or acuity is required, but patience is not optional. Gradually, you are engulfed in mysteries of painting and of something else, supremely indefi-nite—something about existence. Fortunately, I have now had a second chance at the show. It is good to be on amicable terms with Chardin.

It is also timely. At the present moment, when the smell of linseed oil seeps back into the halls of art schools—but without a great deal to show so far, as if paint-ing were a disassembled appliance lacking its instruction manual—new painters struggle with the simplest questions of why and how to paint. Chardin dealt rather exclusively with such questions. You've heard of a "painter's painter." Chardin is painting's painter. He doesn't so much use paint to produce effects as solicit its favor to precipitate miracles. Though a gregarious man who was in the thick of his time's art life, he was fiercely secretive when he worked. I think it was because of chagrin at how abjectly he depended on serendipity. No one could plan the characteristic beau-ties of Chardin's work. They happen to us because they happened to him, sweating at his easel over what threatened to be dull messes. The *philosophe* and pioneering art critic Diderot reported that at the Salon of 1773, Jean-Baptiste Greuze, the leading genre painter of the day, was observed to pause before a Chardin and then to pass on, "heaving a deep sigh." I imagine Greuze thinking, Some guys have all the luck! That painting, *The Jar of Olives*, is not at the Met, but any of a dozen that are could have stung Greuze equally. I recalled this anecdote while noting an astonishing color, a smoldering orange, that sounds a deep bass note in *The Jar of Apricots* (1758). Were I a rival of Chardin, I might briefly consider hanging myself.

Chardin had a sheltered, illustrious career despite toiling in the lowly modes of still-life and genre painting, with its mundane themes of working-class and bourgeois life. Born in 1699—three years before the arch showman of the Rococo, François Boucher—he arrived during a low point for French painting. Watteau died

in 1721, leaving no artistic heirs who were remotely his peers. The French court even imported painters from Venice to pep things up, but they proved disappointing. Legend has it that when the young Chardin showed his work anonymously, some academicians went into raptures at the discovery of an unknown Flemish master. The previous century had seen the golden age of Flemish and Dutch still life, which was indeed the tradition on which Chardin based himself—but with major differences from the start. With Greuze, he was one of Diderot's two favorite contemporary painters. For nineteen years, starting in 1755, Chardin was put in charge of hanging the biennial Salon of the Académie Royale. Considering the egos of artists, that tenure confirms his reputation as a disarming man. He was married twice. His first wife died, as did two infant daughters. He groomed his only son Jean-Pierre as a history painter. The two quarreled over money. Jean-Pierre apparently committed suicide at the age of forty-one. This dark note is in key, for me, with the exacerbated sensitivity of Chardin's art. He can't have been easy to live with.

Chardin eschewed the showy, eye-fooling sensations of Flemish still life. With him, the illusion of reality is a conviction won on scanty evidence. You buy it, but when you look carefully, you can't say why, because what's there is just paint. Except in the smallest formats, Chardin's brushwork usually resolves into passing verisimilitude only at distances of six to ten feet. Some of one's strongest pleasure occurs at closer, blurring quarters. Standing back, you see pictures that are about intimacy: domestic stuff, preoccupied ordinary people. Approaching the canvases, you experience something actively intimate: the obsessive passion of the artist to wrest rightness from his material. It becomes hard to distinguish awkwardnesses from inspirations. A smear of orange tells everything knowable about light when it collides with the bottom of a copper pot. Reddish smudges on the cheeks of a servant woman convey the hectic pith of a busy day in *The Return from the Market*—but then, somehow so does everything else in this eventful composition, including a tiny triangle of blue sky over the top of an opened door. That blue patch neatly took my breath away. How does Chardin do it? He paints. He keeps reaping epiphanies that are within the reach of painting, because that—and not copper pots or servant women—is what he is about. He was history's first painter who convinces us that he painted purely for painting's sake, as would not be lost on the greatest of such painters who learned from him: Édouard Manet.

When you think about it, the term "still life" epitomizes painting: a time-consuming investment of the painter's life that holds still to be realized by the viewer, whose life is correspondingly enriched. Chardin's work is Exhibit A for this definition. The art historian and critic Michael Fried wrote an influential book, *Absorption and Theatricality* (1980), that leans heavily on Chardin's genre scenes to explain this dynamic. According to Fried, Chardin's people—think of the famous *Young Man Blowing Bubbles*—are beheld in states of absorption so total that the presence of the work's beholder is negated. Now, that's a bizarre notion. Even a feeling that my presence is "obliviated," in Fried's coinage, affirms my presence,

because who else is feeling it? But anyone might be driven to outlandish ideas by Chardin's eerie, dreaming intensity. Thus Diderot: Chardin's "harmony" is "like what the theologians say about the spirit, sensible in the whole and secret in all details." Not to be left out, I'll paraphrase a remark that Paul Valéry made about poetry: paintings painted by someone other than the painter to be viewed by someone other than the viewer. Any sufficiently shuddery paradox may serve as well. But one signal sensation in Chardin remains untouched so far. I get a whiff of it from the French phrase for still life—"*nature morte*." Chardin is wonderful about death.

Chardin's painted people, especially children, break our hearts because we feel the immense value of their existence but not their existence as a fact. They live so utterly in paint that it is impossible to imagine them living anywhere else. Call them the lively dead. (I find this quality in Vermeer, too.) But the most penetrating of Chardin's themes, for me, involves death explicitly: his still lifes with freshly killed game animals, notably rabbits. The motif came from a tradition of celebrating nature's bounty, but there's nothing festive in Chardin's treatment of it. There's nothing precisely sad, either. He isn't propagandizing for animal rights. Bunnies get hunted, and that's that. Moreover, he couldn't render them with such fantastic accuracy if they were alive. It could be said that they died for art, that Chardin's art hungrily consumes—beyond their shape, texture, and color—their very deadness. Here are creatures, formed for motion, that no longer move. They have embarked on the second career that awaits all beings, as inanimate objects. They lie or dangle in postures that, in life, nothing can assume. They strike me as the deadest things in all of art—vibrantly so. Is this disturbing? It is to me. It verges on an indecency that is more nerve-racking for having no touch of the grotesque, and for serving beauty. Beauty can be a kind of murder, snatching life out of time. So I am led to reflect by M. Chardin.

July 17, 2000

J ohn Currin apologized for the drab surface of a new painting in his studio on the westernmost block of 14th Street, an area dominated by meatpackers that is rapidly artifying along with the gallery boom just to the north, in Chelsea. "I've been waiting to varnish it," the artist said. He plucked a brush from a can and made a few strokes on the canvas—a Northern Renaissance-looking picture of an anatomically impossible but convincingly naked young woman with a zany expression. Wet resin turned clayey oils pellucid. Colors—greenish-brown chiaroscuro background, pale peachy flesh with bluish insinuations—sang. I think I went, "Ah!" This experience was a ritual of the art world before Impressionism sanctified raw paint. Insiders used to gather at a vernissage—the term literally means varnishing—to watch sullen textures combust under the artist's hand. It was a routine transformation of private toil into public magic or of matter into spirit, if one wanted to be moony about it. Proper moderns hated all that. Modern art was a battle among ideologies of "authenticity." In Currin's studio, I reflected that the demise of the ideologies is no longer just around the corner.

Currin is as important an emerging painter as today's art world provides. How important is that? Maybe not terribly, in the universalist terms that big-timers used to hanker after. But he is really something—and he is really something in New York, which for the last three decades has kept its status as the planet's top painting town more by default than otherwise. Currin does kitschy-looking, sneakily rigorous imaginary portraits, mostly of women, using a scrap heap of styles disdained by modern artists. In a meatpacking district, seeing a brush touch a canvas, I felt that something rather significant hung on the event. Like a low-budget remake of a movie classic, the moment was a bit desultory, but it had superb bone structure.

Currin, who is thirty-six years old, is a tall, rangy guy with jutting features and the slightly louche air of a Midwestern kid from just this side of the wrong side of the tracks. He was born in Colorado into an Oklahoma family, grew up in Northern California, and earned a master-of-fine-arts degree from Yale. His artist heroes include an uncle whose amateur paintings ran to "big-busted women and battleships." Currin's artistic stance belongs to a tradition of prairie, white-boy valor that looks macho from a distance and vulnerable up close. In him, the pattern shows up as part of a trend in painting that exalts culturally renegade, acutely sexualized sensibilities. Most of the newly eminent painters are women—including Elizabeth Peyton, whose intoxicating daubs praise languorous young men, and Lisa Yuskavage, a theatricalist of feminine angst. This puts Currin, whose images suggest misogyny, in an uncomfortable position that suits him well. His past lines of winsome, melon-

breasted babes who seem sprung from vile old men's magazines and of randy, over-the-hill-divorcée types—in thickly painted, often unvarnished styles—were deliberately upsetting. Until two or three years ago, I abhorred the stuff as a public nuisance. Then I happened to look closely at it.

No one today makes more telling use of subtle painterly rhetoric than Currin does. The taut and tender concentration of his techniques—he tacitly talks shop with Old Masters from Vincent van Gogh to Lucas Cranach—reacts with the coarse comedy of his images to generate a rare ardor. The longer you look at a Currin, the less you know what to make of it. Finally, you commune directly with permanent conundrums of painting—ambiguities of light and substance, depth and flatness, the works—on the awkward occasion of the artist's psychosexual quirks. Currin unites extremes of low-down grotesquerie and classical elegance. "I want contrapposto without looking Italian," Currin said to me of his nudes' expressively distorted Northern Renaissance anatomies. (He also said, "I prefer the Germans, because they're smokier and scarier.") His figuration is so kinesthetically affecting that it takes a viewer time to notice that, say, a figure's right arm is roughly twice as long as her left one. Currin's women may be unreal (he never works from models and rarely from photographs), but they sure are actual. This art bursts upon our imagination before we can organize ourselves to keep it out.

Currin's take on art history is so erudite and fresh that I was eager for his opinion of the newest Old Master in town. One afternoon we went to the Metropolitan Museum of Art's show of paintings by Dosso Dossi, a heretofore little-regarded Ferrarese Mannerist who made pastiches of Venetian styles—Giorgione, Titian—on arcane literary themes. Currin extolled the "pure goodness" of Dosso's love of painting, a quality that he found all the more cherishable for being handicapped by mediocre drawing and gawkily patchworked painterly affectations. "It's weird to see such good color in such awful art," he said appreciatively. "It's like Titian, only not intimidating." We marvelled together at the loftiness of the second-rate in cinquecento Italy. Currin remarked that a painter learns much more from second-rate artists than from great ones. While we looked and talked, I had the sense that he was mentally breaking off pieces of Dosso's shakily integrated practices and storing them away for future use. Browsing in the Met's permanent collection, we shared the joyous frustration of trying to pick apart the enigmatic seamlessness of Rubens, Velázquez, and Rembrandt. "Just look at that," Currin said almost crossly as he pointed to the envelope of space under a hand in one of Rembrandt's portraits. "It's exact and indefinite. It's like pi—you can keep figuring it out and always be right and never be done." Similarly exasperated, he drew my attention to the uncanny nonchalance with which Rubens rendered preposterous images, such as a fox attacking the hoof of a horse that is trampling it. "Another life-goes-on detail in Rubens," Currin said.

Finally, it was time for something perversely different. Currin led me to a painting that, in my thirty-six years in New York, I had never so much as glanced at. Hung dismissively high on a wall amid other debris of Italian eighteenth-century

decadence, Giovanni Antonio Pellegrini's *Bacchus and Ariadne* presents its histrionic characters in blushing pastel hues. "Simpering mediocrity," Currin pronounced, with satisfaction. "Overwroughtness in spurious form." He beamed at the la-di-dah Pellegrini. "See, he's making the figures demonstrate things that they have no right to demonstrate."

Currin's brand of artistic outlawry is timely. Today's establishment loves art not wisely but too well. Art is administered by sentimentally celebratory institutions, snugged into niche markets of dauntingly efficient commerce, and paraded through auction houses as a kind of glorified funny money. In this context, to be frankly unlovable seems a prerequisite for meaning anything vital. For Currin, it's not that old things—such as gleaming windowpanes of varnish or the use of the female nude to mirror male emotion—are new again. It's that "old" and "new" are exhausted categories. The past is present now. Dosso Dossi and John Currin are not contemporaries, but their paintings, inhabiting the same city at the same time, converse collegially. If the notion startles, it's because we are not accustomed to it yet. But we will be.

February 22, 1999

LATE, LATE DE KOONING

The last paintings of Willem de Kooning are spectral orphans of the twentieth century, left on the doorstep of the twenty-first. I have in mind the immense, eerie body of work—more than three hundred and forty large canvases, of which only several dozen have been shown—that de Kooning produced while, by all accounts, he was losing his mind to Alzheimer's. The paintings date from about 1980 until the artist "finally drifted away from his brushes in mid-1990," in the words of MoMA curator Robert Storr. (De Kooning died under nursing care in 1997, at the age of ninety-two.) They are de Koonings with a difference: more deliberate and leaner than the work of his tumultuous previous phases, with simpler colors often played out in sinuous ribbons, but firmly scaled and virtuosically composed. There is nothing geezerish about them. When they burst on the art world in an exhibition in 1996, journalists jumped on the Alzheimer's angle. Explanations were sought for the extended creativity of a man who, after 1986, could no longer sign his name. Oliver Sacks, quoted in that show's catalogue, seemed to settle the matter. " 'Style,' neurologically," Sacks said, "is the deepest part of one's being, and may be preserved, almost to the last, in a dementia." In any case, the importance of de Kooning's extra innings transcends issues of gerontology. His last period tells a story about painting and the meaning of art which could not be more timely.

"Willem de Kooning: In Process," curated by Klaus Kertess, is at the Corcoran Gallery of Art, in Washington, D.C. Kertess uses paintings, drawings, and adjunct material—mainly tracings on vellum-like paper—from the years 1971 to 1987 to explore de Kooning's working methods. Painterly procedure was always the sinew of de Kooning's art. When we look at almost any picture that he made after 1945 or so, we dive into the middle of something whose beginnings are obscured and whose ends hang fire. The middle is where de Kooning liked to be, deploying his gifts and skills in the tactical emergencies of an uncertain battle. To guarantee surprise, he regularly sabotaged his own facility by drawing with his left hand or with his eyes closed, shuttling configurations from one painting to another, and squashing wet paint surfaces with sheets of newspaper. (Peeled off, those sheets became a species of chance monoprints that, like the tracings, defy categorization: are they art works or merely, in the phrase of one art historian, "work product"? Their fortuitous beauty is enough for some people; there is a market for them.) De Kooning's self-scavenging techniques led him not so much forward, from one thing to the next, as incessantly sideways, from one thing into another. This helps to explain the longevity of his genius: he didn't have to remember what he was about. Through his routines of serendipity, his art could more or less keep track of itself. Meanwhile, his hand never lost its cunning.

That hand was already formidably adept when de Kooning, who was just twelve when he began studies at the Rotterdam Academy of Fine Arts and Techniques, immigrated to Hoboken in 1926, at the age of twenty-two. During the next twenty years, he developed history's most eloquent brushstroke, which, thick or thin, communicates shape, line, substance, direction, contour, speed, and pretty much every other trope that paint can embody. Picasso is said to have called de Kooning's work "melted Picasso," a remark that was canny, if self-centered. Western painting, in general, went molten in the Dutchman's oven. Clement Greenberg, in 1955, called de Kooning's pride "Luciferian." "Were he to realize all his aims," the imperious critic wrote, "all other ambitious painting would have to stop for a generation since he would have set both its forward and its backward limits."

Such dominance was not to be, as Greenberg, to his satisfaction, already knew. (He and de Kooning despised each other.) The rules of avant-garde painting had changed. Conceptual control supplanted de Kooning-esque lyrical invention. Jackson Pollock and the other "big painting" Abstract Expressionists had, without necessarily intending to, sparked a revolution in art as design: painting that is substantially complete in its initiating idea. Then came Jasper Johns, Andy Warhol, Frank Stella, and the era of what the critic Harold Rosenberg acutely but too dismissively called art works as "packages." Rosenberg's indignant championing of de Kooning—whose practice he had exalted in his flashy Existentialist theory of "Action painting"—did the artist no favors in the new, tough-minded art world. When radicals pronounced painting dead, there was no doubt about whose funeral they fancied. De Kooning's isolation in contemporary art fashions after 1960 or so accounts for the orphaned air of his late work. A present historical shift explains the work's sudden authority. All the cocksure movements of the last century have collapsed into a bewildering, trackless here and now. This condition turns out to be de Kooning's perennial garden.

In the 1960s, de Kooning's style was swimmingly sensuous, playing touch-and-go with smiling female flesh and moist landscapes. In the 1970s, his paintings turned more abstract and violent, with screeching colors and a climactic air—shooting the works. Then began the artist's fighting retreat. The paintings of the 1980s display progressive losses and resourceful compensations. He stopped executing swift, mighty gestures and began representing them. Shapes that suggest big, audacious strokes are composed of cobbled, careful little strokes. One senses spontaneity at a filtering remove; it's like hearing jazz over the telephone. De Kooning's last phase lacks his familiar antic anxiety—the emotional edge that he once characterized as "No fear but a lot of trembling" (riffing on Kierkegaard, his favorite philosopher). The evolution of a motif from one late picture to another can seem a matter less of inspiration than of impersonal will. It's as if the motif itself—such as a scribble of two women in a drawing of 1980, which recurred in paintings in 1987—were calling the shots. If feelings had bones, these paintings would be skeletons.

Late de Koonings are hard to describe. It's not that they lack definition and harmony. Their adagio loops and wristy flares, mostly in primary colors, carving up

bright white grounds, hang together like passages of music. But there is no sense of a governing intention, much less of the sublime contrariness with which the artist once joyously shredded pictorial norms. The octogenarian de Kooning did not forget how to paint, only why. Imagine a Greek tragic hero onstage without a chorus to give his speeches their fateful meaning. The role of the chorus falls to us, the audience. But what do you and I know for certain about painting's fundamental mysteries, which, at last, had de Kooning wholly in their grip? The subject of his late work is a vertiginous oneness of matter and spirit, and it demands humility. I am reminded of something that William James wrote in *The Varieties of Religious Experience* about a particular state of mind "in which the will to assert ourselves and hold our own has been displaced by a willingness to close our mouths and be as nothing in the floods and waterspouts of God."

May 7, 2001

THOMAS EAKINS

Thomas Eakins, perhaps the greatest American artist before Abstract Expressionism, was American by the usual test: he couldn't have been anything else. The same might be said of his art, which is styleless. There is no Eakins look. There is only a distinctive pitch of ambition and excellence. A magnificent retrospective at the Philadelphia Museum of Art, organized by the curator Darrel Sewell, endorses the opinion of the artist's older friend and hero Walt Whitman: "Eakins is not a painter, he is a force." Cannily intermingled paintings, photographs, drawings, sculptures, and miscellaneous artifacts—such as grisly casts taken from parts of dissected cadavers—reveal the artist as a yeoman genius, strenuous in all things. Eakins made aesthetics sweat. It is astonishing how contemporary he feels today.

Like Whitman, Eakins was a prophet of American inventiveness and self-invention, fired with an almost scary sincerity. In a letter from Paris, composed in 1868 when he was twenty-three and mastering the skills of French academic painting, he wrote, "I love sunlight & children & beautiful women & men their heads & hands & most everything I see & someday I expect to paint them as I see them and even paint some that I remember or imagine make up from old memories of love & light & warmth." The operative word turned out to be "someday." Unlike Whitman, Eakins would never luxuriate in the world. But he never ceased preparing to do so. As a teacher at the Pennsylvania Academy of the Fine Arts, he enlisted science, mathematics, photography, and technical ingenuity in a grand pedagogical program that aimed to put art on a solid footing with life in the present tense. His paintings can seem not so much culminations as by-products of this prodigious effort. Even his portraits, which include some of the finest ever painted, have an air of demonstration about them. His big multi-figure compositions of rowing races, operating theaters, and men and boys at play remain visions of possibility, visual essays about what a world-class American painting might be.

Eakins was born in Philadelphia in 1844 and, except for four years of study in France and Spain, lived in that city until his death, in 1916. That his father was a teacher of calligraphy helps to account for Eakins's punctiliousness in all matters of technique. The young artist took to academic training with a zeal that proved remarkably immune to the sentimental longueurs of his beloved teacher in Paris, Jean-Léon Gérôme. If he ignored Courbet and Manet and, later, the Impressionists, it may have been because he felt "modern" in his bones and saw no need to sacrifice the intricate powers of conventional know-how. He chafed only at drills in drawing from plaster casts and at other postponements of working with paint. Like Manet, he was inspired by the Spanish Baroque (Velázquez, especially) and its way of painting

outward to the contour of a form rather than filling in a linear outline. His interest was concentrated on central figures; his backgrounds are perfunctory. Eakins's element was life class. The studio nude obsessed him both in principle—as the touchstone of artistic competence—and personally. His devotion to coed life classes got him fired by the Pennsylvania Academy in 1886. One senses why from many of the show's engrossing photographs, taken by Eakins and his circle, in which getting naked seems the folkway of an aggressively earnest bohemia. Pansexual heat glowed in dim rooms that smelled of dust and varnish.

This may not be a minor point, but the show's otherwise marvellously detailed catalogue essays are quaintly reticent about Eakins's sexuality. There are a few telling anecdotes. One concerns Maud Cook, a relative of the lovely young model for *The Concert Singer* (1890–92)—a brilliant painting so true to life that some scholars assert, from the look of the singer's mouth and throat, that she had to have been uttering the "e" sound in "rest." (We know that the song was Mendelssohn's "O rest in the Lord," which Cook often sang for Walt Whitman, at the poet's request.) Eakins alienated Maud Cook by insisting that she pose nude for him. The art historian Marc Simpson quotes her as saying that he " 'kept after her' … making his eyes 'soft and appealing' and dropping into a Quaker 'thee'—'gentleness combined with the persistence of a devil.' " Three years later, having forgiven him, she sat for one of his supreme female portraits, wearing a demure pink dress. Before I knew the story, I had decided that *Portrait of Maud Cook* was one of the most erotically charged pictures I had ever seen. My point is not that Eakins may have been a wolf—who cares?—but that animal instinct and professional commitment were tightly knotted for him in a manner that seems deeply Puritan. Call it heroic hypocrisy—an attitude, long popularly associated with medical practice, that exalts certain vocations to shield them from moral taint.

Eakins's portraits are tense standoffs between intimacy and integrity, conveying his avidity for the sitters while making no secret of the anxieties that attended the painting of them. More than one observer has remarked—inviting comparisons with Rembrandt—that we can see Eakins's people thinking. To judge from their expressions, their thoughts are not joyous. Only two figures of the many that the artist brought to breathing life strike me as expansively happy. They are the eponymous surgeons in *The Gross Clinic* and *The Agnew Clinic*, standing back from their bloody handiwork with their scalpels. Eakins renders them as demigods incandescent with pride and the world's applause. They are plainly surrogates of the artist as, brush still in hand, he regards a painting well done.

Isn't the poetry of consummate and fearless work what we love in Eakins? Many critics have tried to define his astringent glory. Clement Greenberg observed acutely, "The visionary overtones of his art move us all the more because they echo facts. This is perhaps the most American note of all." Greenberg described Eakins's manner as "a neutral, natural style not so much because it was shared with others as because of the honesty and appropriateness with which he used it, without

flourishes, without 'retouching,' without either elegance or inelegance." Even his lesser works communicate a hard-won victory over the human frailties that cloud normal seeing. Ambiguously, those weaknesses include the very "adhesiveness" (in Whitman's great word) that drew the artist to his subjects. Whatever else Eakins had in mind when he begged Maud Cook to strip, he knew that she would make a good picture. For him, the dignity of art may have stood in an inverse relation to the nobility of its motive. His best subjects are the rawest or the humblest. His single truly bad painting is a Crucifixion.

In 1875, Gérôme arranged for a number of works by his former pupil— among them, the dazzling sailboat painting *Starting Out After Rail*—to be shown in the Paris Salon of that year. A witty French critic noted the pictures' photographic qualities and wondered "whether these are not specimens of a still secret industrial process, and that the inventor may have maliciously sent them to Paris to ... frighten the école française." That tiny shock was an early warning that American painting was destined to operate according to its own rules, with spontaneous, eventually intimidating power. Already Eakins could push the logic of French academic art to modern extremes, because for him, as an American, it was only logic, unchecked by French sophistication. To Whitman's "barbaric yawp," he added a barbaric precision as stark and challenging as skyscrapers against the sky.

October 22, 2001

LUCIAN FREUD

Lucian Freud, the subject of a huge retrospective at Tate Britain, in London, is living proof that national character still counts in art, globalization or no globalization. The musky realist painter is extremely English. He hails from Germany—but so does the royal family. (He arrived in 1933, at the age of eleven.) As a grandson of Sigmund Freud, he boasts a brilliant bloodline. Unlike people of lesser stock, whose behavior is what one would expect from them, Freud enjoys the distinction of being perennially, albeit mildly, scandalous. In his eightieth year, he continues to spend long hours scrutinizing unclothed flesh in his dilapidated studio, in Holland Park. His glumly pungent nudes have a challenging air, as if daring anyone to judge them less charitably than the proud, brooding artist judges himself. He is a notorious gambler, mostly on horses. His personality exudes flavorful amounts of grumpiness and dash. As if all that weren't enough, he paints well. He is a national treasure.

I find Freud's work hard to like and almost impossible not to admire. It constitutes a superb performance in a socially charged role. What this has to do with its artistic qualities is a question tangential to his prestige in England and among Anglophiles everywhere. One feels rather like a spoilsport—or an American, if that's not the same thing—for bringing it up.

Freud began his career during London's cold-water wartime and postwar years as a kind of modern-arty, melancholy Pierrot, channelling styles that were in vogue at the time. His early work at the Tate features Klee-like fantasies, Magrittean scenarios, displays of showily meticulous technique resembling Andrew Wyeth's, and melting pathos in pictures of downhearted young people with enormous, sad eyes. Much of this is better than it sounds, because it is keyed to a refined Romantic fervor. There's a true adolescent ache in the young Freud, of a sort that we indulge readily enough in Picasso's blue period. Not that Freud illustrated the sufferings of an impoverished bohemia. He found sufficient pain in the existential states of privileged characters who visibly do not know what to do with themselves. Their world suggests J. D. Salinger's with poor plumbing. Though catchy, Freud's fledgling styles were brittle, relying on a second-rate gift for drawing that tilted toward caricature, the most English of graphic proclivities. Around 1960, he broke through to fluency, and even profundity, by concentrating his energies in paint for flesh's sake. His great theme became the incorrigibly unhappy animal beneath the skin.

Hardly a painterly prodigy, as his clotted early canvases confirm, Freud taught himself to break up planes of faces and bodies into patches of color, Cézanne fashion, and to knit them together with close-toned hues and continuous textures of juicy

brushwork. He achieved a distinctive, notably tactile way of modelling. It's as if his figures were brought into being by cumulative soft and rough touches—a caress here, a grab there. Occasional buildups of strokes in certain passages, usually faces, advertise a protracted struggle to get the details right. His colors are glowering and earthy, with virtual odors to them. "Raw umber is to Freud as pink was to Matisse," the curator and critic Robert Storr once remarked. No painter alive is more exciting in areas a few inches square, where Freud's brush may nuzzle into the hollow of a hip or cradle the exact weight of a sagging breast. This is more than a matter of skill, because the action symbolically unites hand, eye, mind, and sexual feeling. Too grossly frank to be conventionally erotic, the nakedness of Freud's subjects nonetheless evokes states of crude, indiscriminate arousal: dumb lust. This may explain the slightly prurient cast of the artist's celebrity. But what Freud does or doesn't do with his sitters is irrelevant to what he does as an artist.

Freud's knack for caricatural likeness gives his subjects, who tend to be people he knows, rather than professional models, enough hints of an interior life to offset the impression of a meat rack. That these lives appear awfully grim surely owes something to the rigors of interminable posing, which would put anyone except a congenital exhibitionist in a foul temper. On rare occasions, Freud has painted outrageous showoffs, usually gay men. (He is assertively straight himself.) His paintings of Leigh Bowery, the late man-mountain Australian performance artist, are, psychologically, his most interesting works. In these pictures, one compulsive performer faces off against another. The look in Bowery's eye is assessing, like a gladiator's, as he carefully flaunts his spectacular body. More generally—even in portraits of the artist's mother—Freud's gaze dismisses personality to home in on animal energy. His work suggests that having to be someone in particular is an onerous, perhaps tragic fate. (His grandfather's famous essay *Civilization and Its Discontents* comes to mind.) In his paintings, only the occasional dog seems at one with itself, as a sinewy, insouciantly ugly bundle of instinctive being.

Freud's self-portraits are pictures about the ordeal of ambition. They put the artist not only on view but on trial. Is he measuring up? In a bizarre painting from 1965, *Reflection with Two Children*, he looms as a truculent but anxious giant, looking himself in the eye. The children—his daughters—appear as tiny, marginal images, suggesting remote concerns. (This is not a man whom you'd ask for help around the house.) In a more recent self-portrait, *Painter Working, Reflection* (1993), he stands naked in his studio at night with a palette knife in hand—a beast at bay and possibly dangerous. It's a terrific painting, with a seething, half-despairing drive. It's as if he were discovering the figure of himself by repeatedly bumping into it in the dark.

Enthralling as Freud's brushwork can be, his art goes numb when viewed from a distance of more than five feet or so—the remove at which paintings become pictures. I defy anyone to recall, as a vivid mental image, a whole composition by Freud, complete with objects and background. (For comparison, try the test on

a Bonnard, a Balthus, or a Hopper. They deliver.) My own recollections of his paintings zoom in on figures or, as often as not, qualities or parts of figures. I think of a young woman's effulgent, all-over blondness or of Bowery's convex Hoover Dam of a back. Freud's friend and peer Francis Bacon, who focused even more furiously on the figure, dealt with the background problem by abstracting it in flat zones of uniform color. But Freud insists on sustaining the realist fiction of a world that can be entered. It's almost touching to watch him try to stay interested and expressive while filling in floorboards and windowsills. Though his pictorial stages are sometimes jazzed up with unusual viewing angles, they remain a construct of petrified conventions. He is apparently aware of this. In one large group portrait, he seems to mock his own static artifice with the present-tense detail of water flowing from the spigot of a sink. The notion of laboriously worked-up figures sharing the moment of a gurgling sound is comical, in a clunky kind of way.

For the most part, drama surrounds rather than suffuses Freud's work. This is part of what makes him so English, as is the prestige accorded an ultra-conservative style that in any other culture would have had trouble being taken seriously. (Over here, Andrew Wyeth remains a regional reproof to all aspects of urbanity.) It is a truism to say that the English, at least in the Home Counties, around London, are congenitally theatrical, steeped in codes of behavior that both uphold the class system and counter its pernicious burdens with infinitely nuanced shades of ridicule. If you're not in on the game, it need take no account of you. But there's a special dispensation for sufficiently intriguing originals. Like Bacon's histrionically miserable homosexuality, Freud's Jewish, Continental, angst-ridden roots, abetted by his exalted pedigree, have played equally well in art journals and tabloids. What's required of a successful English artist, beyond being good enough, is that he make a "character" of himself. This goes as much for contemporary Y.B.A.s (the Young British Artists of swinging renown) such as Damien Hirst as it did for Oscar Wilde, and in Freud's case it rises to something like sublimity.

Freud is not only the maker of his art but its protagonist, enacting mastery in more ways than one. He is less a painter than "the Painter," performing the rites of his medium in the sacristy of his studio. (He would no more spiff up that legendary, shabby space than a music-hall comedian would throw away his signature battered hat.) There's more than a trace of Picasso in his stand. The critic William Feaver, writing in the Tate catalogue, tells how Freud, as a young man, was given the task of delivering a Picasso *Weeping Woman* to a show in Brighton: "He put it on the seat opposite him in the railway carriage and looked at nothing else the entire journey." Freud later recalled being mesmerized by Picasso's transformational magic, his ability "to make a face feel like a foot." He plainly imbibed much of the great man's attitude as well. Freud approaches his sitters with a muted version of the erotic fascination and domineering intent that Picasso brought to his portraits of Dora Maar and, really, to everything else he did. But the Spaniard's studio agon was fiercely playful when not playfully fierce. Ultimately, its force yields the autonomy and

surprise of a grandly resolved art, in which the subject is consumed to a fine ash of remembrance. By contrast, Freud's wrestling with his models is rote and circular, like the repetitive imbroglios of a bad marriage. Still, even his flaws put him in good company.

In the United States, as in most of Europe, the issue of judging art according to the dancer or the dance long ago tipped decisively toward the latter. We feel that works of art should register in their own right, without anecdotal folderol. We grant authority to impersonal histories, principles, and theories. Compare Freud with his American near-contemporary Philip Pearlstein, another painter of large, unprettified nudes. Versed in New York School abstraction, Pearlstein creates pictures that are formally as tight as drums, and that declare themselves completely and strongly from any distance. But Pearlstein's paintings are cold and dry. Hot, moist Freuds are more fun, despite their incoherence. Standing close to them, I sometimes have the odd sense of passing through a looking glass—or is it a time machine?—from the art world that I know into one marked by lusher, dirtier satisfactions. For a moment, it strikes me that this, precisely, is what I like. Then the mood evaporates. Still, the persistence of so seductive an affront to international rectitude merits esteem.

July 8, 2002

GIACOMETTI

I've discovered a rewarding way of looking at sculptures by Alberto Giacometti, who is the subject of an elegant retrospective at MoMA. Stand behind them. Examine their backs and peer out over their shoulders, if they have any. (Most of them do; Giacometti was terrific at shoulders.) Gaze into the space into which the figures are gazing. Suddenly you have a sense of how Giacometti's art inhabits the world— worriedly, with touching eagerness. You understand how much the figures—the early Surrealist "objects" no less than the famous skinny statues that occupied the artist from the 1940s until his death, in 1966—strive to please, and how hard this is on them. They may bring to mind dreams in which one is thrust onstage without a script. Viewing them from backstage failed me only in the last galleries, which feature works from the finally self-confident climax of Giacometti's five-decade career. A ghostly stage manager started shooing me out into the audience, where I belonged.

Giacometti was born in 1901 in Stampa, Switzerland, into an artistic family. His painter father encouraged him, and his younger brother, Diego, the designer, was a lifelong intimate. Alberto's hypersensitive nature received a jolt in 1921, when an acquaintance with whom he was travelling fell ill and died. Witnessing the event left him with a fear of death that bordered on panic. (He couldn't sleep without a light on.) But he was a gregarious habitué of cafés, and since he tended to work in spurts, between long stretches of fretful idleness, he had plenty of time to indulge himself. From 1927 on, his home was a shabby, barrack-like studio building in Montparnasse, warmed by the comings and goings of friends and admirers. His circle included most of the leading avant-garde artists and writers in France, among whom he moved as a craggy, humorous personage. Imagining him invokes the romance of Paris—not as a city of light but as a metropolis of soiled rooms, chance encounters, and eroticized intelligence. But something stern about him forbids sappiness.

Giacometti was the most uncomfortable great artist of the twentieth century. Existentialist? Sure. Jean-Paul Sartre's canonization of him in postwar Paris made sense. But then so had André Breton's embrace of him as a Surrealist paragon in Paris between the wars. Anyone pushing a philosophy of dissatisfaction would deem the Swiss artist exemplary. Giacometti was grateful for acceptance, and his readiness to flatter the Zeitgeist seems to have been a cause of his anxiety. You can see the problem in the first gallery at MoMA. Youthful drawings, paintings, and busts of firm, Apollonian rigor abruptly give way to fashionably Dionysian totems and fetishes. Giacometti's gifts overqualified him for the easy things that his age demanded. He was equipped for grand, public art on symbolic themes, and, toward the end of his life, that is what he achieved.

Still, his Surrealist period produced two startling, one-off masterpieces, both from 1932: *The Palace at 4 A.M.* and *Woman with Her Throat Cut*. These marvels stand out in art with lightning-bolt majesty, as Coleridge's *Kubla Khan* does in literature. *The Palace at 4 A.M.* is a preternaturally stilled tableau made of delicately tinkered wood. Its components include a chess-piece-like female figure; a hanging, not quite human spine; a soaring, skeletal bird-thing; a ball nested in a spoon-like shell; and a bit of glass ceiling. Freudian critics have shown that the symbolic content is anything but mysterious—or interesting. (You know: mother, father, sex, death.) What awes us is the poetry of the work's exquisite proportions, and an expressive urge that is at once vertiginous and very, very careful. Looking at the piece from behind, I felt the outward rush of its passion to connect, to reach the last rows in the theater of the world. I loved Giacometti at that moment. Love is, among other things, the experience of identifying with another person's sincerity. It is rare in art, where impersonal operations of style normally regulate emotional connection. In the case of the brutal *Woman with Her Throat Cut*, a detached response is impossible.

The work is pictorial, like nearly all Giacometti's sculpture. It assumes a gaze from above—perhaps that of a sadistic voyeur, if not a murderer. It shows a spavined figure with spread legs; a tiny, screaming head at the end of an arched, notched neck; and limbs that issue in outlandish shapes, including a leaf-like blob suggesting a splash of blood, on which rests a cylindrical weight. (A miracle of formal inspiration, the weight pulls the piece together, anchoring its frenetic elements.) For insight into the work's power you might want to sit beside it, on the floor, and absorb the complex tensions in the gnarled intersection of body, neck, and arms. *Woman* is an essay on specific spasms of physical agony. From a low vantage point, any sense of voyeurism melts away. To render suffering so precisely is to know how it feels. Finally, notice the gold-tinged patina of the bronze: theater again. Giacometti had an inclination to beguile.

Giacometti shed Surrealism's embrace in 1935, when Breton excommunicated him from the fold for returning to studio figuration. He spent the war years in Switzerland, producing sculptures so minuscule that, after the Liberation, he brought them to Paris in six matchboxes. At MoMA, one of the miniature figures stands on a massive base, traumatized and game. It is like a wisp of flame, almost but not quite extinguished. Giacometti's mature repertoire of emaciated figures grew from his matchbox Lilliput. No other European artist weathered the demoralizing ordeal of the Second World War so creatively.

A peculiarity of the MoMA show, which was mounted by a team of curators led by Christian Klemm, is its inclusion of forty Giacometti paintings. Most of them are portraits, made after the late 1940s, which pay relentless attention to the sitters' heads. Heavily reworked line and paint yield clenched visages in auras of mud. Giacometti stated his aim this way: "To see a head, to see it alive, to maintain it so." There was something compulsively fascinating for him in face-to-face encounters with people. A viewer's avidity will likely prove exhaustible. The paintings are

impressively honest, but their ritual qualities consume more energy than they transmit. Though always a compelling draftsman, Giacometti had little use for the resources of painting. As a painter, he remained a sculptor—digging into space, groping for contoured mass. The effect of imposing these concerns on a recalcitrant medium becomes tiresome. One suspects a promotional motive in this show. There are a great many Giacometti paintings out there; they have never enjoyed a robust market.

Viewed conventionally, from the front, Giacometti's signature sculpted figures seem like the ravaged but ultimately heroic victims of wasting forces. The forces come from outside. It's as if the air in which the figures stand had tried to devour them. Their vibrantly tactile surfaces register less as outside boundaries of their bodies than as inside boundaries of the world beyond. Even the smallest of the figures become monumental in their resistance to surrounding space. At MoMA, the very light crackles in the big rooms that contain the late work. More than any abstract sculptor, Giacometti anticipated the blunt presences of Minimalist art which induce acute physical self-awareness in viewers. A Giacometti—representational, pedestalled, and vertical though it may be—can put us on the spot almost as effectively as a floor piece of metal squares by Carl Andre. At the same time, his figures maintain vestigial traces of subjectivity, in the thrust of a chin, the tilt of a hip, and the set of a shoulder—calling to the heart. You can think and feel about his work indefinitely, without using it up. The best Giacomettis take you to the limit of your capacity to be moved by art.

October 29, 2001

"We can define El Greco's work by saying that what he did well none did better, and that what he did badly none did worse," the Spanish painter and scholar Antonio Palomino wrote in 1724. That violently mixed assessment struck me as just right when I read it on a wall of the Metropolitan Museum's current, tremendous El Greco retrospective. Critical quotations, pro and con, pepper the show's superb installation by the curator David Davies; they vivify the warring opinions provoked by El Greco in his lifetime and ever since, except for a spell of near-oblivion that ended in the nineteenth century, when, like Vermeer, he was rescued by French aesthetes. A bit later, Picasso took him as a formative influence and thereby installed him in the boiler room of modern painting. El Greco feels at issue in art again today, as new painters, notably John Currin, raid museums for nuggets of refractory inspiration. To consider the Master of Toledo is still and always to engage in argument—with oneself, as likely as not. At the show, I found myself alternately cheering and cringing, inwardly, like the fan of a talented but goof-prone sports team.

The glory and the problem of El Greco are the same: spirituality. No other great artist takes this fundamental, usually ineffable aspect of experience so literally, as an open secret. He does so in terms of strict Catholic doctrine, but with an energy that a person of any faith, or of none, may recognize. His art affirms spirituality— the awareness that glimmers at the headspring of consciousness, prior to thought and feeling—as the primary fact of life, always on tap. This jolts people into love or loathing of El Greco, depending on how they relate to the spiritual in themselves. Spiritual intimations trickle through all minds, however obscurely, and even while discounted or ignored. El Greco delivers them with a fire hose.

Crete was a Venetian colony when, in 1541, Domenikos Theotokopoulos, as El Greco never ceased to sign himself, was born there. He trained as an icon painter in a variant of the Byzantine manner, whose formulas were aimed less at representing the divine than at summoning it. In Venice for three years, from the age of twenty-six, he assimilated the most advanced painting of the day: Titian, Tintoretto, Bassano. Venetian painterly rhetoric—bodies in dramatic motion, open brushwork, clarion color—imprinted on him, but without changing his metaphysics. He failed to start a career in Rome, where he seems to have burned bridges by disparaging Michelangelo, whose carnal sublimity—submerging the spirit in straining muscles—was bound to affront the young Greek. El Greco reportedly offered to repaint *The Last Judgment* in a more seemly manner. Still, he picked up tricks of composition from Michelangelo, as witness the rhythmic aggregate of bodies in his

several versions of *The Purification of the Temple*—Jesus scourging the sacrilegious. He was a quick study.

By 1576, when he was thirty-five, El Greco had followed his ambition to Spain, whose art-loving King Philip II was on top of the world after organizing European forces against the Turks for the monumental victory at Lepanto, in 1571. El Greco made an apparent bid for royal favor with a ghastly painting, *The Adoration of the Name of Jesus*, which is an arduous hodgepodge of practically everything that he knew how to do, from medieval grotesquerie to Titian-esque elegance, and features a passage of unforgettably hideous orange. (In El Greco, successful color comes and goes like a gambler's luck.) Turned away at court, he alit in Toledo, the ecclesiastical capital of Spain, where he remained until his death, in 1614. Records of furious litigation over payment for most of his major commissions bespeak an obstreperous character. He lived high, at one point renting twenty-four rooms in a palace and employing musicians to play while he dined. He had, and acknowledged, a son by a Spanish woman soon after arriving in Toledo; he never married. Active intellectually, he pressed for official recognition of painting as a liberal art. To gauge the status of painting in Spain at that time, consider that El Greco was paid three hundred and fifty ducats for his first major Toledan commission and (albeit ten years later) five hundred and seventy for crafting the picture's frame.

El Greco's temperament was on time for one of the most disputatious eras in European history: the Counter-Reformation. The Inquisition and Ignatius Loyola's Jesuits were on the march. At the same time, though with some reluctance, the Church chose to exploit rather than to suppress the intense, gorgeous, personalized writings of the mystics Teresa of Ávila and John of the Cross. The Protestant threat argued for letting popular wildflowers bloom. El Greco found his path to fame as a pictorial rhapsode of militant piety. Is his blend of iron dogma and unbridled spontaneity a paradox? It is certainly special. El Greco's later ecstatic paintings are somewhat downplayed in the Met show, which concentrates on his terrific, strange, less well-known portraits. Lacking any consistent look, the portraits adapt Venetian styles with antic originality—one tour de force after another, striking the odd spark of psychological insight but conveying little sense of everyday social engagement. El Greco's two greatest portraits might as well be classed with his religious paintings, as spiritual images. One conjures up the ravishingly alert friar-poet Hortensio Félix Paravicino. The other is "A Cardinal," who is generally acknowledged to be the Inquisitor General Niño de Guevara. Modern eyes see the bespectacled prelate—tensed in his vermillion robes, suggesting a frozen flame atop a torch—as repellently cruel; but I think that El Greco regards severity as part of the man's important job and a good thing for everybody. The portrait is savagely upbeat.

I am of the party that questions El Greco's authorship of *A Lady in a Fur Wrap* (surmised to be from the late 1570s), an enigmatic portrait whose vivacious ease with a pretty woman seems alien to him; if it is his, it may either depict Doña Jerónima de las Cuevas, the mother of his son, or betray a holiday of passion that left

no other historical trace. The most persuasive evidence for an attribution to El Greco is how poorly, in so fine a work, the sitter's hand is rendered. When not stylizing hands and feet as willowy, tapering forms, he could be an amazing klutz with those items of anatomy. Truth to nature didn't interest him. He preferred variations to themes, stepping up to a canvas and whaling away. He was most himself—vulgar and supreme, pummelling and thrilling—when excitedly envisioning a force that I think of as upside-down gravity. Try this: Turn a reproduction of one of the tall mystical paintings on its head. Observe how the stretched, writhing figures snug down luxuriantly, enfolded by a thick liquid medium of clouds and sky, into which they are sinking. The figures' elongation is like that of descending blobs in a lava lamp. Seen upright again, the vertical tug or, really, suck of the composition—a slow-motion celestial tornado—is easy to read. To enjoy the effect, you must let it commandeer your own body in sympathetic imagination. I find that I can soar readily on the thermal of, for example, *The Virgin of the Immaculate Conception* (between 1608 and 1613), with its bizarre rocket form of an angel's wing seen end on. Clinching the deal is a visceral paint texture that makes the picture a kind of palpitating body in itself. El Greco's great subject is the translation of matter into spirit, caught on the cusp.

Finally, the show left me with rather an overdose of exaltation—as I realized upon emerging from it into the Met's gallery of early Baroque paintings, including two by Caravaggio of fleshy, louchely simpering boy musicians. I've never felt gladder in my life to loiter with those rascals. Not for them any divine updrafts. They're fine with gravity, among other involuntary powers. Throw in music, wine, fresh fruit, and whomever they're vamping, and Heaven can jolly well take the night off.

October 20, 2003

PHILIP GUSTON

Around 1967, Philip Guston abandoned the tremblingly sensitive, lofty Abstract Expressionism for which he was revered. In its place came an outburst of gross cartoon imagery: gregarious Ku Klux Klansmen with fat cigars; one-eyed heads, like lima beans, in need of a shave; interiors ajumble with liquor bottles, cigarettes, food, and painting gear. Guston, who died of a heart attack in 1980, at the age of sixty-six, had seemed the most compunctious member of American art's greatest generation. Intimations of figures sometimes haunted his abstractions, only to be visibly suppressed—he was a knight of emotional restraint. When his new work was shown in bulk at the Marlborough Gallery in New York, in 1970, it was as though an elegant veil had parted and out had stepped a yakking geek. I was one of many people who hated the show, and I found myself half-agreeing with the headline of a famous pan by Hilton Kramer, in *The Times*: "a mandarin pretending to be a stumblebum." "Mandarin" seemed wrong; a better analogy, for me, would have been mountain-dwelling scholar-poet. But the rest fit the masochistic bearing of a style that felt all the more grotesque for being executed with the artist's insinuating brushwork and ticklish color.

That moment retains its shock in the current Guston retrospective at the Metropolitan. Reliving it, I understand both why it took me more than a decade to come around to late Guston and why I now regard that work as the most important American painting of its time. The reason in each case is a traumatic upheaval of the 1960s. Late Guston belongs among other explosive, harshly significant cultural departures of the era. Bob Dylan, plugging in an electric guitar at the Newport Folk Festival in 1965, also abruptly trashed a precious taste with which he had been identified. It seems appropriate that Guston lived in Woodstock, New York, where he had moved in 1947. His breakthrough work in 1967 even seemed to echo "underground" comic-book stylists of the day, notably R. Crumb, though evidently he was unaware of them at first. (The resemblance points to shared influences. Both Guston and Crumb took inspiration from such classic comic strips as George Herriman's "Krazy Kat.") I loved rock-and-roll Dylan, but I clung to a faith in high-toned abstraction as the pinnacle of contemporary art. Guston's 1970 show—in retrospect, modern painting's Appomattox—left me feeling betrayed.

Guston was born Philip Goldstein to Russian Jewish immigrants in Montreal in 1913; he was the youngest of seven children. The family moved to Los Angeles seven years later. Philip drew obsessively, often holed up in a closet with a bare light bulb. (That bulb is a leitmotif in his late work.) When he was ten or eleven years old, he found the dead body of his father, Louis, a blacksmith who had been reduced to

working as a junkman. Louis had hanged himself. Jackson Pollock was Guston's classmate and best friend in high school. Budding leftists, the two were expelled together for leafletting against the school's emphasis on sports. Pollock left for New York in 1930, while Guston remained in California, profiting from friendships with cultivated older artists and intellectuals. He acquired his lifelong passion for Old Masters—Piero della Francesca was a god to him—and embraced the Depression-era fashion of Social Realism. His fascination with the Ku Klux Klan began early. In a drawing that he made at the age of seventeen, a Klansman in a group that has lynched a black man fingers a rope with apparent anguish. Guston said of the K.K.K. figures in his late work, "What would it be like to be evil? To plan, to plot." There's a harrowing touch of *Heart of Darkness*—upriver, where the beast thrives—to this aspect of Guston's imagination.

After working on murals in Mexico, under the aegis of David Alfaro Siqueiros, Guston moved to New York in 1935, stayed with Pollock, and joined the mural division of the Works Progress Administration. He married Musa McKim, an artist and poet and his inseparable companion for the rest of his life. He hung back from the trend toward abstraction in the work of Pollock and other friends, including Mark Rothko. In 1941, he left New York for Iowa City and St. Louis, where he taught for six years. As late as 1945, he was painting in a politically tinged, Surrealistic vein. *If This Be Not I* is an enigmatic allegory of slum children costumed in the manner of a Venetian carnival; the picture is notable mainly for soft blues, dirty pinks, and other uncannily sentient colors. He finally went abstract in the early 1950s with a mode that art-world wits promptly dubbed "Abstract Impressionism": drifting masses of short, worried strokes in delicately abrasive, glowing colors. During the next decade and a half, that style became more dramatic, with dominant reds and blacks, broader handling, and jostling forms like possibly living things astir in shadows. Guston had a de Kooning-like knack for making scraps of contour that are pregnant with descriptiveness while describing nothing but themselves. No one has ever had a more charismatic touch. (The plangent brushstrokes that Jasper Johns wielded with irony in his flags and targets are Guston-esque.) *To Fellini* (1958), a quaking abstraction evocative of carnival joys and fears, strikes me as a supreme feat of sheer painterliness—existentialism à la Rubens.

Plainly, something is brewing in Guston's manner of the early and middle 1960s, as mask-like black forms hover in jam-ups of pewter grays, ardent blues, sickish reds, and the occasional, blaring green. Then, boom. All hell doesn't so much break loose as move in and set up housekeeping. Klansmen in what look like surgically sutured hoods flagellate themselves, take spins around toon towns in lumpy cars, engage in bang-bang-you're-dead finger-shooting, and paint images of themselves. Abject old shoes, some at the ends of bodiless legs, pile up like the debris of obscure atrocities. Belligerent arms brandish garbage-can lids. A bean-head may lie face down on the ground, contemplate empty bottles and other tokens of bad habits, or direct a thousand-yard stare at nothing. An oddly insistent horseshoe shape recurs:

the Greek omega. Drowning deluges of water rise. Hilarious, weirdly compassionate caricatures of Richard Nixon, with a colossal phlebitic leg, occupied Guston for a while. The manner of drawing in the late work is beyond coarse. (Crumb is Ingres by comparison.) But everywhere, realizing boundless varieties of wonder, there is that buttery, tender, wonderful stroke, and those colors like materialized day and night and pared flesh.

Late Guston scared me. Thrashing about in my personal share of the time's chaos, I had thrilled to a promise, in his painting, of inviolable aesthetic elevation. Plausible father figures were scarce in the 1960s; here was a cherished one running amok. (In a fine, sorrowful memoir by his daughter Musa Mayer, *Night Studio*, which was published in 1988, Guston emerges as a warm but relentlessly self-absorbed dad. Once, in her early childhood, she writes, "Philip spent hours making a cookie for me, cutting up currants, marking the reins and halter of a beautiful Greek horse.... When I saw it, I cried, 'Oooh, my cookie,' and reached for it." But it was taken away and mounted on the wall, as art.) Now I recognize as heroic Guston's surrender of a lifelong yearning for august refinement, which was always strained and tinged with falseness, coming from a tragic junkman's son. Guston felt guilty, in later life, for having changed his name, in 1937—for denying what he was. "I got sick and tired of all that purity!" he said. His cartoon personae were thus the opposite of self-invention. In their disorder, he found peace. For young artists who were less interested in spiritual reassurance than in how to make the beleaguered art of painting newly credible—in varying degrees, most of the important painters of the past thirty years—he became a father figure indeed. His example renews a timeless truth about creativity: the royal road to the heights leads down.

November 3, 2003

Marsden Hartley was a great artist whose greatness is of a piece with the provincial clumsiness of American high culture in the early twentieth century. A strong Hartley retrospective at the Wadsworth Atheneum, in Hartford, confirms the lasting grandeur of the Yankee modernist, who stands in the history of modern art like an increasingly unavoidable, bumpy detour. At different points in his career (he died in 1943, at the age of sixty-six), Hartley was inspired by French masters, primarily Cézanne, and by German Expressionists, notably the Blue Rider group, which included Wassily Kandinsky. He adored Germany and had extended stays in Berlin. He participated in the fast-track salons of his day: Alfred Stieglitz's in New York, Gertrude Stein's in Paris, John Reed's in Provincetown, and Mabel Dodge Luhan's in New Mexico. A secretive homosexual, he was, in his later years, part of an elegant gay scene that formed around the photographer George Platt Lynes in New York. He fitted in nowhere. Solitude owned him.

In retrospect, Hartley's best art—made in Berlin from 1913 to 1915, and especially in Maine, starting in the mid-1930s—looms so far above the works of such celebrated contemporaries as Georgia O'Keeffe, Charles Demuth, Arthur Dove, and John Marin that it poses the question of how his achievement was even possible. Like Edward Hopper, a very different painter and Hartley's only equal in their generation, he possessed a self-reliant temperament that pitted gritty American resources against the intimidating authority of European art. The utter freshness of the Hartford show— even apart from the presence of unfamiliar gems that have been turned up by the curator, Elizabeth Mankin Kornhauser—marks Hartley as both an aesthetic and an ethical hero. Beauty comes and goes in his work, but intuitions of truth are constant. Hartley's work confronts the viewer with the question: Do you live in a way commensurate with such honesty?

Hartley was fabulously ugly, in an Abraham Lincoln way; a big man, he had a long face that joined a high dome, deep-set eyes under sloping brows, a huge nose, and, over all, the look of an extraordinarily intelligent hound dog. In photographs, his gaze is often worried but always firm: he stood his ground. He was born Edmund Hartley in Lewiston, Maine, the youngest of eight children of English immigrants. His father worked in the cotton mills. After his mother died, when he was eight, his father remarried and moved the family to Cleveland, where Hartley studied at the Cleveland School of Art and became devoted to the writings of Ralph Waldo Emerson and Walt Whitman. (The earliest painting in the show is a brooding little picture, dated 1905, of Whitman's house in Camden, New Jersey.) In 1899, Hartley came to New York, and worked his way through Impressionist, Neo-Impressionist, and Fauvist styles (*Storm*

Clouds, Maine, from 1906–07, is a serendipitous marvel). He imbibed spiritualist ideas, and met and was influenced by Albert Pinkham Ryder. He also took on his stepmother's maiden name, Marsden. In 1912, he set off for Europe.

The heraldic semi-abstractions that Hartley made in Berlin in the years before and after the onset of the First World War are such icons of modern style that, seeing them one at a time, I have sometimes tired of them. Their conjunction of jazzy Cubist composition and rough Expressionist handling can have the air of textbook demonstrations performed with forced high spirits. The panache of the pictures that are dedicated to Hartley's lover Karl von Freyburg, a German soldier who was killed early in the war, strikes a weirdly manic tone of mourning. The Hartford show has rejuvenated my appreciation of these works. Seen in quantity, they disarm the viewer with the restless variety of their formal invention. Berlin liberated Hartley artistically and sexually. His sorrow at the loss of von Freyburg, of whom little is known, only amplified his gratitude to the man. In the paintings that display the initials "Kv.F," the artist used his gifts to resuscitate the fallen hero, whose emotional presence Hartley would not let dissipate. This intention is felt in the almost violent compression of these works, in which all the elements go bang! simultaneously, without flying apart. Nothing else in that epoch of applied Cubism—think of the airy expansiveness of a Robert Delaunay—really compares. In Berlin, Hartley did something new that has stayed new.

In 1915, the political pressures of the war forced Hartley to return to New York. Because of the apparently pro-German nature of his paintings, with their military symbols, including von Freyburg's posthumously awarded Iron Cross, his reception in artistic circles was chilly. He entered upon nearly two decades of wandering, both geographically and artistically. Uncertainty plagues his lovely but brittle Cubist still lifes, his Cézanne-esque landscapes, and, here and there in different genres, a cultivation of bulky forms, outlined in black, that steer increasingly close to the style of Max Beckmann. (Parallels between Hartley and Beckmann, though barely mentioned in the Wadsworth's formidable catalogue, seem an obvious, rich field for future study.) Sojourns in Mexico and the Bavarian Alps contributed to the mature flowering of Hartley's talent. He developed a sense of mystical immanence in desert landscapes and a tactile appreciation of the contours of rocks and mountains. (He once declared, "As a painter, I *have* to have a mountain.") His paintings of a woebegone hamlet, delectably named Dogtown, inland from Gloucester, Massachusetts, mark a turning point. Hartley visited the place many times, producing works that distill lonesome ecstasies of communion with subjects that he had all to himself, if only because no one else would have noticed them.

Along the way, he made what I regard as the world's best bad painting, *Eight Bells Folly, Memorial for Hart Crane* (1933)—a farrago of crude, private symbols jammed together as if their shelf life were about to expire. Crane, the seraphic, desperately ambitious, miserably homosexual poet, who committed suicide in 1932 by throwing himself off a ship in the Caribbean, was a natural subject of identification for Hartley, whose

description of his own painting is worth quoting. It exemplifies his odd spirit of soberly deliberated abandon: "There is a ship foundering—a sun, a moon, two triangles, clouds—a shark pushing up out of the mad waters—and at the right corner—a bell with '8' on it—symbolizing eight bells—or noon when he jumped off—and around the bell are a lot of men's eyes—that look up from below to see who the new lodger is to be." There is much more, including numerological folderol concerning the figures 2, 9, and 33. But the whole is infectiously wild, with frothing paint in resonant deep blues. Once you start looking at it, you may find it absurdly difficult to stop. Defiantly over the top, this cacophonous work suggests an effort literally to wake the dead.

Death was Hartley's most efficacious muse. Having memorialized von Freyburg and Crane, he became deeply engaged by the deaths of three members of a Nova Scotia fishing family—two brothers and a cousin—who drowned in 1936. The naïve-looking style of Hartley's paintings of the Masons is one of the most successful feats of modern, self-conscious primitivism. In one of two paintings in the show, entitled *Fishermen's Last Supper*, the doomed brothers are depicted with asterisk-like stars over their heads, as they sit at table with their parents and sister. Hartley wrote, in an elegiac poem about the tragedy, "For Wine, they drank the ocean— / for bread, they ate their own despairs...." His idealizing of the Masons had an erotic aspect. He had written a fierce love poem to one of the sons, Alty, including these lines: "Hair stood on end like fury-fire / mouth blowing steam of thick desire / we will go, you will go, you will / not go, without me." It seems that in the pain of loss Hartley touched the bedrock of his feelings.

Hartley's last years, which were spent primarily in Maine, are a poetic adventure of art and place comparable to that of Gauguin in the South Seas or Monet at Giverny. Hartley percolated down into himself and perfected a rugged, often dark but always glowing style of understated symbolism. (After Beckmann, that style may be considered the foremost late advance of modern Expressionism.) His sexuality is apparent in his grave renderings of taciturn, hunky fishermen and athletes—with blocky pectorals, huge nipples, and sprays of body hair that are like semaphores of fascination—but their rapt tone is hardly different from that of his seascapes and still lifes. Like Whitman, Hartley grew into an easy oneness with the real, in all its guises. You always recognize a late Hartley—you feel it as a complete, solid, wise thing almost before you see it.

"This is no book; who touches this, touches a man," Whitman wrote, and it is impossible to judge Hartley fairly without entering into that kind of emotional contract with his paintings. His obdurate romanticism made him a marginal case in histories of modern art that were keyed to stylistic movements and formal innovations. (In the 1940s, Clement Greenberg wrote appreciatively of Hartley's manner while remaining testily wary of his subject matter.) Like other great modern individualists—Edvard Munch, Beckmann, Hopper, Balthus—Hartley profits today from a long condescension that has preserved the shock of his singularity. The Dogtown master is having his day.

February 3, 2003

HITLER AS ARTIST

Adolf Hitler was an artist—a modern artist, at that—and Nazism was a movement shaped by his aesthetic sensibility. Cosmopolitan Vienna incubated his peculiar genius as well as his hideous ideas. These views have been in the air recently, and a trenchant scholarly exhibition at the Williams College Museum of Art, in Williamstown, Massachusetts—"Prelude to a Nightmare: Art, Politics, and Hitler's Early Years in Vienna 1906–1913"—advances them. The show's curator, Deborah Rothschild, was inspired by *Hitler's Vienna: A Dictator's Apprenticeship*, by Brigitte Hamann (1999). A forthcoming book, *Hitler and the Power of Aesthetics*, by Frederic Spotts, promises an interpretation of Hitler as "a perverted artist." Earlier this year, a show at the Jewish Museum, in New York, "Mirroring Evil: Nazi Imagery/Recent Art," featured mediocre conceptual work that addressed the Third Reich with lame-brained allusions to commerce and sex. By trial and error, a special analysis is in progress. It won't alter our moral and political judgments of Hitler, whose crimes remain immeasurable, but it sure shakes up conventional accounts of modern art.

Hitler was eighteen years old when, in 1908, he moved from Linz and took up residence in Vienna. He walked the same streets as Freud, Gustav Mahler, and Egon Schiele, but he did so as one of the city's faceless, teeming poor. He often slept in a squalid homeless shelter, if not under a bridge. Intent on becoming an artist, he failed the art academy's admission test; his drawing skills were declared "unsatisfactory." A thin, sallow youth, he wasn't cut out for physical labor. With help from a friend, he earned a meagre living drawing postcard views of Vienna and selling them to tourists. Jews were among his companions and patrons. Although he was fanatically pan-German—caught up in visions of an expanded Germany, which would incorporate Austria—he had laudatory things to say about Jews at the time. He proved, however, an apt pupil of the city's rampant strains of anti-Semitism, which exploited popular resentment of the wealthy Jewish bourgeoisie that had arisen under Franz Josef I, the conservative but clement—and, effectively, the last—Hapsburg emperor. Hitler studied the spellbinding oratorical style of the city's widely beloved populist, anti-Semitic mayor, Karl Lueger.

The young Hitler was wild for Wagnerian opera, stately architecture, and inventive graphic art and design. His taste in painting was—and remained—philistine. He swore by Eduard von Grützner, a genre painter of jolly, drunken Bavarian monks. Hitler's own stilted early efforts were the work of a provincial tyro who was ripe for instruction that he never received. (The show includes a passable watercolor of a mountain chapel, from a commission that was secured for him by Samuel Morgenstern, a Jewish dealer.) As with any drifting young life, Hitler's might have

gone in a number of ways. The most exasperating missed opportunity was the possibility of working under the graphic artist and stage designer Alfred Roller, a member of the anti-academic Secession movement whose sets for the Vienna Court Opera's productions of Wagner, which were conducted by Mahler, foreshadowed Nazi theatricality. With a letter of introduction to Roller, Hitler approached the great man's door three times without mustering the nerve to knock. As it turned out, he seems never to have consorted with anyone whose ego overmatched his own. Grandiose and rigidly puritanical, he was a figure of fun to many of his mates in Vienna's lower depths. He accumulated humiliations on the way to becoming a god of revenge for the humiliated of Germany. Meanwhile, his adopted city fired his imagination. In *Mein Kampf*, he recalled, "For hours, I could stand in front of the Opera, for hours I could gaze at the parliament; the whole Ring Boulevard seemed to me like an enchantment out of the *Thousand and One Nights*."

"Prelude to a Nightmare" affords a revelatory view of Vienna's glory days, from the young Hitler's worm's-eye perspective, just before the First World War. The show anatomizes Hitler's enchantments and disenchantments with well-written wall texts and judiciously selected art works and artifacts. It documents scenes of imperial pageantry which, darkened and streamlined, would be echoed in Nazi rallies; and it sketches movements and individuals in the arts and politics as they must have appeared to the young man. Among the political voices are the racialists Guido von List, who, beginning in 1907, helped popularize the swastika as a sign of Aryan purity, and von List's crazy disciple Jörg Lanz von Liebenfels, who believed that Aryan women, if not forcibly segregated, would inevitably fall for the demonic virility of inferior races. Hitler imbibed it all.

The show also features works by Klimt, Schiele, and other Secession artists who would later enter the Nazi lists of degenerate art. Hitler despised them for their insults to classical ideals of human beauty and for what he called, in another context, "liberalistic concepts of the individual." But he embraced cleanly abstracted and geometric styles, which later informed his own design work (notably the stunning Nazi flag) and his shrewd patronage of the gifted youngsters Leni Riefenstahl and Albert Speer. In lengthening retrospect, it becomes harder to credit categorical distinctions between Nazi aesthetics and those of redoubtable modern movements in architecture and design, including the Bauhaus. They share roots in avant-garde Vienna.

Hitler's rise remains mysterious—if only as to the precise amount of dumb luck involved—but it makes unnerving sense when viewed in terms of an eager artist's capacity to assimilate, synthesize, and apply the influences of his time and place. "I used to think it could have been anyone," Deborah Rothschild has said, referring to the leader of the Third Reich. "But I don't think that anymore." Indeed, the show leaves no doubt that Nazism was a singular invention and that Hitler was its indispensable author. Without him, Fascism might well have succeeded in Germany, but nothing foreordained Nazism's blend of dash and malice, its brilliant technology

and skulking atavism. It seems clear that Hitler employed artistic means—hypnotic oratory, moving spectacle, elegant design—not just to gain power but to wield it in the here and now. Meanwhile, he needed a political line—a cause, an enemy—that would be more dynamic than pan-Germanism. The fact that he came by the cult of Aryanism and anti-Semitism belatedly suggests that they developed as much in service to his artistic ambition as the other way around. All racism, on some level, is aesthetic, as a projection of "the ugly." Nazism, in a horrible way, was a program to remodel the world according to a certain taste.

The Williams show rebuts the comfortable sentiment that Hitler was a "failed artist." In fact, once he found his métier, in Munich after the First World War, he was masterly, first as an orator and then as an all-around impresario of political theater. He was also deluded. He had no vision of the future apart from ever grander opera. He met his end—which, as a deep-dyed Wagnerian, he might have anticipated but apparently did not—as a quivering wreck of the boy who had been so awed by imperial Vienna. A photograph in the Williams show catches a puffy Führer in his last days, as Berlin lay in ruins, gazing rapturously at a tabletop model of Linz, which he envisioned as the cultural center of Europe, remade as a modern Valhalla. It is an appalling image, which suggests that the Second World War was incidental to a downtown redevelopment project. Rothschild, in a wall text, draws this moral from her show: "The union of malevolence and beauty can occur; we must remain vigilant against its seductive power." I disagree. We must remain vigilant against malevolence, and we should resign ourselves to the truth that beauty is fundamentally amoral.

August 19, 2002

INGRES

F ew things in existence induce aesthetic delirium like Jean-Auguste-Dominique Ingres's best portraits, which are his best works. The paintings' glassy, scintillant precision amazes to the verge of panic. Their ardor for flesh and flesh-friendly fabrics raises sensuality from obsession through decorous hedonism to reverence. They put excruciating craft in service to wild luxuriance. Of course, the artist's signature odalisques and other tours to mythic loveland do the same, but so pathologically as to exude a surreal goofiness. Take the Louvre's famous *Roger Freeing Angelica*: naked cartoon babe chained to cartoon rock, cartoon knight poking cartoon dragon. Whoop-de-doo. Ingres's portraits, though they are bizarre in their own ways, defy condescension. This is clear from the first comprehensive exhibition of them in more than a century: "Portraits by Ingres: Image of an Epoch" at the National Gallery in London. It's a monumental show despite the defensive subtitle, which seems to beg mercy for the pictures as historical artifacts. (Imagine promoting Rembrandts as souvenirs of old Amsterdam!) What Ingres achieved in portraiture remains definitive and tremendous: style for style's sake, with a human face.

Born in 1780, the son of an artist/craftsman, Ingres was a painter from childhood, with scant education in anything else except music. (His love of fiddling left to language the proverbial phrase for an avocation, *violon d'Ingres*.) He was a blazingly apt pupil and assistant of Jacques-Louis David. In 1800, he painted the candelabra and the footrest in David's Neoclassical touchstone portrait of Mme. Récamier. Having mopped up most of the academic painting prizes on offer, the young artist made his public move at the 1806 Paris Salon, with several paintings, including the huge, terrifying *Napoleon I on His Imperial Throne*—an apotheosis of the totalitarian sublime that might have struck even Joseph Stalin as a tad over the top. In the time-honored Parisian hazing ritual for vulnerable newcomers, the critics flayed the young Ingres, ridiculing his "barbarous" sensibility and his fatuous ambition. Partly out of wounded feelings, he lived most of the next eighteen years in Rome.

There is epochal interest, for certain, in Ingres's Roman portraits, especially those painted during the six years of Napoleonic occupation, which ended in 1814. Like carpetbagging imperial flunkies in a Graham Greene plot, French opportunists in Italy strutted nervously in positions of secondhand power that ranged from civil engineer to King and Queen. Ingres was their perfect portrayer, because, like them, he built his models of authority—and of charm—from the outside in: a gestalt of settings, clothes, accoutrements, and gestures. The people in all his portraits are fictional beings cobbled together in collaborations (or is it conspiracies?) of artist

and sitter. How mere matter and sheer manner can combine to create uncanny life, as if by Frankensteinian lightning bolts, is this artist's enduring secret.

Consider the eyes in an Ingres portrait. They aren't the windows of a soul or of anything else. They are accessories: top-drawer eyes in the choicest fashion, which for Ingres always meant Raphael-esque. The same applies to Ingres-brand anatomy. Are the arms of his women improbably pudgy, given the delicacy of the facial features? Raphael adored pudgy. If you want slim biceps, go down-market. Meanwhile, many a body constructed by Ingres would fall apart if it undertook to walk across a room. The right shoulder in perhaps his single most glorious portrait, the New York Frick Collection's *Vicomtesse d'Haussonville*, apparently emerges from the poor girl's rib cage. But, again, go argue. We're talking about once-in-a-lifetime ravishment here, not aptitude for tennis.

Thirty-some years ago, I fell desperately in love with that countess, and a part of me, like Dante after he got a load of Beatrice, will never recover. (My heart jumped when I came upon her in London: "You here, too?") Other people I know have been smitten to the bone by Ingres in a similar way—a way that is rivalled, among the Old Masters, perhaps only by Vermeer. Like Vermeer—though with full-blooded vulgarity, in contrast to the Dutchman's exquisite compunctions—Ingres pins general ideals of beauty to specific sensations. He credits us with the ability to experience aesthetic rapture in everyday circumstances, with no effort beyond that of an intimate glance.

Along with being fastidiously elegant, Ingres was truly barbarous—an abject flatterer, first and last. As a classicist without an ounce of nobility, he was just right for a nostalgic society that sought legitimacy through possession and display. He tacitly merged his era's anxiously rising bourgeoisie and anxiously sinking aristocracy in a showy oligarchy of wealth and taste. The Ingres test of worth is ease. To appear relaxed and vivacious in an uncomfortable, staggeringly expensive getup amounts to righteousness. Tailors and couturiers are the unacknowledged legislators of this world. The crowning effect of Ingres's artifice is an impression of naturally distinguished personality. You can more or less see how he does it, with off-the-shelf expressive tricks: eyes that are "intelligent" or "melting" or "laughing," or, in the fully equipped luxury line, all of the above. But if you can resist being seduced I do not understand you. "I please, therefore I am," Ingres's people as much as say. "You like me. You can't help liking me. Of course, you envy me. Who wouldn't? But if you were in my place you couldn't behold me so satisfactorily. Here is my secret: I exist for you. But you knew that already."

Ingres wins our hearts with a mad generosity of surfaces, which discount depth of any kind. He is a positivist of silk and skin. If one can't touch it, the hell with it. The quivering, silvery tension of his draftsmanship conveys the hunger of his own touch, disciplined by worshipful alertness to the tilt of a chin or the fold of a sleeve. But the very infallibility of Ingres's line, in this show's scores of drawings, rather wears out its welcome. Are his monotonously fawning pencil portraits-for-pay of English

tourists in Rome different, in their essence, from the products of a Washington Square sketch artiste? Ingres is a slick performer. It's just that when his slickness passes into the metaphysical complexities of oil painting the result overwhelms.

There is no light in Ingres, only radiant effulgence, and no space, only material presence. Part of the giddiness he imparts is a kind of visual oxygen shortage. One can endure just so much of it. If you visit the show, avoid blowing your whole fund of concentration in the initial galleries, which take you through the Roman years. The best comes later—with the notable exception of *Madame de Senonnes*. This astonishing masterpiece of 1814 pictures a notorious lady whose red velvet dress is an all-time advertisement for the busty, hipless Empire style. Ingres's great period for portraits starts in the 1820s, when he returned in triumph to Paris and could thenceforth pick and choose commissions. Has anyone ever worked harder? Ingres labored for many years on some of his best portraits. Louise d'Haussonville gave birth to two children (her third and fourth) amid sittings.

The wonder and the weakness of Ingres were nailed in 1855, by Charles Baudelaire, who wickedly bracketed the seventy-five-year-old patrician master with the thirty-six-year-old parvenu wild man Gustave Courbet. Baudelaire wrote, "The heroic sacrifice offered by M. Ingres in honor of the idea and the tradition of Raphael-esque Beauty is performed by M. Courbet on behalf of external, positive, and immediate Nature. In their war against the imagination they are obedient to different motives; but their two opposing varieties of fanaticism lead them to the same immolation." Ingres an enemy of imagination? Think about it. "A man with a system," Baudelaire called him, who "believes that a happily contrived and agreeable artifice, which ministers to the eye's pleasure, is not only a right but a duty."

Baudelaire's linkage of Ingres and Courbet was even more brilliant than the poet could know. Split the difference between Ingres's pernickety artifice and Courbet's instinctual anarchy. What you get is, roughly, Édouard Manet. That is, you leap ahead to the first full cry of modern art's proposition that visual pleasure is not only a duty but practically a science and a civic religion. Art of the ensuing century would launch one system after another. What enthralls us about Ingres's portraits is the violent intensity of a system that pretends not to be a system at all but just a courteous way of hailing some estimable citizens.

March 29, 1999

ÉDOUARD MANET

Édouard **Manet was a man-about-town** and a bourgeois sophisticate who died, almost certainly of syphilis, at the age of fifty-one in 1883. His work caused public scandals, which tormented him. He wanted to please. In the revolutionary formation of modern painting, he was, by general agreement, first among equals— George Washington at the easel. In art history, Manet's style is a revolving door between a classical past and a chaotic future that is still with us. Anyone who advances a theory of modern art must have serviceable ideas about Manet. But when one really looks at his paintings, ideas vanish. Beauty, poignancy, and a sort of happy shock prevail. What is Manet's essential quality? I think it's innocence. His friend the poet Stéphane Mallarmé hazarded as much: Manet's eye is "the eye of generations of city-bred childhoods." The ardor of Manet's work is as limpid as the gaze of an interested child. I love him.

"Manet: The Still-Life Paintings," at the Musée d'Orsay in Paris, presents the artist's underappreciated work in the tabletop genre. It is a somewhat scrappy affair, short on masterpieces. This turns out to be a virtue. A viewer is admitted to the work-shop of the artist's technique and rhetoric, which are indistinguishable from his soul. Manet's still lifes fall into two main groups. The first, from the 1860s, adopts motifs of seventeenth-century Flemish, Dutch, and Spanish still-life painters, and of the eighteenth-century intimist of the genre, Chardin. These pictures are self-consciously showy, exuding decorative panache. The second group consists of works that Manet painted during the pain-racked last years of his life. Most of them memorialize bouquets that were brought to him by friends: roses, peonies, lilacs, tulips, carnations, and pansies in glass or crystal vases against dark grounds. They are desperately moving. Would they affect us so deeply if we didn't know the circumstance of their making? I think they might. Filling out the show are one-offs and tours de force, including portraits with significant still-life elements and some delightfully illustrated letters to friends which were written during the artist's final years.

I was surprised by a dawning conviction that still life wasn't a sideline of Manet's art but fundamental to it. What are his celebrated figure paintings but still lifes in which people are objects of a particular variety? It's a fact that Manet was a terrible portraitist—too respectfully well mannered and too shy, I think, to express anybody else's personality. He was also too honest, perhaps. (What mood, besides glum torpor, can a person who must hold still for hours and days convey?) Only when Manet's affection for a sitter is intense does a portrait sparkle. A great example, not in the show, is a lounging, smoking, apparently talking Mallarmé—a ravishing paint-ing whose real subject may be the painter's bliss in the poet's company. Then there

are his sui generis portraits of the painter Berthe Morisot, with whom he was plainly in love, albeit perhaps chastely. (She married his brother.) The d'Orsay's inclusion of *Berthe Morisot with a Bouquet of Violets* (1872), a smallish half-length portrait, is justified by a pendant painting of Morisot's accoutrements: the bouquet of violets, a closed fan, a folded letter. She is dressed for outdoors in a chic black coat, hat, and scarf. The flowers add a grace note at the spot where the coat gapes below her throat, exposing a tiny triangle of shadowed skin. Morisot stands in raking light against a bright gray-and-white ground. She makes dispassionate eye contact; her piquant features are both less and more than beautiful. The painting goes off like buried erotic dynamite. It raises effects of charm to a level of agony.

Manet, the urbane, couldn't be trivial. For him, attention equalled life. He is the greatest city painter for the same reason, even when he paints, say, fish on a table in the manner of a long-gone Flemish master. Fresh seafood and old paintings are amenities of a proper metropolis, and, by enjoying both at once, Manet exalts the rangy economy of a city mind.

He was a natural. The son of an eminent jurist, Manet settled on art after a stab at a naval career. He studied with the liberal academician Thomas Couture, who stunned him by condemning his nascent realism. Manet was regularly blindsided by negative reactions to his work. He kept expecting his sincerity to be recognized. He probably contracted syphilis in his not especially wild youth. He married a Dutch woman older than he was; his renderings of her are dignified and sweet. He was both an upstanding bourgeois and a political leftist, devoted to Émile Zola. "He had a lithe charm which was enhanced by the elegant swagger of his walk," a friend said. "No matter how much he exaggerated his gait or affected the drawl of a Paris urchin, he was never in the least vulgar." Manet suggests a contradiction—a naïve dandy.

At the d'Orsay, I tested the still-life paradigm for Manet's art by visiting *Le Déjeuner sur l'herbe* and *Olympia*. The former, as a satiric pastoral, proved the less co-operative, but still-life elements certainly add to the nonchalant aplomb of this sublime pastiche of Giorgione and Raphael. For the first time, I found myself contemplating the heap of doffed clothing in the lower left corner. The detail bespeaks common sense: when you get starkers at a picnic, you want your stuff out of the way but in a handy place. Meanwhile, invisible quotation marks around the borrowed poses of the picnickers anticipate a central novelty of modern art that may be termed still life by other means: collage. The figures feel less depicted than imported, like animate stage props.

Here's a pop quiz: in *Olympia*, how many things is the model, Victorine Meurent, wearing? Time's up. Six: a high-heeled slipper (its mate has come off), a ribbon choker with a pearl attached, a pair of earrings, a bracelet with another dangling jewel, and a flower, perhaps a hibiscus, in her hair. Every item renders her more naked, of course, as do the fully clothed black maid proffering a gorgeous bouquet, the bristling black cat, and the sumptuous topography of fringed coverlet, yielding pillows, and wrinkled sheets. Without all those objects, the painting would be a nude. With them, it's a general-

alarm fire. People are driven to imagine exciting stories that interpret Victorine's detached frontal gaze. She must be looking at a gentleman caller or a client, right? But really, as with every instance of eye contact in Manet, she is looking only at the artist. Her expression is calm because she is a professional model working, in a studio, for a professional painter. She is at ease because she and Manet understand each other. The fiction of a courtesan is a deliberate reference, not an exotic fantasy. It's a joke, set off by the use of a name that suggests divinity. Who is being kidded? I think it's anyone whose workaday vocation entails seduction. A painter, for example. Olympia is Manet.

Many people regard Manet as ironic. I don't. I think he is witty and profound, often simultaneously. Consider two paintings of asparagus, both from 1880. The first one shows a bundle of pale, tender stalks on a bed of greens on a marble table. It was bought by a collector who insisted on paying a thousand francs instead of the eight hundred that Manet had asked. The second painting, of a single stalk perched on the table's edge, arrived at the collector's door with a note: "There was one missing from your bunch." This little work, the payoff of a wispy jest, happens to be one of the most magical paintings in existence. It concentrates sensuous arousal in a manner that verges on the sexual but remains in the realm of food and furniture. Its fullness of life suggests a thought: Manet ate the asparagus after he painted it. Painting and eating, art and sociability, loving and liking all flow together—even in a glance at a stray vegetable. Only Manet could have made such a picture.

Manet's work has spent a century looking old-fashioned because its radical style isn't radical in the standard modern way that was developed by Cézanne: tones confined to mid-range, the better to eliminate depth illusion, to liberate color, and, in general, to rationalize art-making. Manet's method is to polarize tones. He was quoted as advising, "In a figure look for the highest light and the deepest shadow, the rest will come quite naturally: often it's nothing at all." I presume that today we are free of twentieth-century bias. No apology need be made for Manet's jagged chiaroscuro, which is notably lyrical in his last florals. These paintings reinstated lurching lights and darks in his work after a spell during which he studied Impressionism—an influence that lingers in speedy, summarizing notations of light. But his bouquets are substantial presences in penetrable space. "I would like to paint them all," Manet said of flowers. So he did. Every blossom feels at once unique and suffused with the memories of a million kin. When a bright-yellow petal curls down around a salmon-colored shadow, it's as if a bard of roses were singing a secret of the tribe. The glass vases abolish mystery. We observe the sustenance of cut stems, crazed by refractions through the wettest water you've ever seen. Each of Manet's paintings raises its subject into a present time that forgets the past and ignores the future. Each is a lesson about dying: don't. Only be alive. Manet gave his illness short shrift. Told that one of his legs was gangrenous and required amputation, he said, "Well then, if there is nothing else to do, take off the leg and let's be done with it!" When death felled him, it hit a moving target.

November 20, 2000

MALEVICH'S REVOLUTION

In 1915, in Moscow, Kazimir Malevich painted a black square against a white ground on a canvas about two and a half feet square and called it a work of Suprematism. It was an extreme act of art and philosophy that has stayed extreme. *Black Square* makes its first appearance outside Russia in "Kazimir Malevich: Suprematism," a concise, bewitching show at the Guggenheim in New York. The painting looks terrible: crackled, scuffed, and discolored, as if it had spent the past eighty-eight years patching a broken window. In fact, it passed most of that time deep in the Soviet archives, classed among the lowliest of the state's treasures. Malevich, like other members of the Revolutionary-era Russian avant-garde, was thrown into oblivion under Stalin. The axe fell on him in 1930. Accused of "formalism," he was interrogated and jailed for two months. He had been trying, in vain, to regain official favor with pictures of mildly abstracted figures. When he died, at the age of fifty-seven, in Leningrad in 1935, his friends and disciples buried his ashes in a grave marked with a black square. They didn't fulfill his stated wish to have the grave topped with an "architekton"—one of his skyscraper-like maquettes of abstract forms, equipped with a telescope through which visitors were to gaze at Jupiter.

The generation of Russian artists, designers, poets, and thinkers who caught fire just before the First World War, rose to institutional privilege under the 1917 Revolution, and then were crushed is characterized by grandiosity and grandeur— and tragedy, in abundance. "When the mode of the music changes, the walls of the city shake," Plato wrote. Artists who transformed all given modes of visual art while the walls of Russia more than shook could hardly avoid hubris. They had an unfortunate habit of scheming against one another, as well as against any artists whom they deemed outmoded. Realist painters stored up resentments for a day of vengeance. When the day came, Malevich proved luckier in his posterity than such colleagues as his arch-rival Vladimir Tatlin, the crack artist-engineer who had opposed Suprematism with what briefly seemed the politically impeccable doctrines of Constructivism. The Constructivists rejected pictorial composition in favor of machine-like structure, and dedicated their art to socially useful purposes. Most of Tatlin's work disappeared. The fluke of a retrospective in Warsaw and Berlin in 1927 left nearly seventy works by Malevich in the West—among them MoMA's talismanic *White on White* (1918), a cool white square on a warm white ground. Malevich's work is a modern touchstone. But there remains something incomprehensibly bizarre about his achievement and his personality, as if he hailed, indeed, from Jupiter.

Malevich was born in 1878 to Polish-speaking parents in Ukraine. (His father worked as an administrator in sugar refineries.) He received an art education in Kiev, moved to Moscow in his late teens, and was soon active in avant-garde circles, including the Moscow Art Theatre. He became known for Cubist paintings on themes of Russian folk culture. In 1913, he designed sets and costumes for a legendary "Cubo-Futurist" opera, "Victory Over the Sun." (I once saw a conjectural re-staging of that work, in Los Angeles; it was noisy and perfectly opaque.) Such was his personal charisma that he attracted many talented followers, who carried Suprematist motifs into decorative, functional, and architectural specialties. By 1919, he had established a power base at the art school in Vitebsk, where his faction had rudely ousted Marc Chagall from the directorship. (Chagall envisioned a school that was open to all tendencies; the new order would have none of that.) Malevich's most important ally, El Lissitzky, transposed Suprematism into a jazzy, superficial formal repertoire. Travelling often to Western Europe, Lissitzky helped to popularize the new Russian aesthetics under the general rubric Constructivism, producing a lasting confusion about an avant-garde whose dynamism was inseparable from its profound philosophical disagreements.

At the Guggenheim, thirty-eight paintings and many drawings and architektons track the flowering of Suprematism from 1915 into the early 1920s. The first works consist of single shapes—square, circle, cross, rectangle—in black and white. Then come those same shapes in various combinations and colors, with such impudent titles as *Painterly Realism: Boy with Knapsack—Color Masses in the Fourth Dimension* (a black square and a smaller, tilted red one). Thereafter, assorted quadrilaterals, triangles, disks, and lines gang up, balletically, in white non-space. Some works recall Kandinsky, but without Kandinsky's vaporous air of fantasy. Malevich's paintings, even when complex, are joltingly direct. Some are in better physical condition than others. (The Stedelijk Museum, in Amsterdam, has taken wonderful care of its Maleviches, which look brand new.) All are most peculiar objects: brusquely handmade incarnations of a cerebral realm in which the laws of physics fall away. Malevich insisted that he painted in four and, later, five dimensions. Having consulted his own arcane writings on the fifth dimension, which he termed "economy," I conclude that we're not meant to understand. Although he constantly invoked the authority of science for his experiments, he was religious, and even mystical, in temperament. When his art clicks, it's with a shudder of the sublime.

Visible brushstrokes in the paintings fascinate: whistle-while-you-work, perfunctory filling-in that goes carefully fussy at the edges of shapes. There's an ineffable sweetness to the artist's hasty, human touch that consorts piquantly with the radical headiness of his program. Opposing qualities of hand and brain generate a tension that distinguishes Malevich from his Western counterpart, Piet Mondrian. The Dutch artist mostly suppressed the marks of his brush and took infinite pains to make his designs readable in terms of gravity and bodily balance. He never stopped being a landscape painter at heart. Malevich's weightless formal relationships would

make kinesthetic sense only in outer space. I like to imagine those paintings in their original context, holding forth on the walls of dingy, cluttered rooms. (Installation photographs of the time help.) Nothing else in the world looked like them. Malevich hatched Suprematism secretly in 1915, to prevent anyone from stealing a march on him. One day, the artist Ivan Puni unexpectedly walked into the studio, and Malevich felt that he had to go public with his innovations immediately. He needn't have fretted. Innumerable painters have produced similar works since then. None have attained his punch.

Alone in his generation, Malevich looked both backward and forward in the history of art. He acknowledged having been inspired by the numinous compactness of Russian Orthodox icons. (When *Black Square* was first shown, it was hung in the angle of two walls, as icons often are.) Beyond that, his abstractions amount to piece-meal analyses of devices that are fundamental to Western painting, such as spatial recession in two beautiful works from 1917 and 1918, in which colored planes appear to dissolve backward into white mist. A lingering conservatism is apparent in the title of *Four Squares*, a painting from 1915, which is quartered into equal black and white segments, checkerboard fashion. Shouldn't that be *Five Squares*, the fifth one being the painting itself? Malevich's apparent unconsciousness of this fact indicates that he clung to the convention of the canvas as a window on a fictive reality. His paintings remain pictures. But even now they feel pregnant with creative possibili-ties, approaching nothingness not as an end but as a pivot for renewal. "It is from zero, in zero, that the true movement of being begins," he wrote.

By 1920, under relentless pressure from the accelerating radicalism of the avant-garde, Malevich succumbed to the view that, as he said, "painting was done for long ago, and the artist himself is a prejudice of the past." (Around that time, Tatlin's follower Aleksandr Rodchenko painted three canvases monochrome red, yellow, and blue; he declared them the "last paintings.") Malevich continued to paint, but began dutifully to give himself over to socially virtuous architectural research, fabric and dress design, and, rather touchingly, Suprematist teacups. It was a painful development, as was the artist's dismal return to representational imagery. The Revolution was dining on its children, just slowly enough to make them, in desperation, compromise their principles one by one.

June 2, 2003

PICASSO'S LUST

The Museum of Fine Arts, in Montreal, has a show, "Picasso Érotique," that will give you fresh thoughts about the twentieth century's definitive artist. Here's one of mine: all Picasso's pictures are dirty. They are rooted in lust and cultivated with glee. Love has very little to do with them, and forget romance. The word "gallantry" will do for the finer gestures of Picassoid amour, such as the exquisite pathos of his Rose Period carnival folk and the august monumentality of his Neoclassicism. But even at his most refined, the Spanish rooster crows. Picasso said that for him sexuality and art were the same thing, leading us to believe that he made love as he made art—with domineering audacity and gloating pride. I imagine that his every kiss was signed "Picasso." Certainly, his every work of art memorializes self-delight: "Picasso is doing this!" As a practical matter, he required consenting others—willing women, attentive viewers—but to indulge them more than he had to was beneath him. I'm accustomed to feeling used up after any Picasso show: shaky with pleasure and not so much sent on my way as seduced and abandoned. Sometimes I despise him. But I'll always return to him.

"Picasso Érotique" is not just another Picasso show. It is the most illuminating of the many I've seen. It is extensive, with about three hundred and fifty works, and it brings into vivid focus three previously blurry periods of crisis for the artist: youth (until 1905 or so), midlife (the Surrealist phase, starting around 1927), and old age (several years before his death, at the age of ninety-one, in 1973). The show persuasively argues that Picasso's successive styles, including Cubism, are more or less transparent masks or costumes for his sexual avidity, whatever else they are, too. If *Les Demoiselles d'Avignon* were present, the case would be clinched by that revolutionary nexus of the obscene and the analytical—a handshake between the Marquis de Sade and Pythagoras. (Studies for *Demoiselles*, along with related works, fill in.) The show's candor is overdue and bracing. It cuts through the miasma of gossip about the artist's mistresses that has long been Picasso scholarship's expedient for coping with sex in his work. "Picasso Érotique" does provide a time-line of photographs and capsule biographies of his seven leading ladies, from Fernande to Jacqueline, but the art on display quickly confirms that his chief passion was always for himself in action as an artist and as a lover.

The show opened at the Jeu de Paume, in Paris, last winter. It will not visit the United States, for reasons that I'm afraid are self-evident. It begins with a fabulously effective coup de théâtre by the Montreal curatorial team, led by Jean-Jacques Lebel—a reconstructed, full-scale fin-de-siècle brothel bedroom with a projection of ancient, highly explicit porn films—that would be inconceivable in a public museum south of Quebec unless accompanied by politically earnest wall texts. The installation posits sexual experiences that were routine for the teenage Picasso in Barcelona. The room is

not just squalid and hot; it's cheerfully so. It assumes a worldly, resilient maturity in viewers. How often does anything made in America do that? Well, there's something to be said for the joys of shockability. The musky European allure of "Picasso Érotique" gave me a madeleine hit of nostalgia for the art house in Minneapolis where I first tasted espresso and beheld Brigitte Bardot on screen, more than forty years ago. The Montreal show delivers what those old, subtitled films only hinted at. The first picture is a sketch of two donkeys in flagrante that Picasso made when he was twelve years old, and the show proceeds with works that are graphic in more ways than one. The drawings range from trivial, raunchy caricatures of his friends dallying with prostitutes— images that affirm the men's-clubby charm that brothels had for the artist's circle—to sensitive renderings of sexual activity that breathe a quiet intensity. In a delicate drawing in blue ink, a lover of uncertain gender performs oral sex on a woman who covers her eyes with her hands, perhaps to concentrate on her delight. The lovely image conveys a truth—that sexual sensation is internal and invisible—that Picasso would spend a lifetime combatting. His art is marked by the devising of one pictorial stratagem after another for turning bodily consciousness inside out.

The Montreal selection of Picasso's early pornographic images covers the standard repertoire of sexual conduct, plus bits of bestiality and a vision of murder by strangulation. Only male homosexuality is excluded—except for one crude cartoon joke in which an artist, as he grasps the hand of a naked woman labelled *Glory*, is buggered by a critic. Odd symbolic motifs include a female nude who nestles inside a god-faced phallus and a woman who displays her vagina while reclining in another, gigantic vagina. In this rough context, works of beauty startle. *La Toilette* (1906), a masterpiece from the Albright-Knox Art Gallery, which shows a willowy nude doing her hair in a mirror that is held by a clothed woman, demonstrates Picasso's transmutation of randiness into erotic poetry. It also marks the onset of his confidence as a master. Bouts of insecurity seem to have triggered his reversions to explicit sexual themes after 1927— when, miserably married, he took up with the young Marie-Thérèse Walter—and toward the end of his life. In the first instance, he re-engineered the female body as an ensemble of strictly erogenous parts and projected himself as Jupiter or the Minotaur, for whom love and rape are interchangeable. Many of these works are familiar, but some in the show, depicting penetration, are new to me. Regarding Picasso's last phase, I never suspected the profusion in them of coital grapplings, often attended by male voyeurs.

It is sometimes guessed that those voyeurs represent Picasso in impotent decrepitude, but there seems to be no evidence for the notion. Indeed, the funniest, most sweetly sexy works of the artist's career take up the theme of voyeurism. A special treat of the show is a suite of twenty-five marvellous etchings—made in the course of twelve days in 1968—that imagine Raphael doing the deed with his model and mistress La Fornarina under the eyes of a male watcher, usually Pope Julius II. The sex is necessarily athletic, because it doesn't occur to Raphael to let go of his brushes and palette for convenience's sake. The Pope sometimes lurks but more often sits at ease on a throne or on a chamber pot. In some of the pictures, he seems disapproving. In others,

he appears to be having a whale of a time. (If anyone in attendance is grumpy, it's Raphael's rival Michelangelo, occasionally shown lurking under the bed.) If the eighty-six-year-old Picasso was ruing his senescence at the time, he forgot it in the course of spinning sensual and hilarious fantasies. The etchings celebrate a delirious conflation of art and sex, of looking and doing—a higher mathematics of eroticism that consigns the usual physical criterion of conjugal performance to the status of pedestrian arithmetic.

Sex served Picasso as an indestructible substitute for the social agreements and systems of belief that had previously grounded art in the world. Not for him the utopian or Arcadian, progressive or quasi-religious programs of other modern artists; he scorned both abstraction and distinctly contemporary subject matter. Not that he made tactical choices in these matters. His temperament was his destiny, as his rare missteps prove. (Despite his intentions for *Guernica*, that great painting fails as propaganda by dissolving a topical outrage into myth. His later attempts to be a good Communist, with images of peace doves and the like, account for perhaps his only truly bad work.) As a result, his art can never become dated, let alone old-fashioned. A virtuosic modernizer in form, he was a skulking primitive in content—not only premodern but prehistorical, revelling in primal mud. Like the makers of the Lascaux petroglyphs, he was essentially a graphic artist. He was a swordsman of the thrusting line. His curves often ache to straighten, as if they were bent springs; and the caress of his paint-handling is no smoother than a cat's tongue. No matter how attenuated the sexual charge of his work became, it guided his choices of mark and color. Is there something repellent about Picasso's bullying machismo? There certainly is—when you aren't looking at his art. When you look, he's got you by the scruff of your instinctual being.

We make a mistake when we imagine that genius must be complicated. It is the opposite. We ordinary citizens are complicated, expending much of our biological energy just to keep our fragmented selves in working order. Einstein reported that his theories were born in fantasies of "visual" and "muscular" activities; only when these fantasies felt satisfying and could be repeated at will did he begin doing the math. Compare this to Picasso's famous boast that he never sought but only found. What the intellect of each man required was already present in his body, whose dark knowledge had unimpeded access to the dials and levers of abstract reason. "Picasso Érotique" gives teeming evidence of a process by which low-down impulses modulate, as they rise, into prodigies of intelligence. The mechanism has a minimum of moving parts. (Picasso can seem to have had just two, of which one was his brush.) Most art education relentlessly emphasizes great artists' loftiest achievements—which, like $E=mc^2$, reduce us to clueless awe. Picasso's goatish stuff in Montreal takes us down the scale, making the germination of his art matter-of-factly apprehensible. The phenomenon is no more or less mysterious than any other fact of nature—and is as little answerable to our approval or disapproval. We needn't live with Picasso, thank goodness, but only brain surgery could stop him from living in us.

July 9, 2001

TOUGH LOVE: JOAN MITCHELL

At a boozy dinner party that I attended in a New York walkup nearly thirty years ago, a woman announced that she was getting married. Joan Mitchell, who was there, exploded. How could anyone even think of doing something so bourgeois? The buzzer sounded. It was Mitchell's longtime lover, the French-Canadian painter Jean-Paul Riopelle. He wanted to speak to her, but he wouldn't come upstairs. From the landing, she told him in scorching terms to leave her alone. Back at the table, she resumed denouncing the insidiousness of marriage as a trap for free souls. The buzzer again. Another cascade of profanity down the stairwell. I was awed. Here was craziness of a scary and rare order. Those who knew Joan Mitchell pass these kinds of stories around like sacred-monster trading cards. But Mitchell's personality was one thing, and her art is entirely another. They share only the energy of a towering original who, ten years after her death, in France, where she lived near Monet's gardens at Giverny, has yet to receive her due.

"The Paintings of Joan Mitchell," at the Whitney in New York, should remedy that. This dense, dazzling retrospective of works spanning her career, from 1951 to 1992, confirms that Mitchell was not just the best of the so-called second-generation Abstract Expressionists—a status already hers by common consent—but a great modern artist who started strong and improved with age. Her work at the Whitney makes it hard to imagine why anyone would want to paint other than abstractly, revelling in the liberty and purity of oils wielded with articulate passion. Mitchell seems to me the best argument for redressing the long-standing bias against contemporary expressionist painting that was mandated by Clement Greenberg in his promotion of mannerly Color Field abstraction. (According to Mitchell, she was "kicked out" of a gallery owned by Lawrence Rubin after Greenberg told the dealer, "Get rid of that gestural horror.")

Mitchell was born in 1926 to a wealthy family in Chicago. She was lavishly educated in literature and art by her mother, Marion Strobel, the co-editor, with Harriet Monroe, of the leading American magazine of modern verse, *Poetry*, and at a private school that she later described as "progressive, not conventional, full of Jews." (I quote from the introduction to the Whitney catalogue, by the show's curator, Jane Livingston.) Her maternal grandfather, a bridge engineer, imparted a love of structural design. Her father, a dermatologist and an amateur artist, pushed her to excel in all things. As a teen-ager, she became a championship figure skater, as well as a diver and a tennis player. She said that she chose a painting career to escape her father's control. (In psychoanalysis for much of her life, she surely plumbed that subject.) She was a natural—witness the chromatic

inventiveness of several landscape gouaches that she painted in art school. In 1949, she married her former schoolmate Barney Rosset, whose eventful ownership of Grove Press began in 1951. Their intense union ended in divorce a year later. In New York, she made a point of befriending Willem de Kooning, Philip Guston, and Franz Kline. Another ally was the poet Frank O'Hara. She held her own in the hard-living downtown scene. This wasn't easy for a woman painter who—unlike Helen Frankenthaler, Lee Krasner, and Elaine de Kooning—was not the mate of an alpha male. She kept an apartment on St. Marks Place but lived mainly in France, where her work was always well regarded. Indeed, she might be seen as the last great foreign-born French painter, invigorating Parisian painterly cuisine with American nerviness and New York rigor.

One stayed alert around Mitchell. I recall her raffish and severe presence: a long, handsome face framed by huge eyeglasses and a straight mop of dark hair, wreathed in cigarette smoke. A wry set to her mouth would portend the utterance of something startlingly smart and, as often as not, scathing. But when she painted she sang, almost despite herself. Several works from the 1960s, which she termed "very violent and angry paintings," are among the most subtly lyrical of her career. In the catalogue of a companion Mitchell show at the Edward Tyler Nahem Gallery in New York, the curator and critic Richard Francis catches their quality with a quote from Andrew Marvell: "Annihilating all that's made / To a green thought in a green shade."

The earliest work at the Whitney is the precocious, ten-foot-long *Cross Section of a Bridge* (1951), whose wittily bashed-up Cubism recalls both Marcel Duchamp's *Nude Descending a Staircase* and works by de Kooning from the late 1940s. In the next painting, from the same year, that style melts like tallow, signalling the influence of Mitchell's most significant forebear, Arshile Gorky. Unlike peers who aped the styles of de Kooning or Pollock, Mitchell absorbed Gorky's earlier modulation of Picasso and Surrealism into a formal language of counterposed line and color and thick and thin textures. Gorky understood that emotional eloquence is an effect not of theatrical gestures but of varied contrasts and rhythms, in which surprising disjunctions join in a harmonious whole. For Gorky's insinuating linear figures, Mitchell substituted the shapes of strokes made with brushes of different sizes. At times, every mark seems to have its own personality.

The success of the drips and runs in Mitchell's pictures, which she painted on upright canvases, suggests preternatural luck. There isn't a wrong note in her cadenzas—only a swarm of piquant, fugitive grace notes falling like loose change. Every element has a rising, hovering, or sagging weight, achieved by her finesse with relative densities and by a supreme sense of color. ("She could make yellow heavy," Brice Marden has remarked.) A resistance to repeating herself produced no signature motif but an impression of musical variations on a silent theme. Like Monet, Mitchell used colors redolent of nature and juxtaposed them to mingle in the eye, though not to create illusions of atmospheric light. Like the greatest Monets—the

Rouen Cathedrals and some of the Giverny near-abstractions—her best paintings amount to metaphysical conundrums: you don't know what you're looking at. It's paint, of course, but as a medium of contradictory connotations. One thickly worked triptych, *Wet Orange* (1971–72), struck me, to my happy bewilderment, as both all wall and all window. Mitchell also had something of Monet's spookily disinterested professionalism. Straight from the shoulder, she employed her talent and troubled fury as if they were nothing but tools.

In the Whitney catalogue, the art historian Linda Nochlin quotes Elaine de Kooning: "I was talking to Joan Mitchell at a party ten years ago when a man came up to us and said, 'What do you women artists think....' Joan grabbed my arm and said, 'Elaine, let's get the hell out of here.'" The mission of Mitchell's animus was to get her out of situations that threatened her initiative. The situations generally involved fatherly importunity or condescension. The personal wasn't political for her—she was leery of all solidarities, including the feminist one—but, rather, a daily battle that had desperately high stakes. Her orneriness was the palace guard of her lyricism.

July 15, 2002

BRUCE NAUMAN

Bruce Nauman's *Mapping the Studio I (Fat Chance John Cage)*, a video installation that has opened at the Dia Art Foundation in New York, is five hours and forty-five minutes long. It consists of seven large DVD projections (each about twelve feet high by fifteen feet across) on the walls of a cavernous room. The gray-green images, shot in darkness by infrared light, are low-angled, static views of small areas inside Nauman's studio at his ranch in Galisteo, New Mexico. They are still lifes, essentially, though at varying intervals they are animated by skittering mice, a prowling black cat, and a streaking moth or two. The animals' eyes glow spookily. Night sounds are heard: wind, barking dogs, a faraway train whistle, a water heater kicking on, a violent spate of rain, an insect bumping against the microphone, desultory vocalizations of the cat. Using a relatively cheap automatic camera, Nauman taped the footage in hour-long chunks over a period of several months in 2000. Abrupt changes in a scene—objects appearing, disappearing, or shifting—indicate the start of a new segment. Once in a while, the artist's cowboy-booted legs can be glimpsed leaving the premises after he has turned on the camera. The enlarged digital images flutter and shimmer, as the camera's dithering sensor continually readjusts to the lights and shadows. The overall effect is swimmy and subaqueous.

Nauman, who is sixty years old, is the most durably respected and also controversial of living artists. Some people, who object to his controlling, hermetic ways, can't stand him. Others—Naumanians, if you will—hang on his productions as on the utterances of an oracle. (I'm a Naumanian.) Nauman was born in Fort Wayne, Indiana, the son of a salesman for General Electric. At the University of Wisconsin, he pursued serious studies in mathematics and music, and then abandoned them in favor of old-fashioned training in drawing and painting. He discovered contemporary art on visits to the Art Institute of Chicago. At the University of California, Davis, in 1964, he went cutting-edge with a run of exploratory works in many mediums. These led to a dazzling show at the Leo Castelli Gallery in New York in 1968. Nauman is commonly regarded, along with Richard Serra and the late Eva Hesse, as one of the Big Three innovators of Postminimalism. From the Bay Area, he moved first to Pasadena and then, in 1979, to New Mexico. There Nauman trains horses and raises cattle, among other activities that help him to endure legendary spells of artist's block. A persistent theme in his work is the question of what, if anything, it means to be an artist alone in a studio, faced with the daunting challenge of making something out of nothing. One iconic early work is a spiral neon sign that reads, "The true artist helps the world by revealing mystic truths." Is this profundity or rubbish? It's both and neither; it's Nauman.

Mapping recalls the pioneering videos that showed the young Nauman taking gruelling, choreographed walks in his empty studio. Those works played with the notion of the artist as a cottage industrialist of meaning, whose every deliberate action in his working space can't help but be art. Nauman was responding to a cultural situation that was new in the 1960s: the dubiously avid embrace of formerly underground avant-gardism by mainstream audiences. His stance was aggressively skeptical. Nauman's formative influences included Marcel Duchamp, Samuel Beckett, and Ludwig Wittgenstein—masters of doubt. In works that featured nerve-racking environments (a corridor so narrow that you could pass through it only sideways; an empty gallery in which his recorded voice could be heard snarling, "Get out of my mind, get out of this room!"), he made caustically whimsical pocket theater out of his own painful self-consciousness, as if to signal the ridiculousness of the whole enterprise. In that period, Nauman alienated quite a few viewers. I remember feeling threatened, almost to the point of panic, by works that imposed themselves mentally as Serra's looming sculptures do physically. But gradually I got the hang of Nauman's honesty, of his self-abnegating discipline. He plays rough but fair. He has influenced generations of artists as a free-floating conscience—producing art out of the deepest, most stubborn anxieties of their common vocation.

I've experienced most of *Mapping* in one of the rolling and swivelling chairs that Dia thoughtfully provides. By my calculation, it would take roughly forty hours and fifteen minutes to miss nothing in any of the projections. (Expect a few dedicated art students to log the full vigil.) I was bored for a while, then intermittently entranced, and, finally, drawn into pleasurable states of meditation. I found myself rooting idly for the cat to catch a mouse. (Doesn't happen.) The studio's clutter—bits of sculpture, crates, buckets, a drawing in progress, chairs, tools, unidentifiable detritus—became talismanic, as warming and worrisome as if it were my own. Nauman's work often weaves a spell that might be called ready-to-wear narcissism—an acute self-awareness belonging to no one in particular. There is no Nauman style. Many of his works convey emotional tones that are palpably antic or sorrowing or angry, but what he shares with viewers is, ultimately, the heavy calm of his loneliness. With *Mapping* the tranquillity feels subtly dire. What happens to one's creations and possessions—one's world—when one is gone from them? They continue to exist, indifferently and very nicely, *Mapping* answers with a whiff of dread.

Nauman says that *Fat Chance John Cage*, the subtitle of *Mapping*, preceded and may have germinated the piece. He came up with the sassy phrase as a work in itself for a proposed group show in London, in which artists were invited to pay tribute to the late aleatory composer, who was an important influence on Robert Rauschenberg and Jasper Johns, among others. Is Nauman for or against Cage? Both, I think. Given that the most continuously engaging aspect of *Mapping* is the product of its seven soundtracks, the work might be considered a Cagean concert with visual accompaniment. The visual elements are Cage-ish, too. They record the eponymous activity—mapping—by mice, bugs, and a cat. Little by little, the critters visit and

trace just about every contour of the given spaces. But the spaces and their contents aren't neutral; they represent somebody's life. And the surveyors are vectors of feral energy, as pitiless as cemetery worms. Cage, the sunny guru of silences and random sounds, endorsed chance as liberating and fun. Nauman gives us the bad news: chance is the universe's way of telling us that we reason and desire in vain.

Nauman's reputation comes as close to being global as that of any other contemporary artist. A mark of his success is the scrappy look of a studio in which finished work never stays for long. Only useful things maintain dignity in it: chairs, a sink, the cat's litter box. (Come to think of it—and *Mapping* affords nothing if not time to think—a litter box is a stirring emblem of nature in amiable accord with culture.) The rest is evidence of former exertions, which, like words repeated until they become nonsense, seem increasingly pointless. This effect is desolating, even scary. But stick around. There is reassuring grandeur in the scale and unity of the piece, hinting at an order of comprehension beyond the personal and even the human. Meaning persists as a possibility that cannot be eliminated. Nauman reports that, soon after the cat's star turn, the animal disappeared, probably a victim of coyotes. After that, he had the mice exterminated. Life goes on, if only because it has nowhere else to go.

January 28, 2002

FOLK AS ART

The new New York American Folk Art Museum, on West 53rd Street, is a pleasure machine, and its two inaugural exhibitions amaze. One, "American Radiance," is a collection of some four hundred objects given to the museum by Ralph Esmerian, the chairman of AFAM's board; the other is a selection from the museum's voluminous cache of visual and written material by the Chicago recluse Henry Darger. The Esmerian collection is an epic poem of connoisseurship. Darger was one of the singular artists of the twentieth century. Taken together, the building and the shows make lively philosophical trouble. Each word in AFAM's name—"American," "folk," "art," and "museum"—acquires fresh, wobbly spin. Formerly called the Museum of American Folk Art, this reborn institution challenges conventional thinking about whirligigs and needlepoint samplers and a mad Chicagoan's midnight lucubrations.

Designed by Tod Williams Billie Tsien, the skinny building's lobby and four gallery floors are dominated by service facilities. Stairways, a balconied atrium, and the elevator housing occupy space that might appear absurdly disproportionate to the nooks and corridors that are left over for exhibits. But the elaborately accommodating arrangement whets a viewer's powers of attention. At most museums, solid encounters with two or three works make my day. In two visits to AFAM, I've been jolted by scores of things—sometimes one after another, bang bang—that normally I would be tempted to ignore. The architectural strategy is jazz-like. Displays occur on offbeats of the space's perambulatory rhythms, such that each object feels like an unexpected discovery. The effect suggests a hip retail store, like Prada; but AFAM's goods are the opposite of glamorous. They absorb us in legacies of people who are orphans of history.

"Folk" are vitiated citizens. They belong to communities at odds with society. They may be set apart on religious principle, like the Shakers; by clannishness, like the nineteenth-century Pennsylvania Germans, a special focus of the Esmerian collection; as the result of ostracism, like racial minorities; or because of poverty or other ill fortune. Folk status may crystallize around things that were once ordinary products of cottage industries but have since gone obsolete—exotically old-fashioned. "Outsider" artists, such as Darger, are folk cultures of one, oblivious of professional or communal standards and the existence of peers. The terms "folk" and "outsider"—never mind the spineless euphemism "self-taught"—are hard to use without condescension, affirming a superior knowingness in the speaker. The stereotypical folk-art fancier is conservative and patronizing. Folk art can be to art as pets are to the animal kingdom.

AFAM's curators confront the basic problem—otherness—by scrupulously acknowledging their role in cherishing relics of bygone or eccentric purposes. "American Radiance" begins on a carefully chaotic note, with three items: a small Pennsylvania slipware dish that, in 1966, was Esmerian's first acquisition; a tin tuxedoed man that was made in Long Island City in 1930; and a wooden sled decorated with the painted scene of a fancy-dress party by a New York amateur artist, June Ewing, in 1983. Only a collector's irrational certitude explains the grouping, which accents the oddity of its components. I wasn't sure I liked how that natty tin man was looking at me, with a complacent air of knowing something I'll never know. I felt a tremor of intimidation—the emotional signature of otherness that doesn't deign to ingratiate itself. Nearly everything on view possesses similarly obdurate dignity.

Each of the show's eleven sections amounts to a sparkling mini-show. Portraits by itinerant artists vivify a genre that was scuttled by the invention of photography. Outdoor paintings include one of the finest of Edward Hicks's *Peaceable Kingdoms* and an anonymous, smartly tidy view of an industrious harbor emblazoned *Situation of America, 1848*. Every object holds its own in arrays of painted furniture, Pennsylvania ceramics, decorated wedding documents, narrative watercolors, scrimshaw, and even walking sticks. A red earthenware covered jar, with ridged and incised, glaze-daubed horizontal bands, would meet anyone's daily requirement of beauty. A section entitled "Girls at School, Women at Home" made me reflect that needlework samplers, which advertise their makers' names, are no more self-effacing a medium than wild-style graffiti. They seethe with personality. Three exquisite silhouette drawings by Bill Traylor, a former Alabama slave who died in 1949, stand out. But even unknown, generic craftsmen speak distinctively, their voices amplified by Esmerian's exacting taste. The show enforces respect.

Henry Darger might reasonably be shown at MoMA, instead of at AFAM. To me, he seems as significant a figure as Henri Rousseau, who was the first and—it turned out—last unschooled genius to win undisputed membership in the twentieth-century canon. (Rousseau had the advantage of well-connected promoters, such as Picasso.) The presence of AFAM's Darger show on the same block as MoMA points to the prevailing schism between outsider and insider art which, increasingly, makes no sense. Art is art—an argument that AFAM advances with considerable force. Darger (pronounced with a hard "g") was born in 1892. After his mother died and his sister was adopted, he was abandoned by his father to institutions for orphans and the "feeble-minded." He worked at menial jobs, scrounged in garbage cans, walked the streets talking to himself, and attended Catholic Mass every day. When he died, in 1973, his landlord found his apartment piled high with manuscripts and scroll-like watercolor paintings on paper—the labor of six decades. Central to this extraordinary legacy was a fifteen-thousand-page novel entitled *The Story of the Vivian Girls, in What Is Known as the Realms of the Unreal, of the Glandeco-Angelinnian War Storm, Caused by the Child Slave Rebellion*. The book is a richly imagined account of the fair and foul adventures of the seven Vivian girls in league with Christian

adults and virtuous monsters against murderous enemies. Darger's paintings—with imagery derived from magazines and coloring books—loosely illustrate the text while constituting a pictorial genre all their own. Their composition and uses of color deserve to be called masterly.

Darger's work is rough stuff in many ways. Battle scenes run to extravagant gore, and a physiological oddity dismays. Why do nearly all of Darger's little girls, when naked, sport penises? I don't know, and, on the evidence of attempted explanations that I've read, no one else does, either. Frolicking or fighting, the kids engage in nothing that looks like sexual behavior. If that counts as innocence, it's not terribly reassuring. One is in deep waters here, where precedents—William Blake? Lewis Carroll? Balthus?—are remote and few. Dismissing Darger as some kind of weirdo is not an option. His cosmos is thought through and expressed with imposing integrity. It can't be picked apart. Recent signs of his influence—they include *Girls on the Run*, a book-length poem by John Ashbery—indicate that the Vivians are conquering their way to iconic status.

A nagging problem of folk or outsider art—long responsible for its quarantine from serious consideration—is naïveté. One view holds that such work differs from fine art as birdsong does from opera. There is truth to this. As I wandered from exhibit to exhibit, I found myself wanting to come upon something by somebody who plainly knew exactly what he or she was doing. Still, there is more raw aesthetic potency in many of the objects at AFAM—for example, an enormous weathervane that represents an Indian chief and, by happenstance, is riddled with bullet holes—than one encounters at most shows in Chelsea of hot young artists, who could learn a lot from this new museum, starting with the indispensability of delight.

January 14, 2002

BARNETT NEWMAN

Barnett Newman was forty years old when, in 1945, he made the first of his surviving paintings. (He destroyed his earlier canvases.) From then until he died, of a heart attack, in 1970, he produced a mere hundred and twenty or so paintings, about half of which are now in a formidable retrospective at the Philadelphia Museum of Art. The late bloomer was not promptly recognized. Even most of Newman's fellow Abstract Expressionists scorned his art's drastic simplicity, and, year after year, almost all the critics, except Clement Greenberg, savaged him. His reputation as one of the great moderns took hold only in 1959, when Greenberg arranged a show for him at French & Company, a gallery on Madison Avenue. The event caused a stir that developed into a storm of renown, though it attracted no immediate buyers. As late as 1955, Newman had sold only one painting to someone other than a friend. For most of the 1940s and 1950s, he and his devoted wife, Annalee Greenhouse, who was a high-school teacher in Queens, lived mainly on her salary. Compared with Newman, the proverbially neglected Vincent van Gogh was an overnight sensation.

It is useful to keep this background of struggle in mind while viewing the Newman retrospective, which, authoritatively organized by Ann Temkin, the museum's head curator of modern and contemporary art, holds forth with imperious ease. Even when he was ignored, Newman aimed his art at museums. He promoted his monochrome fields of paint, which bear one or more of the vertical stripes that he termed "zips," with grandiose rhetoric. Consider the title of a painting from 1950–51 that is a touchstone in the collection of MoMA: *Vir Heroicus Sublimis* (*Man, Heroic and Sublime*). With this eighteen-foot-long, five-zip, red canvas, the artist advanced an ambition to conjure more spiritual content out of less physical form than had seemed conceivable in any previous (or subsequent, for that matter) twentieth-century art. Most people today take the work's intention and its success more or less for granted, but we really shouldn't. By doing so, we dull the lasting shock of Newman's audacity and lose touch with the significant discomfort of his contemporaries.

Born in 1905 on the Lower East Side, Newman was the son of Jewish immigrants from Russian Poland. While making tentative stabs at being an artist, he graduated from City College, having majored in philosophy, and reluctantly entered his father's menswear-manufacturing business. Crippled by the Depression, it folded in 1937. Three times, Newman took and failed a test to qualify as a high-school art teacher; his artistic skills were judged insufficient. (In fact, he was a crude draftsman.) A political anarchist and all-purpose gadfly, he ran for mayor of New York in 1933 (Fiorello LaGuardia won), and founded an intellectual magazine for civil servants that lasted one issue. Finally, in

1944, he caught fire as an artist, making drawings that nudged biomorphic Surrealism toward pure abstraction, with an emphasis on color. His zip, which he developed through trial and error, came to maturity in a 1948 painting, *Onement I*, as a taut vertical form that is something between a line and a shape and that either divides or knits the composition, depending on how you choose to look at it. The more you try to see the painting as a plain design, the more overwhelmed you are by its irrepressible ambiguity. Newman took sustenance from close friendships with Mark Rothko, Adolph Gottlieb, and, starting around 1947, Jackson Pollock. Like them, and like Clyfford Still, he found a distinctive route to a new kind of painting, one that exploded the traditional picture and, as much as art can, changed how we look at the world.

I met Newman in 1966, as one could hardly help doing in the art world at that time. He seemed to be everywhere, in his natty suits and British brigadier's mustache, wielding a preposterous monocle. He was buoyant and very warm, especially to younger artists; his friends called him Barney. He was given to oracular and witty utterances. He swore fealty to "timeless and tragic" subject matter. Asked by a magazine in 1947 to address the question "Why I Paint," he wrote, "An artist paints so that he will have something to look at; at times he must write so that he will also have something to read." His most famous quip—"Aesthetics is for the artist as ornithology is for the birds"—gains weight from his enthusiastic absorption in bird-watching. (He also had a keen interest in botany and baseball.) A polymath and a dandy, Newman lived and breathed the cosmopolitan ideal.

The outsized passions and eccentricities of the Abstract Expressionists—enacted on a tiny, obscure, ragamuffin scene—seem exotic in our jaded age. This show revivifies them. As the movement's foremost born-and-bred New Yorker, Newman took upon himself the drama of his generation's determination to eclipse Europe and to set art on a new course—and he made sure that everybody knew it. It's easy to understand why he exasperated his peers. He pushed the new art's interest in the sublime to extremes that could—and could still—seem ridiculous. What his colleagues couldn't grasp, because he was truly ahead of his time, was the prescience of a style that would lay down the law for American art in the 1960s. Color Field painting, Minimalism, and Pop art all took bearings from the vast, stripped-down, acutely scaled presence of Newman's work. (What are Andy Warhol's big paintings except Newmans with images silk-screened onto them?) It is telling that Newman often designed his shows with help from the architect and sculptor Tony Smith, a leader in the evolution of the austere, white-walled spaces that continue to prevail in the world's museums and galleries.

How does one square rigorous aesthetic innovation with hazy religious portent? That's Newman's problem for us. The issue can't be resolved, I believe, but in the face of his best works—preeminently *Vir Heroicus Sublimis*—it falls away. Those paintings rely on brilliantly simple ideas for turning pictorial space inside out by confronting the beholder with the sheer physicality of the canvas. Pollock, Rothko, and Still seized on this trope, too, but always with internal suggestions of visual depth and other picture-ish dynamics. That's part of their poetry. Newman's style is an august prose. Its musically

sequenced zips present one-to-one correspondences with the viewer's body. Their mysterious poise, which recalls the attenuated figures of Giacometti, invades and displaces our sense of ourselves, and the effect is a brief but intense experience that begs to be called the sublime: loss of selfhood to something bigger and nobler than we are. This happened to me with *Vir* in Philadelphia. As I stood about six feet from the canvas, its utter redness ballooned, the nearest zips bowed outward in my peripheral vision, and something like the rush of a dentist's laughing gas suffused my brain. In that moment, any interpretation would have seemed reasonable. If I'd been informed that the painting's title was *God*, I would have bought into it.

It's only art, of course, and I quickly regained my usual self. The art historian Kenneth Clark once remarked that we can experience a pure aesthetic sensation for only as long as we acutely savor the smell of a fresh-cut orange—about two seconds, by my reckoning. That seems right with regard to Newman, who is imperishably radical for having focused all his energies on the cultivation of fleeting, exquisite transports on a grand scale. (Ellsworth Kelly does something similar, though in a practical vein that is poles apart from Newman's allusiveness.) Newman made things difficult for himself by insisting on transcendent meaning. No wonder his body of work is so small. God created the world only once, we're told. Newman put himself in a position of repeatedly saying, "Let there be light," and having it be so. He was resourceful in rejiggering the once-and-for-all effect that he was after—as in the astonishing, almost all-zip *The Wild* (1950), a canvas eight feet high and an inch and a half wide. His mastery of color led to revelatory feats with strong ultramarine blue and then, improbably, with exceedingly weak aqua. His late paintings entitled *Who's Afraid of Red, Yellow, and Blue* are as stirring as a cavalry charge. He made remarkably few bad works.

But when a Newman is less than supremely powerful one feels a bit embarrassed for him. Where to draw the line between wheat and chaff in his paintings is a thoroughly subjective decision, which is apt to vary from viewing to viewing. I shed tears the first time I saw the artist's attempted magnum opus—*The Stations of the Cross* (1958–66), fourteen mostly black-and-white paintings on raw canvas that normally reside at the National Gallery of Art in Washington, D.C.—but I was in a tired and emotional state at the time. In Philadelphia, the series struck me as a major failure made up of minor successes, a work that simply cannot overcome the absurdity of equating Christ's ordeal with Newman's sense of himself as a man with a mission. For me, the most stunning aspect of the *Stations* is the signature that he imposed on most of the pristinely abstract canvases. I found myself riveted by those trumpeting flourishes. In the end, Newman's art is about how he wished to be taken: an artist bestriding history and communicating by house phone with the Almighty. It's dubious, except when he knocks us over the horizon.

April 15, 2002

TINTORETTO

T intoretto was too good an artist for his time's uses; he still clamors for a
proper role, seeking affirmation, four centuries later. This thought came to me as
whimsy, and stayed as conviction, at the Prado, in Madrid, which has just opened the
second-ever retrospective (the first was in Venice, in 1937) of Jacopo Comin, who was
also known as Robusti, and called Tintoretto, or "Little Dyer," after his father's pro-
fession. Tintoretto (1518–94) is the most mercurial of the five undisputed immortals
of Venetian painting—the others being Bellini, Giorgione, Titian, and Veronese—
and I was eager to see the Prado show, because I have never managed to get a satisfy-
ing fix on him. How could someone so great, able to summon the world with a
brushstroke, be so inconsistent in style, and, on occasion, so awful? Stupefyingly pro-
lific, Tintoretto garnished the walls, ceilings, altars, exteriors, and even the furniture
of Venice, performing commissions for free when that was what it took to edge out a
rival. (He was not popular with his fellow-artists.) He brought off one of the world's
largest paintings—*Paradise* (1588–92), in the Ducal Palace, which, at seventy-two
feet long and twenty-three feet high, is so vast as to be essentially unseeable—and
perhaps history's most sustained demonstration of sheer painterly talent, brimming
the Scuola Grande di San Rocco, between 1564 and 1588, with pictures whose profu-
sion and intensity burn the most concerted effort of looking to ashes. But he and his
populous workshop also perpetrated some of the grimmest daubs—murky and
slack—that you ever rushed past with a shudder. I realized, too late, that my puzzle-
ment was a warning. Now I feel that I have acquired a brilliant, neurotic, exhausting
friend who enjoins me to undertake on his behalf campaigns that he bungled when
their conduct was up to him.

Nothing inferior taxes the eye at the Prado, which augments the cream of
Tintorettos in European and American collections with a few loans from Venice,
where hundreds of his paintings—including his greatest works, such as *The Miracle
of the Slave* (1548)—reside immovably in churches, palaces, and galleries. The show
more than overcomes doubts about presuming to assess the artist outside his home
town, which he is known to have left just twice, briefly, in his life. The well-restored
canvases, shown in good light, sparkle and blaze. Some make plungingly deep space
with muscular figures of different sizes; your mind provides perspective that the
artist didn't deign to chart. Others array action on intersecting diagonals, along
which someone is apt to be arriving from somewhere at terrific speed. (There is an
old line that Tintoretto invented the movies; his ways of enkindling routine scenar-
ios, with thrilling visual rhythms that seem to unfurl in time, endorse it.) He drew
with his brush, light over dark—so that shadings came first, imparting a sumptuous

density to forms that are hit with highlights like spatters of sun. He is supposed to have said that his favorite colors were black and white, but he could be every bit the startling and seductive Venetian colorist when a commission required it. With abject competitive fury, he was not above imitating the grand dragon of the Venice art world, Titian, and his designated successor, Veronese.

"As a matter of fact, he almost never takes the liberty of being himself unless someone builds up his confidence and leaves him alone in an empty room," Jean-Paul Sartre wrote in a 1957 essay, "The Venetian Pariah." For Sartre, Tintoretto is an avatar of existential anguish, who was both behind his time—as the last native-born master on a scene ruled by a cosmopolitan élite—and ahead of it, as the ideal artist for a rising bourgeoisie that was too intimidated by the pomp of the ducal republic to recognize itself in his demotic trashings of aristocratic decorum. Intellectuals of the era, while in awe of Tintoretto's gifts, scolded him for being too fast, careless, and insolent; when Vasari credited him with "the most extraordinary brain that the art of painting has ever produced," it wasn't meant as unalloyed praise. (Vasari also called him the medium's "worst madcap.")

As a boy, Tintoretto is said to have entered Titian's workshop as an apprentice but was thrown out after a few days, having either frightened the master with his aptitude or irked him with his personality; at any rate, Titian's attitude toward him was plated with permafrost. Little is known of Tintoretto's subsequent training. His earliest surviving work, from the early 1540s, is anti-Titianesque—radically sculptural and draftsmanly, embracing Central Italian influences. Then something happened that the art historian Alexander Nagel compares to the bluesman Robert Johnson's "going down to the crossroads and coming back with scary new powers." *The Miracle of the Slave*, made for the Scuola Grande di San Marco, electrified Venice. Its unprecedented range of spatial, chromatic, and kinetic effect suggested a synthesis of "the *disegno* of Michelangelo and the coloring of Titian"—a contemporaneous formula, often cited, for ultimate greatness in painting. He was roundly hailed, though Pietro Aretino, Titian's literary ally, added a caveat about his lack of "patience in the making." Commissions came in bunches to the new hero, but solid status skittered out of reach.

He compensated by striving to engulf the town. Meanwhile, Titian refused to slacken his grip on preeminence, let alone die. When he finally expired, at the age of eighty-eight or so, in 1576, it brought Tintoretto no peace. Though he was now, by general consent, Italy's leading painter, he responded with pictures as flailingly ambitious and various as ever. Three from the late 1570s triumph in as many styles. In *The Rape of Helen*, the hauntingly lovely captive languishes in the corner of a churning land-sea battle scene, with scores of figures, ranging in size from huge to tiny, which you can all but hear and smell. In *Tarquin and Lucretia*, the naked, lividly fleshy protagonists struggle at the edge of a bed, toppling a sculpture and breaking a necklace that rains pearls. The woman's right hand seems to extend from the canvas,

as if to be grasped by a rescuing viewer. (The Baroque, which took hold two decades later, with Caravaggio, can seem an edited ratification of tendencies already developed by Tintoretto.) *The Martyrdom of St. Lawrence* is a sketchy and fierce nightmare of death by roasting, with an anticipatory whiff of Goya. Tintoretto strongly influenced El Greco, blazed trails for Rubens, and fascinated Velázquez, who acquired his paintings for Philip IV.

"What is a Tintoretto?" the art historian Robert Echols asks in the show's catalogue. The answer might be almost anything touched with genius and a strange, thorny, dashing humor. Tintoretto was reported to be a witty man who never smiled. What is his *Susannah and the Elders* (1555–56) if not a grand lark? A luxuriant, glowing nude sits outdoors, surrounded by a glittering still life of jewelry and implements of beauty, and is ogled by dirty old men (one pokes his bald pate, at ground level, practically out of the canvas) from behind a hedge that forms part of a corridor-like recession into the far background. There are distant little ducks, and the rear end of a stag. But the picture's form is too disorienting to sustain any particular response, including amusement. The backstage space outside the hedge ignores the unity of the central perspective, bespeaking a world that rolls away in all directions, indifferent to pocket realms of mythic anecdote. The effect is stirring and confusing. "Who is Tintoretto's viewer?" strikes me as the really compelling question. No other great artist before modern times, in which shifting contingency affects every enterprise, seems less certain of whom he is addressing, and why. It might as well be you or me as some *cinquecento* ingrate, and, if we happen to think of people we know who may be interested, the artist encourages us to contact them without delay.

February 12, 2007

DEALERSHIP: MARIAN GOODMAN

"Serious," the art dealer Marian Goodman said.** I had asked her to guess how other people in the art world regarded her. Concentrating, she paused between phrases. "Responsible. A passionate advocate for my artists. Batting average pretty good. More wise than unwise." We sat at a canal-side restaurant in Venice, just after sunset—living pleasurably goes with being a successful art dealer. I asked her, "How about 'tough?'" She said, "I don't agree." Pause. "People always say that about women in the art world." I pursued: "Shy?" "I don't know. People say that." (A colleague once remarked that Goodman is the only person he knows who backs away while saying "hello.") She stands five feet high. Her often wary brown eyes peer out beneath dark, girlish curls. She has the softest of New York-accented voices. She appears to retreat even when delighted, ducking her head and grinning to herself. Her conspicuous self-effacement suits a line of work that rewards discretion. It combines with her prestige—Goodman may be the most respected contemporary dealer in New York, for her taste, standards, and loyalty to her artists—to generate a formidably enigmatic air. "Ah, the queen of us all!" the dealer Friedrich Petzel remarked when I told him that I was writing about her. A less enchanted peer, requesting anonymity, grumped that Goodman is "not collegial." (Royalty is so standoffish.) What is Goodman's realm, and what sets her high in it?

In popular culture, the gallery owner is a stock figure of slinky charlatanry, or worse. If a dealer makes the news, it's usually for being accused of tax evasion, money laundering, estate tampering, or some other offense that, in an arcane cash business, may be temptingly easy to commit. When that happens, people savor the cynical rush of discovering garden-variety greed behind a pose of lofty, intimidating sophistication. But there's no getting around the fact that refined sensibility—the real thing, with or without a garnish of pretensions—is indispensable to selling art. In this line, even crooks need taste. An art work is a unique, usually handmade physical object, worthless in itself, around which ideas propagate and dreams are spun. Its value isn't only subjective; it is subjectivity incarnate and portable.

Art dealers operate in a way that is confusingly indirect. Other entrepreneurs of creative production visibly cash in at the point where consumption either occurs (movies, performances) or is made possible (books, recordings). Only art galleries provide a full experience of their goods, free, to a drop-in public that is only fractionally, if at all, a clientele. (Serious collectors don't wait for shows to make their purchases; they might have bare walls if they did.) It's not that gallery owners are unusually philanthropic. To have anything to sell, they must accommodate their artists' will to glory by putting on shows, with advertising budgets, public openings,

and perhaps glossy catalogues, with introductions by hired critics. Money changes hands out of sight, in negotiations that turn on the relative clout of the dealer and the collector. Buyers and prices paid are almost never announced. The standard dealer's commission on sales—fifty percent—reflects the complexity of a gallery's services to its artists: agent and manager in one, publicist, archivist, sometimes assistant producer, and perhaps social director and lay psychotherapist. Dealers help to aim their artists' ambition at obscure bull's-eyes in the culture. Repeated hits earn a dealer a reputation for being a magus or a mountebank, depending on who's talking.

Goodman opened the Marian Goodman Gallery on East Fifty-seventh Street in 1977. (In 1981, she moved it to its present quarters, at 24 West Fifty-seventh Street.) True to the fanatical secrecy of her tribe, Goodman won't speak of revenues. "We do well," is all she would tell me. Walter Robinson, an art-world veteran who edits the online Artnet Magazine, estimates Goodman's annual gross to be in the low eight figures. (According to the Art Dealers Association of America, a trade group, fine art generates between five billion and ten billion dollars a year, worldwide.) Goodman handles leading foreign artists, including the painter Gerhard Richter, the photographer Thomas Struth, the sculptor Thomas Schütte, and the mixed-media documenter Lothar Baumgarten, of Germany; the sculptors Tony Cragg and Richard Deacon and the video artists Steve McQueen and Tacita Dean, of the U.K.; the installation-makers Christian Boltanski and Annette Messager, the filmmaker Chantal Ackerman, the site-specific painter Niele Toroni, and the digital animator Pierre Huyghe, of France; the Mexican aesthetic gamesman Gabriel Orozco; the sculptor and provocateur Maurizio Cattelan and the Arte Povera worthies Giuseppe Penone and Giovanni Anselmo, of Italy; the Canadian creator of staged light-box photographs Jeff Wall; the Irish maker of gnomic slide shows James Coleman; the Dutch photographer Rineke Dijkstra; and the South African film animator and puppeteer William Kentridge. Goodman represents Americans, too, including the sculptor Dan Graham and the conceptualists Lawrence Weiner and, since 1999, John Baldessari—taking the Californian master of photographic montage from the gallery of her oldest competitor, the estimable Ileana Sonnabend.

The Goodman is less prominent than the PaceWildenstein and Gagosian galleries, but its existence gives the art world rare jolts of self-esteem. Though bright and welcoming—with rest rooms that Weiner friskily labelled "We" (formerly "Them") and "Us"—the place emanates integrity. It's a palimpsestic effect of years of shows that, if they erred, did so on the side of high-minded rigor. The gallery occupies the entire fourth floor of its building. Two large rooms, at either end of a long corridor, are congenial to two-person shows or to munificent solos. (Richter always shows in both rooms.) Three or four times a year, on average, a window in the front room is popped out, and works that are too big for the freight elevator are winched up from the street—a costly, nail-biting operation that Goodman incurs by stubbornly refusing to join the nearly total exodus of leading New York galleries to the practicable former garages and warehouses of Chelsea. Goodman's taste is firmly

rooted in the late 1960s and the 1970s, when strong Europeans, having assimilated the lessons of American Pop art and Minimalism, began to erode the creative centrality of New York. That was the last era of idealistic avant-gardes, whose ethical cachet—disciplined contravention of established values—still overshadows contemporary art's wandering present state. Goodman's identification with that tradition gives her a pick of ambitious, lively newcomers who extend and refresh it, such as Cattelan, Orozco, and Dijkstra. Any artist's first show at the Goodman is automatically a big deal.

Goodman began life in New York City as Marian Geller, the first child of an accountant and a schoolteacher. If she wasn't exactly a red-diaper baby, she was roseate. Her parents raised money for the Loyalists in the Spanish Civil War, and she summered at a camp in the Catskills that espoused socialist sentiments, folk music, and baseball. Goodman remains on the left—"a classic American liberal, in the best sense," her friend the radical German theorist and critic Benjamin H. D. Buchloh says. "Her judgment is ultimately aesthetic, but she has a broad understanding of what a privileged existence allows and requires one to do. Her gallery has a certain subtle social horizon of responsibility." Goodman's upbringing gave her a sense of belonging to a principled minority and, with it, a lifelong "fear of mob opinion," she said. She attended the Little Red Schoolhouse and Elisabeth Irwin High School. She was a star second baseman in high-school softball. "My friend was the shortstop," she told me. "Our idea was to look very girlie-girlie and to play the game very well." She added, in a tone of hard fact, "We were terrific." Indeed, there is something of an infielder's grounded equipoise about her, however dissimulated by the voluminous suits she wears by the designer Zoran. She graduated from Emerson College, in Boston, and planned to study journalism but was forestalled by marriage to William Goodman, a civil engineer. "It was before I grew up. I was twenty-one and had two kids right away." (Her son, Michael, is an industrial photographer in New York; her daughter, Amy, is a herbalist in Vermont.) Andrew Goodman, a son of her husband's brother, was one of the three civil-rights activists who were murdered in Mississippi in 1964. Goodman told me of Andrew's funeral, at the Ethical Culture Society, "Outside, the street was full of people. They were singing 'We Shall Overcome.'" At the memory, tears came to her eyes. She shook her head.

Marian Goodman's father, Maurice Geller, had a consuming passion for modern art. (His father, a Hungarian immigrant, was an unsuccessful painter who died before Marian was born.) Maurice had studied engineering but became a Certified Public Accountant during the Depression to support his mother, three younger siblings, and his own growing household. He hated accounting, according to Goodman. In their apartment on Central Park West at Eighty-fifth Street, he mounted "art shows": posters and reproductions, cut from books and magazines, of Cézanne or van Gogh or another modern master, arrayed on the walls for the family's instruction. "I thought my father was mad," Goodman said. "But the way to spend time with him was to run after him to museums." Geller befriended

Milton Avery, the superb American follower of Matisse, and at one point owned forty of his paintings—and almost none by anyone else. Living in the same building as the Goodmans were Sidney and Hansi Janis, who founded the influential Sidney Janis Gallery, specializing in modern and naïve art. They owned the great jungle painting *The Dream*, by Henri Rousseau, which became a touchstone in the collection of MoMA. Goodman remembers playing out jungle fantasies in front of it, by the hour, in the Janises' living room with their sons, Carroll and Conrad (the actor).

Starting in 1963, Goodman attended graduate school in art history at Columbia. She was the only woman in her class. "A teacher told me that I wasn't the kind of person that museums and universities were looking for," she said. She despised the classes: "Teachers with their backs turned to slides, droning on." She said, "I almost quit because of the civil-rights movement—to do something socially useful, to go to law school. I wasn't sure being an art historian was so useful." Meanwhile, she was ignited by a studio course with an abstract painter named Peter Golfinopoulos—"a street guy, so alive. There was so much love there." Golfinopoulos showed with Charles Egan, a dealer of Franz Kline and Josef Albers. Egan became a lasting inspiration to Goodman. "Charles was a W. C. Fields type. A great fan of James Joyce. He was obsessed with *Finnegans Wake*." Goodman recounted a scene in which a major Chicago collector, whose wife had musical ambitions, expressed outrage at a show in Egan's gallery of monochrome paintings by Robert Rauschenberg. Egan denounced the collector as a philistine. As the man beat a retreat, the impolitic dealer shouted after him, "And your wife is a lousy violinist!" Such remarks must gestate at times behind Goodman's bashful mien. Coping with the amateur public is a trial to her, precisely because she lacks any armor of snobbery.

"As a gallerist, it is your unpleasant duty to be friendly to everyone," Thomas Struth remarked to me from his studio in Düsseldorf. "Marian is polite, but somehow she always manages to hold her own ground." (Struth said that when she first visited him, in 1989, "I made a test." He handed her a stack of fifty of his photographs and asked her to select ten. "She looked slowly and picked the best.") "She is one of the most powerful and influential dealers of the twentieth century," the director of the Dia Art Foundation in New York, Michael Govan, says. "Of all of them, she has the least publicly visible presence. She is shy externally, but she has very intense individual relationships with her artists. She has an incredible stable. All her artists are among the most respected in the world, though—with some exceptions, like Richter, of course—they may not be the most commercially viable." Goodman spends "three or four hours a day," she said, chatting on the phone with her far-flung artists—who, Weiner told me, constitute a "clan" like those of no other gallery. Her professional hero is the late Leo Castelli, contemporary art's king in the 1960s and 1970s. "I knew him really well. I was moved by his love of art and generosity with artists. His ethical stature. His warmth. I think of other gallerists who did a brilliant job, but they aren't my idols."

Around 1962, Goodman organized a portfolio of cheap photo-offset prints by New York painters—Avery, Kline, Stuart Davis—as part of a fund drive for the now defunct Walden School, which her children attended. It went well. "I thought, Maybe I could do this for a living," she said. She needed a job. Her marriage was tottering. It was the 1960s. "It all looked like freedom to me." While Goodman did not become actively feminist, she said, "I saw those doors opening and I wanted to walk through." Living apart from her husband, she was threatened with eviction from her co-op for entertaining gentlemen callers. (That was the second of three apartments on Central Park West, where, but for a spell on Riverside Drive, she has spent her life. She moved to her present top-floor apartment in 1973.) In 1964, Goodman proposed a nonprofit publishing project to MoMA; she was turned down. Printmaking was burgeoning in the 1960s, responding to a soaring market and to an aesthetic sizzle provided by Jasper Johns, Andy Warhol, and other innovative artists. In 1965—with five thousand dollars that she made by selling a Milton Avery painting her father had given her (he approved of the sale) and with partners including her friend Barbara Kulicke, the wife of the dominant frame-maker of the 1960s, Robert Kulicke—she opened Multiples on Madison Avenue, near the Whitney Museum.

Multiples published prints and manufactured editions of art objects, such as plastic abstractions by Barnett Newman and cloisonné pins by Roy Lichtenstein. For Goodman, prints had political appeal: art for the many. Her course was irreversible by the time disillusionment set in. "It turned out that the people who buy prints are the same people who buy everything else," she said ruefully. She recalls her shock at discovering, in the late 1960s, that the Lichtenstein pins that she was selling for twenty-five dollars apiece were fetching eight times that in Europe. Speculative frenzy was a new wrinkle in contemporary art. Goodman is convincing in her distaste for it, though she has certainly profited from price surges in the past decade, especially with Richter's works.

In 1968—the year of her divorce and a time when "New York was so insular; for the critics, the sun rose and set on American art"—Goodman had an epiphany in West Germany, when she visited the international art show "Documenta", in Kassel. She said, "Like a lot of people in New York, I swore that I would never set foot in Germany. I was offended by people who bought Volkswagens. When I got there, of course, I looked at the older generation and wondered about what they did in the war. But the younger people were very mature. They had to judge their parents and to make their own values. They got right into the business of life. They didn't have the luxury of contemplating their navels." She saw a filmed performance by the ravaged, charismatic ex-Luftwaffe pilot Joseph Beuys, "moving gigantic planks of wood around" in a way that, for her, evoked the burden of the past. "I thought it was wonderful, though I had a lot of doubts about Beuys." Artists of a leftist bent whom she began to meet and venerate, especially the sly and acrid Belgian conceptualist Marcel Broodthaers, disparaged Beuys's authoritarian and megalomaniacal tendencies. Strains of conservative nostalgia and anarchic animus were at war in Germanic

culture and, eerily, within the souls of individual artists, such as Richter and Sigmar Polke, who together, in the early 1960s, hatched the brilliant German variant of Pop art, which they dubbed "Capitalist Realism." For years, Richter showed in New York with Sperone Westwater Fischer, a three-person partnership that included the serious-minded German dealer Konrad Fischer. After Fischer departed—partly in protest against a new emphasis on fashionable Italian Neo-Expressionists such as Enzo Cucchi and Sandro Chia—Richter showed jointly with that gallery and Goodman from 1985 until 1990. He then opted for Goodman.

After 1968, Goodman began frequenting art events in Europe. She had a success at the Basel Art Fair in 1970 with an edition of Andy Warhol's *Mao* prints— candy-colored icons of the totalitarian sublime, which, for one reason or another, nearly everybody liked. But she got nowhere in New York with her enthusiasm for European avant-gardists. MoMA rejected Goodman again, when she tried to interest one of its curators in Broodthaers. The art market tumbled in the recession of the early 1970s, and her Multiples partners fell away. In 1974, she found herself in business alone, working from her apartment. She stayed up nights, she said, trying to think of tasks for her sole assistant, a young, dauntingly efficient German woman. Goodman was at loose ends personally, "rehabilitating my life." Her frustrated wish to promote Broodthaers was decisive. She started a gallery, which opened on a tragic note. Shortly before the inaugural Broodthaers show, the artist died of liver failure, at fifty-two. (Broodthaers's twisty, cerebral art—including elegant installations of, say, common objects in vitrines, eighteenth-century engravings, ironic texts, and the odd palm tree, concerned with protocols and politics of exhibition—is still a hard sell in America.) Other early offerings of the gallery were shows of the piquant German abstract painter Blinky Palermo and the dandy-ish, esoteric American sculptor and performer James Lee Byars.

Goodman kept company in the 1970s with a trial lawyer, who brought some lawyer friends to an opening where Byars held forth in a gilded tent. Goodman recalled, "James Lee shouted, 'Hear the phi-to-infa!'—something about philosophy—'and it will knock you down!' Then he would jump up in the air and flop on the floor. He must have been black-and-blue the next day." The lawyers politely thanked Goodman for the evening. "I think they were puzzled." She smiled contentedly at the memory. I asked her if such culture shocks were frequent among her non-art-world friends and family. She said they were, and promised to provide anecdotes, but later she begged off. She said, "There are many funny stories, but I've realized that almost all of them are at someone's expense. I don't feel right about telling them." Accordingly, she declined to talk about the most colorful contretemps in her gallery's history, which, as luck would have it, unfolded in the public eye.

Goodman worked closely with Anselm Kiefer for seventeen years, starting soon after she met him, at the 1980 Venice Biennale. It was an auspicious relationship, for her and for contemporary art. Kiefer's grand, darkly ironic works on mythic

and political themes, including disasters of the Third Reich, revived painting's long-dormant potency as a medium of historical imagination. Having started her gallery for Broodthaers, she moved it to a bigger space so that she could show Kiefer's often colossal works. The arrangement began to sour after a huge, disastrous dinner party in Greenwich Village, in May, 1993. The gala was the reclusive German's hubristic idea of a New York social début. His new companion (and present wife), Renate Graf, who had met him while working for Goodman, made the arrangements. Kiefer's sense of timing—the art world was in a foul mood, beset by a crashing market and a hangover from the scene-making frenzy of the 1980s—proved lamentable. Guests were kept waiting for what I recall as the better part of an hour, standing in a dark room. Then we were admitted to a murky industrial loft that was tricked out with candelabra and white veil scrims, with white sand on the floor. Mimes in whiteface, including drag queens dressed as brides, performed non-stop. The fare ran to recherché organ meats, such as bull testicles. "It's funny," the artist Sherrie Levine (who showed with Goodman for a time) mused aloud. "I always thought I could eat anything." Did Kiefer's departure from the gallery, a few years later, stem from his grumpiness at the fiasco? One persistent rumor has it that he was angered by Goodman's lukewarm response to some new work by him. She said only, "We went in different directions." Pause. "I admire him immensely." Kiefer has since shown with Gagosian.

The Kiefer evening notwithstanding, Goodman is celebrated, among friends of the gallery, for the buffet dinners that she has hosted at her apartment after openings. For years, she did the cooking herself. Among her oldest and best friends is Diana Kennedy, the doyenne of Mexican cuisine for the English-speaking world. (On holiday with Kennedy in Chiapas, in 1994, she was awakened one morning by the furor that announced the Zapatista movement to the world.) Goodman travels often, almost always by herself, to take in shows, to cultivate relationships with curators and other art-world people of influence, and, particularly, to see her artists. Visiting them is "like tending a garden," she said. I tagged along on a trip to Cologne last summer when she called on Gerhard Richter at his studio. They met in 1983, at the high tide of the Neo-Expressionist craze, in which the astringent and brainy Richter did not figure. Having briefly shown European stars of the moment such as Georg Baselitz and Markus Lupertz, Goodman decided that both her heart and art's future belonged not with them but with Richter, who was still little regarded in America. He welcomed her overture, he told me, because of his dismay at the course of fashion: "New York was looking in the wrong direction!" Richter later told me that, when Goodman visited him for the first time, "it was a hard forty minutes. I am not a good speaker, not an entertainer. Marian is the same. Each of us sat in front of the other and didn't know what to talk about. At last I said I was sorry, I had to work. I was a little bit angry at myself, for being so stupid." It took me a moment to register that he told the story in praise of Goodman. "I was impressed that she came alone. Other dealers come with another person or an entourage to support them." He added,

"Marian is a presence. She is wise. She has courage." (He gave the last word its French pronunciation.)

True to Richter's account, he and Goodman talked little when I was with them, but their enjoyment of each other was palpable. They did a spot of business about a series of eight different-sized sheets of thick safety glass bracketed to the wall—works meant to be reflected on, in both senses. Dapper and gracious, Richter sketched and numbered them on a piece of paper. Some were already committed to a collection or an exhibition, and Richter would keep two. Two others were set aside for Goodman, if she wanted them. She did. She pointed to another pencilled oblong on the paper and said that she had a buyer for that work who would give it to a museum. "Poor museum!" Richter said. He showed us his new abstract paintings. The first was a large canvas bearing a uniform grid of small skeletal spheres— derived from an electron-microscope photograph of silicate—in fuzzy grisaille: a cold, dizzying picture with an optical vibration and almost an audible buzz. Three other paintings progressively effaced and warmed up the pattern with painterly and atmospheric effects. "It's getting more free," Goodman remarked. Richter nodded. We looked at the lovely, difficult works in relaxed silence.

A few days later, Goodman arrived in Venice to revisit the Biennale for a long look, undistracted by the mobs that had attended its opening. The show's all but exclusive emphasis on young artists troubled her. "Group shows are better with a sense of context," she said. "I realize that everybody is supposed to know the art of the last thirty-five years, but it's important that it be seen. If you put together a show of artists from the 1960s and 1970s, they are all survivors. With young artists, who survives is still to be determined." This led her into mild complaints about the present art world. "It's always the same cycle, since the eighties. Young people get a great deal of attention. Those in mid-career have a harder time. When they are much older, they may be re-embraced." (This recalls F. Scott Fitzgerald's lament that there are no second acts in American lives, with the addendum that there may be a third act if you persevere and have somebody to stand by you.) "I wish there were more sense of balance. The way the art world treats new art has nothing to do with the reality of the situation. I wish we could replace it with more long-term interest in the artist over the span of his life." Among those artists who were highly praised at the Biennale was Gabriel Orozco, for his elaborate, haunting re-creation, in wood, of a rapturously modernistic concrete portico, designed by the architect Carlo Scarpa in 1952, which still stands, badly deteriorated, in a neglected garden of the Italian pavilion. The most highly praised young artist was the Albanian Anri Sala, repre- sented by a lyrical documentary film on the mayor of Tirana, who, to raise public morale amidst economic devastation, had arranged for the city's buildings to be painted in brilliant primary colors. Goodman plans to work with Sala.

Today, the Goodman Gallery employs seventeen people full-time in New York and four at a branch in Paris. Goodman scouts new talent, but cautiously, lest she disrupt the standards and tone that her regular artists set for the gallery. The artists

themselves have influence when it comes to deciding who will or won't join their crew; more than one candidate has been blackballed. She listens to advice. Her friend Benjamin Buchloh alerted her to Struth and Orozco, but she has rejected other of his recommendations. She agonizes when selecting an artist. She said, "The choice of whom to work with goes to one's spiritual core. It starts with intuition, but it's important to reflect on how deep a commitment one feels before one gets involved. One must be willing to keep showing an artist for fifteen or twenty years. The worst thing in the world is to grab someone before one is convinced. It's so devastating if you lose interest." Careful to a fault at times, Goodman regrets having passed up a chance at the Belgian painter Luc Tuymans in the early 1990s, deciding that he was a pale epigone of Richter. She now agrees that Tuymans's tenderly brushed meditations on banal imagery take aspects of Richter's painting to a new plane.

Goodman could save money and gain vastly more visibility by relocating to Chelsea. She has looked into the possibility, she said, but, like some of her European artists, she is chary of that hive of spaces. (The bimonthly guide Chelseart lists more than two hundred galleries, over half of them clustered on four blocks.) "They all look alike. People forget which gallery they are in," she said. A quarter-century ago, she was almost alone among top gallerists in shunning SoHo, whose boomtown ways repelled her. "I saw dealers running after artists, then throwing them out and going on to the next. I was afraid it was contagious." Relatively isolated, her gallery is less a showplace than a base for managing artists' careers. "The most exciting thing for me is working on museum shows," she said. Helping the curators of such shows by facilitating arrangements with artists and collectors "makes me very happy." She ticked off a number that are in the works: Cattelan in London, Baumgarten in Dallas, Huyghe in Fort Worth, Orozco at the Hirshhorn in Washington, D.C., Penone at the Pompidou, and Baldessari, Dijkstra, and Kentridge with touring shows in Europe. McQueen has been in Iraq, photographing, as the official artist of the Imperial War Museum.

What would Goodman do if she weren't dealing? "Maybe teaching art somewhere, maybe in Mexico," she said. "But no. I wouldn't really. I'm a fighter. I would go down with my ship." Pause. "I hate endings. I will do absolutely anything to prevent them." In truth, Goodman without her gallery is as hard to imagine as a sea captain in Wyoming. "Gallerist" is the word she prefers for herself; she dislikes "dealer." What's the difference? She couldn't exactly say. Perhaps she, too, is spooked by the shadiness that clings to her profession. (On the subject of business ethics, I asked her about the practice of skirting sales taxes on cash transactions. "Never," she said. Pause. "I don't think dealers do that anymore." I said I thought that some did. She said, "I like to sleep at night.") But the French-sounding "gallerist" signals something else, as well: an old-fashioned cosmopolitan ethos, for which the Atlantic Ocean is a lake shared by aspirants to transnational culture. New York City used to symbolize that. It still does, chez Goodman.

February 2, 2004

VARIETIES OF MUSEUM EXPERIENCE

The new Pinakothek der Moderne in Munich is designed for looking at art. This makes it unusual among recent museums, in which the display of art often feels incidental to symbolic functions that churches and governmental buildings once fulfilled. Next door to the Alte and Neue Pinakotheks of Old Master and nineteenth-century art, this showcase for modern art completes one of the world's most remarkable museum complexes. It houses a pretty good painting collection, deepest in German Expressionists and Max Beckmann, and superb holdings of drawings, design, and architectural models. Designed by Stephan Braunfels, it is a bland concrete, steel, and glass shoebox on the outside and, on the inside, a dream of subtly proportioned, shadowless, sugar-white galleries which branch off an airy three-story rotunda. In its effulgent atmosphere, you may know for sure where walls are only by where the pictures hang. I gratefully watched colors combust in Kirchners and Noldes under translucent, all-skylight ceilings. (I'll never again think of Expressionist color as generally sour and arbitrary.) On an ordinary, rainy Tuesday in November, the place was thronged with people in festive spirits. The Moderne is a great success.

But then, many new museums win praise and crowds without demonstrating comparable solicitude for their contents. Museums have become hot spots, invested with cultural and civil passions that pay off in popularity. I don't know why this should be so, and I am not well placed to speculate. I'm an art lover. As a class, art lovers don't care much about museums. We go to them for the reason that Willie Sutton robbed banks: they have what we want. We appreciate decent light in tranquil rooms, but we will do without if the art is worthwhile. To ignore the distractions of a bad building or, for that matter, a good one—and I can see how the Moderne's luminous intensity, which casts every art work as an icon, might get on someone's nerves after a while—isn't too hard, if you try. We accept overdesigned spaces, jangling giftshops, rambunctious tour groups, patronizing curatorial wall texts, the babbling-brook mutter of Acoustiguides, and other evidence of marketing and educational policies whose target audience is not us. In the course of things, we do get to know lots of museums, each with its specific inflection of a general type.

The Moderne's excellence is all the more impressive in view of the kind of museum it is. "the civic," I call it. The civic museum represents not only a city's treasures but its prestige and self-image. Its defining ritual is the opening reception at which members of the local elite pride themselves on being up to date. The Moderne tells a story of modernity from a Munich perspective: cautious in its reverence for the past, bold as it approaches the present. A vast Andy Warhol "piss painting"—green

stains of urine on copper emulsion—presided over the museum's grand staircase when I was there, proclaiming unflappable cosmopolitanism. (The work is beautiful, as a bonus.) The sassy choice has special éclat in a city that is burdened, like no other, with monuments and memories of Nazism and a proverbial reputation for cultural conservatism. Civic museums understand that their decisions are always political. As a consequence, they are very apt to overdo pedagogy and social righteousness. (Think of New York's Whitney and the New Museum of Contemporary Art, which perennially do good more often than well.) The Moderne, with exacting connoisseurship and minimal explanatory material, bravely bets that people attend museums for a treat rather than a treatment, at least in Munich.

Other categories in my taxonomy of museums are "the encyclopedia," "the house," "the boutique," "the pavilion," "the laboratory," and—most controversial of late—"the destination," of which the archetype is Frank Lloyd Wright's Guggenheim in New York and the apotheosis is Frank Gehry's Guggenheim in Bilbao. Like many art lovers, I really adore only the encyclopedia (the Met, the Louvre) and the house (the Frick Collection, Frida Kahlo's home in Mexico City). The first is the Home Depot of the soul, with something to requite every mood. It is inexhaustible in a lifetime. The house museum personalizes art-love. It solves a chronic problem of museums: the Pantheon effect. The presence of a work in, say, the Met bespeaks cold, officious esteem for it. It can intimidate. To form a warm bond with the work takes willful concentration. In a house museum, affection rules. The art glows with what William Blake called "the lineaments of gratified desire." It's there because someone, in particular, particularly liked it.

The boutique museum restricts itself to some sharply defined field, idea, or taste. It needn't be small. MoMA is a mega-boutique while being encyclopedic within its range. (To a degree that its majesty makes an optional matter of noblesse oblige, it may also be civic.) It presents creative wares of the twentieth century as aspects of an epic narrative and a constant debate about modernity. Or so MoMA has done throughout its world-changing history. Its present temporary plant in Queens is a pocket destination dominated by a fun-filled lobby, bedizened with video projections. The shorthand name MoMA QNS (say it: "momakins") befits it as a hangout spot for cool rich kids. This makes sense. Such kids, who belong to a demographic wooed by cultural institutions everywhere, may grow up to be board members. But MoMA is sui generis, unrivaled by any other museum on Earth. The Tate Modern in London, which incidentally features the worst lighting and the most obtrusive curating of any museum I know, and the Pompidou in Paris, which despite recent improvements still feels like a convention center on the verge of a nervous breakdown, are overwhelmingly civic in character. Of course, they are great public successes, too.

A museum's true identity resides not in where it is lodged or how it is run but in its collection. The most common fault of museums, and not only new ones, is self-important design that belies middling contents: dazzling package, few cookies. Examples abound. To pick one, the San Francisco Museum of Modern Art's pleasant

collection comes as a severe anticlimax to its grandiose, infernally noisy lobby. Museum boards may find it unbearable to assess the weaknesses of their inventory when conceiving of a proper home for it. They pay for their momentary comfort with lasting embarrassment. The quality of any boutique museum, in particular, depends on an exact or understated match of how it looks with what it shows. America boasts some brilliant ones. Louis Kahn's Kimbell in Fort Worth and Renzo Piano's Menil in Houston are close to perfect, and the Norton Simon in Pasadena demonstrates the happy surprise of encountering great art in an oddball building. Two recently opened small boutiques in New York are triumphant: the American Folk Art Museum, an astute jewel box, and the Neue Galerie, a scholarly salon with the charm of a house museum. It can be done.

The pavilion and the laboratory are variants of the boutique. The first is symbiotic with a park setting, rhyming art and nature. I think of the rambling modern-art Louisiana outside Copenhagen, on a grassy cliff with a view of Sweden, across the sea, and also of the elegant Beyeler in Basel, where I recently saw a Monet show that remains confused in my memory with real flowers, water, and breezes. The laboratory museum is often attached to a university. The Fogg, at Harvard, offers some great paintings, but it's tough for visitors, in the tweedy ambience, to shake a sense that they are looking at gym equipment for pumping up art historians. The Wexner Center for the Arts in Columbus, Ohio, by the cerebral Peter Eisenman, is a laboratory as destination: a deconstructivist folly with uniformly weird, essentially art-proof spaces throughout. You must see it to believe it. Experimental by definition, museums of contemporary art often advertise their provisional character by occupying abandoned industrial structures. The model is still Gehry's consummate 1983 renovation of a warehouse and garage in Los Angeles. Originally dubbed the Temporary Contemporary (it is now, officially, the Geffen Contemporary), it has become a permanent annex of the inveterately civic Museum of Contemporary Art.

The destination museum—part cathedral, part tourist trap, altogether an art work in itself—crowns our globalist era of competing polities and economies. It can be a fine thing, especially when done by Gehry. Usually architecture lags a generation behind ideas in art. ("Art is fast and cheap; architecture is slow and expensive," a friend of mine likes to point out.) The revolutionary Bilbao Guggenheim leaps ahead, making even a first-rate, colossal sculpture by Richard Serra seem old-hat. Contrary to some observers, I feel that the building incorporates spaces that serve traditional art works quite well. But that is scarcely the point for an institution with a scrappy collection and the mission of putting a poky city on the map (which it has accomplished). The place is a joy. So is Wright's Guggenheim, whose design happens to be more hostile to art works than that of perhaps any other museum built before the Wexner. It makes no sense to begrudge such a marvel. It does make sense, in a hard case like Bilbao's, to let a major architect shoot the works on a museum. What's the worst that can happen? (Nobody has to live there.) At best, the result will be a tour de force that makes the world more interesting.

In a city like Munich, which is already more than sufficiently a destination for art, architectural adventures are unnecessary. The Pinakothek der Moderne shrewdly and sensitively accepts being one piece of an ensemble, limiting itself to showing modern art in a modern way. Its "white box" galleries conform to a convention which, for the last half-century, has been the default mode of a civilization that lost any way to integrate art into the world architecturally, decoratively, or spiritually. No one is happy with this situation, I think. Who wouldn't welcome a grand, potently symbolic reintegration—a new Baroque? Gehry's infectious originality is a step in that direction, as are works by today's better installation artists. Meanwhile, we have in the Moderne the acme of the all-white museum, which exalts twentieth-century art's ambitions to be autonomous and transcendent. Artists of our time can only dream of a museum, necessarily different, that one day will ratify their ideals with such percipient flair.

January 13, 2003

I met the confounding genius **Sigmar Polke** at the 1986 Venice Biennale, where the opening of the German pavilion, with a show of colossal paintings by him, was a paparazzi-freaked mob scene. Normally reclusive, the chubby, elfin artist had made an exception for the event. He wore a vast Hawaiian shirt and green satin trousers, and shouldered a massive movie camera, which he whirred at everyone who tried to photograph him. That must be an amusing film—if the camera was loaded. When we were introduced, Polke acknowledged an essay in which I had written of "primordial fear" as an aspect of his art. But no sooner was he cordial than his cordiality (to an art critic!) palpably galled him. Making like a bug-eyed maniac, he thrust his face in mine. "Are you really ... *frigh-tened?*" he roared. As he spun away—back into a party that, in retrospect, seems to me the climax of the 1980s painting craze—I was already cherishing my memory of the moment. I haven't seen Polke since, but he is regularly in my thoughts about contemporary art. Fifty-seven years old, he lives in Cologne, from where he has sent the tricky, gorgeous new paintings, in synthetic resin on polyester, that, at the Michael Werner Gallery, constitute his first substantial New York show since a retrospective at the Brooklyn Museum in 1991. Though nothing here is terribly novel for him, the show finds the artist in peak form: wild and canny, rapturous and sardonic, unstoppable.

In a scorekeeping mood, one could easily argue that Polke and his countryman Gerhard Richter (known for varieties of Photo-Realist and abstract work) are the most important painters of the past three decades. With Anselm Kiefer, Georg Baselitz, and a host of piquant minor figures, they belong to a German painting culture that has often outshone its American equivalent during this period. Not that the comparison is widely made: ignorance, due partly to patriotic chagrin, still dogs our reception of this particular German miracle. In 1963, at the height of the New York art world's imperial afflatus, Polke and Richter, in Düsseldorf, helped hatch an obscure mini-movement in response to American Pop art. They dubbed it Capitalist Realism. Both were from East Germany and both were affected by the ex-Luftwaffe pilot Joseph Beuys's radical shamanism—a holy foolishness laced with postwar sackcloth and ashes. Before parting ways in accord with their drastically opposed temperaments, they painted sibling sorts of acridly funny, obdurately mysterious pictures based on media-derived photography and design. Almost no New Yorker knew of their work until 1980 or so, when it emerged as a decisive influence on the brash painting revival called Neo-Expressionism. Painting had seemed at a dead end here since the intimidating coups of Andy Warhol and Minimalism—gold Marilyns, monochrome geometries—in the 1960s. In Germany, Polke and Richter had turned

the apparent cul-de-sac to sensational account, making painting's alleged death an ironic theme of revelatory works.

Since the mid-1960s, Polke and Richter have been, in truth, what Robert Rauschenberg and Jasper Johns have been, in fond American ascription: the antic brawn and the majestic brain of late twentieth-century pictorial imagination. Leading New York Neo-Expressionists, including Julian Schnabel and David Salle, recycled the Germans' double-jointed—at once sarcastic and Romantic—spirit. Polke and Richter wrested avant-gardist initiative in painting from a too long complacent New York. They did so with audacity that was uniquely possible in Germany's art culture, whose archaic spiritual investment in the artist as prophet, wizard, jester, and/or sacred monster was still intact. The tradition took on special intensity in the 1960s, with a surge of national confidence. From the blandly professionalized precincts of American art, that magical, folkish bent looks enviable, albeit nerve-racking. (It does not conduce to wonderful politics.) From the start, Polke played it like a piano. He attacked painting as if he meant to trash it. He painted on tacky, non-canvas fabrics—printed tablecloths, for instance—with a witches' brew of non-paint chemicals. He used a graffiti-like method of overlaid line drawing, taken from Francis Picabia—modern art's No. 1 bad boy, whose lately resurrected reputation owes a lot to Polke's emulation of him. Polke's imagery came from sleazy cartoons, science fiction, psychedelia, and hippie mysticism.

"Higher powers command: paint the upper right corner black!" reads the inscription on a 1969 canvas whose upper-right corner is painted black. A painting from 1968, captioned *Modern Art*, offers insouciant swatches of geometry, squiggles, and a splash of flung paint: one-stop shopping for a century's worth of styles. Polke's view of art could seem Olympian and scabrous, part apotheosis and part giggling fit. He kept making messes in the studio, and the art of painting kept gloriously rising from them, phoenix fashion. In the main room at the Werner Gallery are fourteen paintings, measuring four by five feet, that glisten with orangeish, lacquer-like stuff. Three more, of the same size, hang in the gallery's office. As often with Polke, the series has an air of being a calculated, cash-and-carry product line. But then so does a lot of Monet: whatever motivates a master to produce is a boon to everybody. The paintings are essentially abstract, but they don't feel abstract. They feature, besides passages of figurative drawing, a real-world aura that points to their sources in commercially printed photography and illustration. The works' subject, Polke says, is printing errors: tiny glitches in photographic reproduction gleaned from newspapers and magnified to surreal effect. It is typical of this mystagogic artist to treat chance industrial goofs as if they were tea-leaf oracles.

When Polke's resinous medium is applied thinly, it turns its polyester ground transparent, like greasy paper. Marks may show through from the back, and shadows of marks may be visible on the wall. Some fabrics are iridescent. Many look webbed with chicken wire—actually, gold-string mesh. Vaporous beauty dances, in a viewer's eye, with tawdry glitz. The designs are grid-happy. The anarchic Polke dotes on

symbols of order in the way that outlaws owe their identity to laws. Besides the mesh, there are painted patterns of Benday dots and raster (the substructure of TV and digital imaging). The show invites degrees of scrutiny ranging from closeup to microscopic. One painting bears an overlay drawing of carbon molecules ("Life's building blocks," science writers never fail to remark). Another presents the image of a strolling man who is, appropriately, a dwarf.

Polke's surfaces glow, variously, like stained glass, hard candy, or flesh. You keep trying to decide what you're looking at. Something sacred can seem entangled with something devilish, as in *Break Domination*, which contains an image, blown up from a medieval manuscript, of a creature that's part human, part animal, and part vegetable. Religious transport seesaws with lowdown hilarity. That's where the primordial fear comes in. Imagine retreating to the inner sanctum of your aloneness—the twilit fundament of self-consciousness beneath coherent thought and feeling—and suddenly hearing a cackle of not very amicable laughter in your ear. Hello, Herr Polke. Some other artists perform such spiritual breaking and entering. I think of Goya, and so does Polke, who elsewhere has adapted notably sinister Goya motifs. Now imagine a contemporary Goya wielding tropes of Dada and Pop, with the attitude of a mean clown. In Polke's work, outlandish fancy hits with the force of fact.

December 7, 1998

FAIRFIELD PORTER

Fairfield Porter, the realist painter, art critic, and heroic eccentric, who died in 1975 at the age of sixty-eight, will be acknowledged as a major twentieth-century artist when we can figure out how. It's a tall order. To start with, there is the problem of who "we" is. Sheltering under the pronoun would have to be both archconservatives such as the critic Hilton Kramer, who has long wielded the cause of Porter as a battle flag against pretty much all contemporary taste in art, and more bohemian types, like the members of the New York School of poets, who were Porter's friends, inspirations, and, sometimes, lovers. These mismatched parties have set the public tone for Porter fandom so far. Our institutional and academic establishments hardly know what to do with this painter of summer landscapes and domestic idylls, and so have regularly done nothing. As for a public that might be expected to enjoy beautiful realism, it isn't apt to relish the serious aestheticism—valuing an image's execution over the image itself—which Porter shared with his hero and friend Willem de Kooning. Porter was no populist.

This leaves me and you, unprejudiced reader, to cope with a succinct exhibition, at the Equitable Tower's AXA Gallery, of more than forty mostly first-rate Porter paintings, accompanied by rich documentary and explanatory material. The show was curated by the writer Justin Spring, whose unsparing new biography, *Fairfield Porter: A Life in Art*, demonstrates that this artist was, at the very least, one of the great American characters, a patrician Midwesterner who was devoted to simple joys with the bedevilled intensity of an inward pilgrim in a nineteenth-century Russian novel. (Among his earliest works are illustrations of Dostoyevsky's *The Possessed*.) Spring's biography complements an even more important book, which was published in 1979 and is still available in paperback. *Art in Its Own Terms: Selected Criticism, 1935–1975*, edited by Rackstraw Downes, installs Porter, who wrote for *Art News* and *The Nation*, among the best art critics of any nationality. Like his painting, Porter's criticism improbably mingles French-flavored hedonism and Yankee starch. Here's a sample: "It may be that to separate pleasure from an object is too hard a thing to do, and that abstract pleasure, like abstract taste or abstract love, is not for ordinary mortals." For Porter, the ordinary was an urgent ideal.

Porter was born real-estate rich in a suburb of Chicago to a family that had deep roots in New England. His gloomy father was a frustrated architect, his dazzling mother a lifelong amateur in social causes and cultural uplift. He was an indifferent student at Harvard, where he took art history with Arthur Pope and philosophy with Alfred North Whitehead. In 1927, he travelled to Moscow, where he had his first

exposure to the paintings of Vuillard and Bonnard, and an audience with Leon Trotsky, who allowed Porter to sketch him. A few years later, in Italy, he was welcomed to I Tatti by Bernard Berenson, to whom he had been introduced by another wealthy young Harvard man, the budding curator John Walker. Settling in New York, he became embroiled in radical politics and painted a mural, now lost, entitled *Turn Imperialist War Into Civil War*. He married the necessarily resilient Anne Channing—a poet and, in the amused words of Porter's mother, "a nymph in the drawing room"—with whom he had five children. From 1949 on, they maintained warmly dishevelled households in Southampton and, during the summer, on an island in Maine. After the Second World War, which Porter spent working as a draftsman for an industrial designer, he became an odd but accepted presence in the art culture that centered on Abstract Expressionism.

I visited the Porters more than once at their rambling old Southampton house. People dropped in frequently, and one of them, the seraphically gifted and mentally shaky poet James Schuyler, stayed on for twelve years. Porter was a gawky, boyishly eager man, forever wrestling with his work and his latest ideas—which, at the time, involved views on the rational superiority of artistic over scientific perceptions of reality. He had no small talk. His abrupt intimacies could take one aback. A favorite topic was his ongoing quarrel about religion with Anne, a Catholic convert. But I wouldn't have minded lingering indefinitely in that vibrant ménage. In Porter's studio I observed the progress of a large, not very successful painting of a lawn party, *July* (1971), that is in the Equitable show. He complained about the trouble he was having with it. "I'm so clumsy!" he moaned. In truth, big pictures had to be an ordeal for him, because he composed with locally intense colors and tonal modulations rather than with an over-all linear design. In "July," the task of making the brightness of the foreground and the sky interact across expanses of huge, dark spruce trees posed an almost masochistic challenge. One desperate expedient— a faint fog of atmospheric light dragged across the spruces—makes me smile today, as I recall a painter of leisure for whom nearly nothing came easily.

But smallish landscapes and still lifes often did come readily amid Porter's struggles, as light lifting will to one who has been hefting boulders. I got the impression that he was a bit ashamed of the fluent, startling loveliness of his seafront meadows and his tabletop flowers and breakfast dishes, but they remain amazing stylistic feats. Nothing else in previous art truly resembles them, despite their thousands of cousins in a French line going back through Matisse and Bonnard to Watteau and Chardin. Porter reinvented conventional genres in two keys simultaneously: realist and, for lack of a better word, performative. He subjected the decayed legacy of Post-Impressionist color harmonies to corrective discipline, making it deliver hard information on observed light and shadow. At the same time, learning from de Kooning, he re-centered painting in the freighted, purposeful stroke—a gesture that can unclench color, tone, contour, speed, and, in short, everything needful at once. Porter was no conservative in style but, rather, the advanced proponent of a tradition

that, except for him, scarcely existed any longer. It was as if he lived in an alternate world with an alternate history—which, defiantly, he really did.

Porter preached the crackpot theory that modern painting had taken a disastrous turn when, led by the Cubists, it opted for the cerebral implications of Cézanne's anxious, fragmentary manner over Vuillard and Bonnard's passionate absorption in visual realities of daily life. What made the idea weird was Porter's apparent belief that he could simply ignore that unfortunate revolution, as one might smooth over a friend's gaffe at a party. He chose to proceed as if the bourgeois intimists—not Picasso and Mondrian—were the dominant figures of the recent past, the ones to be followed and surpassed. His table-turning logic smacked of Marxist dialectics—like the far more influential but also arbitrary system of his ideological enemy, the critic Clement Greenberg. Think of this when you look at Porter's paintings: there is mad, glinting intellectual steel beneath the empirical, sensuous painterly flesh. A stern beauty results. If, in the work's presence, you try to argue its conviction down, you will have your own eyes and heart as antagonists. I predict that, via Porter, a bizarre sense of inhabiting a parallel or shadow twentieth century will appeal to more and more people as time goes by.

It is an interesting stretch, certainly, to conceive of Porter's magnificent *The Mirror* as a landmark painting of 1966, when Pop art and Minimalism ruled the art world and all hell had broken loose in society at large. Be it noted that Porter stayed leftist in politics and, as a critic, wrote signal appreciations of Roy Lichtenstein and Jasper Johns and, in conversation, spoke admiringly of Brice Marden. Never reactionary, Porter insisted only on negotiating the world of chaotic change in his own way. A homage to Velázquez that transcends pastiche, *The Mirror* poses Porter's young daughter Elizabeth before a mirror that reflects himself with brush in hand and, outside the studio window, a white house and an autumnal tree. Polarized tones and dominant blacks, reds, and yellows—recalling Porter's remark, in one of his reviews, "The German flag colors seem to have crept into everything painted around 1914"—give heraldic punch to a gentle vignette. The girl's eyes are a miracle. Porter often had difficulty with eyes (as he did with people), either exasperatedly blurring them or unwisely presuming to render their gaze. (Pure paint, which is his pictorial medium, is not an element that anyone can credibly peer out from.) Caught between outward and inward contemplation, Elizabeth's eyes merge with the painted surface. Their non-expression anchors her in the painting—and anchors the painting in Porter's capacious and complicated sense of life.

April 17, 2000

"**R**embrandt's Journey: Painter, Draftsman, Etcher," at the Museum of Fine Arts in Boston, is a large exhibition of mostly tiny pictures—about a hundred and fifty prints interspersed with thirty-five drawings and twenty-three paintings, only one of which warrants being called a masterpiece: a 1659 self-portrait, from the National Gallery of Art in Washington, D.C., in which the fifty-three-year-old painter appears both care-worn and radiantly alive. But a Rembrandt show is a Rembrandt show: a chance to revel anew in the genius of perhaps the most interesting or, to be exact, the most interestingly interested visual artist who ever lived. His talent and skill seem limitless, but we are never solicited and are rarely even permitted to stand back and admire them. They are always busily employed in getting to the bottom of something. It might be the quirk of a portrait sitter, the comic or tragic irony in a drama, or the depth charge of a religious subject. Rembrandt is a detective. When I look at his pictures, I feel like Dr. Watson bumbling along behind Holmes. Once exposed by the master, mysteries become as plain as day, but I know that, on my own, I would have missed the clues ten times out of ten.

A mystery for Rembrandt may take the simple form of what something that he has not experienced is like. What is it like to commit murder? In a swift sketch with brown ink, Cain kneels on his supine, terrified brother, whose barely indicated face is eerily specific, like that of someone you dimly remember. The athletic killer parts Abel's defending hands with one arm and raises a jawbone with the other. Rembrandt has thickened the contour of the weapon, giving it the right weight to crush a skull at one blow. The drawing establishes that murder requires concentration, a sure method, and sudden energy, and that it hurts. Of course, this isn't just any homicide. It's the first—a cosmic disaster. Faintly limned in the sky, God rests his chin on one hand and observes the event with sombre detachment. Did this image strike Rembrandt as a bit fey? He added a balancing note of horror: a dog eats the remains of an animal that Abel has sacrificed on an altar. Looking at the drawing, you reconstruct the artist's thought and share his satisfaction. If you're like me, you also tremble a little. Rembrandt's courage daunts.

"In selecting the works there has been a special emphasis on Rembrandt the storyteller," the show's head curator, Clifford S. Ackley, writes in the catalogue. It is a welcome stress, aimed at a lingering blind spot in modern taste. Pejorative senses of "illustration" (the qualifier "mere" goes without saying) and the "literary" have embarrassed overeducated viewers of Rembrandt for a century. Like low-down realism—the other pole of the Dutchman's magnet—poetic narrative is close to anathema in most modern theories of art. Great artists who have embraced it—

Edvard Munch, Edward Hopper, Picasso in his Rembrandt-influenced etchings—suffer the peculiar fate of being well loved and poorly explicated. Modern art criticism long ago lost the tools of participatory imagination that, today, belong chiefly to movie critics. Was Rembrandt's art the movies of its day? You may say so if you're careful to add that it also performed functions of photography, fiction, theater, theology, and social anthropology—all with an individualism that engendered continual audacities of technique and style. (Often, you know that a Rembrandt is finished only because, at a certain unruly-looking stage, he signed it.) His was a sensibility new in history, born of the freedoms and appetites of a triumphant bourgeoisie. Twentieth-century types for whom "bourgeois" was a curse had a problem with that. In a real and delightful way, this most famous of artists remains to be discovered in the manner that he palpably anticipated—picture by picture, one viewer at a time.

Rembrandt is in the details. The quality for which he is inevitably praised, "humanity," is too nebulous. "Personality" is more like it. Intimate with both subject and viewer, he dissolves emotional distances. The only halfway boring character in his art is Jesus, who does seem to represent humanity in general for him. What interests Rembrandt in works about Jesus is how other people react to the god-man. The apocalyptic drypoint *Christ Crucified Between Two Thieves* (1653), seen in three versions in the show, conveys Rembrandt's wondering sense of Christianity: the sacrifice of Jesus dropped like a bomb into history, blowing everything askew. In several pictures, he envisions Jesus dead—for example, the limp, heavy body being lowered, with difficulty, from the Cross. Corpses are inconvenient objects. The sight of this one tests belief. Did Rembrandt believe? I think so, but it seems to be the enigma—the fantastic, sheer improbability—of Christ that excited him.

Rembrandt was happiest illustrating the Old Testament, where God is less abstract than in the New. In the print *Abraham's Sacrifice* (1655), an angel grabs Abraham from behind as he is about to slit Isaac's throat. Imagine agreeing to kill your child. The thought scalds. A writer in the show's catalogue decides that Abraham "with a compassionate, protective gesture masks his son's eyes from the sight of the knife." I doubt this. Surely the patriarch is shielding himself from those eyes. Now imagine being tackled in the act. Abraham's face is wild with scarcely nameable emotions, including astonishment at being physically overwhelmed by a youthful androgyne. Abraham is a powerful man. The delicate angel, infinitely stronger, supports as well as restrains him; Abraham may be about to faint. Piling on dramatic detail, Rembrandt renders the landscape of a mountain gorge, the prow of a moored boat, people unconcernedly strolling in the distance, a basin placed to receive Isaac's blood, a ram that God has provided for a substitute sacrifice—all organized pictorially by a diagonal shaft of light from Heaven. The three main figures form a monumental group in echoing, vast space. The print is six inches high.

The show is arranged by genre: landscape, portrait, self-portrait (often in costume and assumed character, like a seventeenth-century Cindy Sherman), and so on. You will want to hear about the naughty bits: Rembrandt's erotica. In each of two

prints from 1646, a man goes at it between the raised knees of a woman who grasps and pulls at his hips. One is a monk who has tossed aside his prayer book for the sake of a farm girl in a cornfield, while an oblivious harvester toils in the background. The monk digs his knuckles into the ground for leverage. In the second print, another man, identically posed, is in bed with a contentedly smiling woman who, for some reason, has three arms (one lies at her side, unengaged in the action). He has parked his feathered hat on a bedpost, suggesting that this tryst is a noonsie. In another, truly spicy work, the aging, satyr-like Jupiter uncovers the sleeping (and almost audibly snoring) Antiope with the unmistakable expression of a connoisseur sniffing a superb wine. The picture, at once refined and gross to a fare-thee-well, is explosively funny.

In saying that Rembrandt's storytelling has been discounted by modern taste, I don't mean that the revered Old Master is controversial, only that he should be. After a century in which our cravings for narrative were attenuated if not shamed in high art, his work has a fresh, even radical sparkle. I came out of the Boston show thinking, in effect, Let's have some more like that. The closest our culture comes is in serious cartooning and, of course, the movies. Art can't rival those vocations for popular impact. But I think that we are already seeing a shift of emphasis in art away from precious self-contemplation and toward eloquent engagement with the world. The means may not be painting. (Just a glance at a Rembrandt may ruin a painter's day.) Video installations by the likes of Pipilotti Rist and Eija-Liisa Ahtila demonstrate the right stuff. It's a question of spirit, not medium. The more alert we are to life in the here and now, the more contemporary Rembrandt feels. He draws us on.

November 10, 2003

GERHARD RICHTER

The German painter Gerhard Richter, who is the subject of a magnificent retrospective at MoMA, is famous for severity, hermeticism, and all-around, intimidating difficulty. His range of styles—from Pop to Minimalist to Photo-Realist and several varieties of abstract—has seemed perversely promiscuous, as if he were heaping obloquy on the very idea of style. An old friend of the artist, the prominent critic Benjamin H. D. Buchloh, used to insist that Richter's work was a calculated demonstration of painting's bankruptcy as a viable art. (In a celebrated interview with Buchloh, Richter flatly rejected this notion.) Even longtime admirers of Richter's work, including me, have more or less assumed that it speaks to arcane, insider concerns and tastes. But what do you know? Surveyed in depth for the first time in the United States, his forty-year career comes off as a rolling hosanna of piquant, good, and great paintings, with something for everyone.

Richter is a philosophical artist, not a philosopher of art. That's the verdict of the show, which has been brilliantly installed by the artist and Robert Storr, a senior curator in MoMA's Department of Painting and Sculpture. Richter has taken on the big critical issues in painting since the 1960s. He has seemed close at times to the position of theorists who argue that technological advances and deconstructive analysis render the old medium obsolete. And Richter's ways of working—they include making oil copies of banal photographs and creating abstractions with a swiftly wielded squeegee—might seem like anti-painting when you think about them. But trying to think at this show is like trying to play three-dimensional chess while drunk. One work after another attains a sublimely pleasurable stillness and silence.

Why has Richter played so many games? Judging from the evidence at MoMA, his aim is to elude the tyranny of any one game, be it conservative or radical. He will not be pinned down. Art is his means of awakening from the nightmare of history, which is a strategy common to Germans of his generation. Seen together, the tactics of his many phases—including excursions into muddy monochromes and austere color charts—cancel each other out; a troubled but passionate will to paint shines through. The show made me wonder why I ever regarded Richter as cold. His stuff aches with emotion, both personal and political, including rage and sorrow at the toll inflicted by a century of disastrous ideologies.

Richter was born in Dresden in 1932. His father, a schoolteacher and a member of the Nazi Party, served in the war. So did two of his uncles, both of whom were killed. Richter, inevitably, joined the Hitler-Jugend. The military glamour excited him, but he hated the company. "I always knew I was something better," he told Storr in an interview. He traces that sense of himself to his mother,

a concert pianist's daughter, who, he said, "always kept me close to 'culture,' to Nietzsche, Goethe and Wagner." In 1946, his father returned from an American P.O.W. camp to, as Richter put it, "most fathers' fate at the time: nobody wanted them." Themes of lost or dishonored fathers recur in his art, most spectacularly in a gloomy suite of forty-eight grisaille paintings (1971–72) of older male culture heroes, among them Puccini, William James, Max Planck, and Franz Kafka. In the 1960s, Richter unnerved his countrymen with paintings of American and British warplanes. One painting shows his doomed Uncle Rudi in Wehrmacht uniform; in another his father looks pathetically buffoonish. Turning to more recent history, he lit the fuse of a furious controversy with a fifteen-canvas history painting, *October 18, 1977*, about the Baader-Meinhof group of terrorists, whose deaths in prison (surely by suicide, though conspiracy theories linger) climaxed a purgatorial decade in Germany. I've seen that adamantine masterpiece many times over the years, and I've given up trying to fathom its message, if it has one. I only know that it hits me harder every time.

One of Richter's first jobs, in 1950, was in an East German workshop for propaganda, where he cleaned slogans off political banners to prepare them for updated exhortations. He soon became a successful mural painter in the prescribed mode of Socialist Realism. On trips to the West, he was exposed to works by Jackson Pollock, Lucio Fontana, and other innovative artists, which opened a new world to him. In 1961, before the Wall went up, he escaped to West Berlin with his wife, Ema Eufinger. At the Art Academy in Düsseldorf, he met Joseph Beuys and encountered fellow East German refugees, notably the volcanically creative Sigmar Polke. Richter and Polke later went their separate ways, but for a while they formed one of the great duos in modern art. Inspired by Andy Warhol and Roy Lichtenstein, they conceived a mordant German variant of Pop art, which they called Capitalist Realism. For Richter, it involved hand-copying photographs from sensational tabloids, advertisements, pornography, and family snapshots—and "unpainting" them by smearing the wet oils. Now and then, he was moved to do something of surprising loveliness, such as the golden blur of a nude Ema descending a staircase.

One of the first paintings in the show is a work from 1963 entitled *Stag*. Hazy gray, dragged strokes describe the antlered beast. A surrounding thicket is all perfunctory black lines. A flat vertical band—a tree trunk—cuts across the stag's body, contradicting depth illusions. (The animal stands behind the tree, but the tree reads visually as background.) Phlegmatic and drab, the work is not alluring; nonetheless, its air of tense deliberation gets under a viewer's skin. Does *Stag* endorse or mock its subject, which is a well-worn sentimental symbol in Germany? Both and neither is my guess. At MoMA, I found it useful to keep the riven stag in mind as a spiritual self-portrait and touchstone of the artist. Richter has a homing instinct for rifts of many kinds. I think he will go down in history for having resolved the conflict between representation and abstraction in painting. By alternating idealist figurative works and matter-of-fact abstractions, he asserts convincingly that they

amount to the same thing: a painting is a painting. For Richter, abstraction is simply a late entry in the inventory of genres—history painting, portraiture, still life, landscape—all of which he has made his own.

But Richter's art is never showoffy—not even when he comes close to fulfilling his desire to paint like Vermeer, as he does in some tender pictures of his third wife, Sabine Moritz, and their baby son. *Betty*, a Vermeer-esque painting from 1988 of a daughter from his first marriage, in which she is turned away from the viewer toward a monochrome canvas, seems to me the single sharpest blow struck in recent art-world debates about the virtues of aesthetic pleasure. It is a one-punch knockout for a revival of beauty. Richter makes no bones about his inability to match his own artistic ideals. "Unfortunately I am not a virtuoso at all," he said to Storr. But he added, "I have some taste." He sure does. His art keenly laments both the shattered tradition of the Old Masters—for example, a befogged, ravishing copy of an Annunciation by Titian—and the radicalism of the great modern shatterers, such as Duchamp and Warhol, who can no longer be emulated except academically. For Richter, honest ambition in painting must now be accompanied by elegiac admissions of loss: fragments shored against a ruin. The sheer quantity of work in the show has a striking effect on his art's despairing fits and starts. Without cohering, the fragments begin to sketch a state of abounding joy.

March 4, 2002

I grew up in small towns in the 1940s and 1950s, and I remember the power of *Saturday Evening Post* covers by Norman Rockwell. Extracted from the mailbox, they went off in one's hands like charm bombs. I would look and look, absorbing a surfeit of meaning that was sweet beyond measure. The sweetness lingers. The meaning, I am interested to note, didn't take. None of the hundreds of Rockwell images that appear in "Norman Rockwell: Pictures for the American People," at the High Museum of Art in Atlanta, rings a childhood bell with me. I conclude that Rockwell's visual fictions, while distinct features of my early experience, simply never linked up with whatever else mattered to me. The only thing that is surely Rockwellian about my recollections of Christine, North Dakota, and Farmington, Minnesota—where, if you must know, I fished in creeks, played baseball, and all that—is Norman Rockwell.

There you have the basic anatomy of my ambivalence on the occasion of a Rockwell revival that shows signs of getting completely out of control. After closing in Atlanta, the retrospective will travel to Chicago, Washington, D.C., San Diego, Phoenix, and Stockbridge, Massachusetts (home of the Norman Rockwell Museum), before opening at the Guggenheim in New York. Rockwell at the Guggenheim? Rockwell in sophisticated glory? Professionally, I am happy to endorse the notion, which seems ever less absurd as time goes on. Rockwell is some kind of great artist. To say what kind is difficult, because our art culture, which keeps score on these matters, has long tended to the view that Rockwell isn't an artist at all. This is no mere adjustment of a reputation but a shift in how we identify and value visual art.

Rockwell's greatness is of a type that hides in plain sight. He is far more subtle an artist than may have been suspected by his tens of millions of fans, whose admiration for him has scarcely abated since his death, in 1978. (Nobody doesn't know Rockwell. According to a teacher friend of mine, this goes for today's art students who are vague about Henri Matisse.) Rockwell is more of an artist than he himself ever ventured to claim, such was his ache for simple acceptance. He embraced the term "illustrator," despite the fact that nearly all his pictures are sui generis—made up from scratch. Steeped in the history and rhetoric of Western painting, he was a visual storyteller of genius. More than that, he was a story-maker, a bard. He didn't illustrate Middle America. He invented Middle America.

Born in 1894, Rockwell was a Manhattan kid, the son of an office worker. He loved it when his father read Dickens aloud at the dining-room table. "I would ... draw pictures of the different characters," Rockwell wrote in *My Adventures as an Illustrator*, his 1960 autobiography. "Mr. Pickwick, Oliver

Twist, Uriah Heep. They were pretty crude pictures, but I was very deeply impressed and moved by Dickens.... The variety, sadness, horror, happiness, treachery, the twists and turns of life; the sharp impressions of dirt, food, inns, horses, streets; and people ... shocked and delighted me. So that, I thought, is what the world is really like." This last sentence stuns a bit. It also illuminates. What the world would always be "really like" for Rockwell was, in a word, entertaining. He came equipped in his soul to join the American entertainment industry, which, amid the tumultuous dislocations of the early twentieth century, took on the role of providing a hopelessly inchoate democracy with ad hoc myths of nationhood.

By the age of twenty-two, after art school and a job as art editor of the Boy Scout magazine *Boys' Life*, Rockwell was doing *Saturday Evening Post* covers under the brilliantly canny editor George Horace Lorimer. Rockwell lived in New Rochelle, from 1915 to 1939, then in Arlington, Vermont, and, finally, from 1953 on, in Stockbridge. He was married three times—always to a schoolteacher. He worked compulsively, seven days a week, including holidays. In his commercial trench, he pined intermittently for the heights of fine art. Between 1931 and 1932, he moved with his family to Paris, seeking invigoration. It was a wash, and he soon returned home. But he never ceased to revere Picasso—"the greatest," he said. At heart, he was as liberal in his aesthetics as he was in his politics. (He was a Roosevelt and, later, a Kennedy man; and he became a timely and effective propagandist for the civil-rights movement.) His *The Connoisseur*, of 1962, in which an old-fashioned gent confronts a credibly caricatured Jackson Pollock painting, expresses Rockwell's perplexed admiration for an avant-garde that he seemed never to resent for scorning him.

I can think of good reasons to despair of Rockwell's art, but, first, certain bad reasons must be knocked down. Cosmopolitan artists and intellectuals of the 1930s— the seedtime of the postwar art world—feared and despised the juggernaut of American mass culture, which they too readily associated with the contemporaneous machinations of totalitarian states. Populism equalled Fascism or Sovietism, and that was that. But American populism has always differed in political character from its European counterparts. It celebrates the individual, steering closer to condoned anarchy than to forced solidarity. The critic Dave Hickey, in an essay for the show's catalogue, terms Rockwell's feat "democratic history painting"—that is, he invests "the everyday activities of ordinary people with a sense of historical consequence." Rockwell is sentimental, but his ruling sentiments are far from trivial. Most of them play variations on the theme of tolerance.

In nearly every Rockwell, someone is discovered to be at odds with something. Take *Saying Grace*, a November, 1951, *Post* cover that pictures a countrified old woman and little boy praying in a train-station restaurant under the eyes of working-class hard cases. The watchers, not the watched, star in the mild drama. Their domain has been invaded. They are variously bemused, but it does not occur to them to react overtly. Their restraint ennobles them. The travellers' piety is safe in

a profane joint, secured by the democratic imperative to make space for difference. It would be unlike Rockwell, in any case, to go gooey over religiosity (except when he was doing commissioned illustrations of F.D.R.'s "Four Freedoms," and the theme of "Worship" forced him to it). He was thoroughly secular. If he suggests any classic American type himself, it is the waggishly atheist country doctor or newspaper editor, a Mark Twain-like observer of human folly who is continually saved from cynicism by a tender heart. In picture after picture, Rockwell enacts a skeptic's escape from the sin of contempt.

Rockwell painted three hundred and twenty-two *Post* covers, arrayed at the midpoint of a show that includes dozens of the original paintings, along with examples of his work for other employers, including Jell-O and Ford. He improved with time. My walking survey of the massed covers—many of them bearing yellowed mailing labels addressed to ancient subscribers—was brisk at first, undetained by jokey conceits in a monotonous graphic layout that incorporated the magazine's logo. My pace slowed as I reached the late 1930s, when Rockwell was freed from that format, and his work began to exude a certain gravitas in key with a darkening era. Coming at last to a long stop, I found myself gazing at *The Homecoming* (1945), one of the artist's rare urban images. A populous explosion of joy on a tenement porch greets a young returning soldier. Mother spreads her arms. Little brother and dog set out for the veteran at a dead run. His probable future sweetheart hangs back shyly. Neighbor kids pop out of windows and shinny down a tree. A workman turns from roof repairs that, from the look of things, are long overdue.

Small and alone, the soldier stands in the building's bleak yard with his back to us. As is often the case with Rockwell, the putative protagonist of the story is the object of the picture's action. We enter the scene by way of the young man's possible feelings, which may be laced with the incommunicable scars of war. In a window appears the embroidered blue star indicating that a household had a man in the service. (I recognized it because I possess one that hung in vigil for my father, whose own 1945 homecoming is among my earliest memories.) The Second World War did a great deal to—and for—America and thus, by organic extension, to and for Rockwell. It took some of the silliness out of his optimism. After the war, his images of community—the social form of love—took on poignance as scenes of precarious comfort. But his congenital, at times daunting, good cheer never really faltered.

Like the classic rural freethinker, Rockwell is a nineteenth-century positivist in his bones, convinced that the world is knowable—and here we come to what I dislike about him. The absolute absence of mystery in his art makes me sick. It explains why, as a boy, I never felt a spark of connection between my small-town existence and small-town life according to Rockwell, despite abundant parallels. He got everything right—except the confusion that flowed in and through my experience. When he rendered childish chagrin, it was with a cozy chuckle, which I find hard to endure even now. In Atlanta, my ambivalence zoomed in on one of his loveliest images: a young girl in an old-fashioned slip frankly appraising her looks

in an antique mirror. Why, oh why, must she have a goddam movie magazine open on her lap? O.K., I know. Rockwell's principled sense of narrative cogency demanded that every visible action have a visible cause. But the effect is suffocating.

Rockwell painted well, by the way. His surprisingly large, dense, and sumptuous canvases seem excessive to the requirements of designs for magazine covers. He mastered a sort of hurry-up chiaroscuro, starting with a transfer drawing that was derived from many preliminary sketches, photographs, and oil studies, and then working out tones in a warm grayish-purple, Mars violet. Then he would apply varnish, so as not to disturb the painting's underlayer while he revised the scumbled lights and shadows to construct images that are at once photographically vivid in their details and painterly over all. Unlike arid paintings by the more respectable crowd-pleaser Andrew Wyeth, Rockwell's work actually looks better in its original state than in glossy reproduction. The artistic gifts that he put in service to feelgood journalism were of no mean order. The implied compliment to popular taste fully justifies people's love of him.

The word "nostalgia" pops up often in references to Rockwell, usually in deprecation. "Nostalgia for an America that never was," goes a typical trope. The characterization is both misleading and dated. It springs from the political ruptures and technocratic hubris of the 1960s, when Rockwell himself was persuaded to forsake themes of national amity in favor of partisan pathos and—as in his idealizations of the NASA space program—the managerial sublime. If anyone caught the falling Rockwellian torch back then, it was Andy Warhol, whose best works raise common images to the pitch of religious icons, uniting public and private joys. At issue is a belief that American society amounts to something like a civilization. Today's Rockwell revival signals a weariness with the rancorous horror that democracy becomes for want of that spirit. Honoring such grace in the past, we ready ourselves to receive its like again.

November 22, 1999

PHOTOGRAPHY RENOVATED: THOMAS STRUTH

German masters are on the march in America this year. First came Gerhard Richter, the philosopher king of contemporary painting, in a retrospective at MoMA. Now there's the towering photographer Thomas Struth, in a retrospective at the Dallas Museum of Art. The two artists are easily linked, and not just because Struth, who is forty-seven, was a student of Richter's at the Düsseldorf Art Academy in the mid-1970s. Struth credits Richter with steering him away from painting and into photography, where his mentor was the Minimalist Bernd Becher. Like Richter, Struth is a comprehensive adept who grounds his medium in a pre-modern, even Beaux-Arts order of genres. He pioneered the aesthetics of the huge color print with a painting-like presence, which has become standard fare in museums and galleries; but he continues to do revelatory things in smaller formats, too. Other photographers make photographs. Struth makes photography, reinventing it from top to bottom. His importance has dawned slowly in the United States, as Richter's did, because he exercises a degree of intelligence that can baffle and even intimidate.

Struth grew up near Düsseldorf, where he still lives when he's not travelling the globe. His father, a banker, was skeptical of his desire to become an artist; his mother, a potter, was all for it. By way of compromise, they supported him in art school on the condition that he study teaching. The pressure may help explain his drive. From the start, Struth displayed an affinity for the self-effacing, subject-centered photographic tradition whose lodestars are Eugène Atget, August Sander, and Walker Evans. He invariably works with a view camera, using available light. His cityscapes, landscapes, portraits, pictures of people in museums and churches, florals, and jungle pictures—taken throughout Europe, America, China, Japan, and Australia—share a spirit of absorptive scrutiny. Like Richter's many painting styles, Struth's various modes do not go off in different directions but, rather, converge on a singular essence: in his case, the world according to photography. Temperamentally conservative, he avoids obvious social commentary, and he has shunned the lately popular trickeries of digital manipulation. (In the latter regard, he differs sharply from his contemporary Andreas Gursky, whose gaudy visions of globalized commerce are entertaining but—literally—unbelievable.) Struth's only interest is in what straight photography can say. Who suspected that it could say so much?

Struth's twenty-five years of mature work began with black-and-white cityscapes that hew closely to the documentary dogmatism of Bernd and Hilla Becher, who have made hundreds of austere, head-on photographs of old industrial structures (water towers, blast furnaces) according to strict rules. (The subject must be exactly centered, for example, and the sky must be overcast in order to suppress

shadows.) Struth pointed his camera down the middle of early-morning, deserted streets, producing pictures that center on nothing. Gradually, as one looks at them, complex information floods in from the peripheries, as if the ranks of buildings had become garrulous in the telling of their stories. Such is the character of the Bechers' Minimalism, which stalks objectivity by reducing authorial decisions to a self-evident system. The Bechers rejected modern ideals of expressive form, such as Edward Weston's metaphorical grandeur and Cartier-Bresson's "decisive moment." When their approach works, a picture delivers a sense of reality with the directness of a body blow. I remember my shock, in the late 1970s, upon encountering Struth's shots of familiar SoHo streets. Even after years of walking down Crosby or Greene (ungentrified, slovenly locales then), I plainly knew very little about them. I had been blind to actualities that were in constant flux around me. Today, those early Struth pictures, whose style is timeless, stir a primal nostalgia like that of Atget's scenes of Paris. Struth returned to his street formula for a tour de force soon after the fall of the Berlin Wall, documenting unbombed, dilapidated East German cities that were like spectral zones of a frozen past.

In the 1980s, Struth began to extend his range by creating uncannily intense portraits. Rarely commissioned, these pictures show people whom Struth knows well. They convey psychological states whose point of focus is the sitters' willingness to be photographed, with a vulnerability that bespeaks extraordinary trust in the photographer. As I meet the soft, confiding gaze of a woman in a red scarf—a former girlfriend of Struth's—I can think of few other individual portraits, short of Rembrandt's, that give me so strong a sense of being handed a soul. Struth's family portraits are exceptional. To make them, he lets the sitters arrange themselves in their homes. Standing beside his camera, he issues one instruction: look at the lens. He then waits for the instant in which every family member is vibrantly present. Viewing these pictures is like facing a firing squad of relaxed but implacable gazes. The constellation of individuals suggests an open book, in which every family secret is bared. But to read it would involve analysis, which is reductive thought; the range of nuance in these pictures is irreducible and overwhelming.

The family portraits—tableaux of love and ambivalence—express the central idea in Struth's work: the humbling force of superficially serene but deeply irrational relationships, beginning with the one between the photographer and the world. The key consideration for all photographers is the choice of subject matter, and on this Struth rests the full weight and mystery of his art. Why document perfectly ordinary buildings in Berlin or Naples, or a disheartening public-housing project in Chicago? Why a high-tech train facility in Tokyo, an early-morning view of Times Square, or the familiar facade of the Milan Cathedral? Why tourists dwarfed by the grandeur of Yosemite or of the Pantheon in Rome? What's the point in looking at big photographs of people looking at big paintings in the Louvre or the Art Institute of Chicago? Why rain forests? (I asked Struth how jungles in Japan manage to look Japanese, as they certainly do in his pictures of them. He said, "They don't have many jungles left

there. They keep ones they like.") In a few instances, we are given reasons for the photographer's choice of subjects: tender, close-up flower portraits and lyrical Swiss landscapes were a project—the loveliest imaginable—for decorating convalescent rooms in a Swiss hospital. More generally, one surmises that Struth may not understand his attraction to a subject until he has photographed it, if then. No matter how meticulously conceived a picture may look, it achieves a feeling of epiphany.

Struth can overreach. A picture from last year shows him looking at the great self-portrait of Dürer in Munich. As it happens, a spiritual kinship between Struth and the god of German art could fairly be adduced, but Struth may not be the best person to adduce it. A current show at the Marian Goodman Gallery, in New York, of new work by Struth—large-scale photographs of people at the Pergamon Museum of ancient Near Eastern art and architecture, in Berlin—suggests hubris. After failing to get satisfactory pictures of ordinary museumgoers, Struth brought in a crowd of his own choosing. The pictures are grand, but the self-consciousness of the "viewers" proves deadening. There is a subtle but fatal difference in attitude between people behaving naturally and people behaving naturally for a camera. Nonetheless, it wouldn't say much for Struth's ambition if he didn't experiment. Such slips as he has had expose just how lofty and demanding is the normal standard of his art, which combines both lucid intellect and an almost saintly humility. Like Atget and Evans, Struth suggests that photography is not a way to possess reality but a way to be possessed by it.

May 27, 2002

LOOKING BACK: DIANE ARBUS

The revolutionary photographer Diane Arbus, who died in 1971, at the age of forty-eight, said, "A photograph is a secret about a secret. The more it tells you the less you know." That's not quite right, on the evidence of "Diane Arbus Revelations," an indeed revealing, though gratingly worshipful, retrospective at the Metropolitan Museum. Confronting a major photograph by Arbus, you lose your ability to know—or distinctly to think or feel, and certainly to judge—anything. She turned picture-making inside out. She didn't gaze at her subjects; she induced them to gaze at her. Selected for their powers of strangeness and confidence, they burst through the camera lens with a presence so intense that whatever attitude she or you or anyone might take toward them disintegrates. Arbus's fine-grained black-and-white film and Minimalist form—usually a subject centered in a square format—act with the virtual instantaneity of punchy graphic design. The image starts to affect you before you are fully aware of looking at it. Its significance dawns on you with the leisureliness of shock, in the state of mind that occupies, for example, the moment—a foretaste of eternity—after you have slipped on an icy sidewalk and before you hit the ground. You may feel, crazily, that you have never really seen a photograph before. Nor is this impression of novelty evanescent. Over the years, Arbuses that I once found devastating have seemed to wait for me to change just a little, then to devastate me all over again. No other photographer has been more controversial. Her greatness, a fact of experience, remains imperfectly understood.

"Revelations" is on a triumphal tour: having appeared in San Francisco, Los Angeles, and Houston, it's scheduled for Essen, London, Barcelona, and Minneapolis. Prepared by curators working with Doon Arbus, the photographer's daughter and the firmly controlling administrator of her estate, it is really two shows: one of them presents the photographs, and the other is hagiography. There is valuable documentation, such as a contact sheet that reveals that the subject of Arbus's famous, horrific picture of a grimacing boy clutching a toy hand grenade was actually a fairly normal-looking kid, with a talent for clowning. (Arbuses often amount to staged collaborations with their subjects; this is a matter not of falseness—she never said she was a documentarian—but of art.) And samples of her aphoristic prose beguile. Arbus could have been a fine writer, had she not ceded that vocation to her adored brother, the poet Howard Nemerov. But the show's moodily lighted installations of biographical materials—snapshots, letters, notebooks, cameras, books, keepsakes—strike me as creepy and pointless, except as fuel for the cult of a spicily neurotic woman who committed suicide. The phenomenon is familiar. Self-destroying celebrities in our culture seem to waive their right to ordinary decencies, becoming

fair game for anybody's poking and pawing. But the tendency, thus reinforced, to confuse Arbus with her work—a confusion shared and exploited by her critical detractors, chiefly Susan Sontag—obscures her art's key personal quality: detachment under pressure, including the pressure of her own harrowed emotions.

Arbus is important not for what she was but for her regular feat of vanishing, as a personality, when her camera clicked. T. S. Eliot's tenet of a necessary separation of "the man who suffers and the mind which creates" cannot be better exemplified than by Arbus at that recurrent moment when we as viewers are abandoned to visions overwhelmingly both fierce and tender. Imputations of "voyeurism" are absurd; voyeurs must feel safe, and Arbus's pictures are like the gaping barrels of loaded guns. Her personal background—sheltered, rebellious child of a cosmopolitan Jewish family; successful, dissatisfied fashion photographer; insecure, hungry spirit—explains much about her life, including her passion for the weird and the seedy. She was a thrill-seeking depressive fortunately not given to drink or drugs but excited, and made reckless, by prospects of rare and strong sensation. Both her genius and her compulsive adventuring, often sexual, took off in the 1960s—abetted by a collective taboo-breaking mania that, in retrospect, makes a pretty good case for taboos. (Arbus was far from the only bruised daredevil of that epoch to have crashed in the early 1970s.) But her cynosure as an artist is a disciplined evacuation of psychic distance between her subjects and the viewer. Compared with Arbus's self-possessed, monumental dwarfs, transvestites, twins, carny folk, nudists, prodigious babies, aging dames, desperately bored suburbanites, and young people palpably facing long odds in life, even the most rigorous pictures by her particular artistic heroes—Walker Evans, Robert Frank, Lisette Model—can seem sentimentally overburdened.

Sontag's notorious attack on Arbus, in an essay from 1973 that became the linchpin of her book *On Photography* (1977), passed one test of great criticism. It asked the right question—about photography's claim to be a full-fledged and legitimate art—at the right time, when Arbus's work had advanced that claim with unprecedented force. Otherwise, the essay is an exercise in aesthetic insensibility, eschewing description of the art for aspersions, often pithy, on the artist's ethics. "Arbus's interest in freaks expresses a desire to violate her own innocence," Sontag wrote. That's insightful, but it's incidental to photographs that transcend the interest and desire of their maker and, in the process, shatter the idea of "freaks" as a stable category of experience. Sontag rushed to rescue the idea. "In photographing dwarfs, you don't get majesty and beauty," she insisted. "You get dwarfs." She noted with bemusement that in Arbus's pictures people who are "pathetic, pitiable, as well as repulsive" look "cheerful, self-accepting, matter-of-fact." She wondered, "Do they know how grotesque they are? It seems as if they don't." They "appear not to know that they are ugly." It's an interesting complaint, suggesting that people who look or behave in unusual ways merit sympathy from the rest of us only if they visibly assent to our disgust with them. Saying such things shows how far Sontag was willing to go in a campaign that aimed, beyond Arbus, at photography itself. She denied it the

power, which she claimed for literature, of altering conventional responses—and even the possibility of being creatively inspired. She wrote, incredibly, "There is a large difference between the activity of a photographer, which is always willed, and the activity of a writer, which may not be."

In fact, Arbus's best pictures feel hardly more willed than, say, "Kubla Khan." Of course, she knew how to put herself in the way of epiphanies. Photography is the art of anticipation, not working with memories but exposing their formation. As such, it has relentlessly usurped imaginative and critical prerogatives of older, slower literature and handmade visual art. Sontag wasn't alone among critics in lamenting the growing hegemony of photography; the best of them all, Baudelaire, immediately saw in the daguerreotype—a "trivial image on a scrap of metal"— "a cheap method of disseminating a loathing for history and for painting among the people." (I take the quote from an appendix to *On Photography*.) To admit that such mechanical, lumpen craft can attain the full consciousness, and self-consciousness, of great art ends the debate. Arbus brought about nothing less by fusing photography's documentary and expressive functions, and charging that synthesis with a conviction of reality so strong that it equals myth. She remarked of her favorite subject, "There's a quality of legend about freaks. Like a person in a fairy tale who stops you and demands that you answer a riddle." She went on to say, "Most people go through life dreading they'll have a traumatic experience. Freaks were born with their trauma. They've already passed their test in life. They're aristocrats." These words, making crystal clear Arbus's personal and intellectual attractions to oddities of nature and society, convey a responsiveness that is also a warranty of responsibility.

March 21, 2005

VERMEER

What is it about Johannes Vermeer? Everyone idolizes the elusive Dutchman who made silence-drenched small paintings, mostly of unremarkable domestic scenes, in the tidy city of Delft almost three and a half centuries ago. (He died in 1675, at the age of forty-three.) Certainly his work is beautiful, but in unsettling ways that shear away from the subjects of the pictures. The mighty red of the hat in *Girl with a Red Hat* confounds like a shocking comment, made in polite company, which only you appear to have heard. The play of sunlight on the collar and cowl of the girl in *Young Woman with a Water Pitcher* also jolts—it could be the secret of life—and when you try to call attention to it, you stammer. With Vermeer, our eyes and minds squabble over what we are beholding. Is it image or paint, realism or reality? We may catch the artist out in tricks, noting, for instance, apparent effects of a camera obscura: variable focus, puddled light, and details whose incredible accuracy owes nothing to traditional technique. But Vermeer beggars any analysis. There is a discomfort—a prickling itch—in my experience of him. Looking and looking, I always feel I have only begun to look.

Vermeer is blatant and ineffable, like the Sphinx. His appeal is both populist and lofty, as if it mixed Norman Rockwell with the music of the spheres. He intoxicates not only art historians and art critics, but no end of novelists and poets. And his stock, never depressed in the twentieth century, is on the rise. I think that our renewed enthusiasm for Vermeer confirms a trend in current taste away from art as a field of educational improvement and toward aesthetic experience as an end in itself. We are revaluing painterly rhetoric of light and color. We have decided that we don't mind being manipulated by artists—in fact, we require it. We demand to be taken out of ourselves. No artist erases self-consciousness faster than Vermeer.

Very little is known about him, but in Anthony Bailey's supple new biography, *Vermeer Then and Now: A View of Delft*, that little goes a long way. Connecting sparse dots, Bailey works up a highly plausible account of the master's life and career. The book perfectly complements a major loan exhibition at the Metropolitan, "Vermeer and the Delft School." Included are fifteen of Vermeer's thirty-five generally accepted canvases, masses of work by other artists, and much documentation of seventeenth-century Delft—a walled and canal-watered town of twenty-five thousand. Many Vermeer fans, who might regard the show as just a few jewels packed in scholarly bubble wrap, will plunge directly into the scrums of fellow-viewers around *Woman with a Balance*, *The Art of Painting*, and the rest. I recommend initial absorption in, at minimum, the works of Carel Fabritius and Pieter de Hooch, painters who are cherishable in their own right and crucial as influences. Vermeer regularly cribbed motifs from de Hooch in particular.

Bailey begins his biography with the explosion of about forty-five tons of gunpowder in an arsenal, in 1654. The accident levelled a good bit of Delft and killed Fabritius, a thirty-two-year-old former pupil of Rembrandt, and Delft's best painter. At the Met, an astonishing little Fabritius painting of a goldfinch perched against a yellow wall points straight ahead to the mature style of Vermeer, who was twenty-two in 1654. A eulogistic poem that appeared thirteen years later consoled Delft for the loss of Fabritius by citing "Vermeer, who masterfully trod his path." In some copies of the poem, the last line ends with "who proved to be as great a master." Bailey speculates that personal diplomacy by Vermeer brought about the upgrade.

No one can doubt that the maker of *The Art of Painting*—a masterpiece's masterpiece, showing a painter portraying a model who is done up as Clio, the muse of history—thirsted for glory. Vermeer's only moderately successful career bespeaks a perfectionism that made him the worst enemy of his own ambition, and not just by keeping his output so small. (Bailey reports that Dutch painters then averaged about fifty paintings a year; Vermeer's rate was two or three.) Here was an artist "impatient to be found out, to be seen," Bailey writes, but so principled that he kept painting himself out of his art. He became "the person who has just left the room, or who is expected at any moment." Did compunction drive him crazy? In his later years, he painted less often and less well. Having fallen into a state of "decay and decadence"—in the recorded words of his wife, Catharina Bolnes—he suffered some kind of collapse and went "in a day and a half … from being healthy to being dead."

The son of an innkeeper who was also an art dealer, Vermeer must have grown up around beer-swilling painters. He became a dealer himself. (The Dutch Golden Age was a commercial enterprise.) Catharina bore him fifteen children and drew him into her Catholicism—a religion that was intermittently suppressed in Delft at the time. A weird late painting in the show, *Allegory of the Faith*, reeks of hysterical piety. It is one of two large, un-Vermeer-ish Vermeers that bracket the artist's great period. The other, done when he was twenty-four, is *The Procuress*, an unfamiliar picture from Dresden that shows a lewd cavalier pawing a complacent prostitute as the leering procuress looks on and a lute player (possibly Vermeer himself) hilariously carouses. It is a jumble of elements, some of which are stunning. The abrupt realism of the procuress's face suggests an actual woman looking out through a hole in the canvas, and the sonorous yellow of the prostitute's dress sets off an eruption of beauty. (Isn't Vermeer the painter of yellow, just as Rembrandt is of browns, Velázquez of pink and gray, and Goya of black? No one else except, sometimes, van Gogh, wrings more eloquence from the sunshine hue.) The goatishness of *The Procuress* and the frenzy of *Allegory of the Faith* expose extreme emotions that were softpeddled in Vermeer's major work, nearly all of which is erotic and spiritual at once, but mutedly.

The Art of Painting is a philosophical picture, like Velázquez's nearly contemporaneous *Las Meninas*, though on a pocket scale. Sitting with his back to us, the duded-up painter—who, like the lute player in *The Procuress*, has shoulder-length brown hair—starts to paint the laurel headdress of the glowing young model, who

holds a trombone and a large book. The two are framed on the left by a cluttered table, an empty chair, and drapery whose pattern echoes the leaves in the headdress, both on the model and in the painter's rendering, building the sense of a metaphysical laurel grove. The drapery establishes the viewer's space, at a shadowy remove from the scene. Of course, our viewpoint is precisely that of the painter of *The Art of Painting*. As we ponder all this, the work melts us with a subtle, plangent triad of the primary colors: yellow book, bluish leaves on the canvas, the painter's red stockings.

I wonder if the healthy-minded Dutch, while admiring Vermeer's skill, didn't find something intolerably neurotic about him. In any case, his art slipped into an obscurity that was compounded by its scarcity and, later, by tangled misattributions. French enthusiasts rediscovered him in the mid-nineteenth century. Bailey notes Marcel Proust's famous excursion, in 1921, the year before he died, to see the artist's *View of Delft* at the Jeu de Paume in Paris. Proust wrote that experience into *À la Recherche du temps perdu*. The writer Bergotte, who is gravely ill, imagines his own whole life in balance with "a little patch of yellow wall" in the painting. Moments later, he falls dead. It is a terminal epiphany like the ignited consciousness of Anna Karenina under the train, though Proust carefully leavens it with irony. (Bergotte's final thought is of undercooked potatoes.) The passage sets a sacramental seal on Vermeer's art as a shrine of artistic devotion. You would think that veneration so exquisite, verging on the epicene, indicates an object of, well, recherché taste. But anyone with eyes can go goofy over this or that little patch of something in Vermeer.

A skeptical friend of mine surmises that our present Vermeer craze reflects yearnings for legitimacy in today's lately expanded upper middle class. This makes sense. You might say that Vermeer apotheosizes material prosperity—not that he was ever well-off himself. (If only because of that horde of kids underfoot, his golden visions of bourgeois serenity had to be vicarious.) I think that Vermeer's ideal was a classless, timeless truth that is returning to the fore in contemporary culture: the essential role that aesthetic pleasure must play in any seriously lived life. Each of us is born with a capacity to see and feel intensely and with precision. Ultimately, Vermeer's appeal is about nothing other than the realization of that gift. Looking at his pictures, we approach the farthest frontiers of a necessary happiness.

April 16, 2001

BRICE MARDEN

"I**t's hard to look at paintings,**" Brice Marden once said. "You have to be able to bring all sorts of things together in your mind, your imagination, in your whole body." Good paintings make the exercise worth the trouble. Great paintings make it seem valuable in itself, as one of the more rewarding things that having minds, imaginations, and bodies lets us do. Marden's current retrospective at MoMA confirms him, at the age of sixty-eight, as the most profound abstract painter of the past four decades. There are fifty-six paintings in the show, dating from broody monochromes made between 1964 and 1966, when Marden was fresh out of art school at Yale, to new, clamorous, six-panelled compositions, twenty-four feet long, of overlaid loopy bands in six colors. (His several styles of laconic form and smoldering emotion might be termed "passive-expressive.") The ensemble affords an adventure in aesthetic experience—and, tacitly, in ethical, and even spiritual experience. There are also some fifty drawings: too few. Marden's drawings (and etchings, which are entirely absent) constitute an immense achievement in their own right, and their resourcefulness and grace are best perceived in quantity.

Marden was born in Bronxville, New York. His father was a mortgage servicer. Inspired by a sophisticated neighbor who painted, Marden grew up avid for art. He underwent classical academic training at the Boston University of Fine and Applied Arts, from 1958 to 1961. Manet transfixed him; he imitated Cézanne and early Matisse. He discovered Old Masters, chiefly Zurbarán, who would give him lasting sustenance. Marden belongs to a generation of tough-minded American painters who arose in the aftermath of Abstract Expressionism and during the onsets of Pop and Minimalism. His Yale classmates included Chuck Close and Robert Mangold, as well as Richard Serra. He is not a minimalist—a label often lazily affixed to him, as to other artists of the era whose deliberate styles register the historical logic of Minimalism (a debunking of pictorial rhetoric and illusion) while resisting its impersonality. He took practical guidance from the work of Jasper Johns and, in his early paintings, adopted Johns's matte, fleshy medium of oils mixed with beeswax—brushing it on, then smoothing it with a kitchen spatula. Marden may usefully be considered a late-entry Abstract Expressionist: a conservative original, the last valedictorian of the New York School. His early enthusiasms included Willem de Kooning and Franz Kline, and thoughts of Jackson Pollock irradiate his career. Barnett Newman looms behind some of his less successful experiments. But the painter who mattered most to the precocious Marden's maturation was Mark Rothko.

When viewing the apparently all-gray or all-beige canvases in the show's first room, try this: approach them slowly from a distance, attempting to keep the surface

in focus. At a certain point, your eyes will give up. The surface eludes them. Sombre color seems at once to engulf you, with a sort of oceanic tenderness, and infinitely to recede. This effect distills that of the furry-edged, drifting masses of ineffable color with which Rothko aimed, he said, to evoke a mood of "the single human figure, alone in a moment of utter immobility." The young Marden's version is cooler and more calculated. He employed the Rothkovian tactics of hanging paintings unframed, with paint running around the edges, low on the wall—commonly centered at about the height of your solar plexus—to address the viewer body-to-body. Further emphasizing the painting as a physical object, a narrow margin of bare canvas along the bottom displays runs and drips of the work's several layers of paint. The device is a mite gimmicky, and Marden soon discontinued it. When using more than one color, he applied each to a separate, abutted panel, in diptychs and triptychs, to literalize their division.

All of this might be deemed mainly clever, in a standard key of 1960s avant-gardism. Certain titles (*The Dylan Painting*, *Nico*) declare citizenship in the decade's rock-and-roll, stoned Bohemia. But the color! It can seem that Marden has not only an eye but a taste, smell, touch, and ear for excruciating tone and anonymous hue. His grays and grayed greens and blues recall the ungraspable nuances of Velázquez and, at times, the simmering ardors of Caspar David Friedrich. (Am I dropping too many names? There's no helping it. Marden, an artist bred in museums, communes rather directly with all past painters whose temperaments correspond to his own.) While working on his ultimate series of monochromes, the exceedingly refined *Grove Group* of the early 1970s, which were inspired by sojourns on the Greek island of Hydra, he made notes on colors that he found in nature: a tree trunk "black brown yellow cold dark"; an olive grove "evasive silver gray green, blue gray green light, black gray browns"; and an Aegean sky "blue, gray, yellow, sulphur, turquoise, yellow, blue." These quotes are from a remarkable essay, in the show's catalogue, by the art historian Richard Shiff, who braces a discussion of Marden's self-abnegating sensitivity—"knowing yourself by forgetting about yourself," in the artist's words— with apposite thoughts from the founder of American pragmatism, Charles Sanders Peirce. Peirce described the transition in the mind of sensation into feeling, defining experience as "consciousness of the action of a new feeling in destroying the old feeling." That universal truth epitomizes Marden's best art, which makes a practically religious tenet of vulnerable openness to "new feeling." It is a romantic faith, and he observed it with the discipline of an eremite monk.

In the late 1970s and early 1980s, apparently with Newman in mind, Marden tried to monumentalize his work with architectonic arrays of panels, alluding to Greek temples. Forced grandeur smothered the lyrical intimacy of his colors and textures. While continuing to paint, he regrounded his enterprise through compulsive drawing, often with ink-dipped twigs, in flurries of impetuous line, informed by Chinese calligraphy, Pollock, and latent, dancerly figuration—"letting the drawing itself do the work," he said. (The antic graphism of Cy Twombly may have been

a factor, but Marden maintains a conservative loyalty to unified composition, as Twombly does not.) This led to pale-colored paintings of linear networks, irregular but tensile (as if lightly spring-loaded), which he made in a fluid turpentine-cut medium, wielding sword-length brushes from the shoulder. His *Cold Mountain* series, of 1989–91, named for the Chinese poet Han Shan, strives with mixed success to maintain the spontaneity of drawing on a very large scale. The concentration required to control the big, ungainly strokes is both heroic and taxing; the works can seem to use up as much energy as they impart. But Marden was onto something. With growing confidence, he developed the lines into freely brushed bands of color. Later, these became slow, deliberate shapes in themselves. As color resumed a leading role in his art, the bands turned determinedly gawky, anti-gestural and anti-calligraphic, making you look straight at them.

Two new mural-size paintings, from a series called *The Propitious Garden of Plane Image*, are his most ambitious to date. Their linear complexity and discordant color shock. They deploy a system. On each of six panels, bands in five of the six primary and secondary colors overlay a ground of the sixth. From left to right, the ground colors are red, orange, yellow, green, blue, and purple. The bands writhe like the snakes of the Laocoön while staying dead flat. The phrase "plane image," Marden has said, emphasizes his constant will to treat picture and paint as one thing. Looking at these paintings is, in a word, hard. They attract and repel in roughly equal measure. As at a party, you're peripherally aware, wherever you are, of things happening elsewhere. Marden thereby introduces an element of time. We are to view the work episodically—our minds, imaginations, and bodies riveted at each point, but without ultimate resolution. On a first encounter, they create sensations not yet transformed into feelings. Win or lose, Marden's wager offers something that is increasingly rare in art: high stakes.

November 6, 2006

ANDY WARHOL

The Andy Warhol retrospective, which began in Berlin last year and has just opened at the Tate Modern, in London, demonstrates a number of interesting things. The first is that Warhol, fifteen years after his death, remains a contemporary; the revolution in taste that he set off in 1962, his year of miracles, rolls on. Second, we have reached a point at which it's possible to distinguish what is good, bad, and O.K. in the Warhol opus. And, third, the Tate Modern, a renovated power plant that opened to ecstatic fanfare two years ago, is a scandalously lousy place for looking at art. Not even gorgeous Marilyns and Maos, hit with spotlights, can pierce the oppressiveness of the museum's galleries, which were designed by the Swiss firm of Herzog and de Meuron. The viewer's sensitivity is punished by ceilings that are too high, bunker-thick walls, dingy floors of concrete and unfinished wood, and uniform, rainy-weekend lighting. The building palpably yearns to be, if not a power plant again, something brawnier than the butterfly corral of an art space—perhaps a neo-medieval hospital or arsenal. The message of the place baffles. Surely, a hatred of art can't have been the architects' motive, though it would explain the effect. I put it down to institutional defensiveness, a puffed-up sense of dignity. (Imagine a Marx Brothers movie scripted by Margaret Dumont.) The museum's much deplored curatorial policy, which is evident in the hanging of its permanent collection, supports this suspicion. Forced thematic groupings of works, dominated by bossy wall texts, amount to grisly autopsies of modern art. But policy can change, as it does, ad hoc, in the sumptuous Warhol show, which was installed by the Tate curator Donna De Salvo. Buildings, on the other hand, are fate. What a pity for art and for England.

Announcing that pleasure will be the show's keynote, De Salvo begins with a group of *Flowers*—large silk-screen paintings from 1964 and 1967 that ring changes on a motif of flat hibiscus blossoms against a grainy ground of grass blades. (Warhol cribbed the image from a tiny black-and-white ad in a magazine.) The choice elated me, because a *Flowers* show in Paris, in 1965, was one of two experiences I had that year that inspired a vocational devotion to art. (The other was a Piero della Francesca fresco in Tuscany.) Warhol's *Flowers*, which mounted winsome imagery on the stern chassis of the Abstract Expressionist big canvas, assimilated the most advanced principles of abstract painting into the larger culture. For many people, this act of levelling will always seem a barbaric assault on civilized values. They have a point, but I am incorrigibly thrilled by Warhol's joining of aesthetic sophistication with mass appeal. Like the Beatles—his nearest equivalent in another field—Warhol invested vernacular idioms with a timeless eloquence.

The first in a spotty selection of early drawings, from Warhol's student days, in Pittsburgh, and his career as a New York advertising illustrator in the 1950s, shows a boy contentedly picking his nose. The style is vaguely Weimar, like that of a sweeter George Grosz. The young artist plainly aspired to a decadence that was both sassy and, à la Sally Bowles, divine—most blatantly in homoerotic drawings that he tricked out with imitation gold leaf. Warhol never drew very well. Drawing is thinking, and his forte was intuitive éclat, not thought. When he started painting from cheap newspaper ads and comic strips, in 1960, he capitalized on a look of slack, messy drawing, which proved perfect for the humble subject matter. In 1962, he suppressed evidence of the human hand in his painstakingly handmade paintings of Campbell's soup cans, and then replaced it with the incidental smudge and grit of coarse silk-screening. Meanwhile, he brought off a number of excellent jokes on high art-paintings derived from paint-by-numbers kits and Minimalist sculptures that, upon first glance, are indistinguishable from Brillo boxes. Some conceptually minded critics deem those Dadaist coups Warhol's most important work, but I think they're bagatelles. In any case, Warhol was a great painter for long enough to matter.

Everyone knows that Warhol said he wanted to be a machine. Few recall him saying, as he also did, that he wanted to be Matisse. I think he split the difference between the two wishes, achieving pictorial art that is like a product of balky, breakdown-prone machinery and also like the fever dream of a Matissean odalisque, in thrall to "luxe, calme et volupté." Warhol was a supreme colorist who redid the world's palette in tart, amazing hues such as cerise, citron, burnt orange, and apple-green. His choice of subjects for his best work—sexy culture heroes and gruesome death scenes—had nothing to do with social commentary. It simply made efficient use of his childhood as a working-class sissy who had been weaned on movie magazines and tabloids.

Warhol's was a bottom-up view of America. Swiftly ascending to the upper crust in New York, he was never tainted by anything middlebrow. He loved both populist glamour and the delicious horror of death by Saturday-night car crash or the electric chair. A poor boy's fear of poverty and a devout Catholic's resistance to doubt made him at once greedy and serene. Add uncanny aesthetic sensitivity and social acuity, and you have a catalyst that, dropped into the art world's chemistry, stayed the same while altering everything.

How decisive a break with tradition did Warhol bring about? To travel back to art before 1962 requires a tourist visa. Meanwhile, his classic paintings of the early 1960s remain wide open to the present, as do the painterly films he made in the same period. His twenty-four-hour film *Empire* (1964), which consists of a single static shot of the Empire State Building, is video-projected in the show to mesmerizing effect. Today, computer technology, which brings photography under painting-like control, spurs new approaches to the formal and poetic mysteries of pictorial experience. One sign of the times is the current celebration of the German painter Gerhard Richter, at MoMA. Richter's œuvre may be seen, with some distortion, as a long, complex extrapolation from Warhol. Another bellwether is David Hockney's fashionable speculation that the

Old Masters secretly relied on optical devices; whatever the merits of this hypothesis, it reflects an increasing readiness to reconsider painting within a spectrum of overlapping visual crafts. Warhol's serial silk-screening of the *Mona Lisa* (the 1963 picture is entitled *Thirty Are Better Than One*) might serve as an emblem for the delirious self-consciousness of so much recent art. I don't much like the work, which is one of the few occasions when Warhol went for easy laughs; his better paintings, in which pure aesthetic sensation transforms subject matter, are too particular to be taken as specimens of anything other than themselves.

In 1965, Warhol declared that he was through with painting, and, in a real sense, he was. Uncharacteristically infected with hubris, he bade farewell to the art world with a quintessentially 1960s show of shocking-pink and chartreuse cow wallpaper and drifting Mylar balloons. I recall the opening, at which the stoned mood was a kind of exquisite stupidity. (The Tate has recreated the event on a larger scale, to the glee of children, who noisily take their museum fatigue out on the balloons.) Warhol expected to storm Hollywood with his filmmaking. Hollywood demurred. His later painting hit a few high points: the totalitarian sublime of his Mao pictures; the vivacity of his still underrated portraiture of celebrities (Mick, Liza, Liz) and paying, would-be celebrities; and the raving spookiness of his self-portraits, with their flyaway hair, which he did the year before his untimely death following a routine surgery in 1987. But, increasingly, painting became a sideline to his business ventures, of which his magazine, *Interview*, has the most to answer for as a template of bubble-brained celebrity journalism. The show ends with striking installations of his later works—vast camouflage patterns, monumental Rorschach blots, gloomy "Shadows" sparkling with diamond dust, rusty spatters of urine on copper emulsion, and silk screens of da Vinci's *Last Supper*, as well as zesty collaborations with Jean-Michel Basquiat. But these pieces strike me more as ingenious ideas for painting than as satisfying works of art. They feel phoned in.

Some people trace Warhol's decline as an artist to the attempt on his life by a disgruntled hanger-on, in 1968, an event that ended the fertile anarchy of his Factory scene. But the process was already under way as a toxic by-product of his phenomenal success. The culture that Warhol manipulated was becoming saturated with his own influence, contaminating the outsider's initiative that had made his best works so surprising. The great Marilyns and Elvises of the 1960s—Elvis in black and silver, solemnly playing a cheesy role as a Western gunfighter—exploded in the initial nanoseconds of a big bang, a convulsion of the world by industrialized popular culture that is still with us. Warhol froze that shock in images of Byzantine poise and force. Art's noble past and uncertain future still meet in his frayed, beautiful, hieratic surfaces, which hark back to ancient idolatries and anticipate who knows what. We have not yet come to terms with these paintings, which refuse to settle down as examples of a period's style. They are as raw, irritating, and urgent as ever.

March 11, 2002

BYZANTIUM'S END

"The city was desolate, lying dead, naked, soundless, having neither form nor beauty." This was Constantinople in late May, 1453, when Ottoman armies extinguished the eleven-century dominion of what was not then called the Byzantine Empire. The writer, a contemporaneous historian named Doukas, recorded the despair of citizens who yearned in vain for aid from the West. To prevent the disaster, two treaties had been made with European powers, subjecting the Orthodox Church to the Pope in Rome in return for promises of military sustenance. The agreements were resisted by many Eastern believers, who had scant taste for ecumenism; and, in the event, no significant help came. Doukas quoted an astonishing sentiment from Constantinople's grand duke, Loukas Notaras: "It would be better to see the turban of the Turks in the center of the City than the Latin mitre." Not for nothing is "byzantine" a byword for counterintuitive complexity in human affairs. It is also the marker of a vast blind spot in common historical knowledge.

The wondrous exhibition "Byzantium: Faith and Power (1261–1557)," at the Metropolitan Museum, has taught me a good deal. I have learned that the term "Byzantium" dates from 1557, when a German scholar coined it from the name of Byzantion, the Greek port city that became Constantinople. The point was to emphasize the Hellenic roots of the empire, whose preservation of ancient texts, objects, and philosophical traditions—notably Platonism—might well have struck a Renaissance intellectual as its most important feature. Retroactively expunging "New Rome," by which the seat of empire had known itself, this tendentious rubric inaugurated the afterlife of a civilization that, apart from Orthodox sects, survives largely in alien archives and imaginations. In 1204, Crusaders plundered Constantinople and installed, as emperor, a Flemish count. Even after the triumphal restoration of native rule in 1261, the starting point of this show, the empire was a routinely abused poor relation of Western domains. Christian Europe's lost fraternal Other, Byzantium is a misnamed, accusing ghost.

Frescoes, temperas, mosaics, reliefs, marbles, architectural fragments, embroideries, chalices, candelabra, crosses, caskets, reliquaries (one stuffed with what seems like enough little silk-wrapped body parts for the assembly of a complete person or two), censers, fans, processional cloths, amulets, a bell, a dagger, books, manuscripts, jewelry, vestments, coins, seals, maps, and, of course, a great many gilded icons—all are presented with theatrical flair, in careful profusion. This is a blockbuster show, which overlays the eponymous "faith and power" of its subject with those of the museum's resources of money, clout, expertise, and scholarship (the bibliography in the doorstop catalogue runs to thirty-four small-print pages).

Art being secular urbanity's substitute for religion, the Met is our Hagia Sophia—the great building in Istanbul that, in its time, has flexibly glorified Eastern Orthodoxy, Roman Catholicism, and Islam.

"Greeks, Cypriots, Serbs, Bulgarians, Romanians, Russians, Wallachians, Moravians, Armenians, Venetians, Genoese, Pisans, Franks, Germans, Seljuks, Mongols, Mamluks, Ottomans, and others" vied for advantage in the tottering empire, according to a fine introductory essay in the catalogue by Helen C. Evans, the Met's curator of medieval art. Multiculturalism was a strength of the Eastern Church, which encouraged the liturgical use of local languages. This fact makes pointed sense of the static, dogmatic forms that we associate with Byzantine culture: they stood against an always potential descent into fragmenting chaos. A vigilant, held-breath tension informs even Byzantine opulence. All that gold and other precious stuff amounts to wealth that is sacrificially tied up in supernatural escrow. Art was no mere ornament to the authority of New Rome. Particular images—Christ Pantokrator (Jesus holding the Gospels and giving a blessing), Jesus the Man of Sorrows, Jesus dead, and, especially, Mary with the baby Jesus—were displayed, often in processions, to legitimatize state functions. The theocratic governance of polyglot Byzantium rested ultimately on the power of the icon.

The Iconoclastic Controversy—anticipating a much later, similar crisis in the West, with the Reformation—raged in the eighth and ninth centuries, when successive emperors embraced the Hebraic and Islamic doctrine that images of divinity (and, perhaps, of anything at all) are idolatrous. The authorities raided churches and slaughtered protesting monks. Two extraordinary empresses, Irene and Theodora, brought about the policy's reversal, backed by variously sophisticated and superstitious theological views. Echoes of the conflict ripple through the Met show in icons that have special propagandistic import. Some claimed the authority of St. Luke, who was held to have painted them more or less from life. Others were declared to have come about miraculously, untouched by human hands. One icon, dating from the seventh century, or possibly earlier, called the Virgin Hodegetria, was the palladium of Constantinople, and, as such, the template for thousands of replicas: Mary as a hieratic goddess holding Jesus in her left arm and gesturing stiffly toward him, as the way to salvation, with her right hand. (The Ottomans enthusiastically destroyed the original when they took the city.) Icons were, and, in Orthodoxy, still are, mediums of holy presence. Their impersonal stylization guarantees their fidelity to a world in which mundane conditions, such as mass and weight, hardly apply. (No figure in any Byzantine image stands firmly on the ground.) Think of icons as visual cell-phone calls from the beyond: you don't look at them; you receive them and respond.

The most exciting revelation of the show, for an art lover, is its demonstration of how Byzantine decay fuelled the Renaissance. Fifteenth-century European—especially Italian and Flemish—adaptations of Byzantine motifs are included in the show, and they arrive with jolts of revolutionary beauty. Between the Virgin

Hodegetria and a 1475 Madonna by Giovanni Bellini, God and humanity got redefined. Bellini's Mary addresses our gaze as a living woman, her divinity not proclaimed but only, by her preternatural self-possession, implied; and Bellini's Jesus is Everybaby, though rendered with subtle suggestions of his fate. The viewer's mind, free to wander, is drawn toward piety by seduction rather than by force. I was surprised by my first reaction to the works by Bellini, Dieric Bouts, Rogier van der Weyden, and other Old Masters—including El Greco, the Cretan icon painter who, a century later, in Italy and Spain, impelled Byzantine religiosity from stern primitivism to hysterical decadence with barely an intervening phase. Having been steeped in Orthodox fundamentalism by that point in the exhibition, I was shocked. For a moment, my own melting pleasure in Renaissance aestheticism felt shamefully corrupt and foolishly dangerous. I recovered pretty quickly, but I still feel the sting.

"Byzantium: Faith and Power" brings a universe of antique arguments to clanging life. Every object makes a claim. Overall, the show mounts a formidable criticism of Western civilization. The perspective is at once strange and unnervingly intimate. It appears at the start of the catalogue, in a written blessing of the occasion by Bartholomew, the present holder of the unreconstructed title Archbishop of Constantinople, New Rome, and Ecumenical Patriarch. He employs a Greek word, translated as "bright-sadness," to characterize the mood of Orthodox believers during the period of the Eastern empire's collapse. He cites the veneration of saints and of "the Theotokos" (Mary) as providing "strength, shelter, consolation, and spiritual reinforcement of a nation, which was in danger and later in bondage." Bartholomew concludes with a prayer that we Westerners "may find faith in higher values and ideals than those that are being offered by the world marketplace." Fat chance. But the Patriarch's admonition—an eerie note in a chorus of busy scholars and professional connoisseurs—resonates with brooding qualities of the show: concreted sorrow, hard wisdom. I came away with a chilled sense of having been warned.

May 17, 2004

GIRLS, GIRLS, GIRLS: LISA YUSKAVAGE

Lisa Yuskavage says that her favorite painters include Giovanni Bellini and Rembrandt. I believe her, even though the thirty-eight-year-old New York artist's pneumatic-looking, morose, and gamy nudes in flamingo colors hardly radiate Venetian sublimity or Dutch discretion. Encountering one of them is like clicking on a radio whose volume control has been set way up: you fear for your visual equivalent of eardrums. I was inclined to ignore Yuskavage's work a few years ago, when she emerged in a wave of new, resolutely strident figurative painters, among them Elizabeth Peyton and Yuskavage's friend and former Yale classmate John Currin. (Currin's virtuosity, which veers between sex cartoons and German Renaissance masters, has overshadowed Yuskavage's achievement and that of everybody else in the field.) But Yuskavage didn't go away, and I came around. Walking through a five-year retrospective of her work at the Institute of Contemporary Art in Philadelphia, I felt like a rock fan parsing nuances in a guitar storm. I confirmed for myself that she paints well, and that good painting is what concerns her. A show of new work at the Marianne Boesky Gallery refines her rough magic with no loss of effrontery. This painter squares simpering, vulgar imagery with reverence for art.

Yuskavage's work paraphrases images of girlie pulchritude from old skin magazines and from photographs that she takes of models, but her essential source is her own obsessive fantasy life. Elements of her plump figure appear in some paintings, she has said. So do various features of her longtime psychotherapist, a woman whose pert, ski-jump nose is a leitmotif. (How gnarled can therapy get? Consider a 1995 painting entitled *Transference Portrait of My Shrink in Her Starched Nightgown with My Face and Her Hair*.) Yuskavage has often painted from little plaster statues, ten of which are in the Philadelphia show as art objects in their own right—sugar-white, grossly curvy figurines of pubescent girls adorned with fake pearls or tiny cloth-flower bouquets. (Fragments of bridal wear are recurring symbols in Yuskavage's iconography.) Studying these maquettes helps her puzzle out the intricacies of light and shadow which, along with high-combustion color harmonies, define her technique.

At first glance, Yuskavage's pictures suggest sophisticated cartooning, but the viewer soon notices her skill at modelling massy forms in depth and teasing out unlikely delicacies of expression. Finally, one succumbs to the surreal plausibility of a painting such as *Honeymoon* (1998): in twilight, a wistful, long-haired girl in an open robe kneels on a bed by a window that looks on a misty gray mountain range. A highlight gleams on the enlarged purple nipple of her left breast. Lurid? Yes, but perfectly in key. In these pictures, body parts routinely transmogrify, as if in

involuntary response to a character's discomfiture. In *Honeymoon*, the purple nipple insinuates a hyperbolic variation on the maidenly blush.

Yuskavage is one of a number of young women painters and photographers who have taken up the female nude. Though rife in our commercial culture, the theme is uncommon in American painting. Our painters since Thomas Eakins have been at least as partial to the unclothed male. Something in our history makes prolonged scrutiny of naked women in artists' studios more troubling than it's worth. In recent years, feminist criticism's shaming attacks on the "male gaze" have amplified national qualms to a point where any man's painting of a female nude is likely to seem roguishly defiant, at best. And so the tradition, such as it is, has fallen, as a guilt-free novelty, into the hands of women. Why shouldn't they reinvent it, as they presumably can, from the outside and the inside simultaneously? Yuskavage shows how. Her seriousness of purpose transforms generic-looking images into figures of individuality.

Yuskavage's personae come across as tender souls who are burdened by surplus flesh and inchoate longings. The young ones are confused. Older characters are confused and tired. All of them appear fated for sex. They are decked out, if at all, in such raffish accoutrements as little jackets that cover only their arms and their shoulders. Some examine their breasts, buttocks, or crotches with suggestive absorption. But in none of the images is the effect pornographic. Lust can't gain traction in these dream landscapes and interiors. Abstracted realms of feverish light, they are hermetic and, once you adjust to their kicked-up color, meltingly beautiful. Defenseless innocence prohibits desire. To me, even the most flagrant of Yuskavage's females seem more daughterly or sisterly than anything else—shielded by taboo. They hover between sweetness and dread. Yuskavage makes weird, darling dolls of "sexy" archetypes in the vein of a worried child playing with Barbie. But there is nothing puerile about her work's rhetorical intensity. Reproduction does not do justice to these paintings. You must view them in person to perceive the refined intimations in their ostensibly clownish style. The subtleties register slowly, building recognitions that, among other things, open royal roads to antecedents in the Old Masters.

Along the way, Yuskavage illuminates present feminine discontents. How can a girl develop a satisfactory body image in a world of industrialized sex and glamour? She can't, Yuskavage implies. She is doomed to contemplating herself through batteries of alien eyes. Two recent paintings—*Day* and *Night*—add up to an allegory. In the first, a blonde in effulgent light daintily lifts her flimsy shirt to behold her sumptuous breasts. In the second, a highlighted brunette in inky darkness grabs at one bare hip with a bejewelled, long-nailed hand. Her eyes are closed. A good-girl/bad-girl duality seems involved. But in both paintings the attitudes of the characters bespeak vulnerability. Their different autoerotic reveries might as well be aspects of one bewildered girl's kaleidoscopic self-consciousness—and, of course, they are. The engine of Yuskavage's art is plainly her own sexual anxiety, which provides a surprisingly rich source of inspiration. When you get past the initially

overwhelming family resemblance of her works, you see that she does not repeat herself. Each image has the authority of a continuing quandary, freshly recast. During my last circuit of the Philadelphia show, each picture was singing a particular song in praise of the act of painting. In the show at Boesky the same effect becomes a chorale. The new paintings, which depict a series of amiably louche nudes in decorous mansion interiors, are less cartoonish than her past work, although they are at least as incendiary in color. Their consistency signals a mature assurance.

In Philadelphia, the show's catalogue includes a reproduction of Bellini's *Madonna and Child Enthroned with Saints*, an altarpiece in the church of San Zaccaria, in Venice. This pellucid masterpiece depicts an angelic young musician drawing a bow across a viola, while six other characters share a mood of strangely tense calm. They are listening. Mary listens with a difference. As usual in Renaissance Madonnas, we understand that she contemplates the terrible end of her child's mortal life. Here her incomprehensible acceptance fuses with the held-breath span of a musical note—a vibration of eternity, suspended in paint. Some such transfixion grips the characters in Yuskavage's art. Sad and silly as they are, they, too, harken to something outside time. The art historian Marcia B. Hall, writing in the catalogue, cites Bellini as an influence on the artist and uses an almost obsolete word for Yuskavage's females—"ignoble." That's just right. These abject beings yearn toward nobility's vested grace, its immunity from ordinary judgment; and their yearning is dignified by the powers of masterly painting. The effect is both funny and painful. It is also piercingly true to the plight of the aesthetically aroused soul in a mass culture of warped ideals. Yuskavage hints that, even here, beauty and truth are as accessible as they ever were. We need only reach low enough to touch them.

January 15, 2001

PARLOR MUSIC: ÉDOUARD VUILLARD

É douard Vuillard, who is the subject of a huge retrospective of paintings, drawings, prints, decorative projects, and photographs at the National Gallery of Art in Washington, D.C., was one of the great fin-de-siècle neurotics who established self-conscious subjectivity as a standard spiritual appliance of twentieth-century culture. He was also the leading homebody among modern masters, a nervous Parisian mama's boy whose intimate subject matter and love of decor extoll the bourgeois nest. I have often thought that Vuillard is absurdly underrated. The density of emotion, the subtle beauty, and the excruciating sense of the eros of private life in his paintings can make other twentieth-century artists seem like louts. I've looked forward to a retrospective like this one for some time, hoping that it would bring Vuillard's achievement into focus and make firm judgments possible. No such luck. Greater familiarity with this artist makes one's assessment of him more tentative rather than less. His best pictures exude a hypersensitive, ambiguous aura of grace. When you are under their spell, you may shudder at the gaucherie of ever wanting something more definite. Even then, however, there is something not all there about him.

Vuillard was born in 1868, the son of a former military man and a corset-maker. His father died when he was fifteen, and the dominant figures of his early life were his maternal grandmother, his mother, and his older sister Marie. He called them his "muses." He continued to live with his mother, whom he adored, and to portray her again and again, until her death, in 1928, when he was sixty. His love life, such as it was, centered on two married, high-powered art patrons, Misia Natanson and Lucy Hessel. A thin-faced, bearded man, he was chronically insecure about his looks and his capacities. It was only after four tries that he was admitted to the Ecole des Beaux-Arts, in 1887. He formed lifelong friendships with the dandyish minor symbolist painter Kerr-Xavier Roussel and with Pierre Bonnard—his twin in art-history books, another "intimist" who housebroke modern aesthetics. Vuillard stands out for the richness of his early, symbolist works, which retained resources of reality-describing naturalism while anticipating the all-out emotionality of Expressionism.

In the 1890s, Vuillard was active in avant-garde theater, designing sets, posters, and programs for plays by, among others, Ibsen and Maeterlinck. In 1894, he created a green gauze scrim for the symbolist play *La Gardienne*, by Henri de Regnier. The backdrop behind the veil, an appalled critic wrote, "showed a dream landscape, blue trees, purple ground, a mauve palace, a Puvis de Chavannes fresco imitated by a color-blind baby." From 1897 on, Vuillard was a prolific photographer of his friends and family. The exhibition reveals this little-known aspect of

his career in a large selection of casual-seeming photographs, aptly titled *The Intentional Snapshot*, that evoke Ibsen's unreassuring naturalism with whiffs of spooky Maeterlinck.

Vuillard did his most astonishing work in the early and mid-1890s, in paintings of interiors that often include his mother and Marie. In the famous *Interior, Mother and Sister of the Artist* (1893), Mme. Vuillard sits solidly in a black dress while the painfully thin Marie, who is standing off to the side in a patterned dress against hyperactively patterned wallpaper, bends, as if to squeeze herself into the frame. A distorted bureau in the background looms like an oncoming truck. Only Vuillard's contemporary Edvard Munch could generate such psychological resonance in figure compositions. Related works include *The Conversation* (1891–92), in which Marie grabs a kitchen chair, as if in defense against her mother's massive presence. It is difficult to tell whether the artist was disturbed or perversely delighted by the strain between the two women, who were both devoted to him. Elevating the almost caricatural *Conversation* are sonorous tones of yellow, ochre, and black. Slow-acting, eloquent color was Vuillard's forte, reinforced by intricate, nubbly paint textures. A sort of dilated gaze, finding as much expressiveness in the details of carefully furnished rooms as in the people who inhabit them, charges every square inch with incipient meaning.

Vuillard would be an excellent subject for a stage play, with a ready-made plot centering on the marriage, in 1893, of Roussel to the spinster-ish Marie. In 1892, Vuillard accompanied his cocky friend on a journey away from Paris, to escape the raging machinations of a servant girl whom Roussel had loved and left. The subsequent union with Marie, which evidently made no sense to anyone else in their circle, may have been extorted as recompense. In any event, Vuillard celebrated the couple's courtship and nuptials in such paintings as *Interior with Worktable*, also known as *The Suitor* (1893), in which Roussel peeks around a door at his fiancée as she toils in her mother's corset workshop. All such cuteness soon evaporated from a marriage that was beset by the stillbirth of a child and riven by Roussel's wandering ways. The two separated in 1895. A reconciliation was brought about by energetic family diplomacy, which is memorialized in Vuillard's *Large Interior with Six Figures* (1897), a darkly gorgeous, grandly theatrical painting in which Mme. Vuillard coolly confronts Roussel's mistress in the parlor of the girl's family. It is a tableau worthy of a Geneva peace conference. Roussel and Marie settled down, though less than joyously, as Vuillard faithfully documented with a stony lunch-table scene, in 1899. Was Roussel a broken man? Was Vuillard happy about it? A stage director in life as in art, he had brought off a thoroughly creepy coup.

Vuillard's work took a conservative, enervating turn after 1898, when except in his superb, frankly decorative panels and screens—he gave up surface patterning in favor of old-fashioned illusions of pictorial depth. The different parts of the scenes, locked into spatial positions, have trouble interacting laterally: they can't get at each other. Vuillard compensated by unifying paintings with color in closer

tones (blacks give way to grays) and by abandoning oil paint for putty-like distemper, a material that he had discovered in his theater work. Distemper—pigments suspended in water-soluble animal glue—is tricky stuff. Known for its use by the dour Old Master Andrea Mantegna, it produces a suave, tactile surface but an arid, opaque look. At best, it glows like sunstruck plaster. But it obliterates the shadowy nuances that gave Vuillard's oil paintings their poetry. Pictures done in distemper read not as mysteries but as virtuoso exercises. In the society portraits of his later years (he died in 1940), this effect becomes actively unpleasant. The compulsive renderings of settings, with their pointless attention to bric-a-brac, cast the sitters as an interior decorator's stilted, finishing touches. In these commissions, he didn't so much portray his self-satisfied patrons as Vuillardize them.

It is interesting to compare the mature Vuillard with Bonnard, who stayed truer to the pictorial flatness that, after the 1890s, became an irreversible logic of modern painting. Bonnard translated a similar spirit of diffused attentiveness into fields of drenching color. Vibrant hues and insistent, itchy brushwork convey the temperature and humidity of domestic scenes. (Stare long enough at one of his water-logged bathtub pictures and you almost feel the skin of your fingertips pucker.) Vuillard had it in him to be the greater artist. He had a much richer comprehension of the social and personal pressures of modernity in the daily life of Paris. In large doses, Bonnard's tireless bliss can cloy, but he kept his priorities straight as a painter, always merging his vision with an appropriate, satisfying style. Vuillard didn't. In the vastly too big Washington show, we sense him being distracted repeatedly, and at last entirely, from the brilliant stylistic insights of his early work. He remains a kind of hero for his refusal to subordinate his fascination with the actual world to a cold modern formalism. But balancing the claims of art and life requires the mental agility of, say, Matisse, who was also, among other things, a *metteur en scène* of intimate situations. Vuillard, after his early years, lost his nerve. Perhaps the Roussel–Marie comedy had rattled him. Or maybe he didn't want to upset his mother.

March 10, 2003

JAMES McNEILL WHISTLER

James McNeill Whistler is among the greatest of painters when you are in the mood for him and irksome when you aren't. He was a radical dandy, who imbued nuances of style with something like moral zeal. Taking him seriously, as he should be taken, requires a willed suspension of incredulity. After flunking out of West Point, in 1855, when he was twenty-one, he turned his back on America and abandoned himself to modish longueurs of London and Paris; he died a hundred years ago, in 1903. For him, the trivial—the just-so fall of a feather boa, say—bordered on the sublime. Some people dote on such socially charged arcana, which upholster Victorian literature; in serious painting, however, a heavy emphasis on manners and mores of a vanished world can perturb, especially when the painting is generally marvellous. (Fashion-intensive portraiture befits the more modest gifts of Whistler's contemporary James Tissot, who was content to simper winningly.) Edgar Degas put his finger on the problem of Whistler when he reportedly remarked to the brash expatriate, "You behave as though you have no talent"—a cruise missile of a bon mot that might have annihilated a man of feebler self-esteem. Now is the time to come to terms with Whistler's subtle, opulent caprices.

"Whistler, Women, and Fashion," an intensely rewarding show at the Frick Collection in New York, arrives on the heels of "Manet/Velázquez," at the Met, a grand exploration of the impact of the Spanish Baroque on nineteenth-century France, which ends with works by Whistler, as well as by Eakins, Sargent, and Chase. Those fin-de-siècle Americans look joltingly good at the Met. Their works make vigorous sense when sighted along a stylistic trajectory that goes from Velázquez through Goya and Manet. They have seemed antique to us only because modern art developed in contrary ways. Whistler and his fellows proved to be a dead-end generation, whose social milieus became anathema to the avant-garde. To reignite the spark of Whistler's contemporaneity, the Frick gives couture subliterates like me a crash course in nineteenth-century women's wear. Four actual dresses, close kin of those in his portraits, join a display of magazine fashion plates that track dress styles from the colossal bell shapes of 1860 to the relatively tailored looks of the 1890s. As I walked through the show, these aids served me the way a phrase book does in a foreign country. I found that I could converse with the paintings, albeit haltingly, in pidgin chic.

One of the masterpieces on view, the Frick's own *Symphony in Flesh Colour and Pink: Portrait of Mrs. Frances Leyland* (1871–74), stars a dress that may or may not have existed. As attendant drawings attest, Whistler designed the flowing tea gown in diaphanous fabric, spotted with embroidered rosettes, over a simple white

underdress. (A mildly risqué fashion of the day, the tea gown derived from the French peignoir and featured a top-to-bottom "Watteau pleat.") Mrs. Leyland, who was perhaps a lover as well as a patron of the artist, stands full length in three-quarters view from the rear, her hands clasped behind her and her introspective, trusting face in profile. The infinitely nuanced colors of the fabric are continuous with those of a Japanese-flavored room. No one knows what the front of the garment looked like, or whether Whistler bothered to complete it. As always, the picture entailed endless posing—a "martyrdom," Frances's husband said, but she insisted that she enjoyed it. (The couple later divorced.) Whistler's Velázquez-influenced, breathtaking portrait of the young Cicely Alexander, done in 1873, when she was eight or nine years old, took seventy long sessions, which often reduced the child to tears; the painting faithfully conveys her grumpiness. Afterward, she and the artist became good friends. Few females could stay mad at Whistler.

He was a lover of women and a hierophant of art for art's sake. Those passions merged in his treatments of clothing, which amount to reversible masks for the sitters and for himself. Fashion gave him the further advantage of access to the dials and levers of high popular taste, where women wielded a power that was denied them in most other spheres. Whistler was the kind of score-keeping narcissist who seeks less to do something—though he worked extremely hard—than to be seen as having done something. He was his own ideal audience. "Wonderful," he exclaimed when he saw one of his own paintings twenty years after its creation. "Such pots and plates and fans!" The work, *Purple and Rose: The Lange Leizen of the Six Marks* (1864), depicts his model and mistress of the time, Joanna Hiffernan, an Irish redhead who is best known for her appearances in torrid paintings by Courbet. She wears several richly embroidered Chinese robes and pretends to paint a Chinese blue-figured jar. (Whistler was a leader in the period's craze for things Oriental.) The colors are amazing, but the paint is overworked and gummy. The young Whistler was in thrall to the social and artistic romance of French Realism, which led him into back-alley bohemias (his first Parisian girlfriend was a gamine called Fumette, who, to make a point, tore up his drawings) and into ways of painting, with Manet-like éclat, that didn't really suit him. After a subsequent, brief association with the fussily Realist Pre-Raphaelites, he hit his stride as a militant aesthete—the pictorial poet of London's salons and foggy twilights—and a fop's fop.

Whistler was so aggressive a butterfly that it's a bit embarrassing even now. He foolishly crossed swords with Oscar Wilde, who easily outclassed him in wit. But his famous, disastrous lawsuit, in 1877, against John Ruskin for a grotesque review—the great critic had written, "I never expected to hear a coxcomb ask two hundred guineas for flinging a pot of paint in the public's face"—addressed a real injustice. It is still shocking that Ruskin refused to recognize, in Whistler's consummate stylistic synthesis, the refinements on his own particular hero, J. M. W. Turner. Contemptuously awarded a farthing in damages, ostracized, and soon bankrupt, Whistler learned cruel lessons about the city that he had sought to enchant. Henry

James noted in 1877 that "the taste for art in England is at bottom a fashion, a need of luxury, a tribute even … to propriety, not an outgush of productive power." Thrillingly, Whistler rebounded with outgushes to remember—notably, two portraits, painted in 1881 and 1882, of the formidable Mrs. Valerie Meux, later Lady Meux. Humbly born and with a shady past, she married a beer baron and became one of the wealthiest women in England. She didn't give a damn about social opinion, and she was rewarded with the stunningly modern-looking *Arrangement in Black: Lady Meux* (in a starkly simple gown, with a huge white fur cape and icy diamonds) and the outrageous *Harmony in Pink and Grey* (voluptuously seductive in a dress that seems corseted from the outside).

Whistler and Mrs. Meux had a falling-out during sittings for a third portrait, but they stayed in touch. In 1892, she wrote to him, "I suppose we are both a little eccentric and not loved by all the world, personally I am glad of it as I should prefer a little hate." A few years earlier, in 1888, Whistler had married his perfect match, the widowed artist and decorator Beatrice Philip Godwin. They became happy fixtures of upper bohemia, intimates of the poet Stéphane Mallarmé and of Proust's paragon of the dandy, the Comte Robert de Montesquieu-Fezensac. After a period of terrible suffering, Beatrice died of cancer, in 1896. Whistler's lithograph of her from that year, wasting in bed but mustering a wan smile, strikes a renewed realist note with a depth of feeling that, one realizes upon reflection, was always present in him. His last years were spent in the company of two of Beatrice's sisters, who appear in crackingly inventive late portraits that look back to Goya and forward to Expressionism. No matter how much esoteric froufrou enters into Whistler's calculations, early or late, his art is emotionally grounded, fully integrated, and often transcendent. Its open secret is a wedding of Eros and artifice such as was achieved by a literary contemporary of Velázquez, Robert Herrick:

Whenas in silks my Julia goes,
Then, then, methinks, how sweetly flows
The liquefaction of her clothes!

Next, when I cast mine eyes and see
That brave vibration each way free,
—O how that glittering taketh me!

May 12, 2003

ABSTRACT MERIDIAN: AGNES MARTIN

Agnes Martin, who is now ninety-two years old, has a show of surprising new paintings at PaceWildenstein in New York and, at Dia:Beacon in Beacon, New York, of paintings from the years when she emerged as an important artist, from 1957 to 1964. This is a good time to take stock of the ascetic abstractionist and of the dedicated idealism, an ever more troublesome aspect of modern art, for which she stands. Her work is too often regarded as a sidelight to sculpture-intensive Minimalism. She was, and remains, a contemporary of the Abstract Expressionists, affected (she rejects the notion of "influence") by Jackson Pollock, Mark Rothko, Barnett Newman, and, notably, her friend and fellow-admirer of Eastern art and mysticism Ad Reinhardt. In the late 1950s and early 1960s, Reinhardt developed what he called the "last painting": velvety black cruciform compositions of barely perceptible squares. Martin's classic pencilled grids, washed with neutral or pale colors on square canvases, are similarly gaunt and meditative, while considerably less doomy. A few days after Reinhardt died, in 1967, Martin gave away her art supplies and abandoned New York, not to paint again for four years. She settled on a mesa in New Mexico, where she still lives. She is something of a recluse, though garrulous in interviews.

"When I first made a grid," Martin said, in 1989, of her breakthrough, in 1960, "I happened to be thinking of the innocence of trees and then a grid came into my mind and I thought it represented innocence, and I still do, and so I painted it and then I was satisfied. I thought, This is my vision." In 1966, in an often quoted statement, she wrote, "My paintings have neither objects nor space nor time nor anything—no forms. They are light, lightness, about merging, about formlessness, breaking down form." Her rather blowsy theories, invoking nature in strictly heady ways and harping on "perfection," consort oddly with her pragmatic, unsentimental practice. Martin's art is flinty in its abnegations and materialist—resistant to metaphor—in its effects. As with Tantric diagrams, you see exactly what the work is, even as, with patient looking, you may undergo a gradual, and then sudden, soft detonation of beauty. Canadian-born, Martin calls to mind her countryman Glenn Gould, who proved at the piano that, contrary to conventional wisdom, perfection is not beyond human grasp. There are human costs to gaining it, of course. It tends to obliterate personality.

Geography matters. Martin is from Saskatchewan, up north on the tabletop of the Great Plains. Being from North Dakota myself, I feel a spark of identification with her art's dry, chilly lyricism. There is nothing cuddly about nature in that neck of the non-woods, where vicious cold and exhausting heat, ceaseless wind, and, alternating underfoot, snow, ice, sucking mud, and black dust try the soul. By way of

compensation, there's sky. A tremendous inverted bowl bells down over every horizon—affording far-distant glimpses of other people's weather. The god of the plains is an orthodox Minimalist, specializing in brute coups of uninflected space and light. Checkerboard roads and evenly distributed grainery towns—mapped in advance, at the time of settlement, by governmental and railroad bureaucrats—advertise humanity as a complementing force of sublime, heartless logic. A sense of existence as seamless and intractable—all one hard thing—crushes and exalts the plains dweller, inducing both humility and lofty intuitions.

Martin came to New York in 1957 at the insistence of her first dealer here, the prestigious Betty Parsons, and she lived and worked downtown, by the East River, on Coenties Slip. She shared the neighborhood with Robert Rauschenberg, Ellsworth Kelly, James Rosenquist, and several other fomenters of tough-minded responses to Abstract Expressionism. All sought sturdy formats for painting that would face up to the masters while eschewing the he-man egomania that marred the "second generation" New York School. Heroic posturing embarrassed an American avant-garde that was conscious of inheriting global art-world leadership. Martin's earliest paintings at Dia:Beacon evince a poignant struggle to find a satisfactory style. They aren't very good, apart from displaying a strikingly talented way with filmy texture and muted color. Then comes the grid. It is square or rectangular, always on a square canvas or sheet of paper, and it usually stops or blurs just short of the edge, such that, in the eye, it jiggles loose and hovers. The works' perfection registers poetically, by an easy Platonic leap from their candid physical imperfections. Inevitable vagaries of the artist's hand—lines of subtly varying thickness, bumping over the tooth of the canvas—take on a certain raciness, as the only signs of actual nature that this art condones.

The grid allowed Martin to command, without fuss, the all-over, all-at-once formal democracy that Pollock, with his drips, had achieved in spasms of inspiration. And it enabled something like the brooding presence of Rothko's color-forms, but in an airy key. From Newman, Martin patently learned how a straight line that is laid under or over, or scored into, a ground of paint may take on qualities of being a discrete shape while registering direction and velocity across the surface. That is, you don't read Newman's or Martin's line as a graphic contour but as an actor in the pictorial field. It anticipates all the eye's ways of seeing. Edge and shape, figure and ground, and matter and atmosphere are reversible, bringing about, for me, a distinct oscillation in the optic nerve. It's not a perceptual flicker, as in Op art, but a conceptual traffic jam: sheer undecidability. My analytical faculties, after trying to conclude that what I'm looking at is one thing or another, give up, and my mind collapses into a momentary engulfing state that is either "spiritual" or nameless.

What is the value, for life, of spirituality as a secular discipline? Martin's art sustains that question, an American preoccupation since the New England transcendentalists, which became newly acute, in art, with Rothko, Newman, and Reinhardt. When unrelated to a particular belief, might transcendence be no more than a

neurological burp, soothing the mind as the alimentary kind does the stomach? I thought about this at lovely, light-drenched Dia:Beacon, a place that devotes a terrific amount of real estate and remarkable architectural skill to implementing little hits of pure aesthetic emotion. An anti-church, it offers, in place of religion, beneficent addiction. (The hits wear off quickly. You want more.) This may be the upward limit of what liberal culture can provide for the common soul. Perhaps it's enough. Certainly, Dia:Beacon stirs grateful awe. Look at what we humans can do!

Some of Martin's new works at PaceWildenstein harken back to her experimental formats of the 1950s: symmetrical arrays of triangles or squares and lines that read as horizons. In one case, a regular trapezoid, black in a brushy gray ground, can be read as a receding ramp, or a pit. It is entitled, weirdly, *Homage to Life*. (It looks thoroughly deathly to me.) These retro versions of Martin's questing early work feel willfully arbitrary. But her regression seems to have tapped new oomph for her stylings of drawn or scored grids and, in another familiar layout, horizontal bands of watery color (grays, blues, and yellows in this show). As always, Martin celebrates, like no other painter, the limited virtues of acrylic paint: opacity and fluidity. One painting, from 2003, is a masterpiece: *The Sea*. Scored, alternately continuous and broken horizontal scorings cut to white gessoed canvas through a white-bordered square mass of tar-black paint. The lines' irregular thicknesses produce a twinkling effect, slightly suggesting a moonless night sky while staying bluntly factual. *The Sea* worked on me faster than any other of Martin's paintings. How could I gainsay anything so efficiently profound? I wonder.

July 7, 2004

" **E**ast Village USA," at the New Museum of Contemporary Art in New York, explores a do-it-yourself art scene that took form suddenly in 1981 and flourished until its equally abrupt end, in 1987. Bold youths stormed an impoverished neighborhood that had been devastated, in the previous decade, by fire and crime. They promulgated nihilistic punk and nascent hip-hop, the rogue glamour of graffiti, haphazard variants of Neo-Expressionist painting, gamey performance art, drag-queen cheek, anarchist political deliriums, and bustling entrepreneurship. Limousines purring outside storefront galleries on grubby blocks symbolized a romance of the rich with the nether classes which gentrified the latter out of house and home, and which betrayed their artistic progeny, as one season's cosseted graffiti master became the next's snubbed has-been. AIDS, fashion fatigue, real-estate speculation, and the lure of a booming SoHo for the more nimble dealers and artists (who were fed up with tenements that afforded few spaces suitable for exhibiting or even making art) withered the scene's shallow roots. There was something toxically facetious about the East Village versions of avant-gardism and *la vie bohème* which heralded a shift to arch self-consciousness in American culture. (Writing in this show's catalogue, Liza Kirwin notes the nearly simultaneous debuts, in 1982, of a trailblazing gallery in the artist Gracie Mansion's bathroom and "Late Night with David Letterman.") But the half-cooked epoch was significant in ways that merit closer consideration than it has received.

The best art in the show, which manages to be both comprehensive and concise, tends to be the least reflective of the street-level East Village experience, with one exception. Nan Goldin's color photographs of determinedly broken youth—from her great, baggy suite *The Ballad of Sexual Dependency*—preserve the desperate, at times literally deathly, ardors of a generation that stayed up late to fit into each day its maximum quotient of mistakes. Her work's formal beauty and aching intimacy transformed a genre of kids-on-the-skids verite that had previously been identified with grainy black-and-white and churlish defiance. (Think of Larry Clark's winsome, strung-out oafs.) In *The Hug* (1980), a bare, muscular, strangely disembodied male arm clasps a frizzy-haired girl in a thrift-shop blue dress. Her face is unseen, but she feels known: daughter, sister, confidante. Flash-lit, with inky shadows, in a corner of a white walled apartment, the picture is a baroque icon, becoming classical as its period qualities recede in time. Thanks to Goldin, the East Village moment lingers as a fable of tear-stained vitality that, thwarted by limitations both personal and cultural, stupidly but somehow magnificently threw itself away in drugs, drink, violence, and spasmodic erotic splendor.

A suggested title for a musical version that would be truer than the formulaic *Rent*: *What I Undid for Love*.

In general, what survives as estimable East Village art is somehow atypical of East Village art, whose definitive keynote was punkish amateurism, and whose strongest mode was ephemeral performance. (Projected videos of Karen Finley, Ethyl Eichelberger, Ann Magnuson, and other galvanic spirits in action are informative, at times hilarious and even moving, tribulations.) Most of the paintings in the show are terrible, ranging from the truculent clutter of David Wojnarowicz, an inchoate *poète maudit*, to the hysterical giggles of Kenny Scharf, whose maladroit cartooning no longer surprises. Marginally better, because they are firmly styled, are a shadowy woman at a window on Times Square by Jane Dickson and a painterly pastiche of a pulp paperback cover by Walter Robinson; they channel raw melancholy and righteous wit in properly low-down veins. Jean-Michel Basquiat and Keith Haring are important special cases, alike in being middle-class sophisticates who mythologized themselves as wild-child graffitists and became international stars. (Both died young, Basquiat of an overdose and Haring of AIDS.) Haring functioned as a one-lad advertising firm for sex and fun; his forte was less art than graphic design. Basquiat was a superb artist who reinvigorated traditions of New York School painting. His talent often complicates the vampings of a dubious persona—petulant, soulful, semi-literate urban primitive—with a self-aware intelligence as unfathomable as that of a Miles Davis solo.

The ghost of Andy Warhol, a demiurgic role model for the East Villagers, wafts through the show; his death, in 1987, no less than that year's stock-market crash, italicized the scene's collapse. Warhol had latched on to Basquiat as a career-freshening protege and collaborator, and Warholian cunning informed the ultra-smart inventions of Neo-Geo, the milieu's one launched movement that attained exit velocity, preoccupying the wider art world for a couple of seasons. Jeff Koons, the magus of an aesthetic that transforms commodities into art, which is then presented as the ultimate commodity, was overqualified for the East Village on arrival. His stunning debut at the gallery International with Monument, in 1985, included *Lifeboat*, an inflatable raft, meticulously cast in bronze, that feels intent on sinking without delay to the center of the earth. (The next-best Neo-Geo artist, Peter Halley, made blocky, jarringly colored paintings whose geometric imagery evokes both microchips and prison cells; these have dated.) And Warhol's Factory-tested protocols of instant, perishable celebrity infused East Village performance and social styles. A happy discovery, for me, is a tape of "TV Party," a cable-access show hosted by Glenn O'Brien, whose mix of stoned talk and often terrific guest performances by musicians and oddball buskers fitfully evinces a Talking Heads-like perfect pitch in deriding pop culture and eating it, too.

The contemporary art world of the early 1980s blew apart into four main fragments, of which the East Village was one. The others were a defensive establishment of older artists, a fashionable confederacy of Neo-Expressionists, and a gang of

theory-mongering Duchampians. All surfed waves of new money. Eventually, even the fragments disintegrated, becoming the sluggish mishmash that has prevailed in art ever since. The East Village contributed the novelty of a New York avant-garde that forsook global perspectives to party locally. (As such, it was a franchise of similar slum Babylons in European cities.) It was directly opposed by a craze in academe for moralizing discourses—deconstructionist, Marxist, Freudian, feminist. Delectable tensions surfaced between these sensibilities. A leading exegete of theory on the scene, Craig Owens, hatched the keenest critique of East Village art, in one word: "Puerilism." (Why the slur's victims didn't promptly embrace it, on the model of "Fauvism," I don't know; maybe they lacked ready access to a dictionary.) Such starchy acuity from one who was himself young points to the split personality of a generation: part hellbent on polymorphous perversity, part hankering for the imperviousness of erudite age.

For me, the single most shocking idea to emerge from the East Village is not recalled in this show. It was a proposal by Walter Robinson to create a lucrative market in a new species of folk art: the crudely lettered, pleading cardboard signs wielded by the homeless who then teemed the city's streets. The signs had everything: funky elegance, patent authenticity, social content, convenient scale, and reliable supply. I tried, and failed, to contemplate those tissues of misery as found art. The gesture of selling them seemed at once grossly ingenuous and vilely cynical, disgracing both art and the market. But suddenly the project (which went nowhere) strikes me as the supremely honest exposure of an anxiety that most of the artists in "East Village USA" squirm to deny or finesse: a double-bind of elitism and populism. Drives to be at once aesthetically impeccable and socially justified generated alternating currents of bad art and bad faith, which only lordly money could be counted on to adjudicate. Some such quandary afflicts all ambitious art in American democracy. The East Village got drunk on it. *In vino veritas.*

January 24, 2005

PAINTINGS FOR NOW: NEO RAUCH

Abounding critical and commercial success has earned Neo Rauch a solo exhibition at the Metropolitan Museum, of fourteen typically virtuosic and befuddling paintings, all made this year. Rauch may be barely known outside the art world, but fame is increasingly superfluous to the establishment of an artist's sinecure. Insider buzz and sales to collectors of the right pedigree are what count. An influential teacher as well as painter, Rauch is the champion of a fertile scene in Leipzig—long an arts center—in the former East Germany. (In Germany, unlike here, teaching is a prized role of art stars.) He was born in Leipzig in 1960. When he was a few weeks old, his parents died in a train wreck, and he was raised by his maternal grandparents. He studied under the tottering academic regime of Socialist Realism, which lingers in his work's frequent suggestions of foul utopias peopled by smooth-browed heroes, laced with Surrealist uncanniness, and given Pop éclat. Aspects of his style bring to mind Goya, Beckmann, Balthus, and Magritte, as well as, in trace amounts, Jörg Immendorff and other West German Neo-Expressionists who affected him in the 1980s. He is a homebody, living with his wife and teenage son in Leipzig, and bicycling six miles each weekday morning to his studio, in an old cotton mill. He teaches two days a week. On weekends, he gardens. His pictures feature structures and interiors familiar from his childhood: in his words, "kitchens, barracks, workshops, and nurseries." With no prior planning, he starts and develops his complex compositions on canvas. He told an interviewer, "I understand myself to be a director of plays." The plays, such as they are, emerge in the process.

Rauch has said that his subjects often derive from his dreams, and that the recurrent character types—sensitive young man, bearded older man, chunky young woman, and proletarian, military, or fire-brigade squad—all represent him. Their behavior stymies interpretation, and even curiosity. It can appear not to interest the artist himself very much. Three men in crimson riding jackets, backstage at a theatre, dominate the panoramic *Para*. One sits at a piano, perhaps composing. The second—huge and bending over, it seems, to fit into the picture—peers at the third, who stands next to a woman in blue, seated with a cello, and parts mustard-colored curtains, as if to check the house. A rustic table in the foreground supports CD cases (a visitor to Rauch's studio in 2005 noticed piles of up-to-date pop music, such as the White Stripes) and, on an anvil, a little hammer and a small red dragon with yellow and green wings. The red-lettered word "PARA" floats above. In terms of narrative content, the work is maddeningly coy—unless you fancy Jungian woolgathering about archetypes and suchlike—but it is so well designed and painted that, once you have started looking, resistance gives way.

Rauch has titled the entire show "Para." The curator, Gary Tinterow, the Met's chief of modern and contemporary art, writes in the catalogue that he believes

the artist "hopes to set in motion a string of associations with the prefix: paranormal, parallel, paradox, and so on." "Paradox" seems wrong, for want of any apparent doxa to contradict, and so does the idea of a response "set in motion." Rauch's stories don't come from or go anywhere, as far as I can tell. Every association—in the painting *Para*, to hunting, music, theatre, and magic—is a cul-de-sac: arriving at it, you must return by the route you took. Rauch's hermeticism is most daunting when his scenes are most nearly naturalistic. Four figures with crossbows inhabit *Jagdzimmer* (Hunter's Room). One young man lights another's cigarette; a bearded man gestures strangely; and a woman pokes at a dead bird on a table. Their poses have the charged solemnity of Balthus, without the erotic crackle. Nothing seems to be at issue for them. (The bird is beyond caring.) But masterly areas of the painting, astonishingly varied in style, captivate. Rauch tends to use oils as if they were poster paints, flatly—often scumbling, rather than glazing or blending, to modulate tones and colors. The result is a surreptitious richness. The rhetorical potency of oils—sensuous texture, light-drinking color, infinite suggestiveness—strains at a short, taut leash. The constrictive effect strikes me as perverse, but it is certainly original. It also anchors Rauch's importance as an artist of and for the historical imbroglio of art today.

Collectors are tumbling over one another to rate contemporary art higher and higher, in a frenzy that feels religious—the market as a medieval cathedral under construction, whose consumption of resources declares the priority of immaterial belief over practical needs. Inflated financially and, through booming institutions, socially, art may never have been more esteemed while meaning less. Rauch's production of handsome, stony symbols of something both momentous and ungraspable happens, by a chance that resembles fate, to mirror the crisis. A bard of Eastern Europe, rooted in the obsolete future of revolutionary hopes, he deploys a deadpan satirical tone of majestic confidence with no conceivable basis in fact. His attitude is profoundly conservative, though not reactionary, if only because it doesn't countenance anything to react against. Rauch's redolences of Socialist Realism are like a dead-virus vaccine: a virulence deprived of its power to sicken and, thereby, forfending sickness. Violence and danger there may be. People are prone to madness. In *Vorort* (Suburb), men in a street burn flags of indeterminate nationality. A sinister, old-fashioned aerial bomb lies nearby. But a yellowish cast of sunset light combines with the yellow of flames to invest the scene with the dreaminess of a fairyland comedy. The situation is grave, but not serious. Rauch's work provides a cultural moment that seeks legitimacy in art with talismans of rhapsodic complacency.

The surprise is that worry-proof conservatism can generate real artistic force. It does so, in Rauch's art, by finding opportunities, in trumped-up fantasy, for recovering traditional aesthetic capacities of painting. Having nothing to say, he says it ever more marvellously. Tinterow helps us gauge one signal quality by extending the show into a room of the Met's permanent collection that contains pictures by such stalwarts of painterly expressiveness as Lucian Freud, Alice Neel, Leon Kossoff, and Georg Baselitz. The collegial affinity alerts the eye to almost subliminal wonders

of brushwork in Rauch's stolid mise en scène. He could do anything that those artists do, the comparisons imply, were he not committed to more important tasks, such as, in *Die Fuge* (The Fugue, or The Gap), reporting the event of a bearded man emerging with a chain from a heaved fissure in the earth, while what appear to be firemen labor obscurely, a man and two women (or half women, merging with each other) levitate next to a brick shed that bears bubble-lettered graffiti, a mountain looms— and that's far from all. Epic and ridiculous, the tableau wields its felicities with a comical lightness, as of throwaway witticisms. My attention to the picture finally focused, with pleasure, on a marginal passage of still life: an unidentifiable animal part in a dish rests on a fish atop a book on a cloth on a table. The detail constitutes a lovely oddball painting in itself.

Come to that, still life seems to be Rauch's lurking, fundamental genre. His people are objects. He arranges them. Everything, including snatches of abstract design or facture, feels imported from somewhere and put in place, where it stays. In *Der Nächste Zug* (The Next Move, or The Next Draw), cigarette smoke, blue-gray on a black ground, doesn't rise or drift; it locks down into a calligraphic abstraction of a vaguely 1940s, European sort. Not that noticing the stylistic echo profits a viewer anything. The more observant you are of erudite allusions in the show (some male figures display particular airs and dress styles of nineteenth-century German Romanticism), the more acute will be your frustration in trying to make sense of it all. If Rauch's work is nightmarish, as some critics have asserted, the effect pertains not to its dramas but to their mockery of understanding. They are not mysterious, because mysteries imply solutions. Rather, they convey that we may know plenty but our knowledge is useless. There is a highly contemporary sting in this. Today, we are flooded with accurate information—letting us confidently judge the failures and iniquities of political leaders, for instance—and we naturally feel that such clarity must influence events, but it only amplifies our dismay as the world careers from one readily foreseeable disaster to another. Rauch sets us an example of getting used to it.

Conservatism takes grim, or not so grim, satisfaction in demonstrations of human folly. It has a major pictorial philosopher in Rauch, who calmly implicates himself, and art, in a vision of futility as destiny. *Die Flamme*, which seems quite explicitly a metaphorical self-portrait, presents a riding-jacketed man, in a landscape, striding the length of a long wooden box of painting materials. He carries semaphorelike flags. His legs are lashed to planks that extend upward to form an X. The flame of the title is a pale flare in the sky, over the distant horizon. The image might be read as an allegory of inspiration contingent on an acceptance of grotesque handicaps. Or it might not. But I think I've never seen an excellent painting that is so masochistically cheerless, to the point of revelling in a contemplation of impotence. I would like to despise the artist for this, but his visual poetry is too persuasive. Present-day reality is a lot more like one of his pictures than I wish it were.

June 4, 2007

T he sweet gravitas of Fra Angelico's paintings may be the all-time best advertising for Christian piety. The early Renaissance master (c. 1395–1455), seen in a rare retrospective at the Metropolitan Museum (the first in the United States and the second anywhere), breathes spiritual gladness—not ecstasy or bliss, nothing strenuous or unhinged—in a palette given to effulgent pinks, ambrosial blues, and embossed gold, which he uses as a color. His secret is sincerity. Wholly absorbed in his subjects, Angelico seems freshly surprised by the poignance of each conventionally composed Madonna and by the unfathomable sorrow of every Crucifixion. Legend holds that he wept whenever he painted the Passion; the tender, gazing concentration of the pictures—including a highly unusual *Christ Crowned with Thorns*, with blood-red eyes—makes this plausible to me. (So much pain, for an undeserved love of humanity.) In predella panels, Angelico retells the adventures of the saints with wondering excitement. They are palpably interesting, remarkably even-tempered people; even having their heads chopped off doesn't rattle them much. And his angels! So nice! Only Angelico, in all of Western art and literature, not excluding Dante and Milton, persuades me that Heaven might be really enjoyable, owing to the liveliness of the company. In the painting *Paradise*, saints and angels stroll skyward through a verdant garden and break into pretty turns of courtly dancing. Eternity is going to be fun for them.

Angelico was born Guido di Pietro, near Florence, of unknown parents. He was a freelance artist, probably studying with Lorenzo Monaco, before entering a Dominican convent in his early twenties. By 1423, he was a friar, taking the name Giovanni da Fiesole. His earliest, tentatively attributed works, sampled at the Met, are lovely drawings for illuminated manuscripts. (Since the first Angelico retrospective, in Florence in 1955, new attributions to the artist have come thick and fast, by the standards of art history, incidentally reducing the already doubtful status of the Late Gothic painter Gherardo Starnina, whose putative touchstone *Thebaid*, a teeming narrative of a monk's travels to Egypt, now belongs to the young Angelico.) The scant record of Angelico's life does not contradict Vasari's portrait of him in *The Lives of the Artists*, written a century after his death, as a devout, obedient servant of his order. To those who wanted work from him, Vasari noted, Angelico "would say with great charm that they should first secure the consent of the prior and then he would not fail them." (For conjoined humility and grandeur, nothing touches Angelico's frescoes in the cells of the Dominican convent of San Marco in Florence: each austere little chamber is graced with a masterwork.) Angelico died in Rome, the most celebrated Italian painter of his generation. Vasari says that he

was always called Fra Giovanni Angelico (Angelic Brother John), though the sobriquet was not documented in his lifetime. Since then, it has alternated, especially in Italy, with Beato Angelico, a nomination for sainthood that John Paul II made official in 1984.

How much weight should be given to the notion of Angelico as a holy innocent? Vasari says that the artist renounced wealth and power and lived "withdrawn from the snares of the world," and he recounts that, on one occasion, Angelico declined to eat meat with Pope Nicholas V, because his prior had not granted him permission, "the Pope's authority in this matter not occurring to him." The show's chief curator, Laurence Kanter, and other scholars, writing aridly in the beautiful catalogue, are at pains to discount the tenor of such tales as a sentimental distraction from Angelico's artistic genius. They argue that he was intellectually acute and stylistically progressive, notably in his response to the innovations in perspective and modelling of his meteoric contemporary Masaccio (1401–28). The corrective would be welcome if anyone needed correcting, but who mistakes Angelico for a cloistered Grandma Moses? There is much to be said for the services to mental clarity of just-the-facts scholarship, a discipline with its own equivalents of monkish virtue. I've just never been more struck by the effective heartlessness of an art history that dismisses all values except those which answer to empirical study. Viewers seeking emotional meaning must confirm for themselves that Angelico's definitive charm is as a storyteller.

Consider the account of the magician Hermogenes. According to the catalogue's brief exegesis of a little panel painting, just ten inches high, this obscure character "summoned devils to ensnare Saint James, but the apostle turned them on Hermogenes instead. The devils bound Hermogenes, but James ordered him freed as an act of Christian charity, and offered him his own staff as an amulet against the demons." The picture shows the sumptuously robed, unhappy sorcerer being untied at the saint's direction. A gang of satisfyingly dark, furious, fire-spewing devils riot behind him. The complex composition—five human figures, a colonnaded palace, a house, trees, and mountains—is improbably airy. That and the rounded mass of the figures and the deft spatial recession of the architecture are extremely sophisticated for their time. But style, in Angelico, never trumps story. James's extended staff disappears behind the man who is freeing the magician: the occlusion hints at a jump in time—the offer of the staff is a future action, which waits on the untying. Such medievalish devices for packing sequential events into single frames are far from incidental to Angelico's significance. They are even, perhaps, the timeliest features of his work today, when possibilities of narrative and illustration preoccupy more and more artists in mediums from painting to comics to performance.

Be warned that, at the Met, getting in the swing of Angelico's art takes some effort. The frescoes and the major altarpieces that are his greatest work are necessarily absent, and many of his sixty-eight temperas on wood in the show are variously abraded, battered, overpainted, or badly restored fragments of plundered ensembles.

It can be hard at first to distinguish their motifs from the standard fare of the early fifteenth century. The supplementary works in the show are of no help in this regard, emphasizing later—and distinctly lesser—artists whom Angelico influenced. But these impediments have the consequence of proving Angelico's intimate glories, which blossom given prolonged attention to the details of execution. If I could take home one work from the show, it would be a small panel, *The Annunciatory Angel*, that is part of an Annunciation scene. The androgynous angel, in pink robes with a slash of blue, leans forward as if into a gust of wind, one hand on his chest and the other beginning to advance in a gesture of offering. The face is intent but serene. A swiftly brushed wing, of brown feathers, merges with the gilt background, above a swath of patterned floor in convincing perspective. The delicately roughened surface texture gives sensuous immediacy—suddenness, even—to a figure that feels less lit and shaded than made of materialized light and shade.

Angelico brought celestial essences down to earth, gently. His style harmonizes elements both archaic and innovative. His Madonnas and Crucifixions retain the hieratic structure of the Gothic, but with a diminished sense of upward thrust. At the same time, he soft-pedals the realistic weightiness of bodies, which Masaccio developed and Piero della Francesca would perfect. It's as if rising and descending forces acted simultaneously in Angelico, with gravity given a slight edge. The effect of tensed, subtle buoyancy is rhetorical. It pronounces Angelico's idea of religious grace. Just think of Heaven, he implies, and its soaring immateriality will suffuse the here and now, making a miracle of physical existence. Notice how often the hands of Angelico's subjects gesture horizontally, parallel to the ground. Somehow, side-by-sideness is a felt condition, even of his single figures. Visually advancing color counterbalances illusions of deep space. Angelico's ruling quality is equipoise—of back and forth, right and left, down and up, this world and the next, medieval halos and Renaissance flesh. His appearance in New York is no mere visit but a visitation.

November 21, 2005

CÉZANNE VERSUS PISSARRO

In terms of a viewer's chief experience, "Pioneering Modern Painting: Cézanne and Pissarro, 1865–1885," at MoMA, is a show about Paul Cézanne: what he did, how it works, and why it's classical. Camille Pissarro, a likable man and a pleasing artist, important in any number of contingent ways, is not in the same league as that driven revolutionary. Not since the similarly titled "Picasso and Braque: Pioneering Cubism," in 1989–90, has MoMA, or any other museum that I can think of, produced such a pitiless comparison of stylistically related painters, one great and one just very good, with results that are instructive—providing vigorous exercise for the thinking eye—while sort of painful. The mismatch isn't as drastic as it might have been, because the Cézanne in this show, which stops when he was forty-six years old—eight years younger than Pissarro—had yet to attain the full flower of his talents. (To see that, take the escalator to the first gallery of the permanent collection, where five Cézannes, dating from 1885 to 1906, reign in clenched, strenuous majesty.) But, from the start, there's no contest. The show's drama is ambient, in the fact that it has been allowed to happen. It was organized by Pissarro's great-grandson, Joachim, a curator in the museum's Department of Painting and Sculpture. This lends an air of fond nepotism, which proves peculiarly subversive. As if slipped past a nodding door-keeper, Pissarro's earnestly ingratiating pictures jangle the museum's policy of fiercely screened modernness—a Draconian mania that is ever more played out.

The idea of their being pitted against each other would have surprised Pissarro, a French-Creole Jew from the West Indies, and Cézanne, a coarse Provençal. Their quarter-century friendship, during which they sometimes painted side by side, was forged in shared senses of social alienation and a generational crusade. (It ended after Cézanne holed up for good in Provence, in the mid-1880s.) In Pissarro, Cézanne found an older colleague who didn't laugh at his gaucheries. They met in the period of the 1863 Salon des Refusés, when the insurrection against the academic art world had rallied around the incendiary figures of Gustave Courbet and Édouard Manet. Cézanne and Pissarro, in their earliest paintings here, are thoroughly, earthily Courbet-like, immune to Manet-esque, sparkling urbanity. Abetted by their critical champion Émile Zola, they aimed their competitive rage outward, at the establishment. Pissarro, a declared anarchist, recommended burning down the Louvre. Cézanne characterized art schools this way: "Teachers are all castrated bastards and assholes. They have no guts!" We are on the familiar ground of modern art's creation saga, with knights of the new beset by howling and jeering philistines. Are we ready to be over that coercive romance? If so, team membership in the avant-garde no longer elides the differences between the amiable Pissarro and the unbending Cézanne.

Take one of several telling juxtapositions on offer: Pissarro's *The Conversation, chemin du chou, Pontoise* (1874) and Cézanne's *The House of the Hanged Man, Auvers-sur-Oise* (1873). Each is about two feet high and a bit wider; both show roads in rural towns, with steep-roofed houses. The Pissarro, set in a wooded valley, with two small figures, is quietly sumptuous. Layered, highly varied patches and strokes— *les taches* and *les touches*, the standard ingredients of School of Paris painterly cuisine—in greens, grays, and gray-greens conjure masses of absolute summer under a blue-blushing sky. The tonality and chroma of the scene's allover milky light are monotonous, in a manner typical of the artist; they are tasteful. Pissarro was prone to superfluous nuance and conventional pictorial unity. Now Cézanne. Looking down into a cluster of buildings on a hillside, he sorts out an astonishing congeries of overlapping planes and textures—anticipating the nested bumps and hollows of tactile space that would one day preoccupy Cubism. Though the picture has been called his Impressionist masterpiece, its glowing colors suggest not scintillant atmosphere but molecular oneness with walls, trees, and dirt that are drenched in sun and shade. Light and what it illuminates register as one thing.

A work of art, Zola said, is "a corner of the creation seen through a temperament." Pissarro and Cézanne swore by that individualist credo, which enjoined truth to raw sensation and its sincere rendering. Every proper artist "is more or less a realist according to his eyes," Zola went on to say, brilliantly. Pissarro and Cézanne both painted what they saw, but Cézanne went farther, in painting *as* he saw: point to point, with alarmed responsiveness to every zone, contour, and passage. He had the stronger, more peremptory temperament, to put it mildly. Cézanne wedged his eccentricities of vision between art and nature, and neither has been the same since. As he developed, he let compositional harmony take care of itself, which it does by way of edge-to-edge, fairly gruelling intensity. Cézannes can seem to have as many centers of attention as they have brushstrokes. They are also rarely much fun to look at. (It helps to imagine that you are a painter yourself, attending a master class.) He isn't interested in making anything easier for us than it was for him. He's barbaric, still. Pissarro, bending his sensation to picturesque and decorative charms, is civilized. Even when I'm disappointed with the spirit of one of his works—keenly so by a timidity in the almost swashbuckling *The Climbing Path, L'Hermitage, Pontoise* (1875), which features some forward-crowding splotches that shrug off realist description—I can't help but get pleasure from it. And there's nothing felonious in that.

This show reminds us that the difficulty of Cézanne is the spiritual cornerstone of MoMA. In the early twentieth century, influential artists and intellectuals in Europe and America agreed to exalt Cézanne's obstreperousness as the echt modern mind-set, thereby instituting a cultural oligarchy of experts which even now, though with mounting self-doubt, stands against popular tastes. You can't say something bad about Cézanne in the discourses called "modernist" any more than you can gainsay Jesus with language from Christian liturgy. Such is the authority of Cézanne's

attitude that only palpable surrender to it may win another artist approbation. The humbling of Pissarro in this show is thus as foregone as that of Braque was in "Pioneering Cubism." Braque, for all his extraordinary abilities, needed Cubism in order to enter the modern canon, as Pissarro needed Impressionism. Picasso, like Cézanne, needed only to show up. Writing in the exhibition catalogue, Joachim Pissarro doesn't explicitly complain of a deck stacked by his employers against his ancestor, but he verges on it when he proposes to understand the dynamic of the show "as a spectacular chess game . . . rather than as the first step toward modernism." This amounts to a plea, against ideological correctness, for values of old-fashioned connoisseurship, which are nugatory only for people who take no joy in using their eyes.

"Cézanne and Pissarro" is best savored at close quarters. Bring reading glasses. The two painters, during the height of their relationship, did indeed play a kind of chess, with ingenious technical moves and countermoves. In how many ways can a roofline abut foliage or the sky? What is the syntax of meadows? What color is shadow? At one point, each artist was painting with a palette knife in one hand and a brush in the other. Smooth and creamy alternate with rough and crusted, reflecting or absorbing light. Recent X-rays have revealed an intermittent, shared innovation that has been termed painting "in reserve": contours that started out as slivers of bare canvas, rather than lines, between shapes. The gambit, which makes drawing a by-product of painting instead of its armature (and which portends a good deal of later practice, as in Henri Matisse's tour de force *The Red Studio*), helps to explain an often remarked sense, in Cézanne, that edges aren't boundaries but places where paint, surging across the surface, changes color. In command of the same device, Pissarro characteristically soft-pedalled. Why couldn't he bear down a little more? It's a question about the kind of personality required for an art of combative ambition. The answer may be that, unlike his congenitally aggrieved colleague, Pissarro was too contented a man ever to be satisfactorily modern.

July 11, 2005

"**W**hat he had of art,** he had from me," Michelangelo complained of Raphael, whose early career, from 1500 to 1513, is the subject of an enticing exhibition, "Raphael: From Urbino to Rome," at the National Gallery in London. Michelangelo, who was eight years older than his contemporary but survived him by forty-four years—Raphael died on his thirty-seventh birthday, in 1520—thus claimed first place in what could have been a long line of miffed masters. "Influence" scarcely covers the relation to Raphael's work not only of Michelangelo and the other titan of the High Renaissance, Leonardo, but also of Raphael's father, Giovanni Santi; Perugino, who may have been his teacher; Pinturicchio; and Fra Bartolommeo. The show, which incorporates works by most of those elders, demonstrates that the prodigy from the Marches extracted the formal essence of each man's art to feed a synthetic style that would become a beau ideal of Western painting for the next four centuries. Raphael was preternaturally talented in all elements of picture-making, afire with ambition, and so charming that no one, be it a colleague, a mistress, or a Pope, could do enough for him. I don't like him. I fairly swoon before his best paintings—including, in the show, the *Alba Madonna* (1509–11), *Portrait of Pope Julius II* (1511), and *Portrait of La Velata* (1512–13)—but his perfectionism has something callow at its core. His relative neglect since the late nineteenth century, when the academic tastes that exalted him succumbed to the sterner inclinations of modern art, is no more than a trifle unfair.

An only child, Raphael was breast-fed by his mother—this was unusual for the time—at the behest of Santi, an accomplished poet and courtier as well as painter, who was determined to shield his son from the low company of peasant wet nurses and their kind. (The young Michelangelo had suffered and, ultimately, profited from just such rough society.) Raphael's childhood, though marred by his mother's death, when he was eight, was sheltered, rich in aristocratic culture, and industrious. He was assisting in his father's workshop at the age of eleven, when Santi died. Entrusted to an uncle, he obviously thrived. The show opens with a startlingly adept and subtle self-portrait drawing from his adolescence, which depicts a clear-eyed, self-consciously irresistible boy. Equally precocious paintings from the same period, though rather forced in their prescribed religious content, conquer the style—sharply contoured active figures in atmospheric landscapes, sumptuously colored—of Perugino, then the leading painter of Central Italy. (Raphael's practical edge, from the start, was a yeoman's approach to preparation, proceeding through many drawings to fully resolved cartoons that were transferred to surfaces, usually wood, for painting. Other artists worked this way, but none more pertinaciously.)

At the same time, Raphael not only absorbed the decorative grandeur of history paintings by Pinturicchio but provided that artist, almost thirty years his senior, with designs for major frescoes in Siena.

In 1504, at the age of twenty-one, Raphael arrived in Florence to take on Michelangelo and Leonardo, who were both working there. Perugino's manner vanished from Raphael's style, which soon displayed Leonardo's "chromatic unity, interlocking gazes, and pyramidal composition," in the accurate judgment of the art historian David Drogin. A portrait drawing from 1505 to 1506 closely follows the *Mona Lisa* (1503–06), complete with a game approximation of the dumbfounding smile. Raphael added sugar to Leonardo's recipes, softening craggy landscapes into beamish vistas and demystifying shadows with warm tones. Meanwhile, Michelangelo's twisting, contrapposto figuration invaded Raphael's pictures, sometimes directly. He copied a stretching Christ child from a Michelangelo relief and, with adjustments, popped it into the *Bridgewater Madonna* (c. 1507). (In how many endearing ways can a naked baby disport itself on a mother's lap? The Renaissance counted them.) And a dashing, ever so slightly epicene drawing after the sculptor's *David* bespeaks less inspiration than light-fingered grand theft. Gravitas falls away, leaving gladness in finely muscled, limber flesh. Raphael passed every subject through the filter of his self-contentment.

In 1508, it was on to Rome, where Michelangelo was starting to paint the ceiling of the Sistine Chapel—and would never forgive the architect Bramante, his friend, for allowing the young challenger a sneak peek at the work-in-progress. Raphael applied what he had seen to become the premier decorator of the Vatican. In that role, he went on to produce frescoes and tapestry cartoons (which are outside the scope of the London show) that counteract most misgivings about him, including mine. Those works realize a genius for architecturally integrated design—mighty compositions of vivacious figures in deep space, appearing to expand the real area of a room—which constitutes Raphael's original, sadly truncated, contribution to art. It hardly matters that much of the actual painting was done by assistants: the pictures' majesty is chiefly a feat of organizational intelligence. Having inherited Bramante's position as the Pope's head architect, Raphael might today be at least as famous a designer as a painter but for his premature death. He had it in him to outgrow the simpering allure for which we are obliged to remember him. As it is, the powerful composition and exquisite color of the circular *Alba Madonna*, from the National Gallery of Art in Washington, D.C.—in freshly restored mint condition—must compete with the longueurs of cutely manly toddlers (Jesus and John the Baptist) and a Virgin decked out in racy chic, which, as a religious painting, is an epicurean travesty. (The English Pre-Raphaelites of the nineteenth century quixotically sought to restore painting to the point before Raphael "ceased to be a truly Christian painter," in the words of the art historian Nicholas Penny.)

Rome fell hard for Raphael's charisma. Vasari summarized his greatness this way: "Nature sent Raphael into the world after it had been vanquished by the art of

Michelangelo and was ready, through Raphael, to be vanquished by character as well." Raphael's "gentle humanity" was unsullied by the "touch of uncouthness and even madness" that marks most artists. He "was never seen leaving his house to go to court but that he was accompanied by fifty painters, all able and excellent artists, going with him to do him honor." He was a confirmed lover. Vasari writes that the only way one patron could get Raphael to finish a commission was by moving his mistress into quarters at the site. (Picasso made a late series of lyrically pornographic etchings in which Raphael and his amour engage in necessarily acrobatic congress, given that he never lets go of his palette and brushes.) Vasari gives as the cause of Raphael's death a fever enkindled by too much sex. Pope Leo X, who succeeded Julius in 1513, "wept bitterly" at his passing. Vasari exclaims, "When this noble craftsman died, the art of painting might well have died with him; for when Raphael closed his eyes, painting was left as if blind." It was left with an untenable model, certainly.

For me, Raphael's version of the beautiful is the sublime of the pretty: sheer comeliness, to the nth power. His paintings lack the element of reverent awe that informs beauty. They are about liking, albeit intense liking, rather than love. In this, Raphael was less a creator of the Italian Renaissance than its definitive human creation, a demigod whose capacities rivalled those of the divine. It's perfect that Leo X evidently planned to make this skirt chaser a cardinal. That was the historic moment when the profligate amorality of Rome, financed by the sale of what amounted to get-out-of-Purgatory-free passes to the faithful, brought on the Reformation. (Luther posted his "Ninety-five Theses upon Indulgences" two and a half years before Raphael's death.) The next youthful phenomenon of Italian painting, Parmigianino (1503–40), trying to square Raphaelite pleasures with the time's mounting religious and political anxieties, kicked off the long, floundering hysteria of Mannerism. There would never again be anyone like Raphael—as his more alert contemporaries must have sensed—because never again would a fully developed, energetic, urbane culture coast on a tide of such complacent aplomb.

November 22, 2004

MINIMALISMS

A bicoastal brace of mighty exhibitions—"A Minimal Future? Art as Object 1958–1968," at the Museum of Contemporary Art in Los Angeles, and "Singular Forms (Sometimes Repeated): Art from 1951 to the Present," at the Guggenheim in New York—scans Minimalism, the dominant idea in art of the past forty years. The L.A. show is powerful, though a mite oppressive. The New York show is full of delights, albeit softheaded. The stereo effect of the two gives depth to one's thoughts about a cultural revolution that encompasses our era—identifiably in music, architecture, and design, and tacitly in most other fields—much as the Baroque did that of the seventeenth and eighteenth centuries. As a movement in the 1960s, Minimalism corresponded with the rise of a new art world. Gone were the reigns of bohemian geniuses like Picasso and Pollock—the idols of poets, black-sheep heirs, and assorted amateur cognoscenti on small scenes in big cities. In came waves of academically trained artists, curators, and critics; prestige-mongering dealers; celebrity collectors and patrons; and other players in a rolling spectacle of success for success's sake. Minimalist emphasis on contexts—art as a phenomenon in real space and time—exalted "white-box" museums and ad-hoc venues, including, in the instance of earthworks, the great outdoors. The movement's theoretical cast spawned a thousand Ph.D. theses, written to be footnoted in other Ph.D. theses. Minimalism triumphed without ever becoming popular. As a type of art, it is boring, on purpose.

Both shows center on canonical figures from Minimalism's high heyday in the early 1960s: Carl Andre, Dan Flavin, Donald Judd, Robert Morris, Frank Stella. Both also feature artists who, in the late 1960s, launched Postminimalism, the delta-like spread of derived practices that continues to this day: Sol LeWitt, Bruce Nauman, Richard Serra. Other points of overlap are the hedonistic West Coast variant of Minimalism—colorfully enamelled planks by John McCracken, tinted glass boxes by Larry Bell—and such abstract painters as resisted a Draconian tendency to spurn all painting as "illusionist": Robert Mangold, Brice Marden, Agnes Martin, Robert Ryman. But the shows differ sharply. The Guggenheim's curators, Lisa Dennison and Nancy Spector, dilate; MOCA's Ann Goldstein homes in. "Singular Forms" adduces a fuzzy "reductive sensibility"—"an abiding impulse to pare a work of art down to its elemental core"—that casts Minimalism as the extreme extension of a time-honored taste, with such predecessors as Kazimir Malevich and Piet Mondrian (who are not in the show) and Ad Reinhardt (who is). This approach makes room for plangent abstractions by Ellsworth Kelly, and trippy space-and-light installations by Robert Irwin and James Turrell. It gives the leading role in the movement to Judd, whose astringent aesthetic was also a decorative style, inflecting obdurate objects

with seductive surfaces and gorgeous color: wall-hung cubical modules in polished brass and pink Plexiglas, for example.

By contrast, MOCA's "A Minimal Future?" insists on the movement's jagged break with all past art. The show begins—and climaxes—with a tremendous installation in a vast white room: "black paintings" from the years 1958 and 1959 by Stella, and blunt geometric arrangements of wooden beams, bricks, and steel tiles from the 1960s by Andre. The room's effect is definitive of high Minimalism: enveloping and saturnine. It feels less like the beginning of something than like a funeral. Of course, most art movements are arguments that start with their conclusions. Think of Analytical Cubism, and of Jackson Pollock's drip paintings: alphas that were also omegas, leaving subsequent artists to tease out implicit possibilities. Really big ideas in art, as in politics, transfix the culture until some new insight provides a way to see through and around them. I had hoped, apropos of the Guggenheim and MOCA shows, to announce that Minimalism is at last firmly historical—over, that is, as the background model of what it means to address contemporary reality honestly and creatively on a public scale. No such luck. The Andre/Stella room, in Los Angeles, retains crushing authority. It is deathless, if only because, in order to die, a thing must first live. Minimalism forced all vitality out of art and into its surroundings, the sphere of a self-conscious, mythical being who has starred in art discourse all these years: "the spectator," whom no one has ever met.

The Minimalists adapted abstract art to conditions of anomie in public life which had been decried in the 1950s by such sociologists as David Riesman, the author of *The Lonely Crowd*. Psychologically, the artists grounded their work in the self-emptying state of boredom. With sufferance, boredom may give rise to odd ecstasies of interest, as aspects of existence that elude the busy mind emerge with jewel-edged sharpness. Minimalist art works succeed by occasioning, rather than communicating, bleak epiphanies. The metaphysically evocative paintings of Malevich, Mondrian, and Reinhardt—and of Ryman, Marden, and Martin, for that matter—are quaintly sentimental, by comparison. Among painters, only early Stella seems echt Minimalist, because the work is so desolatingly object-like, though Mangold's dry, shaped paintings, infused with denatured color, feel peculiarly at ease in both shows.

When Minimalist works fail to make something happen for someone, they aren't bad art. They're nothing. There is a high quotient of nothing in the MOCA show, whose criterion seems to be doctrinal correctness rather than, as at the Guggenheim, aesthetic appeal. "A Minimal Future?"—its title taken from the March 1967 issue of *Arts Magazine*—favors artists who are willing captives of Minimalist logic, including several nearly forgotten painters who made a virtual burnt offering of their medium to the new god. What else can be said for a horizontal blue stripe painted, by Patricia Johanson in 1967, on a raw canvas twenty-eight feet long? You get what's supposed to happen. The dear, dutiful spectator walks beside the painting and registers the appropriate experience. This show's great first room aside,

its heart belongs to Morris, Robert Smithson, Dan Graham, Mel Bochner, Michael Asher, and other cerebral types whose art works function mainly as illustrations of theoretical (and occasionally, at least in Smithson's case, poetically sublime) ideas. Morris's influential painted-plywood beams and L shapes of 1964 and 1965—inert as sculpture, with none of the sensational truculence of an Andre—are like fine class projects, demonstrating command of a subject. A similar work from 1965 by Judy Chicago, adding pretty colors, is like a project for a class on Morris. The story told by "A Minimal Future?" leaves Minimalism, which began as an insurrection in the temple of art, crystallizing into a supererogatory academy.

The intellectually messy "Singular Forms" tells a richer tale. It highlights the fact that the movement precipitated a revolution in the decorative arts, which had been beggared by the challenge of bare-naked modern architecture and its immense, numbing public spaces—airports, malls, corporate plazas, and lobbies. As a building that is, in a way, all lobby, the art museum became the perfect laboratory for addressing this problem. Thus the preeminence of Judd, whose involvement with design and architecture and whose loyalty to simple beauty transcended not only Minimalism in particular but the art world in general. Ellsworth Kelly presents a related case. While radically reductive, he has been regarded by critical purists as an old-fashioned modern painter. Does it matter that Kelly's spanking shapes of clarion color, adaptable to any scale, are inexhaustible joys to behold? It does in the end, when merely smart and virtuous art gets shuffled off to the archives. Judd and Kelly are artists before and after they are artists of any particular kind.

We may never get past Minimalism, in the sense of developing a new big idea of what art can and should do in the world. Minimalism nailed the spiritual vacuum at the core of secular society, and the deep-down forswearing of judgment—open-mindedness like a hole in the head—that preserves democracy. The movement's peak revelation of meaning is Maya Lin's Vietnam Veterans Memorial, the lucky hit of an art student who was plainly influenced by Serra. It is about death, which erases all differences. It stirs grief, which is bottomless. It is like an Earth Mother gathering in her broken children. The memorial is also, by its existence, an advertisement of governmental institutions as bravely, profoundly responsible. There's the rub of Minimalism, which always endorses some or another faceless power. Minimalism ends where it begins, at the edge of a cliff. Any reaction against it can only be a turning-back.

May 3, 2004

<p style="text-indent: 2em;">The best reason for going to Venice to look at contemporary art, of all incongru-
ous things, is that any reason for going to Venice is brilliant. I don't love Venice, exactly.
That would be presumptuous. As if Venice cared! On its own planet, that incredible
place—is it even a city?—maintains an implacable self-possession. Tourists goofing with
pigeons in San Marco cannot mar its calm. If anything, they emphasize its aloofness, like
blurs in a time-lapse film. Venice attends only to the progress of light in its scintillant air
and across its celadon waters, building all day, every day, to a long-drawn-out evening
that is the last evening of the world. Feeling alternately blessed and furtive, then, I joined
thirty thousand invitation-bearing artlings for the opening of the 1999 Venice Biennale.
Talk about other planets! The international art world stood out like a sore asteroid, iden-
tifiable by jet-lagged, hectic miens, and the avidity of freeloaders in buffet paradise.
(An Italian friend told me that tourism-dependent Venetians despise the cheapskate
Biennale crowd.) Mutual disgust tinged the attitudes of those who, having slipped away
individually for half an hour—perhaps to a hushed church for a favorite Giovanni
Bellini (mine is a certain altarpiece)—regathered to hail somebody's video installation.
The toneless phrase "What have you seen?", apropos the Biennale, forced itself from
every throat like a confession of spiritual penury, as if we were sipping sodium pentothal
instead of wine. But we were in Venice. What could be bad? In fact, the forty-eighth
Biennale isn't bad. It is the most cogent of the several I've seen—apart from the chronic
embarrassment of those funny national pavilions under the colossal trees of the
Giardini. What does it mean today for an artist to represent a nation? No one knows;
and the question palpably discomfits functionaries of the public agencies that administer
the pavilions. Old-fashioned, rosy internationalism remains a ruling piety, resisting the
brasher tones of global capitalism—though not the odd corporate sponsor—even as
hometown heroes get nudged onto a world stage. Note that very few of the heroes offer
commercially viable products, such as paintings. This Biennale takes a principled stand
for a worldwide archipelago of institutions that are crazy in love with installations.</p>

<p style="text-indent: 2em;">Let's call it Festivalism: environmental stuff that, existing only in exhibition,
exalts curators over dealers and a vaguely conceived public over dedicated art lovers.
The wholesomely witchy American artist Ann Hamilton, known for obsessive make-
work projects, has engineered cascades of bright-fuschia powder down the inner walls of
our Neo-Colonial pavilion. The powder picks out bumps of Braille lettering said to tran-
scribe readymade poems by the late Charles Reznikoff: versified court records of murder
and mayhem in the American heartland. You can get dizzy trying to parse Hamilton's
political and mystical symbology. Or you can simply observe that the piece is very pretty
and be on your way, feeling obscurely virtuous. In passing, I remark a consistent</p>

American policy of choosing, for recent Biennales, artists of a minority-group and/or eccentric ilk. Chalk it up to bashful compunctions of a superpower, refraining from artistic gunboat diplomacy. Hamilton's effort earned the lukewarm approval of most of the people I talked with. My interlocutors enthused, if at all, over the Belgian pavilion, where the art can be hard to see, because (don't ask why) the building fills now and then with dense white fog. More appropriatedly hailed, by many, was a great video work by the Finn Eija-Liisa Ahtila. Video projections, which are ideal as Festival Art, show signs of developing into a sure-enough art form that splits aesthetic differences among film, theater, music, and sculpture. The trick is in turning television's monotony to disarming effect. After giving casual attention to Ahtila's two-screen moral fable that suggests condensed Ingmar Bergman, I was stunned to find myself desperately moved. She is onto something: intimate storytelling in public, a life experience shared with strangers.

Video artists, or artists who use video, dominate a huge group exhibition organized by this Biennale's director, the Swiss impresario Harald Szeemann. He might be said to have invented Festivalism, with a fiercely avant-garde show, entitled "When Attitudes Become Form," in 1969. Now he presides over the mode's mandarin consolidation. The occasion encourages generalizations. Thus: What *is* Festivalism? It is anything that commands a particular space in a way that is instantly diverting but not too absorbing. Viewers must not forget that they are in a crowd. Nor should the crowd pile up for too long at any point. The drill is ambulatory consumption: a little of this, a little of that.

It is enough to hurt the feelings of a discriminating art critic. Szeemann's show seemed as little anxious for my opinion as Venice is. The reason, in his case, is an approach geared to quantity rather than quality of response. This was dramatized by the far-travelling thunder of fairly atrocious drumming, by viewers, on a hundred or so chairs and beds covered with taut animal skins, by the Chinese artist Chen Zhen. The show teems with emergent Chinese artists, by the way. A lot of them are prone to the callow preoccupations with sex and brash sentiments of the newly liberated. But the Chinese contingent displays unmistakable flair for the éclat of righteous Festivalism. In Chen's drum room, I grabbed sticks and whaled away, along with everybody else.

Installational art used to nurture quasi-political hostility to "commodity capitalism." That's over. The battle line between non-sellable and sellable works has become a cordial abyss, with carnivalesque Festivalism, on the one hand, and, on the other, humanity's timeless commerce in objects of esteem. What's afoot is a global rationalization of the art game, whereby one type of artist stays in the studio while another becomes familiar with many airports. The peripatetic kind may look like the winner in Venice, but it is, in fact, the less secure. Will governments, corporations, and other institutions keep supporting it? Only if regular people voluntarily come, and happily come again. As with so much else today, the goddess of the box office stands in for blind Justice, weighing the future on her disinterested scales.

July 5, 1999

PICASSO IN MADRID

Pablo Picasso is having a tough summer in Madrid. He can handle it, though with nothing like his usual insolent panache—you can feel him sweat. The occasion—"Picasso: Tradition and Avant-Garde," a double exhibition at the glorious Prado and at the Reina Sofía, the desultory national modern-art museum—is purely celebratory in intent, marking the twenty-fifth anniversary of the patriation of *Guernica*, after, at the artist's behest, it had waited out in New York the dictatorship of Francisco Franco. The mood is implicitly nationalist, embracing a man who, in 1936, was named the director of the Prado, in absentia, by the republican government, but who never lived in his native land after 1904. (He liked to boast, "All these artists finally belonged to me.") The shows just happen to put Picasso's greatness to severe, vivid tests. By general agreement, he was the best artist of the twentieth century. How good was that? His sheer significance, as the god of modernity in painting, has always beggared ultimate judgment. Now the issue is being forced, at the Prado and the Reina Sofía, by direct comparisons of his work with that of the Old Masters who, from time to time, were important to him, either as models or as goads—notably Velázquez and Goya. The results probe Picasso's artistic weaknesses—he had some—and give focus to doubts about the quality of the monumental egotist's one major painted political statement, created in response to the German bombing of a Basque town, in 1937.

At the Prado, a compact retrospective of about forty borrowed Picassos, in chronological array—from precocious sketches, after Velázquez, that he made at the museum in 1897–98, while still a teen-ager, to a bravura canvas, *Musketeer and Love*, from 1969, four years before his death—are interspersed with germane works from the museum's incredible permanent collection. *La Vie* (1903) and *Boy Leading a Horse* (1906) grapple with El Grecos, and *Self-Portrait with Palette* (1906) and two Cubist portraits face off against a Poussin and a Ribera. The determinedly ugly *The Serenade* (1942)—a contorted musician plays for a grotesque reclining nude— confronts one of its likely Renaissance inspirations (or targets), Titian's gorgeous *Venus and the Organ Player*. The selection of Picassos is strong but might have been made stronger, with, say, *Portrait of Gertrude Stein* (1906) and *Harlequin* (1915), in place of lesser works. As it is, Velázquez's *The Triumph of Bacchus* (a sly young god attended by tipsy guys you would recognize in the first low-end bar down your street) runs rings around Picasso's classicizing portrait of his son Paulo as a Harlequin (1924) and even the great *Three Musicians* (1921), whose deftly interlocking planes suddenly seem so much empty trickery. Seen through an archway into the museum's main hall, *Las Meninas* craves congress with *Les Demoiselles d'Avignon* (1907), but,

instead, the greatest of paintings must abide Picasso's Velázquez pastiches of 1957—bagatalles in which he seems less an arch parodist than an abject buffoon. Other Old Masters on hand include Rubens (his copy of Titian's *Rape of Europa*, which amounts to a collaboration that is beautiful beyond measure), Veronese, Zurbarán, and Goya (*The Naked Maja*).

The Reina Sofía concentrates on *Guernica*, which has resided immovably at the museum since 1992, supplementing it with related drawings, and with two of its three most formidable rivals (David's *Death of Marat* is the missing third) as paintings of political violence—Goya's *The Third of May 1808 in Madrid: The Executions on Príncipe Pío* (1814), from the Prado, and Manet's *The Execution of Emperor Maximilian* (1868–69), the complete version, from Mannheim. Mano a mano, Picasso stands up brilliantly to Ribera, Zurbarán, and Poussin, suggesting that the attention to stark fact in the first two, and the rational method of the third, were historic steps in Picasso's direction. The proximity of blue- and pink-period pictures to El Greco's grandiose *Trinity* confirms a familial affinity that is often remarked on. Picasso was excited by El Greco's vertiginous formal inventions, and he dismissed the earlier painter's religiosity as one would a revered brother's harmless crotchets. (But questions of belief haunt the show. Picasso had faith only in himself, which makes him both heroically modern and, in his present company, a figure of relatively wizened, sour spirit.) Titian, Rubens, and even Veronese are again another matter, exposing the poverty of Picasso's color. His forte was linear and analytical—hard and dry. He wielded color resourcefully and keenly, to intensify contrasts, but the sensuous eloquence of real colorists, for whom meaning is inseparable from decorative effect, was outside his ken. That's why, rant as he did against the effeminate inferiority of decoration, Picasso could never completely shake off Matisse. And that's why comparing Picasso with Velázquez reinforces the latter's pre-eminence. Velázquez has no discernible limits in any capacity of his art. He is Picasso plus Matisse—adept at blacks and grays as plangent as Matisse's reds and blues.

Picasso's smartest decision in *Guernica*, a consummate feat of pictorial intelligence, was to limit its palette to black and white. He thereby forged his chief handicap into a thematic weapon, inferring that war is no time for indulgence and, by evoking the look of a newspaper, factored in the modern experience of comprehending catastrophe (and of inflicting it) at a distance. Proto-Pop, the trope anticipates the use of grainy tabloid photos in Andy Warhol's *Disaster* series. Other aspects of the work are less persuasive. There is the question of temperament. Do we believe an identification with victims of cruelty from a man who, in small ways, enjoyed being cruel? His many pictures, from the same time, of Dora Maar weeping are poignant enough. But who made her cry? ("Women are machines for suffering," he once remarked.) Most gravely, in terms of rhetoric, the representations of carnage—a screaming woman, a limp baby, a severed arm clutching a sword—are ingenious but remote, instantly generic emblems. *Guernica* is more impressive as graphic design—a gigantic poster, complex but firmly knitted and legible at a

glance—than as symbolic expression. It is a cartoon about atrocity in the abstract. The one emotion that burns through is the artist's controlled anger. Picasso couldn't help making this picture, like all his others, be about himself.

There is, however, no gainsaying the unquenchable authority of *Guernica* as an icon, especially in Spain. Its arrival there, in 1981, heralded a national liberalization, whose fragility was made apparent by the painting's initial display, in a building near the Prado, flanked by vigilant soldiers of the Guardia Civil, inside a cage of bulletproof glass. (*Guernica* still sparks conflict: the first questioner at a press conference for this show asked when the painting would be coming to the Basque region, to which the Reina Sofía director answered, in essence, "Never.") At the Reina Sofía, you can now get quite close to the bare surface of the vast canvas (more than twenty-five feet long by more than eleven high) before a rope intervenes and, should you lean forward over it, as I did, a discreet alarm sounds. But it's impossible not to feel that an invisible envelope of practically religious passion, a collective emanation of generations of viewers, shields the mural. Simply, no other work of a bloody century so successfully—that is, to a lesser degree of failure—apostrophizes the character of total war. If the emotionally devastating Goya and even the eerily detached Manet are far superior in conjuring lived horror, with flowing blood and choking gun smoke, it's because they belonged to times when organized violence could still be convincingly registered in specific detail, at human scale, and painting had not yet lost its grip on external reality to photography and on historical fiction to the movies. How good was Picasso? The best anyone could be then, and unlikely to be equalled anytime soon.

June 19, 2006

ROBERT BECHTLE AND PHOTO-REALISM

I first encountered the underrated Bay Area artist Robert Bechtle's great painting '61 Pontiac (1968–69), which is in his present retrospective at the San Francisco Museum of Modern Art, in a 1969 group show in New York. It was among the early examples of Photo-Realism, a populist, generally lightweight movement that flourished beyond the pale of that time's strivingly serious art world, where recondite Postminimalism ruled. The painting was as good as American Photo-Realism would get: a vision of and about life in these United States as telling as little else since Edward Hopper, and a philosophically rich interplay of painting and photography that brings to mind Gerhard Richter. Seven feet wide, on three abutted panels, '61 Pontiac shows the artist and his family standing beside a creamy-white station wagon on a suburban street in the midday sunlight. The source is obviously a photograph—Bechtle had begun to work with slides projected onto canvas. Neatly bearded, subdued Dad, in a short-sleeved business shirt and baggy corduroy trousers, rests a hand on the head of his restive young son, in short pants and sneakers. Sturdy, long-haired Mom, her eyes in deep shadow, holds their uninterested little girl and smiles. She may be speaking. Details are slightly blurry, testifying to the snapshot's loss of definition when blown up to such a size. Of course, it isn't possible to describe a painting—a tissue of decisions—as "blurred." So the artist's faithfulness to the vagaries of photography is part of the picture's form and significance.

I remember being rattled by the middle-class ordinariness of the scene. For one thing, it was the last sort of image that one expected from the vicinity of San Francisco in that epoch of hippie revolutionizing. But the work did not feel conservative. Untouched by either sentiment or irony, it seemed, as it still does, entirely unconcerned with its own approximation of an American demographic ideal. Gradually, you register that it is beautiful. Translated into oil paint, the Kodachrome colors of flesh, grass, and Mom's striped skirt take on sumptuous, dreaming intensity. Though derived from the click of a camera, the image has none of what Roland Barthes termed a photograph's "punctum," its quotient of inaccessible pastness. In '61 Pontiac time balloons forward, backward, and sky-high. I sense the droning, sheer duration of days in suburban neighborhoods in mild climates, an immensity laced with a familiar terror: boredom, our foretaste of being dead. Nothing can happen there. Or something can—a family of four pauses beside a station wagon, whose predictability makes matters worse. In this and many subsequent works, Bechtle is a fascinated diver in the ocean of interminable American afternoons.

The Whitney Museum in New York bought the painting in 1970, but Bechtle's career—managed in New York by the insouciantly commercial OK Harris

gallery—attracted almost no further critical attention. The local avant-garde was in one of its "painting is dead" phases and was automatically dismissive of things Californian anyway. Meanwhile, the work's equable take on bourgeois America suggested a different country from the infernal regions ritually evoked by counter-culturalists. Today, when most art of 1969 is snugly historical, '61 Pontiac stays fresh. That's because the spiritual realities that it channelled have not changed. The problem of how to live in this land, as it actually is, has outfaced all attempts to escape or transcend it. And the benumbing domination of our visual culture by cameras, of one kind or another, is as urgent a challenge to painting now as it was when Andy Warhol wedded mechanical imagery to high art four decades ago. Bechtle exploits the strangeness in humdrum photographs of the obvious, and he does so with the sort of reticent, stubborn grace that marks most of the Bay Area's finest painters—David Park, Richard Diebenkorn, Wayne Thiebaud.

Now seventy-two years old, Bechtle was born and grew up in the Bay Area, the son of a teacher mother and an electrician father who, during the Depression, resorted to selling door to door. (Hoover Man [1966] shows a rangy, cowboy-hatted dude with a vacuum cleaner, backlighted outside the partly opened front door of a house; his posture trumpets a wish to be anywhere else in the world.) Bechtle won early recognition as a budding artist. He was excited by art in Berlin, when he was stationed there as an Army private in the mid-1950s. He attended the California College of Arts and Crafts, in Oakland, where he purposely avoided studying with Diebenkorn, fearing infection by the master's then epidemic influence. A long tour of Europe in 1961 and 1962—coincidentally, near the time of a similar and also decisive sojourn there by his Southern Californian contemporary Ed Ruscha—nurtured Bechtle's independence of mind. On the return trip, in 1962, he saw a groundbreaking show of Pop art at the Sidney Janis Gallery in New York. He wanted something of that newness, he has said; but, typically for him, it could not resemble what others had done. Back home, paintings of gloomy interiors—expressing a melancholy streak that, suppressed thereafter, exerts a subliminal gravity in all his work—soon gave way to plein-air depictions of cars parked on nondescript streets. An exasperating struggle to manage the foreshortening of a black Cadillac in 1966 occasioned Bechtle's first use of slides, as an aid that became a content of his art.

Bechtle's paintings do not yield first impressions. I immediately feel that I know them thoroughly, as if from a prior life. This may be an effect of their congruence with the sorts of things that the brain, in self-defense, refuses to remember. Designed to seek import in what meets our eyes, we are equipped with ways of recognizing the unimportant in a flash, and blocking it from consciousness. Bechtle zeroes in on the always seen and never noticed—without giving it importance. (He differs in this from other Photo-Realists, who tend to congratulate a subject for having been chosen by them.) Alameda Gran Torino (1974), a masterpiece, is a nova of banality. The station wagon can't help but be only and exactly what Detroit fashioned. Hot sunlight can't help but glint from a bumper and produce a

faint reflection of the windshield on a garage door. A closeness between the green of the car and that of a background shadow is unusual, but so perfectly meaningless that your mind may panic at the waste of its energy in beholding the fact. Then something peculiar can happen: your reflexive sense of the picture as a photograph breaks down, and the object's identity as a painting, done entirely on purpose, gains ground. Look closely. A congeries of tiny freehand strokes delivers an inconspicuous patch of foliage. The whole work is a feat of resourceful painterly artifice. At last, it's as if the original photograph were a ghost that died and came back as a body.

Bechtle's later work has grown in ease and virtuosity, with occasional loss of tension. Recent lovely charcoal drawings and aquatint etchings relax into exquisiteness. And he returns now and then to dim interiors, usually featuring himself gazing outward, which are more oppressive the better they are painted. (To Californians, might being indoors feel tragic in and of itself?) It can't be comfortable to accept that, by the nature of one's talent, somebody else's parked car amounts to a more compelling self-portrait than anything done with a mirror. That's Bechtle's lot. His street paintings vibrate with everything that his personality—like common photography, and perhaps like suburban society—bottles up. As in *'61 Pontiac*, charged indirection skirts fatalistic comedy when family and friends appear. *Alameda Chrysler* (1981) portrays the artist's formidable, white-haired mother, snazzy in a bold flowered shirt and checked slacks, beaming beside her brawny coupe, against a near background of dark-green, sun-dappled shadows on trees, topiary, and a white house. It's a gorgeous day. Grandma's in clover. Life is incredibly complicated, and the proof is that when you confront any simple, stopped part of it you are stupefied.

May 9, 2005

TELLING: WINSLOW HOMER

Winslow Homer's first oil painting, which he made in 1863, when he was a twenty-six-year-old freelancer illustrating Civil War scenes for *Harper's Weekly*, shows a Union sharpshooter in a tree, balancing a rifle for an imminent shot. The man's perch is precarious. His concentration is total. Nature—soft tufts of dusky foliage, scraps of yellowish sky—attends indifferently. Decades later, Homer recalled having peered at a man through the telescopic sight of a sharpshooter's weapon. The impression, he wrote in a letter, "struck me as being as near murder as anything I could think of in connection with the army & I always had a horror of that branch of the service." This compunction, which I encountered in a text accompanying an engraving of the same subject in a current show at the National Gallery of Art, in Washington, D.C., of about fifty Homers from the museum's collection, surprises me not for its content but because I don't think of the extraordinarily stolid Homer as having opinions. (The sole quote from him that sticks in my mind is a bit of advice to seascape painters: "Never put more than two waves in a picture; it's fussy." Somehow, words to live by.) Certainly, nothing like horror inflects *The Sharpshooter on Picket Duty*, which mainly conveys professional competence. The soldier, with one booted foot athletically braced in a crook of the tree and the other dangling, and grasping a branch on which his gun rests, is all business. The engraved version differs from the painting in one extra detail—a canteen hanging in the tree, indicating a lengthy stay for the sniper at his post. By excluding the canteen, the beginner painter demonstrated an instinct for the difference between reportage and art, even as he maintained an emotional detachment, basic to reporting, that would distinguish him as a great and, particularly, an American artist—ever the undistracted sharpshooter.

Homer keeps getting better, as I've had repeated occasions to notice since responding ambivalently to a major travelling retrospective that opened at the National Gallery of Art in 1995. I was in the right bad mood, at the time, to tax the artist with a spiritual tedium of Victorian-era Yankee culture, which he served doggedly with genre pictures ranging from homesick soldiers to ladies playing croquet to slickered fishermen braving squalls. Partly, I was reacting against publicity for the show which characterized Homer as "America's greatest and most national painter," and not only because it dismissed Jackson Pollock. A Midwesterner myself, I questioned the "national" bona fides of visions of native nature confined to the Atlantic coast and the Adirondacks. And then there was Homer's sexlessness. Undoubtedly heterosexual, he was a washout at romance—no amorous Walt Whitman or even the intriguingly neurotic Thomas Eakins but "a quiet little fellow," in the words of a friend—numb to personal magnetism, female or male,

and with a pronounced distaste for bodies except in action. In my judgment of the retrospective, I did make exceptions for Homer's watercolors, whose translucency coaxed fully sensuous expressiveness from him, and for some late paintings of crashing waves that with their exactly measured, explosive force outdo Friedrich, Courbet, and even Turner. But I was perversely clenched against enjoying the key aspect of Homer's talent, which is based in his early discipline as an illustrator: a prehensile feel for the iconic—the identification of a subject with its representation, such that, in memory, one becomes inseparable from the other. My punishment, ever since, has been to undergo shocks of chastened veneration whenever I happen upon his masterpieces.

Homer was born in Boston in 1836, the middle son of a hardware merchant who, in 1849, went bust in the California Gold Rush. At the age of eighteen, Homer was apprenticed at a lithography shop. Thereafter, he freelanced while studying art in schools and on his own. In 1860, acquiring a copy of the French scientist Michel-Eugène Chevreul's *The Principles of Harmony and Contrast of Colors and their Applications to the Arts* (an analysis of how color interacts in the eye), Homer grounded his practice in modernizing theories that were shared by the French Impressionists, who seem not to have influenced him directly. Living on Washington Square, he had many friends and supporters, though only modest public success. He complained, throughout his career, of being misunderstood. He visited Europe and spent the better part of two years in an English fishing village. In 1884, he settled in Prout's Neck, on the Maine coast, where he gloried in having "no other man or woman within half a mile" and took little note of his growing fame. He lived there, often wintering in Florida, the Bahamas, and the Caribbean, until his death, in 1910.

The National Gallery owns three major Homers: *Breezing Up (A Fair Wind)* (1873–76), *Hound and Hunter* (1892), and *Right and Left* (1909). The first shows a fishing sailboat, with a man and three boys aboard, atilt in a stiff breeze. It is pitched at a receding angle, rising to the left, which Homer liked for boat pictures, including his epic of maritime disaster, *The Gulf Stream* (1899). The marvel of it lies in a tonal modulation of strong color: a luminous blue and white-clouded sky silhouettes the boat and its figures, whose shadowed hues smolder. The contrast nails North Atlantic light, which is bright and clear but frail. The effect has a chill in it, and a tang. Anecdotal details of the scene, such as the boys' delighted postures and the gleam of fish in the hold, make specific a timeless experience. There is a sense of something never properly painted before which now needn't be painted again—a dramatic quality that distinguishes Homer from the Impressionists, who neutralized subject matter. Homer's storytelling put him on the losing side of modern art. Alfred Stieglitz denigrated his work, though with an odd note of respect, as "nothing more than the highest type of Illustration." (Henry James found Homer "almost barbarously simple, and, to our eye, he is horribly ugly; but there is nevertheless something one likes about him," proving that you cannot stay mad at

this artist.) Homer is improving at present because the banishment of illustration from canonical modern painting, after Manet, has worn out. We like stories, and important painting of the past forty years, from Gerhard Richter to John Currin, has become ever more illustrative, and enamored of the one-off image.

The hunting tales in *Hound and Hunter* and *Right and Left* must be taken on faith, because one is so strange and the other is impossible. In the first, a young man in a canoe on a darkling forest lake clings to an antler of a submerged, dead deer while looking at his swimming dog. (In a technique called "hounding," dogs chased game into water to be shot, clubbed, or drowned.) In the second—one of Homer's last works—two foreground ducks taking off from turbulent waters are hit by a distant hunter's double-barrelled birdshot; one has flipped upside down, and the other is transfixed with neck straining and wings spread, startled by death. The birds are black and white, the water several shades of gray with a splash of light blue. A tiny lick of red-orange locates the hunter's gun, and a duck's staring eye has a yellow iris. A ragged cream-colored band along the top of the painting suggests dawn. The picture's muted color harmonies are worthy of Whistler, and the boldly and tenderly worked paint surface evokes Manet. A career that began with a dispassionate shooter draws to an end with unresentful shot ducks. Homer's America, always energetic, is never so calm as when it is violent, in extreme instances of the one moral quality that overmastered, for him, all others: unsimple truth.

August 8, 2005

DADA AT MoMA

What was Dada? What it still is: a word—"hobbyhorse," in French. Baby talk. Supposedly plucked at random from a dictionary by a coterie of war-evading young writers and artists in Zurich in 1916, "dada" was a two-syllable nonsense poem and a craftily meaningless slogan, signalling a rejection of grown-up seriousness at a time when grown ups by the million were shooting one another to pieces on the Western Front for reasons that rang ever more hollow. Reason itself was made the scapegoat. "Let us try for once not to be right," the group's most influential founder, the Romanian poet Tristan Tzara, urged in a quieter passage of one of his careening manifestos. Dada spread like a chain letter among disaffected bohemians after the war. Wired to self-destruct—"The true Dadas are against Dada," Tzara enjoined—it was over by 1924, succeeded by imperatives, like those of Surrealism and Constructivism, to be revolutionary in more focused, even grown-up, ways. It wasn't much of an art movement, though "Dada," an exhibition at the Museum of Modern Art, tries hard to make it seem so. (The show originated at the Pompidou Center, in Paris, where it was larger and far more literary in emphasis.) Dada was a publicity movement.

It revelled in novel styles and in popular media—Cubist and Futurist pastiche, collage, assemblage, film, theater, photography, noise music, sound poetry, puppetry, wild typography, magazines—basically for the hell of it, despite the odd skew, mostly in seething postwar Germany, toward political agitation. Some forms, such as abstraction and machine aesthetics, informed later art; but, as a phenomenon, Dada foretold nothing so much as the marketing of youth fashions. Though hardly commercial, it anticipated a byword of modern advertising: forget the steak, sell the sizzle. The first artist who springs to mind when Dada is mentioned, Marcel Duchamp, would constitute an exception, but he really wasn't a Dadaist. He had already conceived many of his signature "readymades"—common objects, such as a bottle rack and a snow shovel, presented as art—and his magnum opus, *The Bride Stripped Bare by Her Bachelors, Even*, was under way before he had heard of the movement. Apart from accessory japes, such as the mustachioed *Mona Lisa* (1919), his relations with Dada were more diplomatic than creative. A vital order of business, in clarifying Dada, is to pry Duchamp from its clutch.

The show is an elliptical tale of six cities: Zurich, where the leading artist was the collagist and sculptor Hans Arp; Cologne, the base of the Surrealist-to-be Max Ernst; Berlin, featuring the satirists George Grosz and Otto Dix; Hannover, the home of the single most substantial artist to emerge from Dada, Kurt Schwitters; Paris, dominated by the poets, in particular André Breton, who would exterminate Dada by

folding it into Surrealism; and New York, where the wartime presence of Duchamp, and of the Parisian playboy genius and Dadaist par excellence Francis Picabia and the native prodigy Man Ray, anchored a sparkling salon. (Several figures adorned more than one scene. Arp pops up in Cologne, Hannover, and Paris.) Among a cast of dozens are many who achieved immortality in the brief heat of the movement's heyday, such as the German polemicist Richard Huelsenbeck, who later became a New York psychiatrist, and others who were just passing through, such as the glamorous scamp and potter Beatrice Wood. Collagists abound. The quickest technical route to righteous Dadaism was to snip out printed images and compose them to comic, politically rhetorical, or naughty effect. Such things often have a quality at once piquant and jaded, like the morning-after detritus of what must have been a swell party. Schwitters's formally rigorous collages of everyday trash—newspaper fragments, bus tickets—are something more. Schwitters, who was also an innovative poet and a pioneer of installation art, developed an anti-conventional aesthetic that proved endlessly fecund—blooming, for example, in Robert Rauschenberg's *Combines* of the 1950s.

Dada did not attract artists who earnestly practiced straight painting and sculpture. Most works in those mediums in the MoMA show are mediocre—including Picabia's, though his paintings of mechanical forms laced with wordplay and sexual innuendo can seem deliberately nugatory, razzing the very notion of quality. Picabia, a rich heir with a weakness for fast cars, was seriously unserious, playing—and living—out a Rabelaisian afflatus of all-around ridicule. (If you yearn to be a Dadaist, ask yourself each morning what Picabia would do.) Man Ray's amateurish paintings, superb photographs, and gamy found-object pieces similarly strike notes of the right (that is, the wrong) stuff. The show's main picture-maker is the prolific, personally magnetic, opportunistic Ernst, whose tidily irrational drawings, collages, and paintings of the era—essentially superficial glosses on other people's ideas—pander to a middling taste. The occasional underrated minor artist, notably Arp's wife, Sophie Taeuber, pleasantly surprises.

Dadaism was an ancestral vein of cool. Those who wondered what it meant could never know. Because you had to be there, the most informative exhibits at MoMA are video-projected films, especially the delirious *Entr'acte* (1924), by René Clair and Picabia, with a score by Erik Satie. A dancing ballerina, viewed from below through glass, turns out to be beefy and bearded. Duchamp and Man Ray play chess on a rooftop until a jet of water clears the board. A droll Tyrolian marksman is shot to death. His hearse breaks loose from the camel that is pulling it. Mourners follow in a wackily leaping run, filmed in slow motion. The hearse crashes in a field. The dead man, revived, touches the mourners, who vanish. *Entr'acte* was screened during the intermission of *Relâche*, a lavishly produced ballet conceived by Picabia, which marked the absorption of Dadaist high jinks into high chic, spicing the romance evoked by the imperishable words "Paris in the twenties." Calvin Tomkins, in his biography of Duchamp, records that Picabia "advised the audience to bring dark

glasses and ear plugs, and urged any ex-Dadaists among them to shout, 'Down with Satie!' and 'Down with Picabia!'" By then, Surrealism had commandeered the avant-garde. Picabia denounced it and moved to a château near Cannes, where he undertook kitschy styles of figurative painting whose rapscallion tang would give his influence a second life, on the Neo-Expressionists of the 1980s.

Duchamp, a courtly French hedonist from a family of modern artists, wasn't echt Dada, because he wasn't anti-rational. On the contrary, he was anti-feeling, a dandy of pure cerebration who was devoted to the simple pleasures of games, sex, and sociability. Neither cowed nor offended by established values, he mildly enjoyed rattling them—for instance, by submitting a urinal, titled *Fountain* and signed "R. Mutt 1917," to an art show, a gesture still preposterously resonant. "You see, the dadas were really committed to action," he told Tomkins. "They were fighting the public"—by his lights, a bore. Arp betrayed a contradiction within the movement when he remarked that "the Dadaists despised what is commonly regarded as art, but put the whole universe on the lofty throne of art." Nothing could be less Duchampian. Duchamp said of art, "As a drug it's probably very useful for a number of people, very sedative, but as religion it's not even as good as God." The trouble with being anti-art, he suggests, is that it gives art too much importance.

Dada was and remains a drug, of the hallucinogenic type. What young self-styled bohemian of the past ninety years hasn't got at least briefly high on it? I sure did, back in the 1960s. It was temporary heaven to believe that your besetting mentality—adolescent hysteria in the face of a world that had somehow failed to take your point of view into account—was a state of history-blessed grace. Industries of popular culture have since mastered the formula: mix innocence and cynicism, drizzle with hormones, stand back. Today, it can be 1916 again anytime, at the flash of a credit card.

June 26, 2006

JEAN-MICHEL BASQUIAT

Jean-Michel Basquiat, the subject of an important, intensely enjoyable retrospective at the Brooklyn Museum, made nearly all of his best paintings, which are very good indeed, at the age of twenty-one, in 1982. He was not mature beyond his years. He expressed attitudes that are distinctly adolescent, when not childish, in a taunting, arch, almost self-parodic style that started going to pieces the moment it came together. Thereby, Basquiat closely resembled a poet who quit writing poetry before the age of twenty: Arthur Rimbaud. A quotation in this show's catalogue from Rimbaud's *A Season in Hell* sent me back to that work, written in 1873, which gave exalted, hilarious, altogether uncanny voice to teenage narcissism:

My turn now. The story of one of my insanities.... What I liked were: absurd paintings, pictures over doorways, stage sets, carnival backdrops, billboards, bright-colored prints, old-fashioned literature, church Latin, erotic books full of misspellings.... I dreamed of Crusades, voyages of discovery that nobody had heard of, republics without histories, religious wars stamped out, revolutions in morals, movements of races and continents.... I invented colors for the vowels!—A black, E white, I red, O blue, U green.... I turned silences and nights into words. What was unutterable, I wrote down. I made the whirling world stand still.

Basquiat was like that, right down to the sprightly tastes and the romance of recondite erudition. His paintings bristle with antic self-instruction in history, anatomy, mythology, and education itself, as when he proposes an ideal order of knowledge: "1. sports 2. opera 3. weapons." His innumerable mask-like heads exhaustively anthropologize a tribal civilization that never was. And he regularly gave color to sound, finding painterly equivalents for the effects on him of his musical heroes—Charlie Parker, Miles Davis, Jimi Hendrix. As for the deliberate "derangement of all the senses" that Rimbaud recommended to poets, Basquiat was only too game.

He was famous in the art world by the beginning of 1982, and rich soon afterward. Drugs, drink, sex, and bad behavior briefly fuelled, then devastated, his genius. He died of a drug overdose in 1988—"tragically," it says in a wall text at the show which a friend of mine testifies to having misread, at first glance, as "traditionally." Indeed, Basquiat's life and career adhered to a classical (in our day, tabloid) trajectory of rise, fall, and doom, though with an unusually sunny epilogue. Not only do his paintings now sell for ever more millions at auction; serious critical appreciation and art-historical validation, withheld from him in life, are coming around. Basquiat turns out to be the essential American Neo-Expressionist painter of the early 1980s,

the one who made the most of that time's revival—or pastiche, or lampoon—of long-lapsed and despised styles of showy subjectivity in modern art. Simply, he brought lyrical truth to a movement that swam and, ultimately, drowned in facetiousness. Simultaneous references, in one painting, to anatomy drawings by da Vinci and to the steel-driving man John Henry precipitate a funny, unfeigned paean to the literally and figuratively muscular in life, art, and legend. In terms of style, what Julian Schnabel performed with operatic bombast, David Salle with theatrical gall, and any number of others with academic irony, Basquiat brought off with spontaneous conviction. Whatever historical modes stirred him—Expressionism, "primitivism," art brut, Pop—lived anew, for a spell, at his hands, as did the influence of paragons including Picasso, Dubuffet, Pollock, and Twombly. Meanwhile, his unhappy story gave a fresh, perhaps valedictory turn to the myth of the *poète maudit*, a revelatory, self-immolating figure of terrible delight.

Basquiat was born in Brooklyn to a Haitian father—a successful accountant, with whom he had a difficult relationship—and a sensitive, emotionally unstable Puerto Rican mother, who nurtured his talent from an early age. He left home and high school at the age of seventeen and got himself discovered by the art world as the gnomic graffitist called samo (for "same old"). "Pay for soup / Build a fort / Set that on fire," went a typically waifish, seething, and catchily lettered tag. He strove to be a dandy, adept at charming or humiliating others while remaining opaquely cool. (On first meeting him, I mentioned the apparent influence on him of Dubuffet. "Who?" he asked, with a look that booked me on a train to Siberia.) His first studio works were the sensation of "New York/New Wave," a seminal 1981 group show at P.S. 1. The poet Rene Ricard published an influential essay about him (along with Keith Haring), titled "The Radiant Child," in *Artforum*. Basquiat's talent and persona might have been made to order for a moment when the prestige of international Neo-Expressionism trickled down to the streets and clubs of the East Village, and social mobility became talismanic in art even as it declined in society. The hundreds of paintings that he created in 1982 mirrored the roaring spirit of a time that, after the depressive 1970s, had rediscovered the bliss of art, fashion, tremendous amounts of money in rapid circulation, and other forms of concerted indulgence.

The key artistic quality of Basquiat's best work is a seeming paradox. Ostensibly a graphic artist—relentlessly lettering and cartooning, filling surfaces with sketchy forms, and using color, if at all, mainly to fill in drawn shapes—he is in fact a painter to the core, always concerned with a picture's physical character and immediate impact. Every element interacts with every other and with the pictorial space, which develops rhythmic ins and outs and hollows and bumps across the surface, in the way of Cubism. Visually, lines work less as demarcations of the surface than as skinny shapes wriggling atop it. The longer you look at a good Basquiat—and you have to do it in person, because the bodily scale of his gestural marks is crucial—the jazzy push and pull of small and large masses, dark and light tones, and cool and warm colors becomes more, rather than less, complex. Even when a picture is made

up only of words printed in black, like his early transcriptions of samo graffiti to paper and canvas, the visual impression may be coloristic—an effect of the brushed or paint-sticked lines activating rather than merely occupying their off-white grounds, which breathe and glow. You can't learn to do this stuff. It's about talent, served by commensurate desire and concentration—and joy. Plainly, after 1982 painting was increasingly less fun for Basquiat. Pictures become forced, congested, and inert. Nothing moves, in either sense of the word.

It is in the nature of all styles to burn out, but none perish as abruptly and irrecoverably as the precocious. Basquiat was in for a painful artistic crisis even if he could have kicked drugs and developed choirboy habits. As it was, the toll of his bad choices was exacerbated by exploitative dealers and collectors, corrupt companions, and the inevitable backlash that follows extravagant public success. (Would Rimbaud have finessed his looming difficulties by walking away from poetry if he had been as thoroughly rewarded with money, acclaim, and unlimited lovers? No.) Basquiat's is one of the great horrible American lives, already told in a fine biography by Phoebe Hoban (mordantly subtitled "A Quick Killing in Art") and in a delectable movie by Schnabel, starring Jeffrey Wright and, in a revelatory interpretation, David Bowie as Andy Warhol—whose relationship to Basquiat was both calculating and kind. The Brooklyn show, which lacks some of the artist's best paintings, hardly exhausts a subject that interests in no end of ways. As a black artist, Basquiat isn't the Jackie Robinson of the American art world—which, until quite recently, was woefully all but lily-white—so much as its Willie Mays, abolishing forever racial identity as remarkable in the field's top rank. Meanwhile, he had fun with that tension. His witty painting of heads redolent at once of Picasso and of Africa might be seen to close a circle of appropriation that began when the Spaniard visited the Ethnographic Museum (now the Musée de l'Homme), in Paris, in 1907. Basquiat's humor shares with Rimbaud's a particular wisdom: that of the world surveyed by one too young to be answerable for anything in it.

April 4, 2005

MOMENTO MORI: THE AZTECS

The hypercivilized, unimaginably savage Aztecs made war almost tenderly, wielding wooden swords that were edged with bits of obsidian or flint and, in face-to-face combat, endeavoring not to kill their enemies but, commonly by striking at their legs, to disable and capture them. Later, the captives—thousands of them for a rededication of the Great Temple at Tenochtitlan (now Mexico City) in 1478—were led to high platforms, where priests tore out and displayed their still-beating hearts. An especially respected prisoner might be allowed to fight for his life against Aztec warriors, at the last, with clubs and a sword, but his sword was edged with feathers. If he behaved well, his soul would ascend to a "flower paradise," one of the Aztecs' thirteen heavens. (People who died of ordinary disease or old age incurred ignominy in the afterlife.) His body was given to his original captor, who drank the blood and wore the flayed skin until, in the words of the military historian John Keegan, "it and its scraps of attached flesh rotted into deliquescence." The Aztecs, while consolidating their imperial sway over central Mexico, were probably as lethal on the battlefield as conquerors usually are; but, from the middle of the fifteenth century until 1519, when they met an enemy of a bewildering new sort, their main casus belli was a standing order for sacrificial victims. The stability and very survival of the world enjoined it, in the view of their religion. The key belief was that certain gods, having sacrificed themselves to make human existence possible, demanded incessant repayment in kind. No other people known to history practiced ritual murder so relentlessly, on so grand a scale.

"The Aztec Empire," at the Guggenheim in New York, is advertised as the most comprehensive exhibition of Aztec art ever mounted outside Mexico. Backed by Mexican governmental agencies and corporations, it amounts to a diplomatic potlatch, sparing no effort or expense. Its four hundred and thirty-five exhibits, some of them multi-part, of stone and fired-clay sculpture, ritual and domestic objects, jewelry, and early colonial artifacts, place the Aztecs—or Mexicas, as the core group of the empire is properly named—in context with cultures that preceded or opposed them. The works are presented, one by one or in small groups, along serpentine walls covered with dark-gray wool felt, effecting point-blank encounters with their often terrific force. The show centers on objects from the Great Temple, whose treasure-laden ruins were discovered, by accident, only in 1978. Statues of gods and warriors are preponderant—as are animals, which compose a marvellous bestiary that ranges from hieratic snakes and jaguars to an enormous stone flea. (Vegetables were venerated, too; the sleek beauty of a green stone pumpkin, more than a foot long, evokes Brancusi.) Like ancient Greek sculpture, Aztec statuary has lost all but traces of

its original polychrome surface. Mostly gone, too, are teeth and eyes of obsidian and shell, which, in surviving examples, bring figures to burning life. But scarcely anything in the show feels like filler or fails to enthrall. You will want to visit "The Aztec Empire" more than once.

I couldn't shake the thought that most of the show's contents were made with and for eyes that routinely beheld terrible acts, including rites of "autosacrifice," which the Aztecs performed at all their religious ceremonies. (The higher a man's status in the theocratic and military state, the more self-wounding was expected of him.) Handsome basins for blood and body parts abound. Sights and smells of gore attended normal life in Tenochtitlan—children must have grown up liking them. Oddly, the alien and alienating viciousness of Aztec culture makes it more accessible than that of other bygone and tribal nations. It provides dramatic focus. Confronting such things as a blackly humorous skull mask, made from a real skull, we know exactly where we stand with the Aztecs: aghast. The supreme quality of their supple, sensitive, elegant arts may be the scariest thing about them, because it testifies that a civilization based on slaughter steadied and inspired human genius.

"Powerful" is the mot juste for the creativity of the Aztecs, whose familiarity with death-dealing seems to have imparted a rangy, even insouciant fearlessness. A viewer soon recognizes differences between Aztec art and the relics, often similar in motif and form, of the ancient Olmec (1300–400 B.C.), the Teotihuacan (first six centuries A.D.), and the Toltec (900–1150), and of contemporaneous groups, including the Mixtec and the Tarascan (whose blocky, peppily cartoonish figures were imitated by Keith Haring). Something a little loose and relatively vulnerable— perhaps playful, perhaps stoical or beseeching—betrays a non-Aztec provenance. You feel that you could come to an understanding with such folk. Distinctively leaner and meaner, Aztec art projects an absolute, crushing confidence. Seen from the front, one large, astonishing gray stone carving, incorporating a basin for hearts and blood, resembles nothing so much as a modified tank. It represents an eagle whose folded wings are like wraparound tracks, and whose ground-hugging, thrusting shape conjures the growl and shriek of a mighty engine. And a fired-clay "eagle warrior"—stern face set in the gaping beak of a helmet-like eagle's head, arms winged, knees taloned—suggests a prototypical attack aircraft. There were more than a hundred Aztec divinities, but the only visibly happy one in this show appears to be Xipe Totec, a god honored in a rite of flaying. In three clay sculptures, he gaily models lumpy but neatly tailored suits of human skin.

The Aztecs believed that they were living in the epoch of the Fifth Sun. The first four had perished in disasters of devouring jaguars, hurricane winds, a rain of fire, and a great flood, and they thought that their own sun would be destroyed by earthquakes, after one of the fifty-two-year periods between the alignment of their three-hundred-and-sixty-five-day solar calendar and their two-hundred-and-sixty-day ceremonial calendar. (Calendar stones, codices, and other records of Aztec thought are largely absent from the show, whose curator, Felipe Solis, chose to

emphasize figurative art.) The people passed the eve of the appointed day in dread. All fires in the empire were put out, and, when the rise of the Pleiades constellation heralded a new cycle, relighted from a single sacrificial blaze. The visual expression of the Aztec cosmology and theology rivals, in its sheer complexity, that of Hinduism, absent the sensuality. Fertility is represented by several deities, but with explicit reference more often to agriculture—there are lots of corncobs—than to procreation. Aztec figures almost never displayed genitals, in sharp contrast to works by the Tarascan. The Aztecs were not fun-lovers. Misplays in their famous ball-game—a gruelling cross between basketball and soccer, memorialized in the show by a model playing court and balls of greenstone and alabaster—entailed sobering penalties, such as decapitation. A sense that any lapse in duty risked cosmic consequences haunted the highly bureaucratic government and the hierarchical society of nobles (the semi-divine emperor, priests, lords, generals) and commoners (merchants, artisans, peasants, laborers). War offered opportunities for upward mobility. Education, segregated by rank, was universal. An evenhanded judicial system prescribed death for most crimes, including the wearing, by a commoner, of cotton clothes, which were reserved for the elite.

The empire proved a pushover for Cortes, for several reasons. One is that the Aztecs had violated the show-business adage about being careful how you treat people on your way up. Embittered neighbors enthusiastically joined the Spaniards—at whose hands they would suffer, in their turn—to demolish Tenochtitlan, in 1521. The Aztecs, with their ceremonial and sporting approach to warfare, were unequal not just to steel and gunpowder but to soldiers (rather than warriors) who killed pragmatically and rarely bothered to take prisoners. Smallpox completed the devastation. The story that Montezuma II was unnerved by a suspicion that Cortes, in his armor, was the plumed serpent-god Quetzalcoatl—he tried to buy off the conqueror, as one would the gods, with lavish offerings—is disputed by scholars. But it seems clear that the emperor could not think outside the terms of a faith that had appeared to account for all eventualities. To enter the force field of the Aztecs' collective dream, at the Guggenheim, is to reset the defaults of your imagination. We may wish that religiously motivated death cults were beyond the pale of human nature, but they weren't then and they aren't now.

November 1, 2004

INSIDE OUTSIDE: MARTÍN RAMÍREZ

Martín Ramírez, a Mexican laborer who spent the last thirty-two of his sixty-eight years, until his death, in 1963, as an inmate of California mental hospitals, is my favorite outsider artist. Come to that, he's one of my favorite artists, period. His retrospective at the American Folk Art Museum in New York is a marvel and a joy. The power of his often large drawings of trains, horsemen, and madonnas almost renders moot the old, crabbed issue of outsiderness, the wildwood creativity of asocial and eccentric—perhaps mad—loners, which is sentimentalized by some art people and shunned by most. Ramírez remains obscure, though his work has been widely shown since it was discovered by art-world insiders (the Chicago artist Jim Nutt and the dealer Phyllis Kind), in the late 1960s. Outsider art—lately euphemized as "self-taught," a vapid label that inconveniently describes originality in general—comes from and goes nowhere in art history. (The outsider is a culture of one.) It defeats normal criticism's tactics of context and comparison. It is barbaric. Can we skirt the imbroglio and regard Ramírez as an ordinary artist with extraordinary qualities? Let's see.

Remarkably little is known of him. From a family of sharecroppers in the conservative, largely Spanish-Creole state of Jalisco, Ramírez became a small rancher, with a wife and four children. Local legend remembers him as a superb horseman. In 1925, deeply in debt, he joined a mighty flow of Mexican workers to the United States for temporary railroad and mining jobs. Starting in 1926, the three-year Cristero Rebellion—in which pious Catholics battled the Draconian anti-clerical measures of President Plutarco Elias Calles—raged in Jalisco. Tens of thousands died, on both sides. The Ramírez ranch was devastated. Recent research has uncovered a strange tale: Ramírez misunderstood a letter from home to say that his wife had joined the hated Federal forces, and he vowed never to return. In any case, the family lost track of him for years and, but for a nephew's visit in 1952, had no further contact with him. In 1931, he was picked up by police, apparently deracinated, in San Joaquin County, California, and committed to Stockton State Hospital. In 1948, he was moved to DeWitt State Hospital, near Sacramento. It seems that he made drawings from at least the late 1920s on. A sheaf of them sent from Stockton to his family, in 1948, was hung outdoors and later destroyed. What survives is only his mature work, from fifteen years at DeWitt, in a style that must have undergone considerable evolution. Ramírez attracted the enthusiastic attention of Tarmo Pasto, a psychologist and artist who collected and showed his drawings—one exhibition was called "The Art of a Schizophrene"—and provided him with materials and privileges. In a corner of a ward of some seventy inmates, Ramírez alone had a worktable. He rarely spoke

but had, by all accounts, a pleasant disposition. He was given a diagnosis of incurable schizophrenia, tending toward catatonia. Could he have handled normal life among his own people in rural Mexico? There's no telling now.

Rhythmic, expertly managed compositions carve out pictorial space in either, or both, of two ways: with straight hatchings that establish stepped, stage-like recesses; or with curved hatchings that describe receding mounds and valleys. A horseman (at times, a woman), festooned with banderillas and aiming a cocked pistol, or the Virgin of the Immaculate Conception, a snake at her feet, commonly inhabits the proscenium. Trains or lines of cars slither amid the mounds, entering or exiting dark tunnels. Incidental figures and decorative motifs are deftly integrated in extended formats as much as eight feet high or ten feet long. Except for many reworkings of the horseman—which I surmise was popular with Ramírez's audience at DeWitt—variation of design and image is constant, full of surprises. The imagery—which includes stags and other animals, cityscapes with churches, and mysterious arcades—looks childlike but is far from crude. Figures that are jiggered together from odd shapes and objects that are reduced to simple geometries bespeak choice; they aren't failed attempts at representation but refined emblems. Paul Klee and Saul Steinberg, among other modern artists, come to mind, but Ramírez's command of pictorial construction, a kind of strictly paced visual music, is all his own.

Technically, most of Ramírez's drawings aren't drawings at all but encaustic-like paintings, done in a fluid paste of melted wax crayons, at times augmented with charcoal, fruit juices, shoe polish, and saliva. He applied it with matchsticks over pencilled designs. The bizarre medium yields a subtly potent density of colors, including black, which is lost in reproduction. Seen in the flesh, the lines and shadings stamp themselves on the eye. (It's as if your sight had suddenly improved.) Material textures give some works painting-like presence. Even with good paper at hand, Ramírez liked to quilt his surfaces from scraps, gluing them with a mixture of bread or oatmeal, saliva, and phlegm. He might attach strips of paper between his hatch lines, with a tactile appeal like that of chine collé (printmaking on layered sheets). Occasionally, he collaged images from magazines. The results, such as a glamour girl's head and shoulders on a drawn rider, are charming and even witty, but formally ragged. Beyond such japes, the only weak pictures in the show are what are quite likely large worksheets, on which Ramírez rehearsed miscellaneous ideas with little thought to their over-all unity.

What is it like to be an outsider? Outside what? Ramírez worked cogently from within his memory, imagination, and talent. He also belonged to an actual culture, that of a mid-century American mental hospital. His wombish mounds and tunnels lend themselves to psychoanalytic interpretation with suspect alacrity. I'll bet they excited the doctors. (We all develop our personal styles by noticing what people like about us, and exaggerating it.) A weekly movie night at DeWitt in the 1950s probably featured Westerns, which might have reinvigorated Ramírez's memories of his

equestrian days. Trains came and went near both Stockton and DeWitt. Bold drawings of a man seated at a table and, framed above him by converging walls, a passing locomotive—shades of "Folsom Prison Blues"—economically summarize the artist's situation. But Ramírez's work does exude distinct and poignant psychological content: a self-consoling, voluptuous escape into states alternately, or at once, maternal and virile—raptures of a loved boy. He surely suffered, but his subject was an accessible happiness.

Ramírez is one of the Big Three of twentieth-century outsiders, along with the institutionalized Swiss Adolf Wölfli (1864–1930) and the reclusive Chicago janitor Henry Darger (1892–1973), both subjects of memorable retrospectives at the American Folk Art Museum. Ramírez differs in key respects from the two others. Unlike them, he seems not to have suffered a traumatic childhood. Nor did he evince pedophilia (acted on by Wölfli, projected in an epic narrative of girl warriors by Darger). Ramírez's art is less rich in formal invention than Wölfli's and in poetic resonance than Darger's, but it is more stylistically resolved and emotionally concentrated. He has in common with them an extravagant giftedness. All would have been stars in any art school, had they attended one. That they eluded contact with institutions of fine art owes something to personal disarray and something to chance, in a ratio impossible to gauge. It's a small thing, which makes them hard cases, exceptions proving the existence of a rule—that art, to be recognized as such, requires grounding in both individual biography and common culture. What can we do with and about the rush of pleasure and enchantment that the unlicensed genius of a Ramírez affords? I recommend taking it as a lesson in the limits of how we know what we think we know. Unable to regard such work as part of art's history, we may still have it be part of our own.

January 29, 2007

HERE TODAY: THE CHRISTO "GATES"

An art critic was testily perambulating *The Gates,* in Central Park, with his wife and a friend from Texas on the first Sunday afternoon of its installation when he suddenly got a load of their thousands of fellow-walkers and registered the common mood—a sort of vast, blanketing, almost drowsy contentment. He couldn't think of any other occasion on which he had witnessed so many New Yorkers moving slowly when they didn't have to. Each person looked strangely, nakedly personal: not a New Yorker at all, or anything else in particular. The crowd's many-voiced sound had an indoor intimacy, like the bright murmur in a theater, during intermission, when the play is good and everybody knows that everybody knows it. The overall social effect, which was somewhat like that of an electrical blackout or a major blizzard, minus the inconvenience, was weird and terrific. (You could give yourself a nice scare imagining *The Gates* magically removed, and leaving the people looking as they looked—a goofball "Night of the Living Dead.") The voluble disaffection of the art critic, me, collapsed, to the relief of my companions. I had to admit the reason for it, which was that *The Gates* is a populist affront to the authority of art critics, and to accept being just another shuffling, jostling, helplessly chummy citizen.

Of course, *The Gates* is art, because what else would it be? Art used to mean paintings and statues. Now it means practically anything human-made that is unclassifiable otherwise. This loss of a commonsense definition is a big art-critical problem, but not in Central Park, not this week. What the artists Christo and Jeanne-Claude have been doing for three and a half decades is self-evident. They propose a grandiose, entirely pointless alteration of a public place, then advance their plan in the face of a predictable public and bureaucratic resistance, which gradually comes to seem mean-spirited and foolish for want of a reasonable argument against them. They build a constituency of supporters, including collectors who help finance the project by buying Christo's drawings and collages of it. What then occurs is like an annual festival—Macy's Thanksgiving Day Parade, a high-school prom—without the parts about its being annual or a festival. It feels vaguely religious. The zealous installers and minders, identifiable on site by their uniforms and chatty pride, are like acolytes. As with any ritual—though *The Gates* can't be a ritual, because it is performed just once—how people behave during the installation is what it is for and about. Then it's gone, before it has a chance to become boring or, for that matter, interesting.

Those who deplore *The Gates* as ugly aren't wrong, just poor sports. The work's charm-free, synthetic orange hue—saffron? no way—is something you would wear only in the woods during deer season, in order to avoid being shot. The nylon fabric is sullen to the touch. The proportions of the arches are graceless,

and dogs alone esteem the clunky bases. As for the sometimes heard praise of the work for framing and, in the process, revealing unsuspected lovelinesses of the Park—C'mon, people! You don't need artificial aids to notice things. *The Gates* does trigger beauty when, as on the aforementioned Sunday afternoon, a low sun back-lights the fluttering fabric, which combusts like stained glass in a molten state. This effect lasts all of about two seconds—the time span suggested in the observation of the art historian Kenneth Clark that we can enjoy a purely aesthetic sensation for only as long as we can keenly savor the smell of a fresh-cut orange. (Yes, he said an orange.) *The Gates* succeeds precisely by being, on the whole, a big nothing. Comprehended at a glance, it lets us get right down to being crazy about ourselves, in a bubble of participatory narcissism that it will be pitiable to have missed.

February 28, 2005

RUBENESSENCE

My favorite picture in "Peter Paul Rubens (1577–1640): The Drawings," at the Metropolitan Museum, portrays an ox. In black and red chalks, with enhancing traces of other mediums, the work conveys ponderous mass, rippling musculature, bristling hair, and creased and dimpled, somehow palpably warm, skin. Turning its great head to gaze at us with mild, blameless stupidity, this is an ox's ox—likely the pride of one of the farms that Rubens owned outside Antwerp—by history's chief painter's painter. It was executed around 1618, in the early middle of the Flemish master's long, uniformly triumphal career as the leading pictorial decorator, propagandist, and entertainer for a Catholic Europe in the advanced phases of the Counter-Reformation. (As an adroit diplomat for the Spanish Netherlands, fluent in five languages, Rubens worked to reconcile kingdoms riven by religious wars; he also found time to be, among other things, a courtier, a scholar, an architect, a pageant master, a family man, an art collector, and a numismatist.)

What I particularly appreciate about *An Ox* is that it isn't the image of a naked human being. Like many people, I have trouble with Rubens's nudes, especially the female ones: all that smothering flesh, vibrantly alive but with the erotic appeal of a mud slide. (Rubens, owing to moral constraints of the time, rarely worked from nude female models, and many of his women are what they look like: male models imaginatively plumped and upholstered, fore and aft.) Nor do Rubens's characters appear significantly more intelligent than his farm animals. They are puppets of an unrelentingly inflated rhetoricism, numb to pain and immune to wit, that touches ground nowhere in common human experience.

People who like Rubens's paintings will love this show; the rest of us will be hard put not to like it. The drawings are consummate and informative (copies of Michelangelos and of ancient statuary reveal sources of Rubens's style), and they isolate exciting aspects of the artist's talent—notably a truth-telling realism that was not limited to oxen. Rhetoric-free portraits of a Korean man in native dress and of a Jesuit missionary in Chinese costume are clear-eyed confrontations with strangeness that, forgoing exoticism, have a tough, bracing humility. But heightened realism was just a subordinate means for Rubens, as it had been, slightly earlier, for Caravaggio, to accomplish the pictorial revolution of the seventeenth century: eclipsing Mannerism's distorted figures set in window-like, perspectival recesses with rounded, convincing bodies in an airy space that opens outward to envelop the viewer. Realistic imagery stabilizes the meringues of Italian and Northern Renaissance traditions with which he modelled the Baroque in grandiose, public, polemical glory. Today, most of us far prefer the taut, darkling Baroque of

Caravaggio and his followers; but Rubens was the rage in that era, and he affected the development of the two best painters of the seventeenth century (and thus, in my view, of all time). As Simon Schama suggests, in his richly detailed book *Rembrandt's Eyes*, the example of Rubens goaded Rembrandt—his younger would-be rival, barely ninety miles but a political world away, in Protestant Amsterdam—toward the revelation of a new social reality that was as personal, dramatic, and profound as Rubens's artificial paradise was unfelt and arbitrary. And in the years 1628 and 1629, when Rubens was in Madrid to promote a treaty between Spain and England, he coached the rising court painter Diego Velázquez. Like Rembrandt, Velázquez would comb the bombast from Rubens's formal innovations and apply them to a lived circumstance—in his case, that of a refined and cruel Spanish monarchy on the brink of decline.

Painters of my acquaintance dote on Rubens. They readily look past his subject matter to his form and his technique. What Rubens says may not be compelling, but he says it with an unsurpassed eloquence. The art historian Jacqueline Lichtenstein has written, "Standing before the paintings of the great colorists, a viewer has the impression that his eyes are fingers." So it is with Rubens, who equalled Titian—a painter he came to revere in his twenties, during a decisive, eight-year sojourn in Italy—at merging color with imagined textures of flesh and fabric. Also superb are his compositions, which, no matter how teeming, are cunningly economical. Take a detour at the show to the Met's permanent collection and look at Rubens's *Wolf and Fox Hunt*—a stupendous collision of wolves, fox, dogs, horses, and weapon-wielding people which appears chaotic at first but sorts out beautifully, keeping a dozen or so bravura details (note the crazed wolf biting the blade of a spear) in spruce, interlocking order.

On the advice of an artist friend, I tried for a while to regard Rubens's art as a force of nature, no more reproachable for its mindlessness than are summer clouds, or a waterfall. This futile exercise convinced me that the Ruben-esque is, on the contrary, a force of will. More concocted than cultivated, it has the weakness of all "international styles," from Hellenism to the modernistic: the exaggeration of generally admired qualities, absent the grit of a particular culture or personality. I suspect that Rubens attracts painters precisely because his style, being synthetic, presents no integral, daunting mystery. It looks like something you might almost learn to do.

A telling fact about Rubens is the character of his reliance on workshop assistants, which went beyond what I know of any other Old Master. A Danish visitor to his studio in 1621 reported seeing "many young painters who worked on different pieces on which Sr. Rubens had drawn with chalk and put a spot of color here and there; the young men had to execute these paintings which were then finished off with lines and colors added by Rubens himself." That is, Rubens provided designs at the start and tweakings at the end while ceding the middle, critical stage of a painting, in which, through innumerable decisions and unplanned impulses,

thought and feeling become form. He seems to have especially relished the finishing part. (The show includes a few of the hundreds of often fine drawings by earlier artists that Rubens collected and made his own by summarily retouching.) He plainly believed, as did his contemporaries, that he had devised a literally fool-proof manner, and he self-replicated to a degree that would be brazened by no other major artist until Andy Warhol—who positively valued, as an aesthetic sensation, the deadening effect of proxy hands in a work's execution. Rubens's sole excuse was efficiency.

There is no deadness anywhere in the Met show, just a somewhat enervating variety in types of liveliness. Who was Rubens? He never tells. As I've indicated, I like him best when he is effectively no one, just an attentive eye. (Three drawings of lions, made from life, miss nothing about those creatures but their sound and smell.) The rest is ravishment, with something dodgy in it. My keen enjoyment of a sheet of seventeen studies of dancing peasants for a relatively late painting, *Village Wedding* (1635–38), is vitiated by a sense that Rubens was trying not only to emulate his great predecessor Pieter Bruegel the Elder but also to outdo him. (The painting, which hangs in the Louvre, is delightful enough, but vulgar in a way that's endemic to big-budget remakes of classic films.) As for Rubens's scrumptious portrait draw-ings—and even the special case of a staggeringly beautiful study for a saint's head, *Young Woman Looking Down* (1628)—there is always something arch about them. Their charm, not allowed to speak for itself, must be augmented with enlarged eyes and rosy, translucent, perfect skin.

Besides foreshadowing Warhol, Rubens amounted to the Walt Disney of his day—a hardworking industrialist of standardized pleasures. He not only ran his studio as a virtual assembly line; he oversaw the mass production of prints, based on his paintings, and a luxury line in tapestries, for which he provided cartoons. Given the magnificence of his success, there's little wonder that he lacked the shadier, more refractory genius of a Caravaggio, a Rembrandt, or a Velázquez. He was too happy. There is a sublimity about Rubens, after all. It just doesn't quite belong to him, but to a world and a time that made such art, and such a life, possible.

February 7, 2005

NOTHING ON: SEX AND THE VICTORIANS

The Victorians were obsessed with sex. That's our new conventional wisdom about an age of proverbial prudery. It informs a strong, mildly racy historical show, "Exposed: The Victorian Nude," that opened at Tate Britain, in London, last year and is now at the Brooklyn Museum. The zeal with which Victorians kept up chaste appearances is a giveaway, according to a type of analysis pursued by Michel Foucault, among others. When you presume to constrict, divert, disguise, and otherwise finesse a primal drive, you give it the run of your imagination. One of the show's curators, Martin Myrone, notes in the sumptuous catalogue that the word "pornography" entered the English language during Victoria's reign. The show explores attempts to exploit nudity for maximum allure but minimum outright eroticism, from the Ruben-esque fantasist William Etty, circa 1830, to the harsh realist Walter Sickert, eighty years later. With an air of spilling the beans, Myrone and his fellow-curators, Alison Smith and Robert Upstone, supplement the art with naughty photography, and films, made as early as 1896, which offer such delights as a Victorian lady doing a striptease. (Given her profusion of garments, it might be termed a striptoil.) Not for the first time, we are invited to chuckle at Victorian hypocrisy. But wait.

Condescension begs the question of why we should be interested now—as I think we are—in Victoriana, which for most of the twentieth century was an emblem of stuffiness. I suspect that it's because our own supposedly liberated age is itself marked by militant conventionality and bossy moralism. Take a lately enshrined oxymoron, "sexual identity." The phrase conveys a giddy confidence that the magma of sex can be managed with bien-pensant cookie cutters. Here we go again. Certainly, there is something eerily akin to a lot of tedious contemporary art in "The Victorian Nude"—a compulsion to attitudinize, and to subordinate aesthetic experience to warranties of morally correct or otherwise laudable intent. Now, as then, socially imposed self-consciousness trivializes pleasures of talent and skill.

Consider the gratuitous gorgeousness of paintings by the Victorian Lawrence Alma-Tadema and of art films by today's Matthew Barney. Erotica doesn't get tonier than in Alma-Tadema's *Tepidarium* (1882), a luminous small painting of an enervated Roman lass wielding a phallic strigil (a skin-scraper) and a strategically positioned feathered fan while recumbent on pillows and fur. (The work's genteel raffishness is so well judged that the Pears Soap company bought it.) Barney's swanky, gamy, unaffecting allegories strike me as Victorian in a similarly glamourous, strenuously coy way. I hasten to add that Barney is among the most accomplished artists we've got.

When sex is filtered through ideals, individual sex lives are prone to unpleasant surprises. An ur-Victorian legend concerns the trauma suffered by John Ruskin on his wedding night, when he first caught sight of his bride's pubic hair. For all Ruskin, or anyone else, could have known from looking at nineteenth-century British painting and sculpture—which, in this respect, took classical precedents as unalterable law—the mature female pudendum was baby-bottom smooth. As presented in Victorian art, the nude female is a hermetic vessel. For what? For stories and morals. The viewer's gaze, frustrated in its sexual interest, dilates to take in the expression of the figure as a whole. We are diverted from what we're looking at—a naked woman—to what we're supposed to be looking at. In one painting, it's Venus. In another, Lady Godiva, a Nubian slave, or a fairy. Diana, Circe, Titania, Hypatia, Lilith, Galatea, Pandora, Psyche, Andromeda, and St. Eulalia (her martyred corpse) each takes a turn as the heroine of an edifying tale. Images of men, who are sometimes allowed to have genitals (again with classical endorsement), may shade toward the erotic with an androgynous Cupid, Narcissus, or Endymion, but mostly they project tip-top physical fitness. Icarus, Oedipus, Teucer, Perseus, and no end of generic athletes incarnate myths of the virile action hero. It's helpful to think of Victorian art, in tandem with Victorian popular literature, as a preview of the not yet invented movies.

Several alarming images of children in the show—notably, a stupefying hand-colored photograph by Lewis Carroll of a girl posed as a Titian Venus—point to a dark side of Victorian fantasy. But dark for whom? The evil of child abuse authorizes moralistic trends in society today. But I wonder if we should complacently judge the Victorian way of negotiating taboos by camouflaging forbidden acts in fancy dress. Carroll conducted his photo sessions with punctilious safeguards against impropriety. Lacking evidence of abusive behavior on Carroll's part, we may deem him a kind of moral hero—a knight of self-control—quite apart from the literary glories that his obsession yielded. In any event, we can expect no new "Alice in Wonderland" today, and this is probably just as well. My point is that being creeped out by Victorian images of children gives us a mirror experience of how Victorians, back from the grave, might react to an episode of "Sex and the City."

Like the general run of present-day installations and videos, Victorian art was fundamentally literary. "The Victorian Nude" explores aesthetic debates that consumed British artists during the nineteenth century, involving passionate espousals of Greek and Renaissance ideals and cautious responses to their less inhibited and more inventive counterparts in France. The advent of French realism barely registered in England, where storytelling ruled. Regularly inspired by Titian and Veronese, most Victorian painting is intensely colorful. This is easy to forget, because the obtrusive subject matter turns the lush pictures to sepia illustrations in one's head. At the Brooklyn Museum, one amazing painting gives color a central role. Dante Gabriel Rossetti's *Venus Verticordia* (1864–68) shows a bare-breasted dominatrix-type redhead embowered in roses and honeysuckle and holding an apple and an

arrow. The work demonstrates just how radical the Pre-Raphaelites were in their time; unlike the French Impressionists, who expunged all literary fussiness, Rossetti and his circle tuned it up to an unearthly shriek.

"The Victorian Nude" ends with another happy shock, in the form of a great painting from 1900, felicitously titled *The English Nude*, by the too little known William Orpen. An Irishman in London, who became a virtuoso society portraitist in the mode of John Singer Sargent and a painter of sombre scenes from the First World War, Orpen was twenty-one when he made this Rembrandt-like tour de force, which depicts a young woman with long, unkempt hair, seated on a canopied, rumpled bed. She is seen from the side in glowing chiaroscuro—one leg on the bed, the other reaching to the floor. She directs a sidelong, dispassionate gaze at the viewer. Plainly, sex has occurred, but that isn't the subject. She is. According to the catalogue, the sitter was Orpen's "first true love," Emily Scobel, who, disappointed in her dreams of becoming an architect, made her living as a model. She is utterly alive. Her large nose and large feet, pouchy stomach, and air of intelligent self-possession inflect an idiosyncratic beauty. Encountering the picture, I felt I had been sprung from an interminable juvenile funfair into a world of grown ups. Art history isn't at issue here. Orpen's style is archaic, compared with the forward-looking semi-abstraction of Sickert, who was a contemporary. What hit me was the sense that an honest bargain had been struck between aesthetic artifice and actual life, such as the Victorians could not countenance and we, in our frantically posturing art, have lost.

September 30, 2002

GREEK PLAY

Socrates liked it better than costly perfumes: a compound smell of olive oil, earth, and sweat. He would have grown up knowing it from the playing fields and the *gymnasia* (literally, "places for training in the nude") at festivals where, for a thousand years, throughout Greece and its colonies, sport and civic and religious observance and, on the evidence of Greek art, sex meshed. ("Each age has its own beauty," Aristotle wrote. "In youth, it lies in the possession of a body capable of enduring all kinds of contests ... while the young man is himself a pleasant delight to behold.") Athletes oiled and dusted their bodies before competing, and afterward—in an act that had a name: *apoxyomenos*—scraped themselves clean with curved metal implements called strigils, which appear often in vase paintings. I found myself fixating on those tools of soapless ablution at two museum shows conceived in honor of the 2004 Olympics: the profuse "Games for the Gods: The Greek Athlete and the Olympic Spirit," at the Boston Museum of Fine Arts, and the modest "The Games in Ancient Athens," at the Metropolitan. I thought of the dazzling bodies they once touched—perhaps female as well as male. (There were games for girls, too.) Harsh caresses of the strigil thickened the summer smell of honorable, exciting dirt, which, like the vanished colors of Greek statuary and the vertiginous intelligence of Greek religion, can only be imagined now.

Television is odorless. Not much besides a core menu of events and a certain vicarious idealism, overlaid with pompous spectacle that is more properly Roman than Greek in heritage, links the modern Olympics to the ancient. Lost is an intimate fullness of humanity—sensual, intellectual, spiritual—that may be represented by the sublime and funny notion, evoked in Plato's *Symposium*, of Socrates hanging around the *gymnasia* for reasons that included but were not limited to teaching philosophy. Not that I'm complaining. Our Olympics are fun, and at least their sporting element—the pitting of the best against the best, from around the world—is impeccable, though marred now by the tape measure and the clock. The Greeks were casual about measurements and kept few statistics except for who won. We know that the sixth-century-B.C. wrestler Milo, among his other feats, made four consecutive grand slams of Greece's most prestigious games, at Olympia (the Olympics), Delphi, Isthmia, and Nemea. Those "crown" games occurred every two or four years; other festivals, including the very grand Panathenaic, kept athletes busy in between. Team sports were almost unknown—except in Sparta, which also stood out for the violence of its contests and for allowing a considerable degree of female participation. With few exceptions, second place counted for nothing. In each event, the Greeks sought one hero, whom they celebrated, as they did all aspects of their sports, with consummate artistry.

As Keats demonstrated, one gets the most out of decorated Grecian earthenware when caught up in its story lines. This is easy at the Met, and especially so in Boston, given the thematic unity of objects that include sculptures (often Roman copies), reliefs, coins, and such items as discuses of widely different sizes, hand weights used by long jumpers, and an enchanting little ceramic ball that bears a young girl's crudely lettered praise of her favorite athlete. Repetitive images of runners, jumpers, fighters, and chariot racers in action build a visceral intuition of grace and grit à la grecque. The Boston show cogently tracks stylistic evolutions, from the Bronze Age to the Hellenic and beyond (there's marvellous stuff from the Etruscans). Some things are better than others. We grasp anew the supreme mastery and imagination of Greek artists of the sixth and fifth century B.C. in, for example, the goofy glee of two nude males leaping to the accompaniment of a double flute, the grave sensuality of strigil-wielding nude women gathered around a basin, and the oddly unsettling sight of an athlete feeding the accumulated residue from his strigil to a happy dog.

Vase painting is a double craft, of cartooning, which tells a story, and of ornamentation formally adapted to the mass, contours, and colors of a vessel. Classical Greek artists have never been equalled for their simultaneous command of illustration and decoration, realism and abstraction, and humor and awe. (Their nearest rivals are modern: Matisse and Picasso.) The imagery of pretty young people contending, training, cleaning up, or just horsing around is free and easy, with a feel of on-the-spot reportage. Most of the cups and bowls—kylikes, kraters—were used for wine-drinking, in what must be fancied a clubhouse atmosphere. Large amphorae, which were awarded to winners of games in Athens, were less inventive. Essentially as identical as Oscars, they bear an image of the event on one side and of Pallas Athena on the other. They were most coveted for their contents: gallons of valuable olive oil. Prizes and perks varied among the games—from cash to lifelong free meals at public expense—but they were lavish enough to justify the conclusion, by John J. Herrmann, Jr. and Christine Kondoleon, in their fine, deeply informative introduction to the catalogue of the Boston show, that "Greek athletes were professionals," albeit professionals imbued with spiritual glamour.

Three figures besides the local deity (Athena in Athens, Zeus at Olympia) commonly presided over the Greek games: the demigod Herakles and the gods Hermes and Eros. Thus: strength, cunning, and, in Walt Whitman's priceless word, adhesiveness. Especially in Athens, contests might begin and end at an altar to Eros, perhaps ritualizing first the suspension and then the reinstatement of social comity. In between, the operative spirit was agon: pure struggle. The events, including running, jumping, boxing, wrestling, javelin, discus, pentathlon, and horse and chariot racing, all related to warfare, which, constant among the Greeks, was put on hold with the arrival of agents heralding the Olympics. One contest, a form of extreme fighting called the *pankration*, was war for two. "One must wipe out one's opponent by doing everything," Pindar advised in an ode. Absent a scoring system,

bouts continued until one party surrendered or passed out. (The same went for boxing.) Vase paintings display kicks to the groin and a maneouver called *akrocheirismos*, which was designed to break a man's fingers. But killing an opponent got you disqualified; the deceased won.

Besides ferocity, cheating seems to have been common at the Greek games. Indeed, a founding legend of the Olympics concerns the demigod Pelops, who won his wife in a chariot race by sabotaging, to fatal effect, her jealous father's vehicle. The extravagance of efforts to enforce fairness testify to the scope of the problem. Lining the road to the stadium at Olympia were statues of Zeus, called *zanes*, built with money from fines levied on the miscreants and their home cities. (Rather than pay one such fine, Athens staged one of first Olympic boycotts; the oracle at Delphi settled that dispute by threatening the Athenians with a cutoff of services.) How the Greeks would have regarded modern athletes' use of performance-enhancing drugs is easily imagined. If it made humans more god-like, what could be bad? Museums would be exhibiting vases decorated with lyrical scenes of injection and pill-popping.

The Greeks aestheticized everything, and brought a nose for essences (metaphysical as well as olfactory) to bear on shared experience. Commoners and philosophers cheered as one at the games. They still do, to an extent. My own life as a fan convinces me that sport, at its most refined, differs from art in only one crucial feature (which, incidentally, eliminates a need for critics): scorekeeping. Serious artists are fully as competitive as athletes. We're just never sure which of them wins, or even, in our fractured culture, at what game. The Greeks reprove us. Their simultaneous comprehension of immortal hope and carnal funk—of Zeus and strigils—persists, through their art, to remind each generation of a once and (why not?) future betterness in everything.

August 23, 2004

SEEING AND READING: ED RUSCHA

Ed Ruscha, whose work is currently on view at the Whitney in New York in a retrospective of his drawings, "Cotton Puffs, Q-tips, Smoke and Mirrors," and in a show of his well-known photographic books and far less familiar photographs, "Ed Ruscha and Photography," is one of the four most innovative and influential American artists to have emerged in the 1960s, along with Andy Warhol, Donald Judd, and Bruce Nauman. This is not a self-evident statement. Warhol, Judd, and Nauman modelled new relations of art to the world which continue to determine philosophies, methods, and forms of contemporary practice. Ambitious young artists must still come to terms with them, much as modern painters had to keep contending with Cézanne, Picasso, and Matisse. Ruscha's eminence is comparatively ghostly. His gnomic paintings and drawings of words and phrases and his recurrent images of, among other things, gas stations, tacky architecture, pills, mountains, sailing ships, the Hollywood sign, and *The Los Angeles County Museum on Fire* have always struck almost everybody as terrific but perhaps lightweight. For much of his forty-year career, he has been patronized as a Los Angeles—that is, a marginal—artist. What's apparent now is that his work belongs to the art of the past half century as oxygen does to air.

Ruscha was born in Nebraska, in 1937, and raised in Oklahoma City. He moved to Los Angeles in 1956 and studied at the Disney-sponsored Chouinard Art Institute (later CalArts), intending to become a commercial artist. Exposure to advanced art, notably that of Jasper Johns, inspired him to direct his gifts as a draftsman and pictorial designer to experimental, poetic ends. The choice quickly yielded brilliant results, as *Sweetwater* (1959), the earliest work in the Whitney shows, testifies. Eight green ink splashes and four blue ones, in three horizontal rows, occupy a rectangle above the title word, which, like the rectangle, is crisply printed in letterpress. This schematic landscape juxtaposes signs of spontaneity (nature) and deliberation (culture) with swift, amusing elegance. It points toward the more integral effect of Ruscha's mature word drawings, such as renderings, in graphite or gunpowder, of "lisp" in script formed of a ribbon of paper or "pool" in puddled liquid. The effect of such works is a tantalizing standoff, in the brain, between looking and reading.

You can't look at a word and read it at the same time, any more than you can simultaneously kneel and jump. You may think you can, because the toggle between the two mental operations is so fast. Graphic advertisers play that switch back and forth. Ruscha learned to freeze it in mid-throw, causing a helpless, not unpleasant buzz at the controls of consciousness. At one extreme, he intensifies looking with beautiful texture and color, sometimes in strange stains (tobacco, lettuce, blood).

At the other, he electrifies reading with verbal wit. Bodiless voices declare, in capital letters, "they called her Styrene," "honey, I twisted through more damn traffic today," and "brave men run in my family." There are plays on orthography ("he enjoys the co. of women"), scraps of commercial babble ("n' dinette sets"), resounding nonsense ("one night stand forever"), unwitting portents ("discontinued china"), and plausible-sounding but absurd entities, of which a favorite of mine is "aerosol particles suspended in haze." You can't suspend anything in haze, because haze is a condition, not a substance. But the phrase's ring of scientific truth, sold by the beauty of the words and of their ground rubbed with dry pigments (in black and a dispirited tan), won't quit. A concurrent show of new drawings at the uptown Gagosian Gallery sports palindromes, among them "senile felines," "starbrats," "borrow or rob," and "Tulsa slut."

For seven months in 1961, Ruscha travelled widely in Europe, driving a tinny Citroën Deux Chevaux. It was a voyage of discovery, memorialized in "Ed Ruscha and Photography" by a revelatory series of small black-and-white photographs taken with a two-lens camera (the kind you look down into, at a pane of frosted glass, to view the subject). Ruscha was transfixed by signs ("Galerie d'Arts & Lettres" above a curtained window, "Total" snazzily lettered on the side of a grim provincial building) and by things and places that were somehow ripe with signification (an isolated trolley car, pigs' heads in a butcher's shop, Greek ruins). Many of the starkly composed shots recall the magical detachment of Eugene Atget or Walker Evans (both known to the young Ruscha from his studies), only more so. Ruscha's expressive style is often mistakenly called "deadpan." Really, it's no-pan: an attitude of anyone and no one, which seems to have gelled for him in the vulnerable gaze of an innocent abroad. He soon turned that gaze upon his adopted home town, systematized in the documentary delirium of such books as *Thirtyfour Parking Lots in Los Angeles* (shot from the air) and the almost twenty-five-foot-long foldout *Every Building on the Sunset Strip*.

The dominant problem of pictorial art since the 1950s is photography, and, by extension, film and video. The basilisk eye of the camera has withered the pride of handworked mediums. Painting survives on a case-by-case basis, its successes amounting to special exemptions from a verdict of history. Ruscha's importance looms in this context. He may be the first artist who, as he recently remarked, "came to painting through photography." In her catalogue introduction, Margit Rowell, the curator of "Cotton Puffs," makes much of Ruscha's photographic way of thinking, no less than of seeing—a mental knack for framing and flattening thoughts them-selves, as well as things. A word is a thought, of course. But any image, including a photograph, may become an instrument of sufficiently lucid cogitation. Ruscha's textless books (sixteen of them, made between 1963 and 1978; the first, *Twentysix Gasoline Stations*, was shot along Route 66 between Oklahoma City and Los Angeles) are distilled ideas, often subtle. (He selected his parking lots, he has said, less for their geometries than for their patterns of motor-oil stains—a found graphic art of

the driving masses.) The form of the books, both physical and conceptual—their bookness—utterly subordinates the constituent photographs.

The influence of Ruscha on other artists is hard to grasp precisely because it is so pervasive and profound, a matter not of a particular visual style but of aesthetic consciousness in general. Certainly, he affected art photographers, including such Americans as Stephen Shore and Lewis Baltz and the great German Thomas Struth. The German painter Anselm Kiefer has said that his own fruitful involvement with book forms began in response to Ruscha. Artists have always been quicker than most critics (with the chief exception of his friend and frequent exegete Dave Hickey) to catch Ruscha's drift; witness the persistent imputations of "irony" in critics' writings about him. His art is not ironic, for two reasons. First, its rhetorical posture is egoless; there's nobody there to underwrite either sincerity or its contradiction. Second, as a consequence, the humorous thoughts and moody feelings that the works advance and evoke are as ingenuous as sunshine.

Granted, Ruscha's insouciance can unsettle. His playfulness with languages, both visual and verbal, suggests a conviction that they are little more than toys. A vast, breezy skepticism keeps his outlook fresh and clear. It gains philosophical traction from not sparing himself—his profession ("Edward Ruscha, Young Artist," read a business card that he issued in 1968), his stylistic penchants ("romance with liquids," confesses one drawing), his emotions ("despair and disgust," another shares), and his Catholic spiritual bent ("various miracles"). His most telling choice of words, for me, is a bit of Shakespeare that he incorporated into a mural at a library in Miami: "Words without thoughts never to Heaven go." A dramatic irony attends those words in *Hamlet*. Had the futility of Claudius's prayer been suspected by Hamlet, the King would not be alive to complain of it—thereby depriving Ruscha of a beautiful, dire sentiment. Ruscha plays it straight, with tenderness. For him, an all-forgiving Heaven smiles upon the prevalence of our failures to communicate.

July 26, 2004

ACCORDING TO MONA HATOUM

I've been thinking about "Here Is Elsewhere," a group show that just closed at MoMA, in Queens. It was selected from the museum's permanent collection by Mona Hatoum, a Lebanese-born (to Palestinian Christian refugees), London-based sculptor and installation-maker who has been ubiquitous in international exhibitions since the early 1990s. The show consisted of sixty works by twenty artists, most of them dating from the past fifteen years, and all bearing some affinity to Hatoum's own art. I was slow to gauge its importance, beyond agreeing with Roberta Smith, of the *Times*, that it affirmed the value of having artists curate shows from museum collections. Seeing art as artists see it—through a play of sensibility rather than a filter of ideas—cuts against the deadly pedagogy of much current curating, especially at institutions of contemporary art. Strikingly, "Here Is Elsewhere" featured the very kind of art that is most typically accompanied, in museum shows, by didactic, moral-pointing wall texts. Eschewing these, Hatoum submitted topflight examples of such work to a fair aesthetic trial. The perhaps not fully intentional result was revelatory: it enabled a viewer to look at the era of politically rhetorical Postmodernism as history.

Interviewed by the MoMA assistant curator Fereshteh Daftari for the show's brochure, Hatoum associated herself with a tradition, which blossomed in the 1980s, of "deconstructive theories, psychoanalysis and feminism, discourse around identity and the 'Other.'" These concerns became marching orders for a generation of artists, curators, and critics. Daftari, in an introduction, declared that Hatoum's choices "gravitate toward beauty that masks political pungency and familiar appearance that conceals a divergence from the 'norm'—be it gender, sexuality, culture, or race." This lets us know where we are, intellectually: on tendentious ground, where words wobble. (Beauty, an engulfing experience, can't mask anything; Daftari has it mixed up with glamour or prettiness.) Hatoum trotted out a do-gooder shibboleth: "The best art is that which complicates things for you by exposing impossible contradictions, which makes you question your assumptions about the world so that you walk away with more questions than answers." As if anyone goes to art for answers! But Hatoum's eye proved to be far more acute than her attitude.

The videos, installations, sculptures, photographs, prints, and paintings in "Here Is Elsewhere" told a story of gifted artists doing their best under a foreign occupation by political imperatives. There were brilliant things by the African-American painter Ellen Gallagher, the gay visual dramatist Robert Gober, the late Cuban-American installationist social critic Félix Gonzàlez-Torres, and others, each flying the requisite flag of an "identity." The show was an aggressively drab-looking

affair on the whole, but touched with formal and spiritual elegance. In one instance, Hatoum juxtaposed recent works by Gallagher—pale abstractions riddled with grotesque racial symbols, such as tiny "banjo eyes"—with works from the 1950s and 1960s by Yayoi Kusama, a Japanese artist who for many years was a lightly regarded resident of New York and whose feverishly expressive patterning with dots and polyp shapes has lately won overdue recognition. The pairing pointed up a fugitive convention in abstract art, often by women, of loveliness laced with needling discontent. Transcendent humor put early *Untitled Film Stills*, by Cindy Sherman, and satirical appreciations of the prestige of basketball in black culture, by David Hammons, outside the ambit of political reason.

The set of ideologies that bear the brand "Postmodernist" agitated for marginal social constituencies, but did so from smack inside the cultural wheelhouse of universities and other institutions. This irony gave a tinny timbre to a movement that did considerable good as an overhaul of democratic manners and mores for a plural society. In the art world, converging factors produced the irresistible clout of a Zeitgeist: the staffing of institutions (notably, an international network of biennials and the like) with grown-up 1960s lefties, an academic passion for French and German strains of engaged intellectualism, and a generational recoil from the money-drunk saturnalia of the 1980s art scene. Young artists, who must take the world as they find it, inevitably trimmed their ambitions to the prevailing winds. Conservatives, for their part, pretty much just frothed. Trying to assess aesthetic qualities of the period's art made one appear, to the left, as a crypto-reactionary and, to the right, as a sycophantic fellow-traveller. Hatoum's show hinted that it may now be safe again for art lovers to come out and play.

A fine work by Hatoum herself, *Silence* (1994), included in MoMA's current display from its collections, is a perfect emblem of 1990s art. It is a full-sized baby's crib fashioned of scarily delicate clear glass tubing. I reckon that it may be taken to illustrate ideas about the vulnerability of childhood, or about an exile's memories of her own childhood; but these are extrinsic matters. In immediate, inescapable terms, *Silence* poeticizes the museum's responsibility as art's guardian. I get a vicarious chill, thinking of what must be involved in moving and conserving the thing. Merely looking at it feels perilous. Provocative dependency, I realize, was a keynote of "Here Is Elsewhere," in which gestures of fear, hurt, and anger were like a child's partly defiant, mostly anxious testing of unconditional parental love. That's what's left of the art's critical edge, as topical references fade. Viewing the show was like eavesdropping on a troubled family romance.

A feminist video by Martha Rosler, in which she wields kitchen implements as weapons, and the posturing of the late David Wojnarowicz as a victim of society—he was an abused child who became a male hustler infected with AIDS—amounted to tantrums. (I fancy that they have now been sent to their rooms, in storage.) Comparatively sublime were González-Torres's pile of wrapped candies and stack of propaganda (for gun control) posters, free for the taking; they evoked a charismatic

scamp insouciantly dispensing family property to his chums. (You can't stay mad at him.) As a sign of changing times, the younger artists—such as the Mexican Gabriel Orozco, the British twins Jane and Louise Wilson, and the gay American Tom Kalin—came across as the least defensive, like young adults home for an only mildly bristly visit. Then, there was Bruce Nauman.

"I suppose Bruce Nauman is the odd one out in this collection of artists," Hatoum remarked to Daftari. The white male heterosexual master of many mediums—inexhaustibly inventive, philosophically profound, harsh—was repre-sented by *Think* (1993): two stacked video monitors broadcasting a tape (upside down on the bottom screen) in which the artist's face bobs, at a steady rate, in and out of view of a camera that was pointed at a blank wall above his head. With each leap—sweat and labored breathing evince an extended ordeal—he shouts, "Think!" Hatoum observed that Nauman is "a significant artist." Indeed, the artistic tactics of half the works in "Here Is Elsewhere" would not be conceivable apart from his influ-ence. Hatoum also deemed the piece a salutary injunction to viewers. She says, "With the Nauman video, I hear, 'Think for yourself!'" I hear something else: theatricalized frustration at the impossibility of thinking by willing oneself to do so. Nauman is a bard of mental predicaments: tautology, double-bind, Beckettian futility.

Think struck me as a more trenchant, unfriendlier complement to the show than Hatoum imagined. The besetting weakness of politically motivated art is precisely its quotient of willed thought and feeling. One senses that a work's meaning has been nailed down—is effectively over with—before one's encounter with it begins. Hatoum spoke, in her interview, of her wish for "viewers to come up with their own interpretations." But the kind of work that she makes and favors keeps interpretation on a short leash, assuming agreement and complicitous sympa-thy with the artist's point of view—which is not even his or her own, exactly, but a programmatic stance. Darkly comic, Nauman forbids sympathy, even with himself. Truth interests him. He demonstrates the autonomy of spirit which ideal democracy puts within the sufficiently determined reach of anyone.

February 9, 2004

IMPRESSIONS OF CHILDE HASSAM

"He lived with gusto, smoked a pipe, played golf, kept a good cellar, buffeted the East Hampton surf with a great, bronzed body, and worked joyously until his last illness," an obituary notice in the *Times* gushed of the painter Childe Hassam when he died, in 1935, at the age of seventy-five. Hassam was a force on the American art scene throughout most of his prodigiously prolific, half-century career. He was an energetic promoter as well as a practitioner—"whose word was law to 57th Street," a fellow-painter wrote—of poky variants of Impressionism which, having begun in response to Parisian innovation, persisted as bulwarks against further novelties. There are a few fine and lovely paintings in "Childe Hassam: American Impressionist," an overstuffed retrospective at the Metropolitan Museum. Hassam could be good enough to leave one exasperated by his penchant—it can seem a passion, even—for mediocrity. The show valuably reflects on a long episode in the history of American taste. It includes the piquant curio of a silent film, produced by the Met in 1932, that observes the portly artist at work and at play. We witness his rickety golf swing. Somebody's sense of humor, perhaps his own, dictated the next shot: a ball trickles into a sand trap. That's not a bad analogy for Hassam's destiny as a modern artist.

American Impressionism, as a concept, was always oxymoronic, like, say, Canadian salsa. The spiritual drive of French Impressionism was an appetite for sensuous intensity, steadied by formal rigor and an almost scientific detachment. Monet and the others—Monet above all—channelled the optimism of an ascendant audience, the modernizing bourgeoisie, with a here and now in paint that mirrored the here and now of a smiling world. Monet's serial motifs—haystacks, cathedrals—anticipated modern marketing of name-brand sensations, keyed to the latest thing. (Imagine a collector enjoining a dealer, "I want one just like the one that Mrs. Bigwig has, but different.") Monet risked seeming empty-headed. In truth, his style was a coup of reductive analysis. Eschewing any appeal that did not meet the eye—the literary and moral longueurs of the academy—it reengineered painting to serve strictly visual experience. French Impressionism bequeathed to its successor movements—Post-Impressionism, Fauvism, Cubism—a commitment to method that didn't cultivate effects but discovered them. The prettiest Monet shares with the grittiest Cubist Picasso the blinking innocence of a newborn fact. It was the misery of American Impressionists to chase the look of French painting and yet remain numb to both its radical hedonism and its tough-minded gravity.

Frederick Childe Hassam was born in 1859 in Dorchester, Massachusetts, the son of a cutlery merchant who collected American antiques, and who lost his business in the Great Boston Fire of 1872. Childe was the name of an uncle. Hassam

was a corruption of the English Horsham. Welcoming friendly lampoons of its Arabic ring, he took to decorating his signature with a crescent. Hassam dropped out of high school and apprenticed in an engraving shop. By the age of twenty-three, he was set up as a professional artist in Boston. He painted sumptuous street scenes of strolling citizens at twilight, essentially tonal, with tinted, misty atmospheres, often generating pleasant tensions between fleeing perspective and brushy surfaces. These were credible instances of a not quite academic, not quite naturalist, not quite Impressionist international style of the era, sometimes termed the *juste milieu* (roughly, "middle of the road"). Conservative to the core, Hassam gloried in his ancestors, American on both sides since the seventeenth century. He married a woman with a matching pedigree. They were childless. He was a heavy drinker. ("Old Hassam has been off on a bat for three weeks but is all right again," a friend wrote in a letter in 1904.) He and his wife spent the years from 1886 to 1889 in Paris, where Hassam studied with prominent academic painters and fastidiously shunned anything that smacked of bohemia. Thereafter, he settled in New York, with frequent sojourns on Appledore Island, in Maine, and in other picturesque New England spots. After 1919, the Hassams passed half of each year in the decorous art colony of East Hampton.

Around the turn of the century, Hassam plainly had it in him to be an exciting painter. My favorite works in the Met show are two views across Gloucester Harbor, painted in 1899: parfaits with bands of shimmering city and boat-busy water on squarish canvases. The format—in effect, a squeezed panorama—vitalizes Hassam's strengths of summarizing notation and delicately smoldering color, which runs here, as it often does, to luminous yellows and warm blues and greens. The paintings convey personal enthusiasm for a practical-minded place that may be oblivious of its own drowsily cascading summertime splendor. There is a self-forgetful surfeit of pleasures, more than the eye and mind can readily handle. This quality is rare in Hassam, who commonly doles out rapture in conventional spoonfuls, laced with self-conscious, illustrational emphases that are as irksome as explanations of a joke. Hassam spoils, for me, an otherwise wonderful semi-pointillist painting, from 1898, of a governess shepherding two little girls in Central Park by giving her head the "charming" tilt of a fashion-plate model. It's a tiny thing, but shocking for its betrayal of the work's stylistic integrity. It pops the figure out like a paper doll from a tightly woven vision—the cynosure of a spring day—of pale, dappled light and moist, colored shadow. Gratuitous chic turned Hassam vulgar.

A fanatical nativist, Hassam would not admit, perhaps even to himself, the invigorating effects that the French painters had on him. Preposterously, he denied being influenced by Monet. With a humble bow to Seurat at the right moment, he might have attained the poise of a style that was ideal for his gifts: the world compressed to a scrim of opulent color. But the rewards of subordinating his talent to genteel folderol proved irresistible. It earned him membership in a mighty American establishment of holdover nineteenth-century gentlemen whose then

fashionable bigotries are hair-raising in retrospect. He delighted in quoting a characterization, by the leading critic Royal Cortissoz, of modern painting: "Ellis Island art." Hassam's close acquaintance Frederic Remington, the East Coastal Western painter, took things somewhat farther in a letter to a friend: "I've got some Winchesters, and when the massacring begins which you speak of, I can get my share of 'em and what's more I will. Jews-injuns-Chinamen-Italians-Huns, the rubbish of the earth I hate." The immigrant menace was bound to scare self-made men who sensed the vulnerability of their clubby prestige. Having thoroughly compromised himself in the interest of respectability, Hassam faced long odds in an even contest with clever ruffians, just off the boat, who had nothing to lose. Fear may have inspired the late bonuses of his art.

A vigorous still life of pears, from 1918, furtively emulates Cézanne and van Gogh, with broken brushwork that relates at once to the rounded solidity of the objects and to the flat design of the picture; Hassam had eyes to see possibilities that he lacked the guts to embrace. Around the same time, from 1916 to 1919, he made his deservedly best-loved paintings, of flag-bedizened New York thoroughfares. The patriotic mood feels wholly authentic. (So, too, does the held-breath reverence in several Hassams of proud old New England churches. Though reportedly indifferent to religion, he was a pushover for symbols of rock-solid heritage.) The fortune-favored artist had good reasons to love his country, even as he saluted it in a manner that was never more redolent of Monet—who had done stirring work with the same general motif four decades earlier. Wartime emotion moved Hassam to eloquence, which entailed something like true Impressionism at last. The blurred and splintered forms of his flag paintings shiver ecstatically, piling up compositions that collapse perspective into the forward-rushing, all-at-once tumult of a fever dream. American modern painting would not consistently command such sophisticated ardor until the advent of Abstract Expressionism, with its incalculable debt to Ellis Island.

July 12, 2004

AMERICAN ABSTRACT: JACKSON POLLOCK

Half a century ago, on August 11, 1956, an Oldsmobile convertible driven by Jackson Pollock, who was drunk, hit a tree in the Springs, killing the artist and a passenger. It's a dismal enough anniversary—marked with scant attention by the finest art show in New York this summer, "No Limits, Just Edges: Jackson Pollock Paintings on Paper," at the Guggenheim in New York—but glamorous, in its way. Pollock, like other doomed artists and martyrs to fame in his era—Charlie Parker and Billie Holiday, Marilyn Monroe and James Dean—advanced and, by destroying himself, oddly consecrated America's postwar cultural ascendancy. Sometimes a new, renegade sensibility really takes hold only when somebody is seen to have died for it.

Tragedy enhanced Pollock's status as the first American painter, after the corn-belt realist Grant Wood, to achieve general popular renown as a shining native son. Born in Wyoming, Pollock came to New York, from California, in 1930. He was mentored at the Art Students League by Wood's American Scene colleague Thomas Hart Benton. He soon found the Expressionist and Surrealist tendencies of the downtown avant-garde more congenial than Benton's mannered figuration, partly because he was tormented by a belief that he could never draw properly. But a sense of nationalist mandate stayed with him. It's an undertone in his famous reply to the German painter and pedagogue Hans Hofmann, who had suggested that he try working from nature: "I am nature." The glowering Westerner who became known as Jack the Dripper seemed to speak not just for the country but *as* it, in person: the Great American Painter, at a moment that was hot for Great American thises and thats. His helplessly photogenic, clenched features, broadcast by *Life* in 1949, made him a pinup of seething manhood akin to Marlon Brando. It wasn't even necessary that Pollock be a great artist, though he was. Unlike Wood, he countered the humiliating authority of European modern art not by rejecting it but by eclipsing it. Abstraction may have still scandalized most Americans, but suddenly it was a homegrown scandal, with nothing sissified about it. The macho pose, an obligatory overcompensation for aestheticism in the 1950s, ill suited a man whose ruling emotion was fear, which sprung from an anxious childhood in a ragged, nomadic family. But it sold magazines.

Ed Harris's surprisingly trenchant 2000 bio-pic, *Pollock*, showed why it isn't possible to separate the artist's legend from his work. Pollock's all-or-nothing ambition channelled the hopes of an idealistic, conspiratorial milieu. His wife, the artist Lee Krasner, the critic Clement Greenberg, the collector and dealer Peggy Guggenheim, and other ardent sophisticates—abetted by pressure from competing new masters, chiefly Willem de Kooning—groomed Pollock like a skittish

thoroughbred for the big race. Before his myth became a media circus, it was a cottage industry, though conceived in rigorously artistic terms as an overthrow of Cubist and Surrealist conventions in avant-garde painting—of Picasso, in a word. "No Limits, Just Edges" recovers that focus, more through than despite an absence of big canvases. The show's limitation to works on paper (credibly termed paintings, not drawings, because even when the format is small and the medium is ink Pollock's practice obviates the distinction) is a boon to understanding the revolutionary character and protean magic of the drip technique. If there's a weakness in the show, it's an overrefinement in the curating, betrayed by the preference of the organizer, Susan Davidson, in league with other scholars, to call Pollock's procedure "pouring," a fussy nugget of jargon with no support from the dictionary. (Poured paint plays a supporting role in only some of the work.) Not just more accurate and time honored, the vulgar "drip" resonates with a still potent shock of naked materiality which Pollock originated and which has been a major trope in new art (it was decisive for Minimalism) ever since. If we want to be precise about what Pollock did—drawing in the air above a canvas with a paint-loaded stick—the mot juste is "dribble."

Given that Pollock's process remains incomparable, taken up by no other significant artist, his work has not ceased to pose problems of how to discriminate among its levels of quality. This show's abundant service to the eye, in that respect, will come in handy if another anniversary observance, augured a few months ago, comes to pass. I refer to the news that the son of two friends of Pollock's, now deceased, the photographer and designer Herbert Matter and the painter Mercedes Matter, had turned up a cache of thirty-two previously unknown Pollock works, most of them small drip paintings on board. The son, Alex Matter, and the Matters' dealer, Mark Borghi, promised to show them this year. A prominent Pollock scholar had pronounced the work authentic, though perhaps "experimental." Others bitterly demurred. A physics professor decided, based on a fractal analysis of the drip patterns, that the hand that made them wasn't Pollock's. All this played out sensationally in the press, accompanied by faintly plausible but unenchanting reproductions. They looked imitative to me. Of course, artists have been known to imitate themselves. The affair seems to have gone to ground for now. Borghi has said, through a publicist, that no exhibition is in the offing. Lacking the free-for-all symposium of such an event, the Guggenheim show enables quieter, more probing reflection.

Start with a fascinating failure from Pollock's wonder years, from 1947 to 1950. *Number 13, 1949*, in oil, enamel, and aluminum paint, a dead spot in a sequence of fiercely energized pictures, has been cited in defense of "the Matter Pollocks." Like them, it has a blandly decorative effect—in contrast to the unresolved tumult that usually marks a less successful Pollock—but only because a boldly experimental motif proved not to work. After painting an amorphous ground of aluminum, white, red, and green, and before overlaying skeins of dripped white, Pollock executed an irregular network of brushed black diagonal bars. This use of geometric elements recalls earlier work in the show—strenuously forced mergers of regular forms with

surreal figuration and expressive gesture—and looks ahead to the artist's last major drip painting, *Blue Poles* (1952), whose eponymous forms snarl like overloaded lightning rods. In *Number 13*, the bars upstage the drips and downstage the underpainting. Analyzing the work is as instructive as an autopsy. You see the muscles and nerves of an amazing style in repose, which is nothing like the soaring serenity that Pollock attained elsewhere. In his best work, which he produced almost incessantly from 1947 until, after long sobriety, he succumbed to drink again, late in 1950, Pollock mastered a quality reminiscent of van Gogh, who wrote to his brother of being "calm even in the catastrophe."

From early on in the show, you feel the force, however baffled and flailing, of an ambition to reconcile boundless pictorial space (precedented in Mondrian, Kandinsky, and Miró) with raw, emotionally driven physicality. That's what came about when, by dripping, Pollock freed line from description and color from decoration in a work such as *Untitled [Silver over Black, White, Yellow, and Red]* (1948). Warm colors yearn forward; black bites back; silver is everywhere and nowhere; all, as thick substance, configure a wall-like surface. The picture is an improbable but unalloyed visual fact, with nothing mythic about it—nothing American or not American, certainly. Pollock at his peak burned his past conditioning and present turmoil, his very identity and character as a man, and he burned them clean. There's nobody to recognize. That's why it can be hard at first sight to tell a true Pollock from a fake. He prepared us to believe that absolutely anything was possible for him. What determines authenticity for me is a hardly scientific, no doubt fallible intuition of a raging need that found respite only in art.

July 31, 2006

FAIRIES

Take the word "Victorian" out of "Victorian Fairy Painting," the title of an exhibition at the Frick in New York, and you have a redundancy. All painting is fairy painting: materialized visions of immaterial entities that are possessed of some spirit or another. Even the starkest abstract painting maintains in its rectangle a rule of sorcery by which appearance trumps logic and imagination is common sense. We enjoy that, if we like painting. Do we like the paintings in this honey-sweet, hemlock-dripping show? We needn't very much, I think, to find them usefully fascinating. Mostly from the mid-nineteenth century, the oils, watercolors, and whatnot, including a toy theater, memorialize a British craze for gossamer critters which, in the Victorian way, exudes psycho-social wooziness and a remorseless will to charm. To be brief about it, this stuff is the living last word in antique twee. And yet it feels on time for us.

Some of the most interesting younger painters in New York have lately been making figurative, fantasy-driven, small-scale pictures that suggest fairy commando raids on dull convention. I think of John Currin's freakish women and Elizabeth Peyton's swoony rock stars—images that, like conjured fairies, feel born strictly of somebody's wish to behold them. This recent work is unsettling in its insolent sexual and curdled sentimental kinks. But then so is Victorian fairy painting, when you get in among the enchanted toadstools and think about it.

You know which island nation sprouted the toadstools by a prevalent archness that daunts aesthetic contemplation. Britons have rarely taken comfortably to arts that set a premium on self-forgetful sincerity: painting, cooking. Their genius tends toward the self-consciously performative: theater, gardening. When they picture something, they can't seem to help picturing themselves picturing it, and the result is some species of caricature. (Francis Bacon made a howling spectacle of trying, in vain, to destroy this loop.) As it happens, fairy painting may be defined as a hybrid of theater and gardening, with a bonus harvest of Anglo-sexual hysteria.

Lewis Carroll claimed to have counted a hundred and sixty-five fairies in the nocturnal garden of the Scotsman Joseph Paton's gaga 1849 *The Quarrel of Oberon and Titania*. I love it. Mathematics and mythomania: echt Brit. The *Quarrel* parades the surfeits of literary conceit and finicky technique that would make Victorian styles, from Paton's academic folderol to the obsessive scrumptiousness of the Pre-Raphaelites, bugbears of twentieth-century taste. This picture bloats with potted longueurs and showoffy effects. But you know what? It's fun. Let's suspend overeducated judgment for a moment and just gaze. What are those hundred and sixty-five fairies (I take Dr. Dodgson's word) up to? Gambolling, for the most part. Indulging in something like sex, the "something like" being key. The Victorians perfected anti-sensual nudity:

nakedness plus attitude. Attitude puts arousal on hold. Performing erotically, the fairies take no evident note of one another's performance, so sex can't start. It is quite a feat: explicitly orgiastic goings on—shot through with dream and story—that are fit for parlor delectation. Why not be impressed?

Speaking of Pre-Raphaelites, we find in this show the only fairy painting by John Everett Millais: *Ferdinand Lured by Ariel* (1849–50). It presents a stagily tunicked and slippered, little-the-worse-for-shipwreck Ferdinand harking to a naked child of a punkishly green-haired Ariel, who is borne aloft by greenish, bat-like, highly uningratiating fairies. With Pre-Raph cloisonné fuss, Millais draws tedious attention to individual blades of grass and to Ferdinand's embroidered footwear. (I mean, so what?) But he conveys a keenly satisfying take on Shakespeare with his unusually but plausibly scary, malicious Ariel.

The Tempest and *A Midsummer Night's Dream* came in for heavy illustrating by the fairy painters, and so did motifs from and for ballet. This was the era of wafting sylphs and daintily galumphing Wilis. Then there was opium—the tacit collaborator in John Anster Fitzgerald's paintings of drugged sleepers swarmed by creatures from bad neighborhoods of Nod. Not until the late 1960s would pharmacologically induced hallucination again command such popular prestige. And then there was madness. Charles Altamont Doyle, the father of Arthur Conan Doyle, died of epilepsy in a lunatic asylum, in 1893. His watercolor-tinted drawings of frolicsome fairies fall short of delighting. They have a mentally hectic, emotionally numbed air that is familiar from the work of untaught, often institutionalized artists who are termed Outsiders. To Victorian tastes, Outside could be as good as In. Charles had a career—though nothing like that of his brother, the vastly successful fairy painter Richard Doyle, who died at fifty-nine of a stroke.

But the premier mad painter of Victoria's reign, and perhaps ever, was Richard Dadd, who did his dad in. Having murdered the old man in 1843, Dadd fled to France and was arrested after stabbing a fellow stagecoach passenger while on a self-appointed errand to assassinate the Emperor of Austria. He passed two decades in Bedlam, where he was allowed to paint. His pictures are illustrational, in the Victorian vein, but the best of them—notably a talismanic little item from the Tate in London, *The Fairy Feller's Master Stroke*—are also as dense and worrisome as uranium. Viewed voyeuristically through tangled timothy grasses in a darkling gray-green underbrush, the tiny woodsman Feller prepares to axe a hazelnut. Gray-fleshed royals and commoners of a minuscule realm, attended by somewhat lugubrious fairies and a brass band, watch with impassive approval. One needn't be a vulgar Freudian to square this business of busting nuts with Dadd's parricidal rap sheet. Diagnostic readings of art are boring, though, and *The Fairy Feller* does not bore. Looking at it can be a euphoric ordeal.

You keep wanting to turn the lights up. I suppose that Dadd had moonlight in mind, but the leaden illumination hints at something rarer, maybe a solar eclipse. Details we don't care about, like some daisies, glow lividly, while significant figures

founder in murk. The difficulty of seeing feels symbolic of a deeper malaise: a difficulty of being. The Feller is set to strike. It is O.K. for him to strike. The sinisterly glamourous moment tingles with held-breath tension. Nothing happens. The painting is not pretty. Dadd's nine years of labor on it left a surface untempting to the touch. His fairies are plainly the spawn less of air than of soil: Calibanettes. But the work's very grotesquerie guarantees its appeal to contemporary sensibilities. It bespeaks invisible things that someone needed very badly to make visible.

Painting is the medium of the need to see. It is also a medium of the hand, which is the organic emblem of individuality and sincerity. When you paint, your hand distills matter from the rest of you—senses, brain, heart, guts, genitals, soul. Modern art doted on the distilling process while suppressing interest in you, me, or anybody else. Modern art was impersonal. Today, with fairies in our faces, we recognize ever more strongly that modern art is over. For a while, at least, art's future returns to the control of artists, whose quirks and yens—the bases of our trust in them—will govern a search for fresh joys. From art today, we crave discriminations as specific as, say, the difference between an elf and a goblin—and between this elf here and that elf over there. Artists who are bewitched in novel, persuasive, exact ways will lead us on.

November 9, 1998

Notes on the Articles

AMERICA 14
"The American Century:
Art and Culture, Part I,
1900–1950," Whitney Museum
of American Art, New York
April 17, 1999

BEAUTY 17
"Regarding Beauty," Hirshhorn
Museum, Washington, D.C.
November 1, 1999

CALDER IN BLOOM 20
"Grand Intuitions: Calder's
Monumental Sculpture,"
Storm King Art Center,
Mountainville, New York
June 25, 2001

TWIN PEAKS: MATISSE/
PICASSO 23
"Matisse Picasso," MoMA,
Queens, New York
March 3, 2003

A WALK WITH DAVID
HAMMONS 27
"David Hammons," Ace Gallery,
New York
December 23, 2002

RUNAWAY: PAUL GAUGUIN 30
"Gauguin in New York
Collections: The Lure of the
Exotic," Metropolitan Museum
of Art, New York
July 29, 2002

CASPAR DAVID FRIEDRICH 33
Metropolitan Museum of Art,
New York
October 1, 2001

DARK STAR: VIJA CELMINS 36
McKee Gallery, New York
June 4, 2001

LIGHT IN JUDDLAND:
FLAVIN AT MARFA 39
Chinati Foundation, Marfa
September 25, 2000

DEAD-END KIDS:
POLITICAL ART 42
"Open Ends," MoMA, New York
December 11, 2000

BIOMANIA 45
"Paradise Now," Exit Art,
New York
October 2, 2000

"SENSATION" 48
Brooklyn Museum, New York
October 11, 1999

STILL LIFE 51
"Still-Life Paintings from the
Netherlands: 1550–1720,"
Cleveland Museum of Art
December 12, 1999

SEXY SURREALISM 54
"Surrealism: Desire Unbound,"
Metropolitan Museum of Art,
New York
February 25, 2002

THE PLEASURE PRINCIPLE 58
"1900: Art at the Crossroads,"
Solomon R. Guggenheim
Museum, New York
August 7, 2000

MAX BECKMANN 61
"Max Beckmann and Paris,"
Saint Louis Art Museum
March 8, 1999

STILLNESS: CHARDIN 64
Metropolitan Museum of Art,
New York
July 17, 2000

MEET JOHN CURRIN 67
February 22, 1999

LATE, LATE DE KOONING 70
"Willem de Kooning:
In Process," Corcoran Gallery
of Art, Washington, D.C.
May 7, 2001

THOMAS EAKINS 73
Philadelphia Museum
of Art
October 22, 2001

LUCIAN FREUD 76
Tate Britain, London
July 8, 2002

GIACOMETTI 80
MoMA, New York
October 29, 2001

EL GRECO 83
Metropolitan Museum
of Art,
New York
October 20, 2003

PHILIP GUSTON 86
Metropolitan Museum of Art,
New York
November 3, 2003

MARSDEN HARTLEY 89
Wadsworth Atheneum,
Hartford
February 3, 2003

HITLER AS ARTIST 92
"Prelude to a Nightmare:
Art, Politics, and Hitler's
Early Years in Vienna
1906–1913," Williams
College Museum of Art,
Williamstown
August 19, 2002

Index